On the Verge of Photography

Imaging Beyond Representation

Edited by Daniel Rubinstein, Johnny Golding & Andy Fisher

ARTicle Press

BIRMINGHAM, UNITED KINGDOM

ARTicle Press
Birmingham, United Kingdom

This book is supported by Arts and Humanities Research Council,
Birmingham Institute of Art and Design | BCU, and Centre for
Media and Culture Research | LSBU.

Designed by Sheena Calvert & Joseph Bisat Marshall
Editorial work by Hannah Lammin

British Library Cataloguing in Publication Data. A catalogue record
for this book is available from the British Library.

ISBN 978-1-873352-02-1

CONTENTS

ATMOSPHERIC TECHNOLOGIES AND THE POLITICAL

Acknowledgements

Research that breaks new ground and has the potential to re-think the entirety of the field can be a risky and difficult undertaking. The Editors of this volume would like to thank first and foremost the Arts and Humanities Research Council (AHRC) for its generous support of the Photography Research Network, which allowed us to contribute to a redefinition of the foundations of the discipline in light of the digital transformation in culture.

The Photography Research Network enabled us to begin to establish and maintain a strategic web presence and build a unique community of artists, philosophers and scientists whose work was shared via two major international conferences and workshops, one special edition of the *Philosophy of Photography* journal and continuing online and print collaborations. This book, *On the Verge of Photography: Imaging beyond Representation*, emerged from the debates, exhibitions and seminars held at CMCR (Centre for Media and Culture Research, London Southbank University) and CFAR (Centre for Fine Art Research, Birmingham Institute for Art and Design – Birmingham City University) over an eighteen month period of the grant, starting from April 2012.

Due to the collaborative nature of the project, numerous people gave of their time, resources and energy to make this Photography Network and its diverse outputs a reality. Particular thanks must be given to Professor Andrew Dewdney at LSBU whose guidance and dedication to the project made it possible for the entire process to commence. Thanks are also due to Professor John Butler (Head of the School of Art – BIAD) and the Research Funding Committee at BCU for the generous support of this work. Special thanks go to Grace Williams (CFAR Research Assistant), Christopher Camper (web design), Brett Taylor and Luke Robert Mason (technical expertise) – their dedication to the various stages of this project were critical to its success.

This book could not have been completed without the expert design work of Sheena Calvert and Joseph Bisat Marshall and the meticulous editorial work of Hannah Lammin. We are especially grateful for their contribution.

Daniel Rubinstein, Johnny Golding & Andy Fisher

Introduction: *On the Verge of Photography*

DANIEL RUBINSTEIN & ANDY FISHER

*It is a question of extending representation as far as the too
large and the too small of difference; of adding a hitherto
unsuspected perspective to representation – in other words,
inventing theological, scientific and aesthetic techniques
which allow it to integrate the depth of difference in itself; of
allowing representation to conquer the obscure; of allowing it
to include the vanishing of difference which is too small and
the dismemberment of difference which is too large; of allowing
it to capture the power of giddiness, intoxication and cruelty,
and even of death. In short, it is a question of causing a little
of Dionysus's blood to flow in the organic veins of Apollo.*

– Gilles Deleuze, *Difference and Repetition.*[1]

*Everyone is at once a mouth that sucks on the images and an
anus that gives the undigested, sucked thing back to the images.*

– Vilém Flusser, *Into the Universe of Technical Images.*[2]

THIS IS A WORLD of networked digital images in which massive
air-conditioned server-farms create real landscapes and where reality
is found in augmented form on digital screens. Logged into social
networks, life-caching his/her every move, micro-blogging to the

7

world, equipped with smartphones, tablets and helmet-mounted cameras, the contemporary subject can surf the everyday like a layered mash-up made of QR codes and hash-tags as well as sandwiches and pavements. It is increasingly hard to say where digital life ends and physical life begins as every footstep taken can now be live-streamed (on the way to 10,000 steps a day) and each calorie consumed can be archived in the cloud where it forms part of an indelible and ever-evolving data-shadow perused by security services, marketers and lovers. If this multi-layered reality comprising of bits of matter and bits of information appears homey and familiar it is in part due to the ease with which digital images are so readily translatable between different layers of data, code and matter.

The question that animates *On the Verge of Photography* concerns the role played by the photographic image in creating and maintaining this contemporary environment, characterised by infinite bifurcation between the virtual and the real. What happened to the category of the image in the spread and consolidation of computerised processes?

In response to this question it is salutary to remember that until not long ago the photographic image seemed on the brink of being surpassed by such exciting developments as 3D Cinema, Virtual Reality Displays and holographic gaming. However, it now seems that it is the humble photographic image, in all its hybridized digital forms, that encapsulates the interlacing of physical and algorithmic attributes, aesthetic and political forms, which characterise the age of information capitalism. It seems that the digital-born image has become a hinge between these physical and digital modes of existence, combining as it does elements of familiar ocularcentric culture – with its trust and reliance on the true-to-life photograph – and algorithmic processes that problematise the presumption of an ontological connection between images and objects.

Until recently the default position of photography theory was that photography is consumed by the eye. But the digital-born image presents a strong challenge to this foundation and has provoked renewed interest in the nature of photographic representation. Vision and representation have occupied theorists of photography since its inception, whether these categories have been taken at face value in order to celebrate them or their purchase on photographic culture has been challenged. Either way, the relationship between vision and representation has until recently set the frame for our understanding of the photographic. To question photography's status as a visual

form might thus appear counterintuitive. After all, there are few things more apparently obvious than the visual appearances and the representational functions we attribute to photographs.

This is, in part, due to fact that the photographic image in its current cultural form cannot be fully accounted for from any position that begins by taking for granted what an image is. Accordingly, there is no single theory of the image that emerges from *On the Verge of Photography*; neither does it promote any particular methodological approach. Rather, it sets out to provoke questions about the contemporary image and to explore different ways of responding to these questions. *On the Verge of Photography* entertains the idea that the networked digital image has moved us in important respects beyond visual representation. But what might this mean? In their contributions to this anthology, some authors respond to these questions and problems by embracing the idea that there is or should be a "beyond" to representation. Others argue that, despite its transformed terrain, representation remains basic to the production, dissemination and consumption of images and, indeed, to human life. Some pursue critical examinations of novel photographic forms and practices. Others take the contemporary condition of networks as the object of their theoretical attention. These individual analyses and the dialogue that emerges between them will, we hope, serve both to widen and to focus theoretical and critical attention on the recent fate of photography and its relationship to the networked digital image.

This plurality of methodological approaches marks the moment when photography is able to extract itself from dealing only with questions of truth, the archive and the index in order to become interested in its transformed conditions of production, its own states of becoming. One of the consequences of the much lamented loss of ontological connection with the real is that the digital-born image can now be seen for what it is and not only for what it represents. Consider, for instance, that the digital image embodies within it notions of instantaneity and simultaneity which are no less integral to it than the chronology of before and after is to the representational image. In today's visual regime an image can be uploaded to someone's Facebook stream in the morning, "liked" and tagged at various points of the network and by the evening re-emerge as part of diverse and varied series, search results and image-sets that have no linear connection with the event of the original upload: it is trending on twitter, it is siphoned into image mashups, remixed into palimpsets and aggregated with other bits of information to form new images,

texts and sounds, all of the time drawing from an infinite stream
of computer data. Just as the analogue image's relationship to time
could be said to embody the linear chronology of a living organism,
instantaneity and simultaneity are not only the technical qualities
of the digital image, they are also expressions of the mental and
spiritual reality of anyone who is hooked to the network through it.

Once uploaded online, an image can appear anywhere there is a
networked device and it can do so simultaneously across the entire
globe. The digital networked image, it could be said, moves along
two – rather than one – temporal axes. It moves along the axis of
chronological time in which the image maintains connection with an
event in the past, and it also moves along another axis on which the
instantaneity of its dissemination takes precedence. Here an image is
not an archive of past events but a force that shapes the present. For
instance, in news reporting, photography can no longer be reduced
to the documentation of political events as it has become a principal
actor in the unfolding of political situations. In this globalised context,
there are more images produced and disseminated than ever before,
but today we are less sure than ever of what we mean when we talk
about an image and what an image is capable of doing.

There is much more going on with this digital-born image than
meets the eye. If we only talk about the event-image in terms of
visual appearances, we risk missing the infinitesimal complexity of
the underpinning algorithms which account for the fractal-like
ability of the digital image to be repeated, mutated through repetition
and spread through various points of the network, all the time
articulating its internal consistency on the one hand and the
mutability and differentiation of each instance on the other. Within
the digital-born image the logic of representation is augmented by the
logic of self-duplication and mutation. It is as if the photograph is not
the mirror of the world any more, but is itself placed between two
mirrors triggering an endless circulation of reflections. And while the
logic of representation is based on the guiding principle of truth as
correspondence, the logic of *mise-en-abyme* suggests an economy of
repetition that does not depend on correspondence for its agency. This
double articulation of the digital image as a representational image
and as a network event, suggests that the digital-born image is a good
entry point into understanding the mysteries of the online organism.

Perhaps, then, photography is an orifice of the network. But as
long as it is considered from an ocularcentric perspective we stand to
miss crucial factors that shape its meanings and use. If we cannot

understand these forces in conventionally framed visual terms, then what does this mean for any representational uses to which the image might be put? The image is no longer, or no longer only, the passive register of past events. It is active, it has an agency that relates to and has an effect on embodied existence. It comes before and has effects on the real, which resonates with Foucault's understanding of language as having had, in different times, different relationships to representation: '[Language] prophesied the future, not merely announcing what was going to occur, but contributing to its actual event, carrying men along with it and thus weaving itself into the fabric of fate.'[3] Without wanting to reduce the image to language or discourse, or to take yet another linguistic turn, the condition of the contemporary image does seem to be in the process of taking on something like the force and agency that Foucault projects. Language was a force in the world which became subsumed into representation. Photography was born from the womb of representation and has somehow managed to leave this behind.

What can the digital-born image tell us about the categories and concepts previously used to define photography, like the archive, truth, memory and the temporalities of the image as an index of the past? What can the contemporary image tell us about these cherished categories of photography theory, which no longer seem to describe it adequately? If there is one thing to grasp in the face of the digital-born image, it is that we don't know what an image is any more. Rather than dwelling on this as a crisis, one might ask what can we do with this insight?

A possible answer that emerges from the pages of this volume is that multiplicity is one of the conditions of possibility and a determining factor of the digital image and our embodied relation to it. Far from meaning that photography is dead (as many have claimed) important aspects of photography are only now coming into their own. Photography, understood as multiplicity, might just be on the verge of releasing itself from the burden of representation. By foregrounding multiplicity as the determining condition of the digital image, we would also like to suggest the possibility of multiple interpretations of this image that cannot rest on the values of representation. This digital-born, networked and algorithmically constituted photographic image suggests the need for a complete revaluation of its values in order to give it a metaphysics becoming of it.

In contrast to earlier forms of photography, the digital-born image seems defined by how it exceeds familiar terms of visual

experience. What one sees as an image on-screen, for instance, is only conventionally presented to appear the same as the analogue photograph: it is actually a skeuomorph. In reality this image is a variegated field of data that is not bound to obey the material and visual logic often taken to be defining of photography. Conventional understandings of the photograph have tended to concentrate on the material characteristics of film and print, forms for which what happens at their edge has great importance. For example, photography's distinctive manner of excising a moment of time and of framing particular spaces can be said to depend upon the fact that what it shows is structured by what it excludes. Here, what is left out of the frame – and the implied sense of a past and a future pertaining to the moment depicted – give significance to what is visible in the image. These factors have, for instance, been understood in the art historical terms of perspective, composition and artistic intention, and also psychoanalytically, in terms of the uncanny affects that the camera's simultaneous operations of stilling time and cropping space might produce.

On the face of things, on-screen images might seem to obey the same rules as the analogue photograph and to depend upon similar formal constraints for their effects and meanings. But despite this visual similarity the modes of space and time that we habitually identify in the digital image are very different. On-screen, the evocative edges of the photograph – what it shows, cuts off, distorts and thus presents to vision – become arbitrary. Previously it was assumed that the edges, the framing and the cropping of the photo- graphic image were necessary. However, at the level of code, these visible edges are actually continuous with everything else on-and- off-screen. What we are calling the verge of the image is not, in its networked digital form, physically or compositionally marginal. Rather, the verge of the digital image entails the dissolution of defining distinctions between form and content, centre and periphery, image and matter that constituted many of photography's representational strategies. The processing and algorithmic chains of coding that bring images to our screens are always potentially verging on becoming something else and always establishing temporary and labile relation- ships with what they verge upon. These facts register in one's experi- ence of particular images but they also highlight questions about what the contemporary image as such is in the process of becoming.

This is an avenue of thought that foregrounds untamed and unruly elements in the image. It challenges notions of cause and effect

and ultimately remains closed to forms of analysis that seek to resolve the image in clear and precise terms. There is a whole critical tradition that inflected photographic representation with embodiment. Gender critiques and queer critiques, accounts of photography and desire have sought to render representation in the messy terms of bodily processes. But one must also come to terms with the fact that the digital image does not travel along the clean passages that convention might have us believe. Rather than perpetuating the positivist metaphorics of interference-free fiber-optic cables, the passage of information at the speed of light and screens as illuminative epistemological portals we would like to borrow from George Bataille in order to think of the screen-interface as a solar anus, as a 'filthy parody of the torrid and blinding sun' and to collapse "writing with light" into the expanded notion of the digital image as a black hole figured by this anus.[4] One might then ask, with Nietzsche: '[...] how well disposed would you have to become to yourself and to life to long for nothing more fervently than this ultimate, eternal confirmation and seal?'[5]

By naming instantaneity, simultaneity and multiplicity as the forces that shape the field of the digital-born image, we are driven to make two observations on the subject of the detachment of photography from notions of visual representation as a guarantor of truth and as an archive of time. The first is that the time of the digital image is not necessarily chronological, rather it is more resonant with what Nietzsche named "the eternal return" and Heidegger refashioned as "the ecstatic temporality of the 'is'".[6] The second observation concerns the understanding of the technologically produced image as precisely the site at which contemporary subjectivity is being formed and deformed.

Therefore it is tempting, somewhat counter-intuitively, to speculate that photography has not yet really arrived but is only now on the verge of fulfilling its promise. But one might also risk saying that the meaning of being on the verge of photography, in the wake of the digital-born image, is that we are on the verge of becoming like images. What would this mean? Would it be such a bad thing? Far from being the untrustworthy vehicle of manipulation and untruth, the digital image is actually a very accurate image, not, in the first instance, of an external reality but of the ways in which we as humans embody the network and how the network is intertwined with our embodiment.

Notes

[1] Gilles Deleuze, *Difference and Repetition*, trans. Paul Patton (London & New York: Continuum, 2004), 331.

[2] Vilém Flusser, *Into the Universe of Technical Images*, trans. Nancy Ann Roth (Minneapolis: University of Minnesota Press, 2011) 66.

[3] Michel Foucault, 'The Discourse on Language', trans. Rupert Swyer, in L. Searle and H. Adams, (eds), *Critical Theory Since 1965* (Gainesville: Florida State University Press, 1986), 150.

[4] Georges Bataille, 'The Solar Anus', in *Visions of Excess: Selected Writings, 1927-1939*, ed. Allan Stoekl, trans. Allan Stoekl et al, (Minneapolis: University of Minnesota Press, 1985), 9.

[5] Friedrich Nietzsche, 341, *The Gay Science: With a Prelude in German Rhymes and an Appendix of Songs*, ed. Bernard Williams, trans. Josefine Nauckhoff & Adrian Del Carlo, (Cambridge: Cambridge University Press, 2001), 250.

[6] Martin Heidegger, *Nietzsche; The Eternal Recurrence of the Same*, trans. David Farrell Krell,(San Francisco: Harper, 1991), 41. See also, *Being and Time*. trans. Edward Robinson and John Macquarrie (Malden, MA; Oxford: Blackwell, 1962), 334 (§365).

ONTOLOGIES OF THE VISUAL

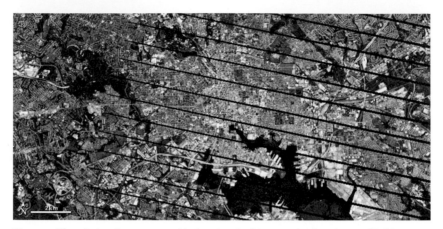

Figure 1. The missing data appear as black stripes in this natural-colour image of Baltimore, Maryland, from May 20, 2009. (NASA Earth Observatory image by Robert Simmon, based on Landsat 7 data.)

I

Atmospheric Correction

S U S A N S C H U P P L I

SINCE 1972 a continuous flow of multispectral information has streamed from 705 km above the earth's surface to ground stations throughout the world, transmitting image-data of landmasses from an orbital pass made every 16 days. The synoptic coverage of the Landsat earth-observation satellite program has produced the most comprehensive archive of the topological dynamics of our planet for more than 33 years. However on May 31 2003 the raw data captured and relayed disclosed a remarkable feature when decoded. In place of the usual full-colour visuals that would typically emerge upon processing, images forcefully striated with diagonal slashes appeared (fig. 1).

A sensor on the Landsat 7 Enhanced Thematic Mapper Plus, the world's the most accurately calibrated earth-observing satellite, had failed resulting in a 22% loss in overall data. Since that time all Landsat 7 images are traversed by a diagonal pattern of dropout.[1]

The malfunction of the Scan Line Corrector, which 'removes the zigzag motion of the imaging field,' had introduced a new visual characteristic.[2] While the Landsat 7 continues to acquire raw data from terrestrial scenes, up to a quarter of this image information has to be retroactively filled-in with data originating from other similar scans. Producing, in effect, a hybrid in which data gleaned from different temporalities is interlaced to create the semblance of a continuous image. 'To fulfil the expectations of the user community for full coverage single scenes, data from multiple acquisitions are being merged to resolve the SLC-off data gaps.'[3] This reparative procedure, or what I prefer to call "atmospheric-correction" in a conceptual nod to another common method of satellite image enhancement is, by its very nature, an act of technical subterfuge, but one not directed towards sabotaging history. On the contrary, its motivation is recuperation and repair. Filling in the gaps in one Landsat ETM+ image with data assembled from another scan taken sometimes weeks later creates an abstract electronic representation that radically re-calibrates the temporal and visual contiguity of the image-event, and calls its indexicality – its ability to account directly for the topological history out of which it arose – into question. As such it also raises certain related philosophic provocations. The diagonal gaps in the uncorrected Landsat 7 imagery are literally "placeholders" for receiving incoming data from the future. The failure of the SLC, in producing a pattern of voided space, registers, by default, the virtuality of atmospheric events yet-to-come. Gaps in a satellite image taken on 9 February 2011 are thus an inducement to a future that will ultimately feed 25 February 2011 back into the system as its digital doppelganger (fig. 2a/2b).

Brian Massumi has suggested that preemption acts not to inhibit a future event from taking place, as per its conventional military formulation, but rather to bring the future into the present as an effect. 'Preemption does not prevent, it effects. It induces the event, in effect. Rather than acting in the present to avoid an occurrence in the future, preemption brings the future into the present.'[4] Unlike Jean Baudrillard's thesis of simulation in which media systems over-encode the real to the extent that they end up supplanting it, preemption doesn't necessarily annul the present, instead it strives to "overlay" the future onto the present as a perceptual event. The example that Massumi turns to is the current system of spectral warning codes used in the United States to alert its citizens to imminent danger and potential threats. The receptor body of the American public is so

Figure 2a – 9 Feb 2011 image/Figure 2b – 25 Feb 2011, filled with image-analysis. Scaramuzza, et al (2004) at Yale University developed a technique to fill gaps in one scene with data from another Landsat scene.

attuned to living in a permanent state of code-red anxiety that they experience the fear of imminent danger as if it has already happened. The dread streaming from the future is internalised within the space of the here and now and thus experienced as an actuality in the present (before anything has happened or will happen). The logic of this transaction between the future and the present does seem to hinge upon confidence in what the future might hold as a likely event. When error-correction is built into a digital processing system it is with the understanding that the system is governed by a probability function that certain events will repeatedly come into being. While it would be misleading to suggest that the black zigzags bring about the "felt-effects" of the future-anterior, it is useful to refract Massumi's conceptualisation of preemption (as that which induces the future in the present) through the post-processing regime of Landsat 7 ETM+ imagery. The very presence of dropout in the images operates as a kind of latency that gestures towards the retroactive re-potentialisation of the present by way of the future. The capacity for images to be read against the grain of representation is a condition that is available to all photographic materials, but it is made explicit when images are composited out of multiple, different on-the-ground realities. Although the image or satellite-scanning event must be retroactively recomposed to create a specular whole, the preemptive

dimensions of this corrective are not bound to the same program (the desire for cohesion) but cut across the smooth plane of visuality to expose, or at the very least trouble, the inherent fiction of the image.

Satellite data (like all digital information) exists firstly as binary code and requires several stages of processing before it can recompose itself into a comprehensible image. Because the processing of raw data gleaned from remote vision technologies is so complex and lacking in agreed-upon best practices a whole new industry assigned with error-correcting its image-data has emerged; notably organised around a distinction between what is seen by machines and how something is processed so that it can be seen by humans. What is clear with regards to the Landsat 7 imagery is the extent of uncertainty that might be present when algorithmic tools are tasked with turning information drawn from different sources into a coherent representational schema or image. While atmospheric-correction is generally designed to remove effects that obscure the surface properties of satellite images such as reflectance, in the case of the flawed Landsat 7 sensor, it would seem that its entire archive of raw scans are equally available for use as algorithmic correctives should pixel attributes align themselves in a relationship of relative symmetry between two discrete image-events.[5] At the time of this writing, I'm not entirely sure how the decision to match and interlace two different images is technically arrived at (whether this is determined by on-the-ground weather conditions or via random sampling of pixels), but we can already see how this act of data-merging across time and space might prove problematic should the image be called to testify within a legal context given the law's need for unadulterated evidence. Even those agencies offering post-processing solutions recognise the compromised nature of such a corrected satellite image and make the source of it's retroactive fix available by providing metadata in the form of a bit mask that details the change in the original value of a pixel. 'In all cases, a binary bit mask is provided so that the user can determine where the data for any given pixel originated.'[6] However this disclosure doesn't mean that their pixelated merger is such that relations can be recoded with impunity. But in making legible the disjunction between temporalities and events we can start to read a micro-politics back into the processing of pixels. By politics here, I mean quite simply a projection into the future that imagines a different version of events – new aesthetic ideas – to that of the present. The binary bit mask, in returning singularity to each pixel, effectively unmasks the fallacy of certainty that scientific

images often carry, reminding us that the present (9 February 2011) can't seamlessly slip into the future (25 February 2011) as a merely a difference in degree organised by the time of month, but should be understood as inaugurating a difference in kind between two different atmospheric image-events and thus two competing versions of history. 'This is why', writes Elizabeth Grosz, 'the question of history remains a volatile one, not simply tied to getting the facts of the past sorted out and agreed on. It is about the production of conceivable futures, the future understood not as that which is simply constituted in the present, but rather, as what diverges from the present.'[7]

Politics enters into the visual field not simply at the level of representation – the content displayed in the image – but at the structural level of its information acquisition, processing, and transmission; at the moment when pure data is captured by sensors, transformed into binary code, assigned pixel values, algorithmically adjusted, composited to produce a digital image, saved in a standardised file format, and transmitted to recombine with others circuits of technical and social assembly. This is what I am calling the micro-politics of [image] processing. All the points of contact between the various networks of information transfer, translation, and transmission that are also points of potential transformation (whether we view this as antagonistic or productive to the overall functioning of the system) that allow difference and thus politics to enter.[8] Politics always operates in the gaps – between coding and recoding – whereas revolution disrupts the fantasy of specular wholeness brought about by algorithmic correctives.

Gilles Deleuze has argued that it is only the 'metamorphosis or redistribution of singularities that forms a history' and that 'each combination and each distribution is an event.'[9] Transposing this provocation to the digital event suggests that each juncture of information processing, from data capture through to conversion and signal relay, is itself characterised by a set of singularities that express conditions attached to that event, which in turn bear upon problematics specific to their manner of dispensation. This is the political dimension of the processing event. The question of politics, following Deleuze, arises out of the problem of information processing, and these problems are themselves "enveloped" in the question of the political as their enabling condition. 'Just as solutions do not suppress problems, but on the contrary discover in them the subsisting conditions without which they would have no sense, answers do not at all suppress, nor do they saturate, the question,

which persists in all answers.'[10] While the problem of the damaged sensor found its practical solution in atmospheric correction (filling in the gaps), the solution opens up a conceptual breach that allows me to reflect upon the micro-politics of algorithmic processing *vis à vis* machine-made images – specifically remote sensing satellite images. To extend Deleuze's provocation to digital processing more generally, one could say that although the operative modality of such processing is considered to be a problem of calculation (between ones and zeros), "processing" is not in and of itself a problem requiring our remedial intercession. Rather, our task is that of "problematizing human events" which in the case of the faulty Landsat 7 sensor came into being through the transmissional regimes of data processing and the networks in which such data is made to circulate as an expression of specific terrestrial events.[11]

Satellite image-analysis has, as we know, produced discourses that have been powerfully influential in shaping the contours of the post-9/11 landscape (perhaps most notably with UN Security Council Resolution 1441 that led to the invasion of Iraq) and yet they have no actual stand-alone legal traction, in large part because they are not subject to any standardised methods of data processing. The uneven treatment of raw satellite data, the algorithmic complexities associated with transforming this coded material into images, and the widespread conviction that such non-human modes of sensing can provide unambiguous representations of conditions on the ground (in spite of their quasi and contested legal status) positions satellite imagery as paradigmatic to a discussion that aims to locate the political within processing. Many theorists have argued that the new perceptual modalities facilitated by computational modes of seeing, from satellite and drone vision to the geophysics of ground-sounding, have so thoroughly abstracted vision that images can no longer guarantee the 'position of an observer in a real, optically perceived world' with the consequence that the conduits of information transfer no longer require the human as their privileged point of reference.[12] This argument can, in part, be traced to much earlier developments in the industrialisation of vision such as the discovery of X-rays, in which emissions could pass through the atmosphere and pierce the body to generate shadowy photographic tracings from at a distance.[13] Referred to as "ghost pictures" because of the mysterious agency that transforms solid forms into ethereal image-matter, the X-ray was the harbinger of a new imaging regime – what film theorist Akira Mizuta Lippit has called a radical form of a-visuality – in which technologies

of remote sensing transgress the physical thresholds of an optically available world.[14] Digital images are also increasingly manufactured by machines to be read and interpreted exclusively by other machines. The proliferation of CCTV data is a case in point as the sheer magnitude of image-capture has necessitated the outsourcing of its low-level image-analytics to other automated scanning processes. This substitution of the human traditions of seeing by technical machines is rendered even more complicated when images are the consequence of elaborate non-visual techniques of observation requiring multiple algorithmic interventions before their data can be convincingly reconstituted into a unified pictorial field. Something that becomes all the more important when these visuals are mobilised as indexical "truth claims" that are called into evidence or rallied in support of statements that provoke action in and on the world.

Is seeing, when derived from numeric code freed from any indexical obligations, able to account convincingly for the histories out of which it developed?[15] Even though photographs resulting from satellite technology have already entered into public forums as corroborating evidence (most notably in the case of Colin Powell's image-analytics for the UN Security Council in February 2003 and in the 1995 documentation of mass graves at Srebrenica), their legal admissibility as stand-alone evidence has yet to be achieved. Until such time that the error-margin of satellite technology is proved to be virtually infallible, satellite images can, for the present, only play a supporting role in courts of law. However this has not diminished their use as a regulatory mechanism or compliance tool.[16] It is the lack of agreed-upon protocols governing the various stages of processing from the recording of raw satellite data, its transmission to a ground station, and its reassembly back into an image-event that have hindered its legal acceptance. In a recent conversation I had with Dr. Ray Purdy, a legal scholar who researches satellites and the law at University College London, he made the point that although codes of practice have been developed by the Home Office for digital speed cameras, at present there are no national or international agreed-upon best practices for the processing and handling of satellite images that would enable such computer-generated images to act as stand-alone evidence:

> A court will be particularly concerned that any image has
> not been processed or altered in a misleading manner. They
> will require further evidence that the satellite photograph

Figure 3. The missing data appear as black stripes in this natural-colour image of Southwest Ontario, Canada from May 25, 2009. (USGS image based on L7 ETM + SLC-off.)

Figure 4. Detail.

came from the original data and had not been mistakenly or maliciously changed in a way that could affect its probity. However the processing of a satellite image in practice is dependant very much on what the image is intended to show. Different interpretations by different operators can result in different conclusions in practice (objects can be removed, positions altered and different colours used).[17]

In order for a digital image to have any legal traction as evidence, approved procedures that guarantee the security of image-data (chain of custody) and standardise its processing from code to pixels (audit trails) are required to secure its legal determination as evidence. Given this predicament, should the stability and integrity of information transfer therefore be held accountable to an originary event, or does the very condition of a highly deregulated commercial satellite market combined with post-processing vagaries render the truth claims of satellite imagery suspect at best? Certainly the long-standing view of the photographic image as objectively congruent with a given external reality still holds within many contemporary discourses, including the juridical, even if it fails to convince within critical photo studies. The point is not to rehearse the contestation of such truth claims, a debate that is already fully worked out, but to reflect upon the provocations that new modes of technical witnessing raise as specifically ethical imperatives for contemporary image-taking/making practices.[18]

In the case of earth-observation systems directed towards uncovering human rights abuses or monitoring conflict (see the recent Amnesty International report on destruction in Aleppo, Syria, July-August 2012 or the Eyes on Darfur project in western Sudan), one might ask whether the algorithmic coding of the terrestrial event can carry any traces of the intensity or violence out of which it emerged? Or is computation evacuated of all political significance until it is recoded and reassembled into an image and narrated, typically by an expert? In my ongoing research on the material witness I have looked at media artefacts, which still manage to archive trace-evidence of the violent events that produced them. These have, to-date, been analogue entities whose material composition lends itself to chemical or physical alteration and with it the capacity to read history back out of matter.[19] The digital, by contrast, seems immune to such ontological contamination, as any incoming information is subject to immediate recalculation producing a new value – a difference of degree – but not a difference in kind.[20] The challenge is thus to relocate aspects of

this broader project (material as witness) within the domain of the digital and its coding processes, which must in turn presuppose a new conception of materiality derived out of calculation and measurement: a provocation for thinking materiality differently, for thinking the digital analogically, that the discussion at hand only initiates.[21]

The question remains: to what extent are digital processes immanent to history and thus able to narrate the particularities of events that enter the circuitry of technical systems as data and exit as images? How might we begin to understand the ways in which coding practices, by virtue of their deep embeddedness in a numerical milieu (which consigns their operations to a sphere of relative invisibility to humans), are also deeply implicated in shaping the kinds of representations that ultimately emerge and with them decisions to act in and on the world? To begin to answer this question we need to work back – forensically – through all the nodes and points of data capture, conversion and recompression, including their transmissional relays with other machinic assemblies. This is what I have begun to do with my analysis of satellite image processing. In resisting the natural tendency to focus exclusively on higher-level image outputs and shifting my attention to the handling of metadata (fixing the phenomena of zigzag) I can begin to track the ways in which different modes of processing intensify connections between data and events.

In the mid-twentieth century the conviction that information could circulate independently of its material substrates and be transmitted without variation between different mediums became pivotal to a new understanding of data as merely a signal passed between nodal points in a channel.[22] This definition of information as entirely abstracted, without signifying connotation, was developed by Claude Shannon in his 1948 thesis *The Mathematical Theory of Communication* when he was a young researcher at Bell Laboratories.[23] Shannon defined information as a "probability function" with no dimensions, no materiality and no necessary connection with meaning. If according to Shannon no message is ever sent, and what is transmitted is only a signal or placeholder for a message, then meaning is deferred to a secondary act of signification that requires the signal's interface with an external interpretative apparatus that can decode its transmissional regimes and restore its signifying content. I have tried to argue for a distributed account of the political that relocates a form of contingent intelligibility within signal processing itself. Ultimately the event of vision "transpires" out an entangled performance between many different kinds of machinic

processes, whether these are analogue or digital in nature, social, technical, or political systems, human or non-human entities, organic or non-organic matter. So while I do not necessarily disagree with Shannon, in the sense that moments when information crosses-over from one system to another do not result in explicit rhetorical signification, nor are these nodes of information transfer entirely devoid of any potential connotation. Just as new photographic theories have parted with Roland Barthes's forceful account of indexicality in suggesting that, at best, the image can attest to an event of some kind having taken place – a camera was present on the scene – without assigning a single immutable reading to the image-event pictured, one can actually harvest a great deal of information from the various stages of digital processing especially at the level of metadata. This information can, in turn, be productively recoupled to an external matrix of events and may even help to redefine our understanding of them. For it is only at the thresholds of information transfer and transmission that certain relations begin to become suggestive and conditional histories start to gain a certain legibility.[24]

There are of course many other forms of satellite image-fixes that I could have drawn upon to make similar points such as ortho-rectification, which adjusts distortion or false-colouration and is used to highlight and contrast vegetative features. However the faulty sensor and algorithmic post-processing of Landsat 7 ETM+ images offers a singularly useful example to explore how the various stages of processing are themselves active agents in shaping the variable contours of the image-event. If satellite systems and remote imaging machines are conceptualised merely as delivery systems for data we loose an opportunity to think about the ways in which such technologies are conditioned by and conditional to the specificities of history: as both capable of making history and becoming a condition for producing new histories. 'The future – that field to which all ethics and politics is directed insofar as they are attempts at amelioration of the past and present – is the condition and very mode of present political, ethical and legal action and effectivity.'[25] Examining the data flows and intensities between machinic processes enables us to redistribute the narrative terrain in which a given image might have settled, an activity that gives rise to new questions and also new problems – and perhaps even a new conception of politics that emerges out of gaps.

Notes

1. Yale University, 'Filling Gaps in Landsat Etm Images' (2011), available at: http://www.yale.edu/ceo, [accessed 6 November 2012].

2. 'Specifically, the ETM+ optics contain the Scan Mirror and Scan Line Corrector (SLC) assembly among other components. The Scan Mirror provides the across-track motion for the imaging, while the forward velocity of the spacecraft provides the along-track motion. The Scan Line Corrector assembly is used to remove the "zigzag" motion of the imaging field of view produced by the combination of the along-and-across-track motion. Without an operating SLC, the ETM+ line of sight now traces a zigzag pattern across the satellite ground track.' NASA, 'Landsat 7' (US Government, 2012).

3. NASA 'Landsat 7'.

4. Brian Massumi, 'The Future Birth of the Affective Fact,' *Conference Genealogies of Biopolitics* (Montreal: Concordia University, Université du Québec à Montréal, Université de Montréal, 2005), 8.

5. Remotely sensed imagery has been used for developing and validating various studies regarding land cover dynamics such as global carbon modeling, biogeochemical cycling, hydrological modeling, and ecosystem response modeling. However, the large amounts of imagery collected by the satellites are largely contaminated by the effects of atmospheric particles through absorption and scattering of the radiation from the earth surface. The objective of atmospheric correction is to

retrieve the surface reflectance (that characterizes the surface properties) from remotely sensed imagery by removing the atmospheric effects. Atmospheric correction algorithms basically consist of two major steps. First, the optical characteristics of the atmosphere are estimated either by using special features of the ground surface or by direct measurements of the atmospheric constituents or by using theoretical models. Various quantities related to the atmospheric correction can then be computed by the radiative transfer algorithms given the atmospheric optical properties. Second, the remotely sensed imagery can be corrected by inversion procedures that derive the surface reflectance. See: H. Fallah-Adl et al, 'Atmospheric Correction' (1995), available at: http://www.umiacs.umd.edu/labs/GC/atmo/ [accessed 2 July 2013].

[6.] NASA, 'Landsat 7'.

[7.] Elizabeth Grosz, 'Histories of the Present and Future: Feminism, Power, Bodies,' in Jeffrey Jerome Cohen and Gail Weiss (eds), *Thinking the Limits of the Body* (Albany: State University of New York Press, 2003), 18.

[8.] According to Warren Weaver, who co-authored aspects of Claude Shannon's information theory, mutations in the transmission of the message are not antagonistic but crucial for systems to evolve in new directions. This idea is particularly pertinent with respect to the transmissional regime of a communications satellite, for example, whose radio transponders receive signals at one frequency, amplify them and send them earthwards at another. At every stage of processing, minute variations and modifications are introduced into the system, which in turn impact upon their potential to accurately account for the sensorial and perceptual realities of out which they emerged.

[9.] Gilles Deleuze, *The Logic of Sense*, trans. Mark Lester, ed. Constantin V. Boundas (New York: Columbia University Press, 1990), 56.

[10.] Ibid.

[11.] Ibid., 55.

[12.] See Timothy Lenoir, 'Makeover: Writing the Body into the Posthuman Technoscape Part Two: Corporeal Axiomatics', *Configurations* 10 (2002), 378.

[13.] On the night of November 22, 1895 German physicist Wilhelm Konrad Röntgen exposed his wife's hand to a series of unusual rays as it rested immobile on a photographic plate. The resulting ghostly view of Anna Bertha's elongated skeletal digits conjured the coming of a "brave new world" in which the potential for dematerialising the corporeal substance of the body by technological means was first realised.

[14.] Akira Mizuta Lippit, *Atomic Light: Shadow Optics* (Minneapolis & London: University of Minnesota Press, 2005), 44.

[15.] In 2011 the US and European Union signed their second Open Skies policy, which further deregulated the aviation industries between the two bodies but also extends the agreement to the private satellite sector. There are no laws overseeing what can be looked at, by whom, and at what scale of resolution. With the exception of Israel, governments have not controlled the commercial satellite image sector and photographs from anywhere can be bought by anyone. See Ray Purdy and Richard Macrory, 'Satellite Photographs: 21st Century Evidence?' *New Law Journal* (7 March 2003), 337-38.

[16.] See Ray Purdy and Denise Leung (eds), *Evidence from Earth Observation Satellites:* Emerging Legal Issues (Bedfordshire: Martinus Nijhof Publishers, 2012).

[17.] Purdy and Macrory, 'Satellite Photographs', 338.

[18.] A new conception of indexicality has since returned in the writings of Ariella Azoulay, in which she examines the ways that people participate in the expanded context of photography understood as a civil, not sovereign, practice. See: *The Civil Contract of Photography* (New York & London: Zone, 2008).

[19.] See Susan Schuppli, 'The Most Dangerous Film in the World', in Frederik Le Roy et al. (eds), *Tickle Your Catastrophe, Imagining Catastrophe in Art, Architecture and Philosophy* (Ghent: Ghent University, the Kask (Ghent Royal Academy of Fine Arts) and Vooruit, 2010), 130–45.

[20.] Computer forensics is able to discern "data remanence" or trace evidence of previous data inscriptions that sit alongside more recent encodings. Although erased digital data is "flagged" by the system as space that is now available for overwriting, data may remain in a residual or partial state of inscription until required, which in turn may also allow it to be recovered by the appropriate technique. See 'Every Contact Leaves a Trace' in Matthew G. Kirschenbaum, *Mechanisms: New Media and the Forensic Imagination* (Cambridge: MIT Press, 2008). However, I still maintain that the phenomena of data remanence does not produce "thick" or topologically sedimented artefacts but merely extends data in space horizontally.

[21.] The re-conceptualisation of information as a new form of matter is implicit throughout this discussion although not developed herein. This view regards information as possessing many of the autopoietic attributes, such as self-modification and measurement that have traditionally been assigned to the category of organic and physical systems. Within physics and the biological sciences information is now being thought as subject to the same kinds of affordances that shape organic matter. Information, like organic matter, is also capable of " self-forming" and "engaging in self-measurement" thus conferring onto information the status of a quasi-material reality. See Patricia Ticineto Clough et al, 'Notes Towards a Theory of Affect-Itself,' *Ephemera: Theory & Politics in Organization* 7-1, Immaterial and Affective Labour: Explored (2007), 61. See also George Caffentzis,

'Why Machines Cannot Create Value; or, Marx's Theory of Machines', in J. Davis et al (eds), *Cutting Edge: Technology, Information, Capitalism, and Social Revolution* (London: Verso, 1997).

22. See chapter two in N. Katherine Hayles, *How We Became Posthuman: Virtual Bodies in Cybernetics, Literature, and Informatics* (Chicago: University of Chicago Press, 1999).

23. Claude E. Shannon and Warren Weaver, *The Mathematical Theory of Communication* (Urbana: University of Illinois Press, 1948).

24. In the Errol Morris film *Standard Operating Procedure* Brent Pack, Army Special Agent in the Criminal Investigation Division takes us through the laborious process of correcting time-codes for the thousands of images taken at Abu Ghraib in order to generate a time-line of events, which can be synced with the prison logbooks. He does this by examining the metadata of each image, which in spite of being repeatedly copied and burned to CD remained intact. By matching similar frames across multiple cameras shooting at different resolutions, each of which registered a different date and time stamp he is able to produce a media archaeology that locates victims and perpetrators within the various temporal strata of Abu Ghraib.

25. Elizabeth Grosz, *Time Travels: Feminism, Nature, Power*, in Next Wave: New Directions in Women's Studies (London: Duke University Press, 2005), 72.

2

The Grin of Schrödinger's Cat: *Quantum Photography and the Limits of Representation*

DANIEL RUBINSTEIN

'It's a poor sort of memory that only works backwards'

– Lewis Carroll, *Through the Looking Glass and What Alice Found There*

Introduction: Through the Rabbit Hole

DIGITAL-BORN PHOTOGRAPHY can be seen as both an indicator and a catalyst of a virtual and incorporeal visuality that constitutes an alternative to the perspectival, oculocentric and linear visual schemas inherited from the renaissance.[1] This new visual regime disposes with the mono-centred grid of Brunelleschi's perspective in favour of a grid of fibre-optic cables, wi-fi transmitters, retina displays and electric power wires.[2] Visual culture has now entered a phase in which

33

computers and not humans are the ones who process, sort, store, archive and distribute images.[3] When computers look at photographs they do not see aunt Helena, a sunset or a birthday cake with candles. Here a photograph is calculable information, not different from other bits of calculable information that we quaintly refer to as songs, films and books. In other words, digital-born photography is now part of the infectious, ubiquitous, seductive and addictive networked environment that underpins not only our interactions with computers but also the way individuals reach out to each-other via social networks, navigate through the city in a way that resembles surfing the web with a smartphone (from one wi-fi point to the next), decide where to go, what to consume and what to do by imperceptibly drawing from a layer of computational, algorithmic, remotely stored and processed information. The availability of this layer of screen-based information determines to large extent each individual's reach into the world and her/his ability to realise plans and projects.[4]

Out of Time

An image on a computer might look like a photograph and this resemblance can prompt discussions about the meaning of the image in the spirit of the Saussureian science of signs. However such semiological considerations are unhelpful as they usually lead to thinking about the image as signifier, coded message or representation and leave some questions unanswered – for instance: what can the digital image tell us about the network, and what is its relationship to time. It is perhaps more constructive to consider the digital image as a layer of ubiquitous information that continually combines and recombines figures, texts, glitches and numbers by passing electronic signals between the nodal points of the internetwork; constructing cells, building new connections and creating proliferating, mimetic surfaces. The time of the digital image is not the linear, chronological time of the photographic archive, but something much more fractal, simultaneous and recursive.[5] Multiplicity and instantaneity are now part of the digital image no less than the ability to order and demarcate historical time was part of the analogue photograph.[6]

Consider for instance that once uploaded to a computer and attached to the network, an image is not constrained to a single physical location but is able to move almost instantaneously from one place to another or appear simultaneously in several places at once. Within each contemporaneous context this blob of data forms a

temporary unity with other images, with varied and discontinuous experiential outcomes. Some instances of the image form "information spaces" that contribute to setting up narrative continuity.[7] In some of these narrations the image might enter a sequence with other images and form a series, yet in other instances the image might fail to link-up or proceed to connect with an entirely different series. It is not only the case that photography is more-than-visual since becoming digital and networked, but also that the visuality of digital photography is augmented by the resonance of this instantaneous transformation – by the ability to affect and be affected, by the unpredictable diversity and simultaneity of the network. A digital image might be directly linked to a time and place in the past, or it can be synthetic, constructed within the bowels of the network purely through computation; but in any case it is also the product of the duplications, variations, transformations, and calculations which are part of the algorithmic and coded structure of the network.[8] As digital images form series, continuities and assemblages they enter into relationships with other images, processes, machines and symbols, and in each instance material connections are formed that create concrete social realities. That the digital image is not meaningless is evident, but it is also evident that it cannot be "read" or "unpacked" with the tools of visual analysis because semiology and representation are unable to follow the narrative diversity in which meaningful sequences are not pre-given but develop out of logical statements, relational conditions, coded transformations and permutations that characterise encoded landscapes.[9]

Thinking Inside the Box

The world-view that asserted the superiority of the representational model persisted more or less unperturbed until the beginning of the 20th century, when this image of the universe was challenged, or rather demolished by the development of quantum theory. Suddenly the deterministic paradigm was flipped on its head; gone was the rational clock model, and the universe turned out to be unpredictable and chaotic, and every clock was to some extent a nebulous, indeterminate and amorphous cloud. This discovery was made by physicists studying electrons, photons and other quantum entities, but their findings had consequences that reached far beyond the sub-atomic level. As Heinz Pagels said in his book *The Cosmic Code*:

> There is no meaning to the objective existence of an electron at some point in space, for example at one of the two holes, independent of actual observation. The electron seems to spring into existence as a real object only when we observe it[...] reality is in part created by the observer.[10]

For Vilém Flusser, the discovery of quantum physics meant that the old categories of matter and form were found wanting. Instead of the centralised logic of representation that emanates from the optical nerve towards the outer limits of space, he proposed to think of matter as made of layers, and not governed by a single set of laws:

> "matter" now looks very much like a series of Russian dolls, one containing the others. The biggest doll is astronomical (Einsteinian), it contains the molecular doll (Newtonian), which contains the atomic doll (where mass and energy merge), which again contains the nuclear doll (where causality abdicates in favour of statistics), which again contains the particle doll (which poses curious problems of symmetry) and the smallest doll is the quark doll (where it is difficult, even meaningless, to distinguish between phenomenon and mathematical symbol).[11]

For the physicist Erwin Schrödinger, the repercussions of quantum physics were so shocking that he devised the thought experiment that became known as "Schrödinger's cat". Nowhere is the strangeness and outwordliness of quantum physics better demonstrated than in the famous exercise that involves a certain cat, a deadly device that can be triggered by a single particle, and a particle generator. What is even more remarkable is that this experiment captures something of the innate ambiguity of the photographic image as it travels between the layers of matter. This is because Schrödinger's cat suggests a new regime of the image, one in which the image is not a placeholder for a linear narrative but the visual manifestation of the difference between narratives.

The experiment places a cat inside a sealed room, isolated from all possibility of outside interference. Inside the room there is a light source that emits a single photon which passes through a half-silvered mirror. When the photon hits the mirror its reflection is split into two. The photon has a 50% chance of going through the mirror and hitting the wall and a 50% chance of being reflected down onto the light sensitive cell. Under normal circumstances, if the photo-cell registers a

beam of light it records it as an image, however in this experiment the wave-function of the photon triggers the photo-cell to smash a phial of cyanide which kills the cat.[12] If on the other hand the photon passes through the mirror without being reflected, then the photo-cell does not register an exposure and the cat is saved.

Now, for someone who is witnessing the event from inside the sealed room, (presumably wearing full protective gear against the deadly cyanide fumes), once the photon is fired the cat will be either dead or alive as we would expect. However – and this is the crux of the experiment – for an observer who is outside the room, the position of the photon is undetermined and consequentially the cat is both dead and alive at the same time. According to classical quantum physics (the so-called Copenhagen interpretation), when the particle is not being observed it does not behave like a particle at all but like a mixture of waves which represent the various probabilities of finding the particle somewhere within the box.[13] However, when an observer is making a measurement, the act of measuring itself forces the quantum entity to choose one or another of these states. The curious and disturbing conclusion is that for each of the observers the factual reality of the experiment is different: for the observer inside the box the cat is either dead or alive, which is consistent with our existential experience of the world, but for the observer outside the box the indeterminacy of the unobserved particle forces the cat to be both dead and alive at the same time. The consequences of this insight could not be greater, for they not only mean that the laws of Newtonian physics do not apply to quantum particles, but they also suggest that the rational logic of traditional physics and mathematics cannot account for the events taking place within the dark chamber of the cat experiment.

Recall that the whole Newtonian-Cartesian framework was premised on the idea that reality can be accurately represented either mathematically with the aid of formulas or visually with the aid of perspective. In either case, to be known scientifically or experienced aesthetically a thing must be other than the knower because a thing is only known as a representation.[14] However, Schrödinger's cat points to the collapse of representation as the idea that knowledge is external to the subject and can be objectively represented.

This is because the bifurcation of the real into two separate realities cannot be represented, or in the words of Deleuze '[t]he diversity of narrations cannot be explained by the avatars of the signifier, by the states of linguistic structure which is assumed to

underline images in general'.[15] Because for each of the observers
reality is different, no unified representation of it is possible. Instead,
difference and not representation is the underpinning principle that
holds the two observers together while simultaneously making them
irreconcilable with each other.

Schrödinger devised the cat experiment to demonstrate the
absurdity of applying quantum logic to something as big and complex
as a cat, but the result was just the opposite. According to Newtonian
laws of motion, not to mention standard logical reasoning, an object
cannot be in two places at once. And yet, Schrödinger's cat stubbornly
insists on being both alive and dead at the same time, inhabiting what
became known as a state of indeterminacy.[16]

Before letting go of the cat, let me spell out the significance of the
feline to photography. The photographic aspect of this experiment is
not only in exposure of the light-sensitive cell to a particle of light but
also – and critically – in the requirement for isolation between the
room with the cat and the observer outside the room. This rupture
exposes the divide between the moment of inscription by light that is
taking place within the camera and the moment of "developing" that
is taking place when a measurement is being made. In this rupture
the ontological condition of the photographic image is revealed as
the difference between two incommensurable states. The principle
of photography is not in the indexical connection between past and
present, nor is it the representation of abstract forms, but in the
visual presentation of time as internally divided. The requirement
for rupture institutes the possibility of an image that captures
indeterminacy and a-symmetry as the very condition of visuality. The
exposure produced by firing a single particle captures the difference
between the two observers. It is neither the dead cat not the alive
one that constitutes the image, rather, the photographic element of
the experiment is the very possibility of the co-existence of the two
and the figuration of the difference between them. In other words,
difference is expressed through the heterogeneity of narrations
underpinned by the bifurcation of time. This bifurcation constitutes
the materiality of the photographic image while at the same time
asserting its indeterminacy.[17] As the digital image on the computer
screen is a configuration of particles that were clumped together by
a computational process, it is significant that a quantum inspired
understanding of photography suggests that apart from the forms
of content such as perception, identity and representation, images
are also forms of expression that contain open ended reflections

on the nature of computation, indeterminacy and the limits of representation.[18]

Getting slightly ahead of myself I want to signal that these understandings prefigure some of the conditions that describe the fate of the photographic image in digital culture. The condition of reproducibility does not warrant a connection with fixed reality. Instead, each repetition of the image opens up the possibility of indeterminacy, variation and multiplication that can pull the image away from an indexical connection with the past. Within the network the image operates on several levels – computational, electro-magnetic, economic, conceptual, particle – and each level produces separate but interconnected affects. The inherent instability of this assemblage makes it impossible to fix the meaning of the image and limit it to the content available to the gaze. Instead, significance and agency are formed by the relations, interactions and dialogues between the different parts of the system. In other words, meaning is established not through the procedure of representation but according to the manifold of relations to the other parts of the network.[19]

Plastic Control

Radical and liberating as quantum indeterminism was, with all the ensuing multiplicities of time and the polyphony of voices on offer, and notwithstanding the energising effect indeterminism had on art and literature, there was still a problem with this world view, which, to put it quite simply, threatened to undermine the whole project of converting all the clocks into clouds. This problem can be summed up as follows: the indeterminism model was at its core a theory that asserted that everything is governed by chance and nothing else. It suggested that the strict rules of the Newtonian clock universe be replaced by randomness, chaos and irresponsibility. In an article titled 'On Clouds and Clocks' Karl Popper sums this up nicely:

> If determinism is true, then the whole world is a perfectly running flawless clock, including all clouds, all organisms, all animals, and all men. If, on the other hand, Peirce's or Heisenberg's or some other form of indeterminism is true, then sheer chance plays a major role in our physical world. But is chance really more satisfactory than determinism?[20]

If everything in life is decided with the throw of a metaphysical dice, what hope is there to build a free and just society? Quite clearly, none whatsoever. If the determinism of the swinging pendulum seemed oppressive and inescapable, then how much more inescapable and how infinitely more oppressive is the thought that we are thrown into an abyss with no logic, no rules and no hope of getting out. This is the kind of desperate abyss that lead the exasperated Dostoyevsky to proclaim in Brothers Karamazov: 'If there is no god then everything is permitted!' It appeared that the discoveries of quantum physics, combined with Einstein's theory of relativity threatened to do more than to simply overturn the old rational paradigm: in addition to heralding the age of nuclear power and supper-computing it also seemed likely to unleash a form of radical nihilism that would jeopardise the very idea of freedom, choice and responsibility and replace them with an entropic mayhem were everything is down to accident.[21]

For Popper the dangers of this kind of nihilism were too grave to ignore. For one thing, this free-for-all indeterminism was only a step away from a fascist state, where no ethical or moral rules apply and everything is determined by pure force. If nihilism is the only certainty, how do you maintain some form of control over the rampant and unrestrained urges that are sure to raise their ugly heads? And to complicate matters further, how do you keep behaviour in check without appealing to the higher power of god, the absolute, or the torture chambers of the secret police?

Popper's solution to this double headed problem of chaos versus determinism was simple and brilliant, and he named it "plastic control". It was simple because he placed a middle point, a kind of halfway-house between the predictability of the determinist clock and indeterminism of the cloud. In positing plastic control as an intermediate membrane or a semi-conductor between determinism and chaos, between the world of representations and the world of probabilities, Popper sidestepped the dualism that maintained that things can only be one way or the other: either a cloud or a clock, either mind of body, image or object. Even more astonishingly, Popper suggested that this layer of plastic tissue is not another system, not a cloudy clock or a clockwork cloud, rather it is the site of consciousness, feelings, desires and sensations. In Popper's own words:

> we want to understand how such non-physical things as
> purposes, deliberations, plans, decisions, theories, intentions,

and values, can play a part in bringing about physical changes in the physical world.[22]

Plastic control is therefore a cluster of appetites, affects and passions that brings together the physical and the analytical, combining them into something both carnal and controlling, both sensual and cerebral. In other words, Popper uncovered a synthetic diagram of social, political, erotic and physical drives that forms images out of chaos. Plastic control does not discipline chaos, but allows it to create connections between bits of matter and bits of ideas that do not fit with each-other like pieces of a jigsaw puzzle and yet they form something like a constellation or an archipelago, or a network.[23]

According to the logic of plastic control, meaning is not to be located in the deterministic world of the clocks but equally neither is it in the indeterminate world of the clouds. As the grey area where feelings, desires, and games of chance rule over logic and reason, plastic control offers a glimpse into non-binary thinking that rejects the dualisms of form and content.[24] In the world of the computer networks, plastic controls are the algorithms that translate the social world of human activity into something that computers can understand as data. And conversely, plastic controls take computer data and make it into something that looks like a photograph when it appears on a screen.

Plastic control allows one to step away from the dialectical reasoning that conceives photography in terms of presence and absence, practice and theory, subject and object. It also exposes the fallacy of thinking about digital photography as being somehow immaterial or virtual. Digital images can be made without a camera, without chemistry, without lenses, even without light, which means that all the old rhetoric about photography being the trace of the real, or having an indexical connection to events in the past does not have to apply to the digital-born image. The idea that photographs have a representational, indexical or signifying connection with events, people and objects in the real world does not need to hold for digital images that rely on electronic signal and computation. The destabilisation of photographic meaning is the direct result of the image being detached from universal notions of representation and re-staged in terms of the plastic materiality that figures the image through difference, bifurcation and self-replication.

This understanding of the digital image as unchained from the dualisms of Western metaphysical thought can help to advance a

way of thinking that is taking on board the material conditions of the network. However, this insight requires the overcoming of the tendency of idealist aesthetics to think of photography as a process that mediates the world with the agency of light to produce legible signs. As the Schrödinger's Cat experiment suggests, the processes that govern particle distribution call for a different distinction between materiality and form. As there is no unified visual field the narrative is in every case irreducibly different. A further consequence to the overcoming of aesthetic representational thought is that the digital image does not have to be understood in visual terms as something to be looked at. Rather the digital image both undermines and transcends representation by actualising an interval between itself and its object. Through its diversity of narrations the digital image acts as a reminder that only the identical, the normative and the similar can be captured by representation while the expressive, the singular and the non-identical remains outside its reach.

It is however salutary to remember that representation operates in two distinct but interconnected ways: as a kind of epistemological code that organises information by creating order out of chaos, and as a political system that organises communities by instituting a shared ethical code. The principle common to all regimes of representation is the exclusion of everything that is singular and non-identical: the barbarian, the freak, the abnormal and the different need not apply. One does not have to be a unicorn or a little green man to be subjected to the exclusion principle: it is sometimes enough to speak with a slight accent, to stutter, to have a lame foot or anarchist tendencies. For this reason, the question for post-liberal political thought is how to inaugurate a community that does not depend on the codes of representation; how to remain sceptical and suspicious about the tendency of images and languages to privilege identity and cohesion over the clamour of disparate voices. Deleuze and Guattari name this non-representational community the nomadic war machine. Its primary objective is not war against the state but resistance to the forms of iconology of the state:

> The war machine is that nomad invention that in fact has war not as its primary object but as its second-order, supplementary or synthetic objective, in the sense that it is determined in such a way as to destroy the State-form and city-form with which it collides.[25]

This dimension of the war machine cements its relevance to the concept of the digital image: the modern capitalist state is marked by the systematic codification of life along the axes of technicity and representation[26] so as to eliminate libidinal creativity that constitutes the only possibility of resistance to empirical reality.[27]

The digital image allows for the non-visual within the visual to become manifest as a diagram of the diversity of fragments. The digital image belongs simultaneously to two regimes of the visual: it is the annunciation of difference as the condition of visuality and it is a computational fractal that has no depth, no inside and no outside. Thanks to this "double articulation" the digital image is both a figure of identity and a figure of transformation of identity into new and unpredictable states. Variation and unpredictability are of another order than representation. They cannot themselves become a subject of representation or be reduced to it. What the digital image is capable of is to express the irreducible schism between the computational and the representational, not dialectically as "lack" or "absence" or "the excluded middle", but as something inhabited and yet non-representational, like the grin of Schrödinger's cat.

Acknowledgements

An earlier version of this chapter was published by www.eitherand.org. I would like to thank the publishers for allowing me to reprint it here.

The argument for post-representational photography as developed in this chapter is inspired by Johnny Golding's writings on fractal philosophy and ana-materialism. I am grateful to Andrew Dewdney and Paul Jeff for reading early versions of this text and for their comments.

Notes

¹· Central to the representational model is the glass-cut distinction between that which the eye can see and that which the mind can comprehend. Descartes famously demonstrated how unreliable vision is by comparing seeing to the actions of a blind man who tries to identify objects by tapping on them with a stick. René Descartes, *Philosophical Writings*, trans. Elizabeth Anscombe and Peter T. Geach (Great Britain: Thomas Nelson and Sons Limited, 1970), 248-9. He argued that the mind, on the other hand, is capable of seeing the truth thanks to the power of reason, which converts the distorted picture painted by the senses into true knowledge. In this way the mind became the true organ of seeing, and the eye (and with it the rest of the body) assumed the role of unreliable witness. This imagistic and pictorial model of the world achieved its most complete development in Kant's *Critique of Pure Reason:* 'Our representation of things as they are given to us does not conform to them as things in themselves, but, on the contrary, that these objects as appearances conform to our mode of representation.' Immanuel Kant, *Critique of Pure Reason*, trans. F Max Müller and Marcus Weigelt (London & New York: Penguin, 2007), 20 Bxx, xxi. Simply stated, this means that I experience the world as a unified time-space continuum not because that is what the world really is but because I experience myself as a unified entity. See also: David Summers, 'Representation', in *Critical Terms for Art History*, ed. Robert Nelson and Richard Shiff (Chicago: University of Chicago Press, 1996), 3-17.

2. Joseph Nechvatal, *Towards An Immersive Intelligence: Essays on the Work of Art in the Age of Computer Technology and Virtual Reality 1993-2006* (New York: Edgewise Press, 2009), 9.

3. For a discussion of a photographic system that does not involve visual presentation but is managed entirely by computers see: John Tagg, 'Mindless Photography', in *Photography; Theoretical Snapshots*, ed. Edward Welch et al. (London: Routledge, 2009), 20-21.

4. Nigel Thrift, *Non-representational Theory: Space, Politics, Affect* (Abingdon, Oxon: Routledge, 2008), 1-27.

5. Johnny Golding, 'The Assassination of Time: (or the Birth of Zeta-physics)', in *Writing History/Deleuzian Events*, ed. Hanjo Berressem and Leyla Haferkamp (Koln: DAAD, 2009), 132-145.

6. On demarcation of time see: Peter Wollen, cited in David Green and Joanna Lowry, *Stillness and Time; Photography and the Moving Image* (Brighton: Photoworks / Photoforum, 2006), 17.

7. "Information space", as a space structured through the flow of information, is drawing on the concept of "timed space", as developed by Parkes and Thrift. See: Don Parkes and Nigel Thrift, 'Putting Time in Its Place', in *Making Sense of Time*, ed. Tommy Carlstein (New York: J. Wiley, 1978), 119-129.

8. On the agency of code and its inherent undecidability (and how this undecidability is politically manipulated) see: Lucas Introna, 'The Enframing of Code', *Theory, Culture & Society* 28, no. 6 (2011), 113-141. On algorithmic photography see: Daniel Rubinstein and Katrina Sluis, 'The Digital Image in Photographic Culture; Algorithmic Photography and the Crisis of Representation', in Martin Lister (ed), *The Photographic Image in Digital Culture*, 2nd Edition (London: Routledge, 2013).

9. Introna, 'The Enframing of Code'. Also see: Gilles Deleuze, *Cinema 2: The Time-Image*, trans. Hugh Tomlinson and Robert Galeta (London: Athlone Press, 1989), 22-40.

10. Heinz Pagels, quoted in John R .Gribbin, *In Search of the Multiverse: Parallel Worlds, Hidden Dimensions, and the Ultimate Quest for the Frontiers of Reality* (Hoboken, NJ: John Wiley & Sons, 2010), 20.

11. Vilém Flusser, 'Immaterialism', *Philosophy of Photography* 2, no. 2 (2012): 219-225.

12. Roger Penrose, *The Emperor's New Mind: Concerning Computers, Minds, and the Laws of Physics* (Oxford: Oxford University Press, 1999), 375-6. See also: John Gribbin, *In Search of the Multiverse*, 170-2.

13. Penrose, *The Emperor's New Mind*, 375-6.

14. Claire Colebrook, *Ethics and Representation: From Kant to Post-structuralism* (Edinburgh: Edinburgh University Press, 1999), 2.

15. Deleuze, *Cinema 2*, 137.

16. Adrian Parr, *The Deleuze Dictionary* (Edinburgh University Press, 2005), 60.

17. Dorothea Olkowski, 'Time Lost, Instaneity and the Image', *Parallax* 9, no. 1 (2003), 28-38.

18. Flusser, 'Immaterialism', 218-9. This is not to suggest that photography became undecidable only since becoming digital. On the contrary, one of the most overlooked and under-theorised aspects of analogue photography is the so called "latent image": the invisible formation of silver halides produced by the exposure of light-sensitive emulsion to light. The latent image is not only indeterminate but also enigmatic, for until it is chemically developed there is no way of finding out what the image contains, yet development also destroys the latent image, effectively severing the connection between the image and the object.

19. Brian Massumi, *A User's Guide to Capitalism and Schizophrenia: Deviations From Deleuze and Guattari* (Cambridge, MA: MIT Press, 1992), 19.

20. Karl R. Popper, *Objective Knowledge: An Evolutionary Approach* (Oxford: Clarendon Press, 1992), 226.

21. 'The underlying idea is that our body is a kind of machine which can be regulated by a lever or switch from one or more central control points. Descartes even went so far as to locate the control point precisely: it is in the pineal gland, he said, that mind acts upon the body. Some quantum theorists suggested (and Compton very tentatively accepted the suggestion) that our minds work upon our bodies by influencing or selecting some quantum jumps.' Ibid., 232-233.

22. Ibid., 229.

23. 'Concepts are events, but the plane is the horizon of events, the reservoir or reserve of purely conceptual events [...] The plane is like a desert that concepts populate without dividing up. The only regions of the plane are concepts themselves, but the plane is all that holds them together.' Gilles Deleuze and Felix Guattari, *What Is Philosophy?* Trans. Hugh Tomlinson and Graham Burchill (London, New York: Verso, 1994), 35-36.

24. This understanding of "plastic control" is inspired by Johnny Golding, 'Ana-materialism and the Pineal Eye: Becoming Mouth-breast (or Visual Arts After Descartes, Bataille, Butler, Deleuze and Synthia with An 's''. *Philosophy of Photography* 3, no. 1 (2012), 99-121.

25. Gilles Deleuze and Felix Guattari, *A Thousand Plateaus*, trans. Brian Massumi (London: Continuum, 2003), 418.

[26.] 'Technicity refers to the extent to which technologies mediate, supplement, and augment collective life; the unfolding or evolutive power of technologies to make things happen in conjunction with people'. Rob Kitchin and Martin Dodge, *Code/space: Software and Everyday Life* (The MIT Press, 2011), 42.

[27.] Theodor Adorno, *Aesthetic Theory*, ed. Rolf Tiedemann and Gretel Adorno, trans. Robert Kentor-Hullot (London: Continuum, 1997), 86.

3

Redundant Photographs: *Cameras, Software and Human Obsolescence*

DANIEL PALMER

> *As inhabitants of the photographic universe we have become accustomed to photographs: They have grown familiar to us. We no longer take any notice of most photographs, concealed as they are by habit; in the same way, we ignore everything familiar in our environment and only notice what has changed. Change is informative, the familiar redundant. What we are surrounded by above all are redundant photographs.*
>
> – Vilém Flusser, *Towards a Philosophy of Photography.*[1]

THE HISTORY OF photography is also a history of automation. And at various key moments – such as when George Eastman pre-loaded the first Kodak box camera with film in 1888 – the activity of photography has been fundamentally altered by changes to the camera

apparatus. Needless to say, the primary aim of automation is to reduce "human labour time (related to a secondary aim of removing human error). Indeed, certain kinds of cameras today – such as those designed to identify car number plates – need no regular human operator at all. Of course automation takes many forms, and is presented to different markets in diverse ways. This chapter concerns the realm of consumer and "creative" photography, where the automation of factors like focus and exposure have typically been sold on the basis that they enable photographers to concentrate on responding instantly to the world around them, rather than investing unnecessary energy engaged in mastering unwieldy technology. The logical aim, as a typical Minolta advertisement from the 1970s put it, is to allow you to 'quickly and easily translate the vision in your mind to your film'.[2] As a tagline for this advertisement makes clear – 'When you are the camera and the camera is you' – the camera operates as prosthetic device.[3] Automation here is naturally linked to the seductions of ergonomics ('The controls are so logically positioned that your finger falls into place naturally') and the guarantees of standardisation ('Everything works with such smooth precision that the camera feels like a part of you').[4] Paradoxically, however, I will argue that, since automation removes decision making from the photographer it has also resulted in situations that render the agency of the photographer more or less obsolete. This has become particularly apparent in recent years, when digital software has augmented the process of making photographs in new ways. Therefore, what I seek to explore are some of the paradoxes of photographic production and the status of the individual photographer in our age of photographic excess.

Experiential Photography

Don Slater has shown that the history of popular photography elicits a conventionalization of '*how* things can be photographed', in which, after Kodak, '*Taking* photographs is itself structured [...] as the paradigm of structuring a complex skill into a few simple actions'.[5] Recently, however, camera makers have sought to give new kinds of control to their consumers, in an effort apparently designed to revitalise and individualise their picture making. These are not the parameters we are necessarily familiar with from the history of photography – of focus, shutter speed, aperture, lens and film. Nor do I refer to auto-face recognition and auto-smile detection. If we are to judge from recent releases, the cutting edge of camera design lies

in software that enables more experimental forms of image capture. Thus, the Lytro "light field" camera, introduced in 2011, which in design more closely resembles a torch than a conventional camera, enables a user to focus the image after the exposure. This is achieved via a combination of micro lenses in front of the normal lenses which break the image down in such a way that the sensor itself captures various aspects of a light ray such as color, intensity, and direction. Software then reconstructs an image so that focus can be placed anywhere in the scene and depth of field can be simulated. Meanwhile, the new Olympus OM-D camera, despite its more traditional appearance, 'aims to change the way in which you experience photography'.[6] Olympus claim in their promotional rhetoric that:

> Its Electronic View Finder (EVF) enables photographers to check the Art Filter effect, colour temperatures and exposure levels in real-time. When shooting, you can instantly "create" a truly unique world and preserve it in exceptional quality. The "world" will be transformed from something you see to something you "take part" in. The OM-D is a groundbreaking new digital interchangeable lens camera perfect for people who want to "take part", "create" and "share".[7]

Of course not all of this rhetoric is new or unique. But the activity of photography, it would appear, needs updating – at least in the eyes of camera company marketing departments. As the use of scare quotes in the Olympus advertisement around the words "world", "take part", "create" and "share" underline, this way of framing the act of photography appears to reflect a certain anxiety on the part of the camera maker about the status of conventional picture making. To be sure, from the perspective of traditional camera manufacturers this anxiety is probably quite genuine, given the declining sales of stand-alone cameras in the wake of increasing quality camera phones that threaten to make point-and-shoot cameras completely obsolete within years. Indeed, the enthusiastic reference to those who wish to *take part in* and *create* a world – rather than merely *take photographs* – represents a new stage in the marketing of cameras. While the appeal to the imagination is a recurrent theme in camera advertising, the recommendations here seem to implicitly critique more traditionally "possessive" behaviours of the photographer. It is almost as though the Olympus marketing department have taken seriously Susan Sontag's

well-known complaint that the camera promotes a "detached" and "passive" way of seeing the world.[8]

These newly "experiential" ways of framing the act of photography are perfectly understandable from a marketing point of view. Camera makers are today engaged in an ongoing effort to commodify photographic activity as a leisure pursuit worthy of a dedicated consumer device. They are now also in competition with the makers of dedicated photo-apps for smart phones. The popularity of iPhone apps such as Hipstamatic and now especially Instagram – simulating nostalgic analogue styles and imperfections within a digitally networked context – continues a long tradition of marketing the experience of photography as fun and above all social. The history of publicity for Kodak, and particularly Polaroid, immediately underlines this point, driven by the imperative of promoting film sales – where most of the profits had conventionally been made. But at the same time, the current rush to experiential photography might also be interpreted as minor crisis in the conception of photography that is sustained by the "possession-based" ideology of what we might call "photographic individualism". No doubt the "I was there" imperative continues to underpin most single photographic acts, but it would appear to be undergoing a subtle but significant reframing. To be sure, Olympus' exhortation to "create your own world" continues to appeal to the photographer's individual ego and the value of their ostensibly unique fantasy worlds. But an individual vision is no longer translated to film, as in the 1970s Minolta advertisement. It is no longer enough to simply "be there", compose an image and expose it correctly. Instead, a photographer can now create a world in the moment of their encounter with it, through the use of features like the real-time "Art Filter effect". In the process, the vision of the photographer is augmented by software. Human vision, you might say, has become not just machinic but algorithmic.

These new cameras – fundamentally driven by software developments – are a response to the condition of photography in an age of online photo sharing. By extension, they are also a response to the new digital environment in which images produced by geographically dispersed individuals, largely redundant on their own, can increasingly be aggregated and organized by metadata into something useful en masse. Flickr, and Microsoft's stitching software, Photosynth, are the two most oft-cited examples of this new photographic universe. Flickr obviously enables a wide variety of conventional photographic practices to continue; however, it also

establishes the possibility of new forms of image organisation via human tagging and non-human calculation – as Flickr's attempt to patent the algorithm for their "interestingness" ranking makes clear. Photosynth is proprietary software that analyses digital images in order to generate a three-dimensional model and a point cloud of the represented space, and then reassembles the images into a near-seamless composite. In what has been dubbed an "algorithmic turn", viewers are then free to explore the assembled photographic space from any direction, including depth.[9] According to a Photosynth press release:

> You can share or relive a vacation destination or explore a distant museum or landmark. With nothing more than digital camera and some inspiration, you can use Photosynth to transform regular digital photos into a three-dimensional, 360-degree experience. Anybody who sees your synth is put right in your shoes, sharing in your experience, with detail, clarity and scope impossible to achieve in conventional photos or videos.[10]

Inspired by research in photographic tourism, "creating a synth", as Microsoft's promotional rhetoric states, 'allows you to share the places and things you love by using the cinematic quality of a movie, the control of a video game, and the mind-blowing detail of the real world'.[11] Thus articulated as a libidinal fantasy of ever-increasing verisimilitude, the user of such software is able to shape and control an image space that is both open-ended and potentially tailor-made to the individual. In the process, not only is the status of the individual photograph reconfigured, the activity of viewing photographs is reinvented as an experiential and pseudo-democratised event even as the images are assumed to remain a transparent broker of the real world.

Roll Film Cameras, Photographic Excess and Modernist Photography

The current experiential and participatory turn in photography is fundamentally antithetical to the modern period of photography. It is well known, for instance, that the Pictorialist photographers were given a shot in the arm by the rise of Kodak and the introduction of cameras that came pre-loaded with roll film. Pictoralism, as a nascent international art photography movement at the end of the

nineteenth century, was largely reactionary – in the literal sense of
wishing to react with individual sensibility to picturesque scenes,
and also in its response to industrial progress. With the rise of
Kodak and instant amateur photography, where suddenly almost
everyone had access to the means of taking photographs, its appalled
protagonists sought to distinguish their activities from the masses of
"snapshooters" by introducing complex and labour-intensive processes
such as gum bichromate printing to ensure their work was seen as
art. Such photographs emphasized the role of the photographer as a
craftsman and sought to counter the argument that photography was
an entirely mechanical medium. Pictorialism was an early form of
modern photography in its embrace of the medium's qualities and the
subjective response of the photographer, but it rejected any taint
of automation.

Or consider the case of one of the best-loved and more influential
photographers of the twentieth century, Ansel Adams. The legacy
of this American photographer goes well beyond his redemptive
landscape images, which are admittedly still revered, and lies
particularly in his insistence on the photographer's absolute control
of the photographic process. For at least three decades various
editions of his instructional books – notably *The Negative: Exposure
and Development* (1949) and *The Print: Contact Printing and
Enlarging* (1950) – were standard texts among serious amateurs and
professionals alike. Key elements of his philosophy, such as the Zone
System – which codified the principles of sensitometry to determining
optimal film exposure and development – became a standard in
photographic courses around the world.[12] Adams' argument was that
the "creative photographer" must master the craft of photographic
technology and the darkroom in particular in order to be free to
express themselves through the finished print. His attempt to establish
artisan credentials for photography relied on a commitment to what
the guru of subjective photography, Minor White, later called "pre-
visualization". While the logic of subjective vision does not determine
the pictorial outcomes, and a variety of results were possible, the
modern photographer essentially treated the camera as a transparent
medium to master, in order to express one's encounter with the
world. Although polarising filters and other chromatic corrections
were encouraged as part of the process, Adams would no doubt
have been offended by the idea of "real time" "Art Filters". Given
the broader modernist privileging of honesty and integrity to one's
individual vision, his general advice was to keep things simple and

never compromise one's vision with technology that cannot be fully understood and mastered.

The modern, or modernist approach is closely associated with the privileging of form – associated with figures like Edward Weston – and "fine print" photographic practices. It represents a complementary approach to that of modern photojournalists indebted to Henri Cartier-Bresson's idea of the "decisive moment" in its emphasis on the integrity of the individual photographer to their subject. However, instead of being an eyewitness to an event, the archetypal modernist "fine art" photographer is witness only to their own feelings in front of form. In both cases, the presence of the photographer behind the lens is essential. In 1978, the curator John Szarkowski famously divided American photography in terms of mirrors or window – where photographers aligned with mirrors focus on self-expression, and windows on observation – but in reality both were dependent on the reflective gaze of a controlling author. Thus the photographer Robert Adams (no relation to Ansel) expressed his conviction in his 1981 book *Beauty In Photography* in the following way:

> Without the photographer in the photograph the view is no more compelling than the product of some anonymous record camera, a machine perhaps capable of happy accident but not of response to form.[13]

Needless to say, in contemporary art discourse, this idea of photography as a "response to form" is out of favour, and the heroic photojournalist is under suspicion. Both, like the "fine art print", have been the subject of broad attack by "postmodern" critics as irredeemably conservative and even inherently patriarchal in their efforts to master the world.[14]

At the same time, in a curious reversal, the idea of the "anonymous record camera" and the "happy accident" have both been embraced in the world of post-conceptual contemporary art. Indeed, it could be argued that the idea of photography as a personal "response to form" had already been undermined from within the field of "art photography" itself. Street photographer Garry Winogrand, for instance, embraced chance and the happy accident. Winogrand famously amassed an unworkably large number of negatives in his effort "to see what the world looks like photographed". When he died in 1984 he left 2500 rolls of film undeveloped, as well as 6500 rolls of developed film he had not seen or edited. Documentaries of the

photographer show him wandering the streets taking pictures in a
seemingly automatic fashion using a motor drive on his Leica camera,
and stuffing plastic bags full of film canisters into a filing cabinet.
Such scenes might evoke the complaint, repeated regularly since the
1960s and typified in the writings of Jean Baudrillard, that the world
is over-saturated with images.[15] As an art critic recently speculated,
the abundance of photographic images has produced a situation
in which no single photograph can 'stake a claim to originality
or affect'.[16] However, such claims of image saturation – at once
iconophobic and iconophilic – invariably miss the point. Single images
operate in various contexts under different spectatorial conditions.
Thus single pictures by Jeff Wall can still command attention in the
art museum, often in light-boxes for maximum impact. Nevertheless,
Winogrand's performance of photographic excess seems prescient
because he treated the photograph, as information, as more or less
interesting. He was completely unsentimental about "previsualization"
or the "decisive moment", and more interested in the camera's
ability to capture slight shifts in movement and angle of view. His
approach, not coincidentally, paralleled the rise of conceptual
artists adopting the camera as an art-making tool for precisely the
reason that Robert Adams disparages: that is, as an anonymous
record camera.[17]

The Pop artist Ed Ruscha famously stated in a 1965 interview
about his work that 'photography is dead as a fine art; its only place is
in the commercial world, for technical or information purposes'.[18] The
photographs in his books, such as *Twentysix Gasoline Stations* (1962),
present exactly what the titles indicate, and appear to be no different
than commercial images. Ruscha's 'collection of "facts"' was followed
by other "serial" approaches in which artists took to the camera only
in order to refuse conventional signs of photographic authorship.
In the case of Douglas Huebler, this conceptual approach amounted
to a something like a philosophy of photography. The operations that
Huebler set up for his "variable pieces" from the late 1960s involved
him taking on the role of photographer-functionary – most notably in
Variable Piece #70, (In Process) Global, (1971) – his life-long project
to 'photographically document [...] the existence of everyone alive'. As
he wrote of his working method in a 1969 statement: 'I use the camera
as a "dumb" copying device that only serves to document whatever
phenomena appears before it through the conditions set by a system'.[19]
Beneath the deadpan pseudo-scientific approach, one might detect
a certain utopianism in Huebler's systematic attempt to decipher the

world through the camera. More importantly, for my argument here, Huebler's role as an artist – performative and mimetic – appears to dutifully reenact the logic of the modern roll-film camera itself.

Vilém Flusser, Redundancy and Digital Photography

Douglas Huebler outlines a position that is given more full expression in Vilém Flusser's 1983 book *Towards a Philosophy of Photography*, as John Miller has perceptively intuited.[20] Flusser posits the photograph as a "technical image" and the camera as a programmable apparatus, one that, paradoxically, programs the photographers (functionaries) who use it. The terms redundant and redundancy are important ones in Flusser's writing, influenced as he was by Shannon's communication theory, and the history of communication technology as a process of increasing abstraction and automation. For Flusser, "redundant" photographs are those that carry no new information and are therefore superfluous. Flusser speaks of 'the challenge for the photographer: to oppose the flood of redundancy with informative images', that is, those that provide the photographic universe with new information.[21] Flusser allocates "snapshots" to the realm of redundant images, and his critique of so-called "creative photography" is based on the idea that most of what people are doing when they photograph is to reproduce clichés set in place by the apparatus.[22] However, Flusser's critique is more complex than often recognized, counterbalanced as it is by his praise for what he calls "experimental photography": 'to create a space for human intention in a world dominated by apparatuses'.[23] Elsewhere Flusser speaks of "envisioners" who actively work against the automation of the apparatus – and at times he would appear to be a straightforward defender of what we already identified as subjective vision. Thus, on the one hand, he pessimistically states that 'the photographer can only desire what the apparatus can do [... and] the intention of the photographer is a function of the apparatus',[24] while, on the other hand, he celebrates "envisioners" as those with 'the capacity to step from the particle universe [of abstraction] back into the concrete'.[25]

In Flusser's essay 'The gesture of photographing', published the year of his death in 1991, but only recently translated into English, he presents what is undoubtedly his most sanguine account of the photographer's potential role. Here, between periods of reflection and moments of action, photography is positioned as part of a phenomenological 'project of situating oneself in the world'.[26] Flusser

goes so far as to call this 'a movement of freedom', 'a series of
decisions that occur not in spite of, but because of the determining
forces that are in play'.[27] Flusser also celebrates the "reflection"
on the part of the photographer engaged in the photographic act:

> The camera has a mirror, and when the photographer looks
> into it, he sees how his picture might be. He sees possible
> pictures and as he looks in this futurological way he chooses
> his own picture from those available to him. He rejects all the
> possible pictures except this one and thereby condemns all the
> other possible pictures, except this one, to the realm of lost
> virtualities.[28]

For a writer better known in the English-speaking world for
identifying the photographer as a "functionary" of the apparatus,
this is an unusually poetic defense of the photographic act. However,
in focusing only on the moment of capture, Flusser ignores the
fundamental role of editing pictures after they have been taken. Given
that cameras are now capable of capturing at least five frames per
second, and increasingly, high definition still images can be drawn
from moving image footage, the image is only "chosen" on the
screen afterwards. In other words, today's photographer may in fact
hold on to such "lost virtualities" (even of focus, for instance, in the
case of Lytro). Thus, one might legitimately ask how the editing of
photographs in software such as Photoshop or Lightroom complicates
Flusser's equation, given that endless different virtual versions of
an image are enabled by the lossless editing of digital files. Rather
than situating oneself in the world in the act of photographing, a
photographer may now approach the world as fluid raw material to be
selected from and manipulated later. In some sense, the photographic
moment has been extended indefinitely. The "mirror" of the camera
(which in fact many do not possess) is no longer merely reflective but
malleable and programmable. And the print is no longer the resolution
of the previsualised image – comparable to the "performance" of the
negative "score", as Ansel Adams once suggested – but one possible
outcome of various software actions.

Flusser's arguments, pitting the photographer against the
apparatus, reverberate in Julian Stallabrass' 1996 essay '60 billion
sunsets'. Stallabrass is concerned with what he calls 'the demise of
the amateur attitude to reality' – by which he means the meaningful
use of cameras that were understood by their users.[29] Stallabrass

romanticizes the 35mm amateur photographer's activity as a zone of freedom, or non-alienated activity, salvaging the hobbyist against the snobbery normally directed at them by professional artists. He argues that the increasing automation of cameras paradoxically disables the amateur photographer by removing their erstwhile control under a haze of electronic sophistry. As he says, 'the camera becomes a mystical object which uses its possessor'.[30] Indeed, although we have identified a shifting pattern of labour away from the moment of capture towards post-production, we know that most photographs are not manipulated later – or only in the most cursory of ways (a visual "boost" upon import to a computer, or the removal of red-eye). Undoubtedly this under-utilised creative potential is another of the motivations for Olympus to shift the moment of transformation to the moment of capture in their OM-D. However, features such as "Art Effects" – as we have seen above, in a similar way to playful camera phone apps – serve largely to mystify the process of capture.

In the digital world, Stallabrass predicted, narcissistic simulations are likely to prevail: 'the represented object loses it rights: there is no bar to unleashed subjectivity'.[31] One is reminded again of the marketing for the Olympus OM-D, which implores users to "create your own world". It could be argued that the resulting multiplicity of atomized "private" worlds prevents the possibility of referring to a shared "public" world. If there is no common world, where does this leave documentary photographers engaged in social change? However, the possibility for "unleashed subjectivity" is also accompanied by an opposing trend: the increasing automation of the process of capture along standardised lines, which seek to remove chance and homogenise image-making. Point-and-shoot cameras increasingly shift creative decision making to the camera instead of the person taking the picture, offering automated modes labelled "intelligent auto" – which detects your environment and adjusts the camera's settings accordingly, choosing the most appropriate scene mode. Face detection and smile capture even decide when the picture is taken. Thus a witty advertisement for Fujifilm's Finepix F70 camera features an image of a funeral with a group of solemn, black-clad mourners – with the digital camera's green focal square brackets locked onto a gentle smile on the face of a young woman. Such software additions are designed to make the camera smarter, and in the process allow the photographer to be less responsive, if not dumber.

Jean Baudrillard, in another echo of Flusser's pessimistic position around the photographer as functionary, once suggested that 'man

himself performs only what the machine is programmed to do and the 'camera is a machine that secretly distorts any specific will, that erases all intentionality, supporting only the pure reaction of taking pictures'.[32] Thus, he wrote, the resulting images 'may be the object's insight into the subject and not, as we commonly believe, the subject's insight into the world.'[33] According to Baudrillard, 'the magic of photography [...] is this involution of the subject into the black box, this devolution of his vision to the impersonal eye of the camera.'[34] Baudrillard's embrace of radical objectivism here must be read with caution, laced as it is with his infamous irony. As a photographer himself, he would have known that photographic images are produced through a human-machine interaction with the world. However, Baudrillard also notes that whereas traditional machines (including analogue cameras) were strangers to humans, and something one felt alienated from, "interactive machines" and "computer screens" do not alienate; rather 'I am connected with them, I am integrated with them. They are a part of me, a part of myself, like contact lenses, like transparent prostheses integrated into the body'.[35] Modern cameras and computers have combined, of course (quite comically in the era of tablet devices such as the iPad, where people hold up a screen to the world in a gesture that is anything but seamless). As a result, one needs to go further than Baudrillard. Since the camera is no longer just a "black box", but a networked digital device, human vision is devolved not merely to the impersonal eye of the camera but to the network and all its protocols.[36]

The Networked Camera

As we have seen, the digital environment for photography – in which images have become just another form of data – helps to enable various forms of post-human vision, such as car number plate cameras that store and match records in computer databases. Paul Virilio has long referred to the production of "sightless vision" and "the industrialization of vision" as part of a logic of modernity.[37] However, my interest here lies in how networked automation impacts on ordinary photographic practice and the idea of the photographer as an individual creative agent. There are of course no clear conclusions to be drawn from the current situation. For example, it could be argued that the combination of camera phones and social networking is making photographic production more individualistic and intimate (the mobile phone is owned by an individual rather than a family, and

images are often deployed in the service of performative presentations of the self on sites like Facebook). On the other hand, as Kate Steinmann has suggested, photography seems to function within social media 'as a collective, transindividual affective practice'.[38] To be sure, social networking software facilitates the collaborative input of large numbers of people in the all-important process of tagging. As Daniel Rubinstein and Katrina Sluis explain:

> Tagging, commenting, titling and annotating of images are essential elements of participation in the social aspects of photo sharing which play a role in creating communities of users interested in specific images[39]

Given the importance of databases in digital networks, one conclusion we might draw is that aggregations of images are increasingly more important than individual images. Indeed, value is acquired through circulation, and the individual author of specific photographs is often unimportant.[40]

The online networking of photography and the participatory world of Web 2.0 is altering the dynamic between photographer and machine in ways that writers like Flusser and Stallabrass could not have anticipated. The digital camera is now thoroughly entwined with the network, and the redundancy of individual views of the world has in some ways been institutionalised. Thus the Dutch site Woophy (WOrld Of PHotographY) encourages amateurs anywhere – in Borges-like fashion – to fulfil its ambition "to ultimately cover every inch of our world map with images that represent the world's beauty". For the exhibition *We Are All Photographers Now!* (2007) at the Musée de l'Elysée in Lausanne, Switzerland, anyone who was interested could submit a photo online. In an attempt to respond to the rapidly changing world of digital photography, submissions were received from more than 7500 photographers from 128 countries. However, rather than one or more humans selecting the work to be shown – in the manner of classic group exhibitions like *The Family of Man* (1955) – each week a hundred images were chosen at random by a computer and printed in archival quality. The selections were shown in the museum for a week before being replaced by the next selection, and so on.

A number of critical artistic strategies have also emerged from this new context. German artist and photography critic Andreas Müller-Pohle anticipated key aspects of the current situation in his 1985

manifesto-like essay 'Information strategies', written at the cusp of the emergence of digital photography. Müller-Pohle predicted that soon 'it will be possible to generate and regenerate literally *every* conceivable – or inconceivable – picture through a computer terminal'.[41] This declaration coincided with Müller-Pohle's critique of conventional photography, which he found "exhausted" as a strategy. Deeply influenced by Flusser's basic position that most photographs are redundant, he wrote of the 'impressionistic gestures' of conventional creative photographers that 'can only be consistent in so far as they are concentrated into "a personal way of seeing"' (stylization), and dubbed this process "photographism". Müller-Pohle's own response as an artist was to turn his attention to the apparatus itself, and to digital code in particular. Müller-Pohle's prediction about generating pictures through the computer terminal has found some unlikely realisations in the form of software tools such as Google Image Search. Indeed, a number of contemporary artists have chosen to use the automated cameras of Google Street View for their creative projects. Artists Jon Rafman, Michael Wolf, Mishka Henner, and others have utilised the space of Google Street View as a virtual form of photojournalism, personalising the impersonal lens of Google's roving cars. Rafman has compared his work with Google Street View to that of classic street photographers like Cartier-Bresson, who sought out "decisive" moments of serendipity.[42] Now, however, instead of a photographer capturing something unfolding in front of the camera, images are found and selected retrospectively, long after the moment has occurred, by scanning and hunting in Google's vast image archives. The photographer is no longer present to the event, only to the monitor screen.

Some of the more adventurous and engaged curators have started to recognise the challenge to conventional ways of thinking about photography posed by networked photography. For the exhibition *From Here On* at the 2011 Arles photographic festival, five artists and artistic directors (Clément Chéroux, Joan Fontcuberta, Erik Kessels, Martin Parr, and Joachim Schmid) signed a manifesto declaring a profound change in photography brought about by the dominance of the Internet and digital creative methods in accessing and distributing images. The display included thirty-six artists who recycle, clip and cut pictures from sites like Google Earth, Google Street View, Facebook and Flickr. The exhibition continued to privilege a creative role for individual artists – reasserting their ability to make sense of the new digital universe – but their traditional role was questioned.

For instance, one of the "photographers" was a cat from Devon called Nancy Bean. In recent years, thanks to inexpensive, lightweight "petcams" that can be fastened to a collar and programmed to take photographs at regular intervals, a number of "photographer cats" have emerged and even attained minor celebrity status. Nancy Bean's owner, Christian Allen, fitted his three-legged cat with a camera as part of his architecture course at the University of Plymouth. The resulting photographs are much as you might imagine – low-angled and often blurry images of gardens and the sky, the underside of cars, the cat bowl, the occasional human or animal encounter, and so on. Admittedly, cat photographers – the most famous is Cooper (www.photographercat.com), an American Shorthair in Seattle who has sold thousands of dollars of his work in galleries – are only as good as the images their owners select. However, they underline not only the redundancy of most photographs, while also hinting at the imminent explosion of images by non-humans. Apparently humans are increasingly incidental to photographic production.

Conclusion

My aim here has not been to evoke nostalgia for master photographers and their frequently grandiose claims, nor to elicit any specific political or aesthetic concerns about image saturation. My point is not to evince nostalgia for the analogue era, but to recognise the current conditions for photographic production. I am particularly interested in whether photography historians, theorists and curators need to start thinking about photographic authorship in more critically expansive ways. As we have seen, the creative act no longer belongs to the photographer alone, if it ever did, but is deferred to software, and to increasingly collaborative possibilities (both human non-human). At all levels – capturing, editing, distributing and receiving – the traditional role of individual human agency in photography is changing. Thus, even as viewers of online images via sites like Photosynth are increasingly 'free to explore an extensive and dynamic image space unconstrained by [...] an authorised or "correct" viewing position', computer software is increasingly capable of reading the images that reside in online databases, both via metadata and image pattern recognition.[43] In short, the decision making that Flusser reserved for human operators is opened up to various modes of software-enabled interactive viewing. This has major implications for how we might think about the idea of photography and its

fundamentally human-centred terms such as "witnessing". I began this chapter with reference to the release of recent digital cameras that seek to extend the creative act via delayed decision making – respectively, post-capture focus, and "real time" engagement with the world via the electronic view-finder. We might now understand these developments as introducing photographic experiences of a particular kind, ones that are romantically attached to the individual who is immersed in the network and yet still struggling to visualize a sense of their own position within it. That is, experiential photography is a paradoxical appeal to resist the logic of the networked apparatus, and its transfer of agency, already underway, from the camera operator to the new functionaries, both human and non-human, of the database.

Notes

1. Vilém Flusser, *Towards a Philosophy of Photography*, trans. Anthony Matthews (London: Reaktion Books, 2000), 65.

2. Minolta print advertisement, 1976.

3. Ibid.

4. Ibid.

5. Don Slater, 'Domestic Photography and Digital Culture,' in *The Photographic Image in Digital Culture*, ed. Martin Lister (London: Routledge, 1995), 134, 141.

6. Olympus OM-D advertising promotion (2012), available at: http://olympusomd.com/en-AU/omd/e-m5/overview/features/#/?page=concept [accessed 21 May 2012].

7. Ibid.

8. Susan Sontag, *On Photography* (Middlesex: Penguin Books, 1978).

9. William Uricchio, 'The Algorithmic Turn: Photosynth, Augmented Reality and the Changing Implications of the Image,' *Visual Studies*, Vol. 26, No. 1, (2011), 28.

10. Photosynth press release, (August 21 2008), available at: http://www.microsoft.com/india/msindia/pressreleases/microsoft-live-labs-introduces-photosynth-a-breakthrough-visual-medium/90/ [accessed 26 June 2013].

11. Microsoft newsletter, (September 2008), available at: http://www.microsoft.com/belux/interactive/newsletter/08-09/articles/photosynth.aspx [accessed 26 June 2013].

12. Sean Cubitt et al., 'Enumerating Photography from Spot Meter to CCD', *Theory, Culture and Society*, Vol. 30, No. 3 (2013) [forthcoming].

13. Robert Adams, *Beauty in Photography* (Millerton, NY: Aperture, 1981), 15.

14. Abigail Solomon-Godeau, *Photography at the Dock: Essays on Photographic History, Institutions, and Practices* (Minneapolis: University of Minnesota, 1991).

15. See Jean Baudrillard, *Simulations*, trans. Paul Foss, Paul Patton and Philip Beitchman (New York: Semiotext(e), 1983).

16 Chris Wiley, 'Depth of focus,' *Frieze*, No. 143 (2011), 88.

17. Jean-François Chevrier, 'The adventures of the picture form in the history of photography,' in *The Last Picture Show: Artists Using Photography 1960-1982*, ed. Douglas Fogle (Minneapolis: Walker Art Centre 2003), 123.

18. Ed Ruscha quoted in John Coplans, 'Concerning *Various Small Fires*: Edward Ruscha discusses his perplexing publications', *Artforum* Vol. 3, No. 5 (1965), 24.

19. John Miller, 'Double or nothing: On the art of Douglas Huebler', *Artforum*, 44.8 (2006), 222.

20. Ibid., 220-227; see also: Flusser, *Philosophy of Photography*.

21. Flusser, *Philosophy of Photography*, 65.

22. Ibid., 26.

23. Ibid., 75.

24. Vilém Flusser, *Into the Universe of Technical Images*, trans. Nancy Ann Roth, (Minneapolis: University of Minnesota Press, 2011), 20.

25. Ibid., 34.

26. Vilém Flusser, 'The gesture of photographing,' trans. Nancy Roth, *Journal of Visual Culture*, 10.3 (2011), 280.

27. Ibid., 289.
28. Ibid., 291.

29. Julian Stallabrass, *Gargantua: Manufactured Mass Culture* (London: Verso, 1996), 36.

30. Ibid.

31. Ibid.

32. Jean Baudrillard, 'The Vanishing Point of Communication', in *Jean Baudrillard: Fatal Theories*, eds. David B. Clarke et al. (Oxon: Routledge, 2009), 21.

33. Ibid.

34. Ibid.

35. Ibid., 22.

36. Daniel Palmer, 'The Rhetoric of the JPEG', in *The Photographic Image in Digital Culture*, ed. Martin Lister, Second edition, (London: Routledge, 2013) [forthcoming].

37. Paul Virilio, *The Vision Machine*, trans. Julie Rose (Bloomington: Indiana University Press,1994), 59.

38. Kate Steinmann, 'Apparatus, Capture, Trace: Photography and Biopolitics', *Fillip* 15 (2011), http://fillip.ca/content/apparatus-capture-trace-photography-and-biopolitics [accessed 21 November 2011].

39. Daniel Rubinstein and Katrina Sluis, 'A Life More Photographic: Mapping the Networked Image', *Photographies* 1.1(2008), 19.

40. Daniel Palmer, 'A Collaborative Turn in Contemporary Photography?', *Photographies*, 6.1 (2013) [forthcoming].

41. Andreas Müller-Pohle, 'Information Strategies', trans. Jean Säfken, European *Photography 21*, Vol. 6, No. 1 (1985), available at: http://equivalence.com/labor/lab_mp_wri_inf_e.shtml [accessed 2 June 2010.

42. Jon Rafman, 'The Nine Eyes of Google Street View,' *Art Fag City*, (12 August 2009), available at: http://www.artfagcity.com/2009/08/12/img-mgmt-the-nine-eyes-of-google-street-view. [accessed 28 September 2011].

43. Uricchio, 'Algorithmic turn', 25.

4

Object Communication of the Photographic Assemblage

Introduction: Technical-Aesthetic Observation

WALTER BENJAMIN, IN his second version of *The Work of Art in the Age of its Mechanical Reproducibility*, expressed a historical opening for media technologies beyond their participation in what he had before called the phantasmagoria of capital and commodity.[1] In it he wrote that the loss of aura in a work was not a loss or destruction of an aesthetic sense, but rather a possibility for a new acquisition of human apperception – precisely a practice and mode of observation – opened up by technology. Film, which was a technological extension of the "photographic device" in its image/shot editing technique, was a form of "play".[2]

Far from arguing that photography and film represent a deterministic technological deployment for mastery over nature, Benjamin describes the establishment or opening of a field of play where it is not merely images, sequences, celluloid and lenses at play. Along with these media, human knowledge, discourse, bodies and practices enter the field, and are repeated for refinement and learning. Benjamin recognizes here what Bourdieu would call habitus and Foucault would label techniques of the self – in Benjamin's case, all through media technologies. Segments of life here are a process of procedures, rehearsal, and then mimesis – Benjamin will identify mimesis as the 'primal phenomenon of all artistic activity' and the human body as the simplest medium for mimetic practice.[3] 'The mime presents himself as a semblance [...] he plays his subject'.[4] In playing and rehearsing through these media, it is not the photograph or the film as work that represent reality (since they have lost their aura), but, rather, the human body, its movements and its identity that become semblances of other things in the world. Benjamin provides a moment of contribution to a post-humanism, importantly, not through semiology, or the discursive or psychoanalytic lenses that would emerge later, but specifically through the analysis of media and human beings. Benjamin's claim is that a new social formation, a new collective, was linked to humanity's future capacity to live and communicate through the technologically mediated rehearsals, as a human being's 'whole constitution has adapted itself to the new productive forces which the second technology has set free.'[5]

Crucial to Benjamin's analysis is his conception of photographic and cinematic technologies – not in the sense of being visual mediums employed by the producer, but in terms of how those technologies function beyond both their visual and aesthetic contexts, as well as the producer's intention. This approach raises the question: what, in specific relation to the photographic and cinematic, is the purpose of technology? In his critical account of technological processes Benjamin combines his historiographic and philosophical approach with descriptions of bodies and objects as well as the spaces of technological procedure. Communication, both human to human and technology to human, matters. His answer to the above question is that the purpose of technologies is that of experiment, where through technologies the process of play strips the human being of its metaphysical character. This is precisely the process he describes in a cinematic "test performance," one in front of a group of experts (directors, producers, etc.) that interact with each performance, one

that is repeated and performed non-narratively, non-linearly. The result of such an experiment, is, again, the transformation of what human is, when:

> the human being is placed in a position where he must operate with his whole living person, while forgoing its aura. For the aura is bound to his presence in the here and now.[6]

Radical Historiography and Media Objects

This observation derives from a larger media history project that analyses computing research documents from the cold war, specifically the period from late 1950s to early 1960s, or the shift from 2nd generation (transistor powered) computers to 3rd generation digital computers (which utilized microelectronics in the form of the integrated circuit). Within this context I take Manuel Delanda's extension of Gilles Deleuze's assemblage theory as a useful way to analyse computers and photography in non-representational, non-hermeneutic terms. I also see assemblage theory as an example of a larger area of media analysis that utilizes the nonhuman as a principle catalyst of change and that integrates critical humanist and scientific modes of thought.

Photographic technology has a twofold historical relation to this development of computers. First, photography fits (too neatly) into computers' past as one technology in official stories of a lineage of visual technologies – from painting, to imagistic, to screen to interface – whereby each new medium takes what is aesthetically useful from its predecessor while simultaneously putting the prior form into a state of precarity. We then see a sequence of "deaths" (of the photographic in the face of immaterial image, of the cinematic in the face of proliferating interactive and small screens, of the televisual in the face of a litany of online content, etc.).

Second, engineers, scientists, the military and burgeoning computing corporations all utilized photography to document computers within their spaces of experiment. As early as 1954 the U.S. military computing research showed signs of being embroiled in a new paradigm of visuality as new fields of knowledge (such as cybernetics) and information formed from shifts in research goals, language, and technological design. Photography played a part in this clamouring and was deployed not only for cataloguing, but also in order to model the changing laboratory and indicate how the technology would

similarly transform institutional, economic, and epistemological forms. I take seriously the theoretical claim that computers specifically, and technologies generally, should be conceived of as historical and cultural agents – what the historian of science Jorgs Rheinberger calls "epistemic things" – those objects of experiment that become "real" in the material operationalizations (laboratories/equipment) and episte- mological forms (scientific theories) that they produce.[7] An epistemic thing, like a gene in biology, or particle in physics, is an object that obtains reality despite, or actually precisely because its conception is "fuzzy".[8] My claim is that, outside of the very specific experimental scientific fields, "medium" is just such an epistemic thing – and so both photography and computing technology become similarly "fuzzy" and withdrawn in their representations to human observers. My purpose is not to show that the digital has resulted in a fundamental shift in visual media culture, in a post-photographic or post-cinematic epoch. I argue instead that there is little or no difference between the photographic and computational that would set computers apart as a medium, communicative form and agent. Rather, what shifts (or should shift) from one to the other is the level or order of observation. What is new but not exclusive to the computing medium is the general question of communication qua communication in which the figures of human machine symbiosis and the interface stand in for canon or form and content of a work – not as representational concepts but as features of reality. The computer is merely another moment where a medium moves beyond its aesthetic and provides a possibility for the mingling of critical humanistic analysis with realist and technoscien- tific thought. Don Ihde describes technoscience as 'the hybrid output of science and technology, now bound inextricably into a compound.'[9] This hybrid is a synthesis of histories, 'that of technologies that go back as far as all human origins, and that of science,' seen as a modern history.[10] The value in a technoscientific historical perspective lies in its unhinging of our belief that an unmediated human sensation exists.

Ultimately, this level of observation does away with the fallacy of an original unmediated experience by which technologies are meas- ured, and when brought to bear on photography yields innovative an- alytic insight within photographic theory. It also does work to bridge the gulf between humanistic and scientific treatments of the visual. As with Benjamin, who expressed affinity both with a technoscientific description of cinematic technologies with non-human purpose of play, there have since been important expressions of non-human purpose correlating with the proliferation of computing technologies.

Gilles Deleuze, whose most famous foray into the philosophy of technology/media was the cautionary tale 'Postscript on Control Societies', expressed another historical way of opening critical thought up to the highly technical and scientific at a moment when the electronic revolution was giving way to the information society.[11] Deleuze borrowed heavily from the observations and figures of experimental sciences, seeing complexity/chaos theories, black holes and singularities as resonating with his immanentist philosophy. In his work with Félix Guattari, Deleuze reconfigured art, science and philosophy as the three fundamental threads of human creative endeavor, all of which engaged with the figure of chaos by casting a plane over it.[12] Further, Deleuze was specifically interested in the meeting of the three planes in chaos, 'the relations between the arts, science, and philosophy', the resonance of thought and mutual creativity revealing that there was 'no order of priority among these disciplines'.[13] In his refusal to order these fields into a hierarchy vis-à-vis their relationship to meaning or creativity, Deleuze insists that none of these disciplines see chaos as a problem that needs to be scientifically or philosophically solved. Rather, it is a space rich in its productive potential as an ongoing problem-space, or the "virtual". DeLanda will identify Deleuze's as a process-oriented philosophy that breaks from the ontological tradition going from Aristotle to Kant, using chaos in order to free problems of knowledge from the subordination to solutions.[14] Ultimately, what constitutes the subsequent assemblage theory is an openness to objects whose purpose is unknown to humans. This intervention is significant in that it is a shift towards recognising an object-oriented approach to purpose, agency and organization. This works only because of the continual integration of scientific and philosophical thought.

For Deleuze, each epistemological thread also comes into 'relations of mutual resonance and exchange at moments of emergence of a type of material organization with purpose; what he and Felix Guattari theorize as a machinic assemblage.[15] It is from this basis that DeLanda extrapolates his notion of machinic phylum, 'the overall set of self organizing processes in the universe', a concept that may be reproduced as a historical figure for the emergence of highly specific organizations in a given particular moment.[16] This self-organization is the translation of autopoiesis from the realm of biological life to the world of inorganic objects, what De Landa considers even more radically as inorganic life.[17]

Theorizing visual images along with their medium in an assemblage places them within what media theorist Ian Bogost calls an Object Oriented Ontology (OOO), which, importantly, conceives of humans as elements but never the sole elements of philosophical thought. OOO draws equal 'attention to things at all scales'.[18] OOO would conceive of medium generated images as expressing a sort of reality to the universe and to any observer therein. Things are real insofar as they exist and have purpose beyond the scope of human observation and intention. Scale here is crucial not as a concept that destroys human perspective (subjectivity) per se, but rather, as DeLanda has argued, that allows movement of analysis between the micro (sub-personal) and macro (extra-personal) scales.[19]

For DeLanda an assemblage is the emergence of a non-totalizing whole from heterogeneous parts, through a process 'in which language plays an important but not constitutive part'.[20] Additionally, DeLanda believes there to be a fundamental distinction between representational constructions and the virtual modeling of physical processes by computing technologies. The motor driving representational descriptions is a "relation of interiority" within language and semantic meaning, where none of the representational parts have an autonomous existence outside their relationships to other terms.

Assemblage theory relies instead on a relation of exteriority, that is, an exteriority of existence beyond human beings. The components of any assemblage, even nouns and verbs within a grammar, exist independently of their relationality to one another, and each also exercises a capacity to affect and be affected independently of anything like a homogeneous rule of language. In this sense, photographs can be seen as part of a concatenation of many things: the scaling down of objects within its *mise-en-scène* to the representational; the chemical and material processes that constituted it; and, beyond the photographic image itself, the cameras, computers, bodies and institutions to which it is connected. Key to this reorganization is the notion of a "within" to photographs, the idea that images contain visual objects whose identities depend on their relationships to one another as well as to the "actual" objects they correspond to. At the heart of De Landa's argument is the idea that symbols carry non-linguistic information, and that there is a possibility for observing this non-linguistic, non-representational information from material, as well as discursive, objects in the world.[21] I wish to extend this possibility to the medium of photography, in a

very specific attempt to analyze the elements of archival photography alongside other physical materials as relations of exteriority whereby forms of signification, photorealistic image, technical sketch, icon, text, number, etc. cease to have well-maintained or decipherable interior "content." Instead, each will be conceived of as a "social entity" not because of particular properties it contains or represents, but rather because of the capacities it has to interact with other social entities.[22] In this sense there is no unified hermeneutic approach or aesthetic sensibility dictating what a photograph "depicts."

Bogost, in assessing numerous strands of object oriented thought, gives an account of how analysis could approach its object non-hermeneutically and effectively translates the metaphysics of OOO into a practical method. Ontography, Bogost explains, is a figure deployed by many object oriented thinkers as a general 'inscriptive strategy' for maintaining a nonanthropocentric vantage point of objects while describing their interrelatedness, in order to show their 'repleteness and interobjectivity'.[23] Ontography accomplishes this precisely because it is not an attempt at ontology, an understanding of the essence of things, but a description of basic relationality (and disruption or non-relationality) in a given space of things.

For Bogost, the list is the simplest discursive example of things that do ontographic work. Lists offer a mere naming, a revelation of object relationality without 'necessarily offering clarification or description of any kind'.[24] Crucially, both narrative and perspective fall by the wayside when listing. A list needs no order or hierarchical organization – it is not a sequence but a series. In addition, the capacity of a list to relate things to one another and to itself does not rely on an author or the origin of its writing. We may build here on a type of writing, based on random or ephemeral observations of things, that need not derive from an essential textuality in analysis. Whereas for Bogost lists do ontographic work on the register of written language, visual images, specifically photographic, do ontographic work when they present an 'exploded view' of the universe.[25] An exploded view diagram, again borrowed from engineering and scientific practices of construction, provides a diagram of the numerous components within a body or organization – the constituents that form a unit – pulled apart yet in proximity and relation to one another. Photography is not merely representational (the implication being that text/*logos* is), but provides a chemical visual catalogue of actual phenomena – it is a "way of looking" that can provide an exploded view of what is generally taken to be a

mise-en-scène.[26] It is here that we may push, with the help of assemblage theory, beyond Bogost's distinction between lists and photographs, between words and images as things. What results is a type of critical observation or analysis that is even further removed from a strictly hermeneutic approach that by its nature values things as it renders them meaningful. Text and photography, when recognized as media or things that have purpose beyond their human designs, are two unique assemblages from a multiplicity of others. From a radically historical media perspective the photographic correlates no more to the real than does writing; just as writing is not a refinement of orality, nor is the present digital image transformative of the photographic.

In what follows I present a list of particular image units including an icon/graphic art (fig. 1), a technical sketch (fig. 2), flow charts (figs. 3, 6) and photographs (figs. 4, 5). The image units are not placed in any particular order based on their analytic relationship, and each has a multiplicity of relationships with one another based on the interiority of visual objects as well as the exteriority from which they were constructed. With attention paid to the assemblage of these units one sees the immensity of exterior relationality based in part on the archive from which they derive, the historical moment of the spaces and bodies that did exist in the past, as well as the bodies and things in the present moment. What begins to form analytically is a litany, an endless speaking of things and butting up against one another. Given Bogost's understanding of photographic images as being diagrammatic and providing exploded views, as well as DeLanda's claim that all elements of the visual or symbolic have non-linguistic information, we can observe the below figures as reorganizing themselves. These images cease to have any figurative relationship whatsoever. A picture is not worth 1000 words and the Figure 2 is not a lower resolution, less-realized visual than a photograph of a data bank would be.

On the interactions among art, science, and philosophy Deleuze concluded that, like any other unique individual or singularity – the members of an assemblage are not individuals as autonomous and closed; a singularity is a tendency to become an event (melting point elements, the tendency of a film cell to emulsify, or the tendency of a scientist to model a particular feature of the universe) – within an assemblage, that the three are fundamentally different.[27] As with any encounter with the other, science could never see art or philosophy outside of its need for descriptions and its production of functions,

Figure 1. Cover page of brochure for Joint Navy/Air Force/Army computer research centre.

Figure 2. Technical drawing of an imagined "Data Bank".

Figure 3. Flow Chart depicting the associative memory
capability of a digital computer circa 1965.

Figure 4. Photograph of woman seated at MAGIC: a machine
for automatic graphic interface to a computer.

MAN-MACHINE
INFORMATION CENTER

Figure 5. A remote visual display test circa 1970.

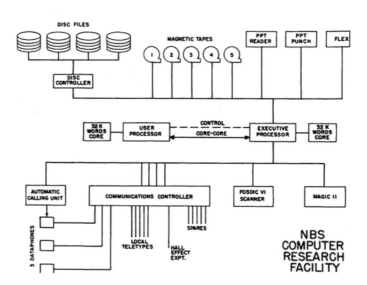

Figure 6. Flow Chart used to depict command control function
of National Bureau of Standards Computer Research Facility.

art can only ever see the production of affects, and philosophy cannot but conceive of the fundamental or metaphysical concepts produced in the other two forms of thought. With all three being creative internally, and a final non-translation of the scientific into the philosophical and vice versa, mediators are fundamental. An observer of any cloth (artist/scientist/philosopher) must recognize that he or she is always working within a group, a series, an assemblage of other individuals:

> If you're not in some series, even a completely imaginary one, you're lost. I need my mediators to express myself, and they'd never express themselves without me.[28]

Deleuze's theory of media here does not mention technologies outright because of its demand that mediators be anything in relation to any other thing, whether sentient, inanimate, or imagined. We find here a peculiar conflation, or rather reconfiguration in Deleuze that can be used to define medium. There is no binary of medium versus non-medium or mediated versus immediate because, as Deleuze claims, the great affinity between contemporary sciences and a philosophy that feels the need to interact with and know it, is the shared imperative that a search for origins has been undone. The concern now is for the "in between". A photograph does not mediate a human vision or aesthetic affect, and a computer does not mediate virtual human to human communication or information – because neither exists in a context that derives from human purposes. The movements of the photographic and the computational through history must be delinked from human design and the line of teleology. Interestingly, then, as in Benjamin's test-performance human, we can begin to discuss human purpose as well, without epistemological constraints such as origin versus end, real versus imaginary, and human versus nature – all the inheritances of a dualistic epistemology in Western Philosophy.

The reconceptualization of media technologies as agents provides a radical historiographic methodology, radical in that the de-emphasis of historical conventions of inventor, time-line, and new versus old. Also, as media histories are becoming an increasingly important form of scholarship in New Media Studies, this conceptualization provides specifically for a radically historical approach to media studies. A radically historical media studies does not merely produce histories of technological objects, but participates in a recursion, a reflexive turning in on itself in order to articulate a history of media

technologies with a history of the development of Media Studies itself. Like Deleuze, who clamoured to know the experimental sciences that were both separate from and interdependent with his immanentist philosophy, media historians would recognize the extent to which their objects of study actively engage them as subjects and move them to the kinds of knowledge they produce. The analysis of images – still, moving, physical and virtual – would become a "nomad science", a mode of knowledge production which, like technological objects, is something that functions beyond the designs of the "sedentary" universalizing fields of science from which it escapes. Nomad sciences treat all of the types of matter that human beings encounter as animated from within by their own tendencies and capacities to both move and be moved by us.[29]

In *Thinking Otherwise: Philosophy, Communication, Technology* communication theorist David J. Gunkel provides a critique of digital reason, a frame of thought extended from modernity's theory of knowledge into the context of digital culture and Internet communication technologies.[30] The figure of reason here continues to generate numerous dualisms based on a fundamentally binary logic: Universal/Particular, Theory/Application, Inside/Outside, Subject/Object, etc.. What results is a fundamental epistemological framework from which scientific and critical observers begin to describe information and communication technologies. What we continue to assume, is that at the "other end of the digital line" as well as what ultimately organizes a computer's role in that line, is a human. Gunkel concludes that though he is seemingly arguing about how to describe and use computing technologies, that the stakes for escaping binary logic is fundamentally about our ethical encounter with the other.

Thinking otherwise about media technologies with nonhuman purposes is one among numerous forms of knowing that addresses the fundamentally ethical nature of otherness. Thinking through technology as a purposive non-human is not to claim that it has a special status or primacy over other non-human members – species or animal beings, organic non-sentient life, general inorganic objects, for instance – it resonates with them all and contributes to a critical mass of pushing humanity/humanism into the plenitude of their universe. What becomes visible between the seeming extremes of nonhuman agency writ large and the dualistic thinking of human tradition, is the in between of ethical other-centric stances of all kinds.

This author recognizes the immense problem of engaging in analysis that "moves beyond" the history of dualistic epistemology in the West. The proposition I've put forth, of our reorientation with things, can in its own right be seen as a sort of progress narrative, falling back into a binary of bad versus good ideas, and nonhuman liberation. But as Deleuze and Guatarri wrote:

> We invoke one dualism only in order to challenge another [...] each time, mental correctives are necessary to undo the dualisms we had no wish to construct but through which we pass.[31]

It is perhaps that, while admitting the limitations of conducting non-dualistic and non-anthropocentric thought, the incessant motivation, driven by an ethics of nonhuman others, can produce a technique of dualistic corrective that may persist in future analyses of media technologies.

Notes

[1] Walter Benjamin, *The Work of Art in the Age of its Mechanical Reproducibility and Other Writings on Media*, ed. Michael W. Jennings et al., trans. Edmund Jephcott et al. (Cambridge, MA: Harvard University Press, 2008).

[2] Ibid., 35.

[3] I use "procedures" here in two senses: one, the segments of life captured by photography and film are, according to Benjamin, specific to those media, understood as a process of playing with those objects through recording, cutting and non-linear production. Two, I am referring to Foucault's use of procedures as very specific bodily techniques that get deployed as proper procedure or conduct when a discipline or field of knowledge emerges around something like cinema or photography.

[4] Benjamin, *Work of Art*, 48.

[5] Ibid., 27. This reading of Benjamin's work is based in part on a lecture and reading of *The Work of Art in the Age of its Technological Reproducibility* by Richard Jennings ant the Northwestern University Summer Institute on Walter Benjamin in 2009.

6. Ibid., 38.

7. See Hans Jorg Rheinberger, *Toward a History of Epistemic Things: Synthesizing Proteins in the Test Tube* (Stanford, CA: Stanford University Press, 1997).

8. Ibid. And see Hans Jorg Rheinburger, *Historicizing Epistemology: an Essay*, trans. David Fernbach (Stanford, CA: Stanford University Press, 2010).

9. Don Ihde, *Postphenomenology and Technoscience: The Peking University Lectures* (New York: SUNY Press, 2009), 41.

10. Ibid., 45.

11. See Gilles Deleuze, 'Postscript on Control Societies', in *Negotiations, 1972-1990* , trans. Martin Joughin (New York: Columbia University Press, 1990), 177-182.

12. Gilles Deleuze and Félix Guattari, *What Is Philosophy?* trans. Hugh Tomlinson and Graham Burchell (New York: Columbia University Press, 1994), 202.

13. Gilles Deleuze, 'Mediators', in *Negotiations*, 123.

14 Manuel DeLanda, *Philosophy and Simulation: the Emergence of Synthetic Reason* (New York: Continuum, 2011), 157.

15. Deleuze, 'Mediators', 123. And see Gilles Deleuze and Félix Guattari, *A Thousand Plateaus: Capitalism and Schizophrenia*, trans. Brian Massumi (Minneapolis: University of Minnesota Press, 1987).

16. Manuel DeLanda, *War in the Age of Intelligent Machines* (New York: Serve, 1991), 6.

17. Ibid.

18. Ian Bogost, *Alien Phenomenology: Or What its Like to be a Thing* (Minneapolis: University of Minnesota Press, 2012), 5.

19. See Manuel DeLanda, *A New Philosophy of Society: Assemblage Theory and Social Complexity* (New York: Continuum, 2006).

20. Ibid., 3.

21. Ibid.

22. Ibid.

23. Bogost, *Alien Phenomenology*, 38. In defining ontography, Bogost keys in on information scientist Tobias Kuhn's ontograph framework, a graphical notation used as a formal language or technical visual "map". The IKEA instructional picture map is his popular example.

24. Ibid., 38.

25. Ibid., 50.

26. Ibid.

27. Deleuze, 'Mediators', 125.

28. Ibid.

29. Manuel DeLanda, *Deleuze History and Science* (New York: Atropos Press, 2010), 76.

30. David K. Gunkel, *Thinking Otherwise: Philosophy, Communication, Technology* (Indiana: Purdue University Press, 2011).

31. Deleuze and Guattari, *A Thousand Plateaus*, 2.

EMBODIMENTS

5

The New Technological Environment of Photography
and Shifting Conditions of Embodiment

MIKA ELO

IN 1889 GEORGE Eastman, the founder of Eastman Kodak Company, introduced the No. 1 Kodak camera with the catchy slogan 'you press the button, we do the rest'. While photography still involves pressing the button the "we" and the "rest" have transformed significantly during the last few decades. In the age of information, 'photography has come to exist within a new technological environment', as Martin Lister aptly puts it.[1] This shift has wide-reaching cultural consequences that also involve our bodily existence, even if no significant changes can easily be recognized at the level of the trigger finger.

It is a widely recognized fact that images are involved in thinking processes. Their status, however, has been heavily disputed. The figurative elements of thinking have been seen now as a sign

of weakness of thinking, now as its innermost strength. Logical
empiricism and early romanticism could be used to mark the two
extremes in this regard.

Thinking, however, does not only rely on imaginative elements
that refer to our bodily experience; it also takes place in the body.
The body is the place where the intellect and the senses come
together and constitute meaningful thinking. Referring to Immanuel
Kant's "transcendental aesthetics" we could say that the body
schematizes.[2] It makes an "image" of reality, and, at the same time,
takes part in it as an image-like unit. Further, the question as to
whether and how thinking finds its place in images is a theme taken
up by numerous philosophers and media theorists. It is all but
self-evident how to demarcate the place of thinking with regard
to living and non-living bodies and the images they, in one way or
another, embody.[3]

In the discussions concerning the relations between image, body
and thinking, interestingly enough, attention has often been turned
to photography. In Jacques Rancière's discussion of the pensiveness
of images, photography constitutes a paradigmatic example.[4] In *How
Images Think*, Ron Burnett takes up photography as a good example
of intelligence programmed into images.[5] Jean-Luc Nancy, in turn,
has paid attention to an analogy between the Cartesian cogito and
photography.[6] He writes: 'Every photograph is an irrefutable and
luminous I am [...] Like the other ego sum, this one is made explicit
as an ego cogito. Photography thinks [...]'.[7] Nancy also insists on the
inseparability of body and thinking in Descartes: 'for Descartes, the
res cogitans is a body'.[8]

Against this background it seems that image, body and thinking
relate to each other in a circular way: both body and thinking make
use of images, both images and bodies think, and both thinking
and images involve a body. Should one break this circle or should
one dive into it? I choose the latter: I dive in, since I think that this
seemingly vicious circle can be turned into a productive one, even
if it soon becomes obvious that one touches here upon the limits of
conceptualization.

I want to ask how photography contributes to this frame of
"bodily schematism". I will focus on the question of haptic realism and
the way it builds on the interplay of three aspects of embodiment that
I would like to call (1) the physical body, (2) the phenomenological
body and (3) the libidinal body. The notion of "haptic realism" refers
here to the peculiar role that touching (both in tactile and in affective

terms) plays in representations that are considered realistic. Using
these terms, I will develop a hypothesis that aims at indicating how a
certain shift in the cultural status of touching might contribute
to reshaping the "photographic" conditions of embodiment in the age
of information.

Photographic Distance and Proximity

It has become one of the commonplaces of recent media theoretical
debates to state that digital media transform the frame of human
experience. It is not difficult to find a consensus on this general level
of the diagnosis of a shift. It is easy, for example, to agree on the fact
that digital media are changing our sense of time and space – the
conditions of our bodily existence – in many ways. Distance and
proximity, in both physical and mental senses, take new forms. The
task of theoretically articulating the details and the transformation
mechanisms of experience that is at stake here is, however, a
much more complicated matter and leads to numerous questions
and debates.

In these debates photography is often claimed to be an outmoded
medium as we live in digital or even post-digital culture. Photography
is, however, booming like never before, both in terms of the quantity
of images produced and the multiplicity of new photographic
technologies and practices. In its current state of rapid transformation
and diversification photography shows rich cultural potential, a
situation comparable to the first decades after the invention of
photography in 1839. As a consequence, photography research is
facing new challenges and gaining a new importance.

Today, photographic technologies are linked to new production
and publishing structures that alter the ways photographs circulate.
This has multifaceted social, economical, political and theoretical
consequences that are difficult to decipher. What to think, for
example, of the fact that with the help of metadata that accompanies
the digital image, moments of capturing, processing, presentation
and distribution can be automatically interlinked in ways that go
beyond visual mastery of spatiotemporal relations? To use Lev
Manovich's terms, it would seem that digitally mediated photographs
are part of another kind of "cultural interface" or "cultural software"
than film-based photography.[9] The cultural status of photographic
images is undergoing a transformation. My question will be: how to
articulate this in terms of "bodily schematism?" How are the intimate

connections between body, thinking and photography currently
changing?

The sense of touch offers a productive starting point for an
enquiry into these questions. The highly ambivalent role that touching
has in western thinking is symptomatic of the tensional relation
between physiological, mental and technical aspects of sentience.
Touch twines together physical and psychical movements and
intensifies them in pleasure and pain. To touch is always, in one way
or another, to touch a limit, to push it and to test it, and, in the same
instance, to attest to it. Touch is sentience at the limits, and thus an
exemplary figure of reconfiguration.

In contrast to other senses, at least seemingly, the sense of touch
makes the sensing and the sensed coincide. When I see a stone, it
is "out there" and does not see me, but when I touch that stone, it is
"right here" and touches me. This sense of concreteness and immediacy
lends the sense of touch a certain credibility. A seen stone can be
made of plastic even if it looks just like a stone, but when I touch it
I can feel the material. It is due to this fullness of touching that the
tactile metaphor of "grasping" can stand for "fully understanding
something". From this point of view the sense of touch appears to
be uncomplicated and immediate. On closer inspection, however,
its status as a sense is rather difficult to grasp. In fact, it is more
appropriate to speak of senses of touch, since touching exceeds the
tactile world and encompasses also immaterial aspects of experience.
Due to its multifaceted characteristics touch also challenges
representational thinking in many ways.[10]

Photographs make this evident in a poignant way when they
touch us at the same time as they withdraw themselves from the realm
tangibility and meanings. As Margaret Olin points out, there is a
tension between the ways in which photographs involve looking and
touching: 'the two activities seem to alternate like a blinking eye,
as though we cannot do both at the same time'.[11] This implies that our
grasp of photographs does not take place in the light of knowledge
only. One might recall here also the thought-provoking claim that
Roland Barthes makes in *Camera Lucida*, according to which
'a photograph is always invisible'.[12] Visibility falls short of explaining
the ways in which we relate ourselves to photographic images.
A photograph is touching when it provokes speech by being mute,
and when it opens up a space for thinking by a gesture of closing
itself off, by being individually separate and distinct. In other words,
a photograph's entry into the realm of representations is mediated,

besides vision, also by a distant touch – not unlike an eye contact that seizes the gaze only as absent.[13]

Touching is a moot point in western conceptions of embodied experience due to its peculiar role as a mediator between the material and immaterial aspects of reality. Different conceptual articulations and arguments, however, almost invariably share the "haptocentric" idea that touching is a way of locating and guaranteeing the contact between different elements of experience.[14] On this basis, reality is understood as being-in-touch-with-something-real. The matter is further complicated by the fact that the different parties to this contact have many names in our tradition: soul, mind, psyche, reason versus body, flesh, sensuality, etc.. Correspondingly, the contact itself has been studied from the point of view of religion, intuition, reflection and synapses.

Touch, as a mediator between processes of signification, affectivity and materiality, figures prominently also in discourses on photography. Various forms of contact play an important role, especially whenever photography is inscribed into the tradition of "true images" (vera icon) or "self-generated images" (acheiropoietoi). Variations of this scheme can be found in Henry Fox Talbot's ideas of "natural magic", C.S. Peirce's "indexical" sign function, André Bazin's "objectivity", and Roland Barthes's discourse on "punctum".[15] With regard to the digitalization of photography the role of touching in its relation to seeing is, however, highly ambivalent. This is not quite unexpected, since, in the experiential horizon of digital technology, the status of touch as a guarantor of tangible reality would appear unstable, as a great deal of what we consider real is anything but tangible – even when we find it touching. At the same time, touch as tactility plays an important role in various forms of interface design. There the implicit aim is to functionalize touch and to integrate it into a system of digital mediations in order to increase the sense of instantaneity and realism. In these settings, touch tends to become represented as a sense that works in synchrony with vision offering a support for optical intuitionism. The question arises of how to relate tangibility to the conceptual, affective and mental dimensions of touch or feel.

In the 1990s much of the discussion concerning digitalization of photography focused on questions of difference between the digital and the analogue. Digitalization was often seen as a fundamental shift comparable to the invention of phonetic writing[16] or that of central perspective.[17] These debates led to various reconsiderations of the

peculiar convergence between notions of photographic realism and discourses of indexicality.[18] Today, as photography has come to exist within a new technological environment, questions of connectivity, mobility and metadata are also starting to play an important part in considerations of the photographic "reality effect". In Frieder Nake's terms, we could say that at the same time as there are ever more invisible indices on the "subface", which are made operative in the construction of photographic "reality effects", the digital 'surface' is modelled on photographic looks that are familiar from film-based photography.[19] Photoshop filters such as "film grain" and "lens flare" are in this respect telling examples.

What strikes me in these debates is the way in which most conceptions of photographic evidence tend to rely on ideas of continuity and causality. Photographic "reality effect" – regardless of whether it is held to be a result of context-related signification or material mediation – seems to be modelled on the "haptocentric" idea according to which the "real" is something we can grasp mentally or touch physically, and ideally both in a synchronous way. In short, the rhetoric of photographic realism builds, in one way or another, on continuity of chains of reference.

At first glance there would seem to be a clear contrast between mental continuity and sensuous contiguity, between the sign and the trace. On closer inspection, however, we can discern that the trace-like character of the photographic image relies, in the last instance, on some kind of authorization, an "authorizing legend" that establishes the continuity of chains of reference.[20] It is telling that even if photographs (and the various layers of metadata attached to them) can be used as pieces of evidence in court, they cannot replace a testimony. The photographic trace needs to be authorized, i.e. "culturally generated".[21] The other side of the coin is that signification processes need to be embodied, i.e. bundled and incorporated, in order to be effective.

Haptic Realism

I would go as far as to claim – this is my hypothesis – that the very notion of photographic realism is "haptocentric" in the sense that it tends to function as a vehicle for reproducing the idea of touch as an objective sense, i.e. as haptic sense operating in the realm of physical bodies. In short, visual capture combined with perceptual and cognitive recognition tends to objectify bodies.

This operation tends to conceal something that we, following Bernhard Waldenfels, could call the "pathic moment" of touching.[22] The term "pathic", derived from the Greek word *pathos*, refers to sensibility, affectedness and suffering. Inherent to the term, although normally ignored, is the concrete sense of being exposed to something excessive and unexpected that can even leave painful marks, such as wounds. In a word, "pathic moment" refers to an exposedeness that is implicated in all forms of touching.

Following Waldenfels it can be argued that as regards the phenomenological body, touching constitutes a prototype of "pathic experience".[23] It is the felt sense of being in the world, of being exposed: to touch is always also to be touched. Although touching is contact with the touched, there remains something inaccessible and withdrawing, something even untouchable inherent to the touched. This withdrawal lends to the contact an affective tension: the touched becomes touching. In other words, touching is over-determined by otherness as strangeness, and it turns out to manifest traits of a "foreign-sense", with respective ethical significance.[24] This elemental asymmetry tends to be ruled out when touching is studied in terms of immediacy and symmetry of contact.

As a prototype of "pathic experience" touch turns out to be a complex field of sensing and feeling. In short, it is the making sense of various encounterings. This elementary function implies that when we consider the sensory distance, we cannot take the separateness of sensor and sensed as our point of departure, because to be exact, they are only articulated as such in touching. Furthermore, the question as to what should be invested in the positions of sensor and sensed is historical. To be able to study the suspension of sensory distance we must take into account "phenomenotechnics", i.e. the technical and technological conditions of each particular time, since the experiences of distance and proximity are also always articulated in relation to them.[25] This shows how the pathic structure of touch brings out the elemental role of technics in the constitution of experience.

My hypothesis is that in "haptic realism" the photographic contact is conceived of in terms of immediacy and continuity, despite its obvious asymmetry. This takes place predominantly in the name of visibility. This implies that as "hapto-visual" appropriation, photography tends to reduce the different dimensions of touch into tactility, that is, into an order where all distinctions are made between the same and the other and where there is the structural possibility for a third party to assess these distinctions. In contrast to this realm

of objective contact between visible surfaces of physical bodies, touch as exposedness has to do with existential integrity, a depth from which any objectifying third party is excluded. This pathic moment of touching is about separation between own and alien, between self and stranger, and remains a matter of singular experience. Touch as a pathic sense is a sense that excludes a third party.

"Haptic realism" would thus be about conflating or confusing these two orders. It would be about equalizing the ways in which distinctions between the same and the other can be made and the ways in which a self separates itself from a stranger. In other words, in haptic realism phenomenological bodies would, tendentiously, be modelled on physical bodies. Here photography builds on a long tradition, since this kind of haptocentric conception of the sense of touch has been operative in western thinking from Plato to Husserlian phenomenology as, for example, Jacques Derrida has painstakingly shown.[26]

The tendency to confuse these registers derives from the visual accuracy of photography as light-writing. This has consequences as regards both material mediation and signification processes. With regard to material mediation, the optical laws of light-writing suggest a natural link between the iconic and the indexical aspects of the depiction. As regards signification processes, in turn, the visual accuracy of the photographic image makes it more tempting to look through the image and see it as a visual representation of an absent thing than to see the image as a strange presentation that brings forth something which finds its origin in the image itself. In both cases there is a tendency to conflate iconicity and indexicality, and to measure photographic evidence in terms of visual likeness.

Formatting Embodied Experience

Digital forms of photography both reaffirm and destabilize this link between iconicity and indexicality. On the one hand, the relation between the "subface" and the "surface" tends to be conceived of (and programmed) in terms of hapto-visual appropriation. On the other, the affective tension potentially involved here turns out to be non-programmable. I try to explicate this ambivalence with regard to the third aspect of embodied experience that I introduced at the outset: the libidinal body.

Here I would like to take up the interesting argument made by Cathryn Vasseleu that digital technologies contribute to the

"formalization of touch" by instituting touch as an objective sense – with the aim of making contact and staying in touch.[27] According to her, digital technologies tend to prioritize haptic appropriation and grasping by detaching the objective side of touching from its affective qualities. The result is an enhanced polarity between two interacting modes of touching: hypersensitive "ticklishness" that is detached from all functional object relations and 'haptic touch' exemplified by the omnipotence of the finger as regards the horizon of real-time telecommunication.[28] This has implications as regards the libidinal body. This is also the decisive point where I see that digitality changes something in the intricate interplay between image, body and thinking that I call "bodily schematism".

In so far as "ticklishness" is a domain of tactile experience that is out of self-coordinatable control, it cannot have any pre-programmed function in digital telecommunication networks, since these are built on the idea that being in contact equals the perception that one is in touch with someone or something. It nevertheless plays an important role in digital tactility.

The enhanced polarity between the two modes of touching that Vasseleu discerns can be seen as a symptom of a transformation of tactile experience that finds its articulation also in the new technological environment of photography. This enhanced polarity becomes tangible in situations where the feedback structure of an interface is engaging at the same time as it lets the lability of the mediated contact come to the fore. Various forms of visual live streaming and instant photo sharing could be used as examples of this.

The psychodynamics of these operations can be studied in terms of Freudian vocabulary. In his article on denial, Sigmund Freud foregrounds parallels between thinking and perceiving by suggesting that they are both based on a "palpating impetus" (tastender Vorstoß), that is, a feeling and testing of the limits between inside and outside.[29] This tactile process of demarcation offers a basis for psychic structures and various defence mechanisms, such as denial. Freud states that repressed representations can enter into the consciousness under the precondition that they are denied. Denial is a process of rationalization that disconnects affectivity from representation. The integration of repressed representations into consciousness takes place only on an intellectual level, and the affective implications of the repressed are cut off.[30]

Denial depends on an intellectual judging function (intellektuelle Urteilsfunktion), which concerns questions of inclusion and

exclusion.[31] The ego decides if something is to be taken in or excluded. The reverse side of this intellectual decision is something Freud calls "reality testing" (*Realitätsprüfung*).[32] The ego tests if an intellectually accepted and thus internalized representation also reappears in perceived reality. What is at stake in both functions is a decision between the inside and outside. The subjective exists only inside, whereas everything that counts as objective must exist outside as well. This double operation of internalization and reality testing makes sure that the relation between the inner representations and their counterparts in outer reality can be mastered.

Against this background, "haptic realism" in digitally mediated photography can be understood as denial of the ambivalence of touch. It is an operation that secures the division between the inside and the outside by representing the affective and physical aspects of contact as relatively autonomous dimensions. Hereby, tactility is prioritized and made into the paradigm of touching. Further, as a media technological form of denial "formalization of touch" appears as a "reality test" that contributes to consolidating those patterns of communication and affective behaviour that fit to its formats.

Following Bernard Stiegler one could also take up Freud's nephew, Edward Bernays', theory of industrial manipulation of libido, according to which 'the fight against economic crises required harnessing consumers' desire to lead them to consume things they did not need'.[33] As the facilitation of the passage from need to desire this "harnessing" allowed for the manipulation of the desire itself, because the passage is constituted by phantasm, i.e. the realm of objects that has reality only in the framework of desire. In other words, the harnessing of consumers' desire is like set design as regards the staging of the desire in a phantasm. For Stiegler, the central question is: who is in control of this set design? In his analysis, the globalized culture industry has led to intensified exploitation of libidinal energy that accelerates the decomposition of desire into drives. In his scenario, finance capitalism itself, epitomized by the short-term investments of the stock market, becomes drive based. '[T]he rule of the short term is the rule of the drive. The drive wants everything right away: it wants immediate satisfaction'.[34]

With regard to the new technological environment of photography, the phantasmatic structure of the libidinal economy becomes tangible, if we think of the ways in which various forms of interactivity that involve photographic images endow the user with a sense of power at the same time as the status of the objects gained access to remain

suspended. Typically, the developers of multimodal interfaces set as their goal not only the richness and realism of sense feedback but also the pleasure that the user can experience. The idea is to have everything related to the system smoothly to hand. When this happens, the pathic moment of touch and the ethical dimensions of feedback remain in a dead angle. The focus is on feedback that affirms recognition and forms in its functionality a circle that feeds the sense of self-power.

Conclusion

The difference between "haptic realism" in film-based and in digitally mediated photography, according to the initial analysis presented here, would thus lie in their different ways of enhancing hapto-visual appropriation. Whereas the haptic realism of film-based photography tends to reduce touch to tactility by modelling the phenomenological body on the physical body, digital environments add to this an affective shortcut by customizing information with regard to the physical body (and its metonymic figure, the omnipotent finger). In their new technological environment photographs engage the viewers, or perhaps more precisely the users, more and more often by being hotspots. With regard to the tensional relation between vision and touch this implies that it is the affective link between the user's body and digital information that tends to motivate the visual appearance of media contents in digital culture, whereas in pre-digital visual culture the most powerful substrate of affectivity was made up by visual appearances. In both cases the pathic moment of touching tends to be concealed. In Stiegler's vocabulary, this kind of tendency is regressive: it marks the destruction of desire and the passage to the level of unbounded drives. This process takes the form of a 'disordering of the aesthetic' that, despite of its regressive tendency, opens up also the possibility for a 're-constitution of a new libidinal economy'.[35]

The rather schematic and hypothetical argument I have presented here has the implication that when analysing photographic truth claims and reality effects we should take into account not only technological formats but also conceptual, affective and sensuous processes of formatting. As I have indicated, a careful consideration of the multiple senses of touch operative in haptic realism offers a productive starting point for this. Against this background, the new technological environment of photography appears as a site where the ambivalent tendencies of touch are negotiated. Photographic

interfaces, i.e. the ways in which photography faces the body, provide something like an "aesthetic horizon" for the experience in the age of information by engaging the contradictions of our time at the level of the senses.[36] The way in which these processes are intertwined in and through photographic images makes up the highly ambivalent and historically variable setting of the photographic conditions of embodied experience.

———————————————

Notes

[1.] Martin Lister, 'A Sack in the Sand. Photography in the Age of Information', *Convergence: The International Journal of Research into New Media Technologies*, Vol. 13, No. 3, 2007, 251-274.

[2.] See: Immanuel Kant, *Critique of Pure Reason*, trans. F Max Müller and Marcus Weigelt (London & New York: Penguin, 2007).

[3.] "Bodily schematism" and "embodiment" have been conceived from numerous points of view. On the one hand, thinking has been seen as an embodied phenomenon, and on the other, a certain "schematicism" has been linked to body. About 100 years ago, Henry Head and Gordon Morgan Holmes, in 'Sensory disturbances from cerebral lesions' *Brain*, Vol. 34, No. 2-3 (1911), introduced the notion of body scheme in neurology, and this notion has figured in many ways in biological sciences ever since. On the side of the humanities Jacques Lacan's theory of the "mirror stage", Didier Anzieu's theory of "skin-ego" and Maurice Merleau-Ponty's Phenomenology have been widely influential in studies of different aspects of embodied experience. See Anzieu, *The Skin Ego*, trans. Chris Turner (New Haven: Yale University Press, 1989); Merleau-Ponty, *Phenomenology of Perception*, trans. Paul Kegan (London and New York: Routledge, 1962). Interesting attempts to articulate the dynamic exchange between bodies, images and thinking can be found also in contemporary "image science", or, *Bildwissenschaft*. See Hans Belting, *An Anthropology of Images: Picture, Medium, Body,*

trans. Thomas Dunlap (New Jersey: Princeton University Press, 2011);
Gottfried Boehm, *Wie Bilder Sinn erzeugen. Die Macht des Zeigens*
(Berlin: Berlin University Press. 2007); Horst Bredenkamp, *Theorie
des Bild-Akts* (Frankfurt am Main: Suhrkamp, 2010); John M. Krois,
Bildkörper und Körperschema, ed. Horst Bredenkamp and Marion
Lauschke (Berlin: Akademie Verlag, 2011).

4. Jacques Rancière, *The Emancipated Spectator*, trans. Gregory Elliot
(London and New York: Verso, 2009).

5. Ron Burnett, *How Images Think* (Cambridge, MA and London: MIT
Press, 2004).

6. Jean-Luc Nancy, *The Ground of the Image*, trans. Jeff Fort
(Stanford: Stanford University Press, 2005).

7. Ibid., 105. Emphasis in the original.

8. Jean-Luc Nancy, *Corpus*, trans. Richard A. Rand (New York:
Fordham University Press, 2008), 131.

9. Lev Manovich, *The Language of the New Media* (Cambridge, MA
and London: MIT Press, 2001).

10. Mika Elo, 'Digital finger: Beyond phenomenological figures of
touch', *Journal of Aesthetics and Culture*, vol. 4, (2012), available
at: http://aestheticsandculture.net/index.php/jac/article/view/14982
[accessed 28 June 2013].

11. Margaret Olin, *Touching Photographs* (Chicago and London:
University of Chicago Press, 2012), 2.

12. Roland Barthes, *Camera Lucida. Reflections on Photography*,
trans. Richard Howard (New York: Hill and Wang, 1981), 6.

13. Olin, *Touching Photographs*, 3.

14. Jacques Derrida, *On Touching – Jean-Luc Nancy*, trans. Christine
Irizarry (Stanford: Stanford University Press, 2005).

15. See Peter Geimer, 'Self-Generated Images', in Jacques Khalip and
Robert Mitchell (eds.), *Releasing the Image. From Literature to New
Media* (Stanford: Stanford University Press, 2011), 28-30.

16. Bernard Stiegler, 'The discrete image', in Jacques Derrida and
Bernard Stiegler, *Echographies of Television* (Cambridge: Polity, 2002).

17. W. J. Mitchell, *The Reconfigured Eye. Visual Truth in the Post-
Photographic Era* (Cambridge, MA and London: MIT Press, 1992).

18. See Ursula Frohne, 'Berührung mit der Wirklichkeit. Körper und
Kontingenz als Signaturen des Realen in der Gegenwartkunst', in
Hans Belting et al. (eds), *Quel Corps?* (München: Wilhelm Fink

Verlag, 2002) 401-26; David Green and Joanna Lowry (2003), 'From the presence to the per-formative: Rethinking photographic indexicality', in David Green (ed), *Where is the Photograph?* (Kent & Brighton: Photoworks/Photoforum, 2003) 47-60; Volker Wortmann, *Authentisches Bild und authentisierende Form* (Köln: Von Halem Verlag, 2003).

[19.] Frieder Nake, 'Surface, Interface, Subface: Three cases of interaction and one concept', in Uwe Seifert, Jin Hyun Kim and Anthony Moore (eds), *Paradoxes of Interactivity. Perspectives for Media Theory, Human-Computer Interaction, and Artistic Investigations* (Berlin: Transcript, 2008), 92-109.

[20.] Wortmann, *Authentisches Bild*.

[21.] Ibid., 222.

[22.] Bernard Waldenfels, *Bruchlinien der Erfahrung. Phänomenologie Psychoanalyse Phänomenotechnik* (Frankfurt am Main: Suhrkamp, 2002) 14-16.

[23.] Ibid., 71.

[24.] Ibid., 64.

[25.] Ibid., 361-2.

[26.] See Derrida, *On Touching*.

[27.] Cathryn Vasseleu, 'Touch, digital communication and the ticklish', *Angelaki*, Vol. 4, No. 2 (1999), 159. Vasseleu refers to Immanuel Kant's *Anthropology* and the ambivalent position *Berührung* (referring both to tactility and affectivity) takes there with regard to the distinction between objective and subjective senses (ibid., 155).

[28.] Ibid., 159.

[29.] Sigmund Freud, 'Verneinung', in Anna Freud et al. (eds), *Gesammelte Werke*, Vol. XIV, (Frankfurt am Main: Fischer Verlag, 1999), 11-15.

[30.] Ibid., 12-15.

[31.] Ibid., 13.

[32.] Ibid., 14.

[33.] Bernard Stiegler, 'The Tongue of the Eye. What "Art History" Means', in Jacques Khalip and Robert Mitchell (eds), *Releasing the Image. From Literature to New Media* (Stanford: Stanford University Press, 2011), 224.

[34.] Ibid., 226.

35. Ibid., 227-35.

36. I borrow the very useful term "aesthetic horizon" from Miriam Bratu Hansen. According to her analysis of early twentieth century mainstream film culture, so-called classic cinema, 'not only traded in the mass production of the senses but also provided an aesthetic horizon for the experience of industrial mass society' (Miriam Bratu Hansen, 'The mass production of senses: Classical cinema as vernacular modernism', *Modernism/Modernity*, Vol. 6, No. 2, 1999. 70). It 'engaged the contradictions of modernity at the level of the senses' and contributed to the 'mainstreaming' of the emergence of mass culture (ibid.).

6

Between Bodies and Machines: *Photographers with Cameras, Photographers on Computers*

EVE FORREST

Introduction

PHOTOGRAPHIC PRACTICE, THE "doing" of photography, is no longer confined to using a camera. It can involve a whole host of different technologies: mobile and smartphones, laptops, tablets and large amounts of powerful software. In this chapter I will outline some of the different ways that photographers in a recent study interacted with and oriented themselves around both their cameras and computers, and how, frequently, these technologies became entangled. This discussion has two wider aims. The first is to move discourse on photography away from the dominant representational framework that often ignores the *doings* of the photographer. Traditionally photography has been viewed in purely visual terms and user interaction with the camera is overlooked in favour of the images

produced. In this vein, Jonas Larsen has noted that:

> Photographing is absent from most theory and research jumps
> straight from photography to photographs. They directly go
> to the representational worlds of photographs and skip over
> their production, movement and circulation. The diverse hybrid
> practices and flows of photography are rendered invisible.[1]

Larsen's statement is significant, not just for identifying the diversity
inherent in photographic practice, but also for recognising image and
movement in an everyday context. The empirical research featured
here is part of a recently completed project, in which I studied
photographers based in the North-East of England who use the
website Flickr, and their routines with technology both online and
offline. One of the main findings of the research was that there is a
distinct crossing over between the movements involved in using the
camera and the computer.

Whether one thinks of the habitual bodily actions involved
in using the camera or Flickr, movement is at the heart of these
photographers' practice. Taking photographs is a physical business
requiring constant adjustment of position and posture. The
photographers I observed often walk for miles on end, carrying their
cameras until their shoulders and necks ache, standing outside in the
cold until their fingers grow numb and their legs are stiff and sore.

Whilst on the computer, the body is also moving and interacting;
'the image on the computer screen still demands levels of sensory and
embodied engagement: the slight flicker of the screen, the tap of
the keyboard, the physical movement of operating the mouse'.[2]
At their computers the photographers in my study make micro
movements with their hands and eyes and can spend hours exploring
Flickr, uploading their own content, writing comments and making
contacts. Here too, their eyes become tired and their backs and
shoulders stiff.

The everyday habits associated with photography have
undoubtedly been transformed by mobile phone technology.
Nonetheless, arguably, the practice of taking photographs has not
altered that much in its 150 year history. On the one hand, it should
be emphasized that 'new digital amateur photographic practices are
better understood as emergent in relation to both older photographic
media and technologies'.[3] But on the other hand, the circulation and
interaction with digital images via computers and phones has become

an important part of everyday practice and 'represents a fundamental shift in photography's ontological orientation'.[4]

Frustratingly, however, there has been little research on what photographers actually do when they go out with their cameras. Additionaly, despite the fact that websites like Flickr, Pinterest, Instagram, SmugMug, Photobucket, Facebook and MySpace prominently feature a range of popular photographic practices, discussions of photography, technology and the links between everyday online/offline routines remain relatively ill informed. Nancy Van House comments that 'there remains a relative lack of ethnographically informed research on people's actual, daily practices of photography'.[5] It is hoped that the work discussed in this chapter will enable greater understanding of such practices, as well as indicating potential avenues for further investigation into this under-researched field.

Conceptual Framework

There are many truisms about photography in circulation, especially in literature on the image itself. Perhaps the most enduring of these is that photography is all about capturing a singular moment in time and is exhausted by a concern for stillness. This, for instance, is artfully expressed by Cartier-Bresson in his writings about the 'decisive moment' and it shapes Barthes' influential conception of the punctum.[6] As a result, the importance of movement to photography has been frequently ignored. From the point of view of the image, movement is often seen as the enemy of photography. It leads to the unsightly smudging or blurring of a photograph's subject, for instance. However, as practiced, movement is integral to photography, whether one thinks of the micro-adjustments of hands and feet necessary to position the camera or of those whole-body movements, such as walking, which bring photographer and subject into proximity with one another.

We need to move away from discussing photography in visual terms that rely on such representational frameworks. An alternative philosophical approach is required in order to understand issues of practice, which place the body and movement at the heart of photography. Phenomenology offers a way of exploring photography and its associated practices by considering the way they are enacted and experienced in a everyday contexts. In its broadest sense, the phenomenological approaches have been utilised to enrich our

understanding of diverse practices such as hill walking, driving and
watching films. However, no similar study into everyday photography
practice and related areas such as movement, technology and the
body has been conducted.[7] Three authors, informed in different ways
by phenomenology, will be employed below to explore these issues in
more depth: Maurice Merleau-Ponty, the human geographer David
Seamon and the anthropologist Tim Ingold.

Both phenomenology and photography are bound up with
complex issues of vision, seeing and movement. The work of
Merleau-Ponty, with its focus on perception, embodiment and
habit, is particularly useful when reconsidering photography and its
relationships between body, camera and computer. For Merleau-Ponty,
'habit expresses our power of dilating our being-in-the-world, or
changing our existence by appropriating fresh instruments'.[8]
From a phenomenological perspective, the photographer becomes
part of the visible landscape, but also needs distance to capture
it, so he or she is simultaneously of the world and outside it. The
phenomenon of this dual relation to the world is recognised by
Merleau-Ponty, who writes that as we 'step back to watch the
forms of transcendence fly up like sparks from a fire; it slackens the
intentional threads which attach us to the world and thus brings
them to our notice.'[9] Photographers similarly step back from everyday
entanglements in order to capture and reflect what others may not
see, but of course they are always still firmly *of* and *in* the world. In
this context, as Taylor Carman notes 'visibility is neither surface
appearance nor sensory stimulation. It is the intuitively felt reality of
things disclosed to us as part of a dense, opaque world [...] in which
things show up amid things'.[10]

Photographers are often interested in things "showing up"
particularly when they find that they have captured something
others pass by unnoticed . It is not that they literally see differently
to others, rather that they may be more attuned to everyday
visibility as the variety of textures within the world open up to them,
because 'seeing the visibility of the visible requires stepping back
from our ordinary naive immersion in things'.[11] Many photographers
tend to take their cameras out with them whether they intend to
take pictures or not. This habit means that the camera becomes an
extension of the body, an instrument that both extends the reach
of vision and is incorporated into the wider *body schema*. When
discussing body and habit, Merleau-Ponty gives the example of the
typist, explaining that:

> When the typist performs the necessary movements on the
> typewriter, these movements are governed by an intention
> but the intention does not posit the keys as objective loca-
> tions. It is literally true that the subject who learns to type
> incorporates the key bank space, into their bodily space.[12]

The same can also be said for the photographers in my study, who
through habit have learned to integrate the camera into their everyday
space and routines, both by *using* and *carrying* their camera with
them as they walk around. Their habitual use of the computer, too,
means that their fingers come to find their way around the keyboard
and touch-pad with the same ease.

The subject of people "finding their way" in everyday life is also
of interest to the anthropologist Tim Ingold, who is concerned with
questions relating to movement, routine and dwelling (and has also
been influenced by the work of Merleau-Ponty). Ingold is critical of
the symbolic or rationalist tendency within anthropology, and instead
proposes that 'meanings are not attached by the mind to objects in
the world [...] rather these objects take on their significance [...] by
virtue of their incorporation into a characteristic pattern of day-to-day
activities.'[13]

To this end, for Ingold, finding one's way about is crucial for
dwelling or habitation and 'it is [...] through the practices of wayfaring
that beings inhabit the world.'[14] Phenomenological considerations
surrounding the ways in which photographers routinely find their way
around with their cameras can be extended further into examination
of their online behaviours. Flickr actively encourages members to take
time and explore the content and the billions of different images that
are publicly available.

Ingold's vocabulary of wayfaring and path finding is also useful
when considering the inherently non-linear structure of online
environments such as Flickr. The site continuously mutates and grows
as users interact and connect, generating millions of multiple paths
through their daily movements. For this reason, even if the user is
familiar with Flickr, there is always the possibility of finding new
areas and connections to follow. In Ingold's terms, it is a place where
users 'know as they go'.[15] Although he has not written specifically
about online orientation, in a recent work a brief footnote does touch
upon it: 'experienced users, tell me that [...] they follow trails [on the
Internet] like wayfarers [...] for them the web may seem more like a
mesh than a net. How we should understand "movement" through

the internet is an interesting question.'[16] This idea will be explored in more depth later on.

David Seamon also places movement at the centre of his writing. His *Geography of the Lifeworld* studies the everyday complexities 'and inescapable immersion in the geographical world' via the '*body ballet* [now described by the author as *body routine*] – a set of integrated gestures, behaviours and actions that sustain a particular task or aim'.[17] This distinctive approach emerged from a branch of human geography that came to prominence in the mid-to-late 1970s through authors such as Edward Relph and Yi-Fu Tuan, which 'shifted analytical focus from social space to lived-in place, seeking to supplant the "people-less" geographies of positivist spatial science with an approach that fed off alternative philosophies – notably existentialism and phenomenology'.[18] Seamon also utilises the work of Merleau-Ponty to investigate everyday actions and he argues persuasively that our relationships with place and our habitual routines are complex. They are not merely symptoms of automatic reinforcement nor simply conditioned by set thought processes (as is argued by cognitive and behaviourist theorists). Instead, Seamon writes that everyday interaction and movement 'arises from the body', which is 'at the root of habitual movement'.[19]

Seamon's ideas have recently been revived in diverse areas such as urban planning and media studies, but so far have never been applied to photography and visual studies.[20] Although the work of Merleau-Ponty and Ingold has been utilised by Sarah Pink within the context of visual studies there has generally a been a deep reluctance by authors in this field to move discussions about photography on from the traditional *image-centric* approach in order to focus on everyday practices and movements with the camera and associated technology.[21] What follows here is an attempt to show the potential of this phenomenological framework, and ultimately to take photography out of the still and into the world of movement.

Photographers with Cameras

What makes the connection between the photographer and their camera so distinctive? The findings of my study suggest it is a combination of two things: the body and its habitual movements with the camera. The movement at the heart of this close relationship means that during the photographic process, body and machine become entwined, which can be understood in terms of Seamon's

claim that 'phenomenology is as much a process as a product'.[22]

The relationship between the body and the machine here is a complex process and the corporeal and sensual interaction between each part builds over time, forming a strong connection. Through repetitive use the camera becomes an extension of both the photographer's hand and vision. Throughout my study it became clear that the photographers used their bodies in multiple, unexpected ways with the camera. But it is not only in the *taking* of photographs that movement plays an important role. Other areas require the body to be fully engaged, such as posing and posturing in front of the camera when one's picture is being taken or getting light spots in front one's eyes due to the brightness of the flash. Later still, whether uploading the images from the camera to the computer or even handling the paper copies and leafing through a photo album, the body is always fully engaged in and by doing photography and can be seen more widely as 'the site of activity and engagement with the world'.[23]

When photographers go out into the world, whether they decide to take pictures or not, they often take their camera with them. They become attached to their cameras: it becomes habitual, natural and they feel a little lost when they don't have the instrument by their side, in their pocket or around their neck. Different participants told similar stories:

> When I was younger, I was stuck in the house, so I would always walk about with [the camera] and now it is just habit [...] I carry my camera with me all the time I just always have it with me. If I don't have a bag with me I feel like something is missing.

> I have this [compact] with me 70-80% of the time when I am out of the house. Even when I go to the pub, I always have it tucked away in my coat pocket; you never know what is going to happen!

> When you put that camera around your neck and you feel its weight, you activate something, like I have my photographer's hat on.

Going out with photographers as they used their cameras demonstrated to me that movement was an integral part of photographic practice. Taking photographs can often feel like hard work and it is potentially a very physically demanding pursuit. When out walking together we were battered by the wind and rain and wandered for

miles. We carried heavy cameras and manoeuvred into isolated and empty places that were damp and dusty. One photographer I spoke to told me:

> As soon as you put the heavy lens on, you do hunch over [...] the other [camera] is too bulky so I carry the compact. I have the wrong bag and when you are taking a picture on a hill or something you start sliding down it with the weight of all the lenses gets you off balance and things [...] you feel very lop-sided and when you get home you are aching from carrying it around.

In a phenomenological context, the practice of photography switches from 'a way of seeing, to a specific mode of *being*' which allows the photographer to have a heightened 'sensory engagement with the environment'.[24] Carman explains that 'our bodies are constantly, though unconsciously and involuntarily, adjusting themselves to secure and integrate our experience and maintain our grip on the environment'.[25] Repetitive encounters with the camera are important in creating a rhythm that allows the photographer to immerse themselves in their environment, as they start to notice how and where they go.

The camera is a machine that becomes easily incorporated into the wider *body schema*, and this allowed the photographers I observed new insights into their locale. The habit of taking the camera with them each time they ventured out guided their movement around the city. For Merleau-Ponty, 'it is the body which understands in the acquisition of habit'. Noticing the details of the world around them becomes second nature to the photographers and a natural part of their practice.[26] Seamon discusses the importance and role of 'noticing and heightened contact' in everyday life, which in this case could be specifically applied to the photographers' interaction with both the city and their cameras.[27]

Seamon describes noticing as 'a thing from which we were insulated a moment before, flashes to our attention'.[28] I believe photography is connected to a form of *heightened noticing* and photographers are often actively engaged in both looking for and noticing different scenes, people and places with their camera. One participant told me:

> I like getting out and about. See even the other day, I thought I

will walk into town from where I am down the road where the
RVI [a local hospital] is on the left and the park is on the right
I normally walk down there, straight into town but when you
have the camera you think, I should walk a different way. You
think I have walked down this road before I am not going to
see anything particularly different but if you go down the other
street you might see something good!

Another told me that 'when I am going out in Sunderland, I go where
I think I am going to get good photos [...] you see the world totally
differently [...] you are keeping an eye out.' Noticing soon becomes
a habit that changes the way photographers engage with the world
even if they don't have a camera with them. The relationship between
camera and photographer goes deeper than simply interacting with a
machine, it fundamentally changes the photographer's movement
with their body and ultimately, the way they view life.

Photographers on Computers

Whilst it is vital to examine the physical and habitual character of
taking photographs, for all of the participants in my study being on a
computer was also an integral part of their practice. Aside from their
interaction on Flickr most used some kind of post-production process
to enhance their pictures. One participant explained that:

> Photography is not just about pressing the shutter; the post-
> process work-flow is as important to the final image as is
> the viewpoint selection, in-camera composition, physical
> camera settings, etc. A more "typical" day of photography
> would probably mean I have four or five hours (weather and
> inspiration permitting) and then several more – over a few days!
> – working on the images.

Many photographers spent as much time on their computers as they
did with their cameras and when they were not processing their
images they were uploading photographs or browsing the content of
Flickr. Once Flickr had become part of a daily routine, they would
come to know certain parts and features of the site intimately and
would repetitively visit them, much the same way as they would
offline places. Indeed often the two crossed over as one photographer
told me 'if I have seen something that someone else has taken a

picture of [on Flickr] that would make me want to [go out and] do something different!'

When clicking quickly on the photographs on his favourite group pages, one photographer continually kept going back and revisiting the group sites and looking at the images there. In a similar way, another went between his personal and group pages, as well as the central Explore page, always in continuous, repeated movements. The movement of the photographers also subtly changed as they interacted with the site and, to use the metaphor of walking, shifted from a purposeful walk as they did the more administrative duties (checking messages in group sites and leaving feedback and comments) that developed later into a more explorative stroll around the site.

What I want to emphasise here is that the photographer in front of the computer is not passive, they are actively using their body combining their skills with movements and familiar gestures, and there are significant overlaps and similarities between movements online and offline with the camera. In one example, when they like what they see outside with the camera, they press the shutter release; on Flickr they click with the touchpad or mouse on the picture that their eye is *drawn* to. When holding the camera they would briefly glance at the back screen to see the image they have taken, quickly taking position with their body again, getting ready for the next shot. On Flickr they quickly scroll through the photostream of the photographer, and if they like the photograph click the *favourite* button and move on to the next.

The crossover between movements in an online/offline context is to be expected, as the 'body subject can transfer its movements over similar contexts', and certainly there were similarities when photographers were using both the camera and computer.[29] Although their sessions on Flickr are to an extent unplanned, ultimately they are exploring the same places (groups and certain features) repeatedly. In a similar vein, there are features on Flickr that they never use or visit, just like destinations in the city. One photographer enjoyed "scouting about" on Flickr, however I noticed he limited the areas he visited online to the same local places as his offline walking habits, visiting and revisiting areas that were deeply familiar even if they were captured by other Flickrites.

I would like to expand a bit more on how photographers find their way around Flickr, which continued this pattern of repetition. Although he has never explicitly written about online movement, I would particularly like to highlight areas of Ingold's writing on

perception and orientation which is helpful in opening up discussions of what people do as they move around online places. Ingold's more recent work has considered the lines and the paths we make as we move around and he considers the world not as a network of points but as a *meshwork* of interactions where people 'make their way *through* a world-in-formation rather than across its preformed surface'.[30]

Taking these ideas a step further, I believe that the photographers on Flickr make their way through the site via similar paths and movements which are guided by routine encounter. Although Flickr is a huge site, which is also in a continuous state of formation (consisting of billions of photographs, with many more comments and tags), the photographers I observed tend to visit the same places and familiar group pages on the site, and to interact with the same people. When one photographer was scrolling through one of the groups he was a member of, he commented to me that it tends to be 'the same old faces that you bump into' on the group pages: of the 4000 members of this particular group, only around 100 or so seem to regularly upload images for the daily competition. This is also the case for the group meet-ups offline, and of the several that I went to it tended to be the same photographers that both organised and attended.

Flickr's construction – its different environs and groups, its various and infinite paths – allows the user to find their own, unique way around the site. Other participants told me separately that:

> I am probably on [Flickr] most days not for a huge amount of time; I live on the internet, I work with websites, it is a constant distraction. Even if I am not posting photos, I might just check if someone has made a comment, have look at some of the groups I am in just generally keeping in touch.

> I am [on Flickr] everyday, if the PC is on I have it running on the background, I usually have a look to see if anyone has uploaded anything new from my contacts and see what it is, maybe make a few comments: I will look at what they have done.

Writing about dwelling and perception, Ingold proposes that 'knowledge is cultivated along paths [...] and that people's knowledge of the environment undergoes continuous formation is the very course of them moving about in it.'[31] Ingold's vocabulary is useful here precisely because it fits the shifting and transient architecture of Flickr.

The site is continuously mutating and expanding as users interact and connect, generating millions of multiple paths via their movement around it. If these paths were drawn with a pen, they would resemble a jumbled, dense meshwork of lines.

Ingold believes that the dominance of the network model (where the emphasis is put on the *connections* between people and things) is flawed.[32] Instead he insists our entanglement and habitation along the trails of everyday life is messier than a well-ordered network diagram might suggest. Members of Flickr are not all connected together point-to-point through their membership (most are not linked at all). Even their images can carve separate paths from their owners, as other photographers click on the photographs to add notes or make them a favourite to revisit later. In this context it is useful to recall Nancy House's statement that 'digital photographs have slipped the bounds of materiality and may have a life of their own, outside the control of their makers.'[33]

There are many different routes around Flickr and there are endless possibilities for users to find their own unique path on the site. I believe it is the inherently explorative feel of Flickr that has led to its global success. The language used throughout the site encourages users to find their way around a place rather than simply logging on to another site, deliberately mimicking their wandering strategies offline. Flickrites are being encouraged to conceive the site as a *somewhere* rather than just an abstraction. Due to the way photographs are randomly labelled and sorted (via folksonomy) there is every chance of finding a photograph in one search, then never coming across it again. This *uncovering* of content is more akin to when photographers notice things or places with their camera, and depending on what they find it can spin off and lead in different directions.

A further example of this is the aptly named Explore page, which asks photographers to find pictures on the site and asks if they wish to 'Explore interesting photos by choosing a point in time', whilst offering numerous 'places to Explore' including on-site features like the world map, the most recent uploads, the calendar, or the blog.[34] It is interesting to note the explicit reference here to *places* rather than *pages*.

The construction of the whole Explore page actively encourages random clicking so users can look at geotagged photos, see photographs from a year ago today or look at a few favourite sets where 'stories are told, themes are developed, junk is collected'.[35] The use of the words *stories* and *collection* here links back to the

analogue practices of narration, gathering and revisiting photographs in albums. There are of course many other ways to get around Flickr and through visiting places other than the Explore page there is every chance that one could stumble upon the same groups or pictures at random via their own exploration and wandering of the site.

Conclusion

> In studying technology the role of the body, those who make something, who use it, are affected by it – is integral. By this reckoning the very distinction between body and tool is blurred and each must be seen in a relationship to the other, in combination.[36]

Whether photographers use a digital or film camera, they must still go out into the world to take photographs, and on Flickr, there is always an offline context to online movement. Various technological innovations have meant that photographers can take more pictures than before whilst still performing the old routines in various sites. Online places such as Flickr have become popular, not just through their innovation, but because they offer a place where photographers can exhibit and compare their work, and discuss their passion for photography – something offered by photography clubs for the last 100 years. Where Flickr differs from other websites is that its complex construction assists its members to actively explore the images on the site, mirroring their curiosity and noticings with the camera offline. Flickr is relatively new, but it allows photographers to transfer some of their old routines with the camera to their online experiences, making it a particularly unique place on the web.

Two primary aims were stated above. The first was to move ideas on photography away from the dominant discussions of representation which often overlook the other interesting *doings* of the photographer. Following on from this, the second aim was to explore and reflect upon the relationship the photographer has with the camera and computer, and how their photographic and on-line practice impacts upon their everyday life. The proposed conceptual framework suggested here allows a move away from a representational framework. Instead it borrows from a diverse range of fields including human and urban geography, phenomenological philosophy and anthropology, working alongside media and photography studies to build an alternative approach to thinking photographic practice.

Photographic practices are both diverse and long reaching, and can
be found in many different places online and offline. The relationship
between the body and the machine is a complex process, and the
corporeal and sensual interaction between each part builds over
time as photographers successfully 'throw their bodies into the
performance of meaningful action' forming a strong connection
with the camera.[37] Naturally, this habit then impacts on the everyday
routines of the practising photographer elsewhere. Infused within
these various routines is *movement*: by bodies in the urban and
online landscape and the images themselves as they carve their own
paths on Flickr.

On Flickr emphasis is placed on connecting, sharing and
exploration: its construction has been cleverly engineered to engage
photographers further by mimicking the processes of offline everyday
photography. If the habit of noticing flourishes offline, this also
impacts on the photographer's movement and routines on Flickr.
Certainly, among the photographers I observed, there was clearly
a process of being *drawn* to a random image on Flickr, which had
similar properties to offline noticing with the camera. Visitors and
members alike are encouraged to explore all of Flickr's content, in
the same way that they would explore outside with their camera.

This exploration does come with an important qualification
though. There are numerous ways to search for photographs on the
site: via different tags, favourites, groups, geotags and maps, or via
the content pre-selected by Flickr on pages such as Explore, the clock
or the calendar. Each user has their own preference and routine as
to where they go on Flickr and once it has become established they
tend to stick to the same paths. Just like when they walk around the
city, their wandering around Flickr is selective and they mostly go to
the places they are familiar with.

The relationship between bodies and machines is complex, and
the corporeal and sensual interaction between each part builds over
time, forming a strong connection. Naturally, this connection also
impacts on the everyday routines of the practising photographer.
Fundamental to these various routines is *movement*: of the body in
the urban and online landscape and even of the images themselves.
The different possibilities that these new wanderings offer make Flickr
ripe for further exploration and a fascinating place to understand
more about being a photographer in the world.

To state that photography is more about movement than stillness
sets this research philosophically apart from others in the field

of photography studies, and takes a leap into relatively unknown terrain. As Elizabeth Edwards suggests, it is time that writing was broadened and room made for new insights on the varied practices involved within modern photography – particularly in the era of sophisticated mobile smartphones with video capabilities.[38] Images are produced from a culmination of different experiences, environments and movements, which are all essential parts that make up the multiple layers of practice. Furthermore it is clear that researchers within photography need to start looking at the diverse practices that continue to make photography an important part of everyday life and a thoroughly corporeal practice, whether with a camera or on a computer.

Notes

1. Jonas Larsen, 'Practices and Flows of Digital Photography: An Ethnographic Framework', *Mobilities*, Vol. 3, No. 1 (2008), 143.

2. Elizabeth Edwards, 'Thinking Photography Beyond the Visual' in J. J. Long et al (eds), *Photography, Theoretical Snapshots* (Oxon: Routledge, 2009), 31.

3. Sarah Pink, 'Amateur Photographic Practice, Collective Representation and the Constitution of Place', *Visual Studies*, Vol. 26, No. 2 (2011), 92.

4. Daniel Palmer, 'Emotional Archives: Online Photo Sharing and the Cultivation of the Self' *Photographies*, Vol. 3, No. 2 (2010), 159.

5. Nancy Van House, 'Personal Photography, Digital Technologies and the Uses of the Visual'. *Visual Studies*, Vol. 26, No. 2, (2011), 125.

6. See Henri Cartier-Bresson, *The Decisive Moment: Photography by Henri Cartier-Bresson* (New York: Simon and Schuster, 1952); Roland Barthes, *Camera Lucida. Reflections on Photography*, trans. Richard Howard (New York: Hill & Wang, 1981).

7. On hill walking see Katrin Lund, 'Seeing in motion and the touching eye: walking over Scotland's mountains', *Etnofoor*, Vol. 18, No. 1, (2005) 27-42; Jo Vergunst, 'Technology and Technique in a Useful Ethnography of Movement', *Mobilities* Vol. 6, No. 2, (2011) 203-219. On driving see Eric Laurier et al. 'Driving and passengering: notes on

the ordinary organisation of car travel'. *Mobilities*, Vol. 3, No. 1 (2008) 1-23. On watching films see Vivian Sobchack, 'Phenomenology, Mass Media and Being-in-the-world: An interview with Vivian Sobchack' in Marquard Smith (ed), *Visual Culture Studies* (London: Sage, 2008), 115-131.

8. Maurice Merleau-Ponty, *Phenomenology of Perception*, trans. Paul Kegan (London: Routledge, 1962), 166.

9. Ibid., xv.

10. Taylor Carman, *Merleau-Ponty* (London: Routledge, 2008), 188-9.

11. Ibid.

12. Merleau-Ponty, *Phenomenology of Perception*, 167.

13. Tim Ingold, *The Perception on the Environment* (London: Routledge, 2000), 168.

14. Tim Ingold, *Lines: A Brief History* (Oxon: Routledge, 2007), 89.

15. Ibid.

16. Tim Ingold, *Being Alive: Essays on Movement, Knowledge and Description* (London: Routledge, 2011), 249.

17. David Seamon, *A Geography of the Lifeworld* (New York: St Martins Press, 1979) 15; and Seamon, 'A Geography of Lifeworld in Retrospect: a Response to Shaun Moores', *Participations*, Vol. 3, No. 2, November special edition (2006), available at: http://www.participations.org/ [accessed 1 Sept 2011].

18. Phil Hubbard, 'Space/Place', in David Atkinson et al. (eds), *Cultural Geography: A critical dictionary of key concepts* (London: IB Taurus, 2005) 42. See also: Edward Relph, *Place and Placelessness* (London: Pion Ltd, 1976); Yi-Fu Tuan, Space and Place (London: Edward Arnold, 1977).

19. Seamon, *A Geography*, 40; 41.

20. See Filipa Matos Wunderlich, 'Walking and Rhythmicity: sensing urban space'. *Journal of Urban Design*, Vol. 13, No. 1, (2008) 125-139; Shaun Moores, 'Media Uses and Everyday Environmental Experiences: a Positive Critique of Phenomenological Geography', in *Participations*, Vol. 3, No. 2, November special edition (2006); and Moores, *Media, Place and Mobility* (London: Palgrave, 2012).

21. See Sarah Pink, 'Sensory Digital Photography: Rethinking "Moving" and the Image'. *Visual Studies*, Vol. 26, No. 1 (2011), 4-13; and Sarah Pink, *Situating Everyday Life* (London: Sage, 2012).

22. Seamon, *A Geography*, 29.

23. Vergunst, 'Technology and Technique', 206.

24. Ingold, *Perception on the Environment*, 262 (my emphasis).

25. Carman, *Merleau-Ponty*, 110.

26. Merleau-Ponty, *Phenomenology of Perception*, 167.

27. Seamon, *A Geography*, 108.

28. Ibid.

29. Ibid., 50.

30. Tim Ingold, 'Bindings Against Boundaries: Entanglements of Life in an Open World', *Environment and Planning*, A 40(8) (2008), 1802.

31. Ingold, *Perception on the Environment*, 229-30.

32. Ingold, 'Bindings Against Boundaries'.

33. Van House, 'Personal photography', 128.

34. *Flickr*, Explore front page, available at: http://www.flickr.com/explore/ [accessed 27 February 2012].

35. Ibid.

36. Vergunst, 'Technology and Technique', 206.

37. Carman, *Merleau-Ponty*, 111.

38. Edwards, 'Thinking Photography'.

7

The Athleticism of Imaging: *Figuring a Materialist Performativity*

IN *What is Philosophy*, Gilles Deleuze and Félix Guattari argue
that art's role is to confront chaos, throw a net over it and create
a plane of composition.[1] This is a powerful image, and one that
figures the unwieldy struggle of picturing through which images
emerge in the world. However, for Deleuze and Guattari, the
aesthetic plane of composition should not be confused with technical
composition, the relation between content and form. Rather it is
figured as the productive synthesis of forces constructed as a block of
sensation. According to this materialist ontology it is not the artist
who creates sensations but rather underlying forces in material that
create something "intensely present" that will allow new worlds to
germinate. When this happens, we may "live" the image.

The idea that an image is alive, an intensive presence that insinuates itself into our world so that we "live" it, offers a fundamental challenge to Western aesthetics, and both formalist and post-modernist understandings of the image. According to these regimes of thought, images exist as objects to be manipulated, viewed, appreciated and/or deconstructed by humans. Here, "compositional dynamism" is figured as operating purely within the frame of the work. We are perfectly safe, since it is only an image. However, in a materialist account, the function of imaging is never re-presentational. Rather, it is an event of picturing and mattering and in this encounter we are never safe. The task of imaging is not to illustrate the world, tell a story about the world, provide a stream of information or take a programmatic political stance. Rather, imaging provides the expansive force that undoes representation and creates something unimaginable yet precisely "true-to-life." Where we see a figure, for example, I will ask us to consider not what it is, but what are the conditions through which it works. Whilst a figurative image may appear immediately welcoming, a materialist account invites us to go beyond the figure to the abstract frame-work that holds it together, and us with it. This enigmatic invitation builds us into the image. We are not outside looking at an image but actually become part of the teeming life of the work.

How does one create something unimaginable yet precisely true-to-life? How does one go about achieving the event of imaging where we will be able to "live" the image rather than merely look at it or look out at it? Through returning to the so-called "formal" language of art and refiguring it through a materialist lens, I will map the dynamism of the imaging in which shapes push and shove, lines quiver, rhythms march, vectors pressure and accents glide – in order to demonstrate how the expansive force that *is* art undoes representation and produces something true-to-life.

This mapping will be staged in three movements. Firstly I will chart an encounter with Benjamin Wood's action improvisations and his photo-drawings to argue that images are bodies in fields of force. Secondly I will returned to the Bauhaus of the early twentieth century to consider how Johannes Itten's teachings in his Basic Course on Design and Form allows us to understand how we may live an image. Finally I have an engagement with Stanley Cavell's concept of automatism to step out an argument that picturing may be understood as an expansive force, a material-discursive automat that undoes representation and creates something unimaginable yet precisely "true-to-life."

Figure 1. Benjamin Woods, dispersing a body as a field of specked collisions, 2012, digital picture, variable dimensions.

Ben Woods is a sculptor whose improvisatory practice engages with other people, instruments and specific circumstances and contexts. Through what he calls 'tactful participation' his aim is to actualize 'new possibilities for specific physical arrangements (concepts) and entanglements of bodies, instruments and the world'.[2] Woods sees his action improvisations as a way of becoming aware of the dynamic interplay that occurs between humans and between humans and non-human actants. Of this approach Woods comments that, 'working with action as the redistribution of relations provides a platform for a process of opening or a physicality of openness [...] I work to make visible an agential reality where action is that which forms relations that matter.'[3]

In developing his action improvisations, Woods began to work with the camera to document these actions. In responding to these "documents" he soon came to recognize that the 'documentation images produced from these improvisations were not representational images for the indexing of action in a linear sequence', but were actions in themselves.[4] He see his photo-drawings, 'as a process with its own kind of action, is a propellant of radically open futures for the becoming of the world.'[5]

The claim that pictures 'are specific sets of dynamic physical arrangements with their own force', which is a 'propellant of radically open futures', returns us to the question put at the beginning of this chapter: How does one create something unimaginable yet precisely true-to-life through picturing?[6] This is not to invoke the view that through its mimetic functions the photograph gives us something "true-to-life", but rather to posit that despite its mimetic and representational character, photography is an expansive force that undoes representation and creates something unimaginable yet precisely "true-to-life". How do we go beyond the figure to the abstract framework that holds it together, and us with it?

It is here that I wish to turn to the figure of Johannes Itten, and his Basic Course on Design and Form. The Basic Course was, for a short time (between 1919 and 1923) the foundation course for all Bauhaus students.[7] Modelling his teaching program on that of his teacher, Adolf Hölzel, he developed a program of instruction that was dedicated to exploring the 'means of design' through the 'study of pictorial composition and the fundamentals of colour'.[8] In this course, Itten drew on Hölzel's "means of design" (what we have come to know as the fundamental principles of design) – light-dark, colour, material and text, form, rhythm, expressive forms, subjective forms –

to construct the curriculum for this basic design course.

Itten's teachings have been passed down to us in codified form as "design fundamentals", where form is considered as the manipulation of the various (visual) elements and principles of design. Here the principles of design assume the status of "universals", principles to be applied and manipulated by the artist. Thus in David A. Lauer and Stephen Pentak's Design Basics, 'content is what artists want to say' and 'form is how they say it'.[9] This may be seen to equate with "technical composition", rather than the aesthetic composition that Deleuze and Guattari speak of. We have no sense of the entanglement between the material condition of the artwork and the sensations as they come about. Here pictorial composition is reduced to the internal logic of the relation between content and form.[10] This is what we understand by the term formalism, and forms the key principles that came to underpin formalist art.

The rise of formalist art is inseparable from the emergence of Clement Greenberg as a writer and critic. Through Clement Greenberg's formalism, the "figurative" and the "abstract" become oppositional and abstraction became the privileged term. But is this how Itten conceived of his program or taught the "means of design"? He did not see the figurative and abstract as oppositional separate, but intertwined in each other. Through his teaching he was always asking students to go beyond the figure in order to understand the abstract framework that underpins it.

Itten's teaching methods, unorthodox at the time, aimed to prepare the body and the mind for work through the use of relaxation, balancing and harmonizing exercises. He considered this essential in preparation for the task of picturing. He exclaimed, 'how can the hand express a characteristic emotion through a line when hand and arm are cramped?'.[11] For Itten, experience and tacit knowing became the touchstones that prepared the artist for making pictorial composition. Thus, he believed that 'the characters of [...] materials had to be experience and represented [...] not only seen but felt', and he 'always attached great value to this sensuous grasping of the characteristic quality of all things'.[12]

Through building the world into the body, so that it became tacit, Itten's teaching made a direct connection between the world's textures and rhythms, and the body's rhythms, as well as its manifestation in and through the work. He saw the preparation of the mind/body as a critical phase in the creative process. When, for example, he introduced the "principle" of rhythm in class, he took the students

through the experience of the change in rhythms:

> First I had the students walk in march rhythm, beating time with their hands. The rigidity of this simplest rhythm was to take hold of the whole body. Then I counted off a triple rhythm, so that the stress fell first on the right foot, then on the left. Various changes followed, and sometimes two students would dance to the syncopated rhythm of a record.
> Then these rhythms were drawn; the march rhythm was represented by stressed and unstressed stroke, the triple rhythm by circular elements. Varying intonation determined the motion. When a march or waltz rhythm was stopped after a few beats and continued in irregular intervals, the interruption of the rhythmic movement was felt almost painfully by everyone [...]
> All exercises had to be repeated graphically [...] rhythmic sensation is not mere schematic repetition but can be a flowing movement.[13]

These "felt rhythms" became inscribed in the work. In reflecting on this he observed that: 'rhythmically handwritten forms have their own wind and breath which makes them a living family of forms. [...] When the same letters are written without this breath, the letter forms stand there unrhythmically cold, unrelated and unyielding.'[14] Thus for Itten the principles of design were not abstract "ideal" principles but were the forces that enabled life to get into the work and to create something "intensely present" so that we may "live" the image.

Through his eclectic teaching methods, Itten sought to draw together an intimate and tacit knowledge of materials, an embodied experience in, and application of the "means of design" and strategies to open up the imaginative possibilities in the work of the students. In Design and Form, he comments:

> We worked on geometric and rhythmic forms, problems of proportion and expressive pictorial composition. [...] the study of polar contrasts, exercises for the relaxation and concentration of the students brought amazing successes. I recognised creative automatism as one of the most import factors in art.[15]

Automatism is a term that has recently re-emerged in the lexicon of photography and art criticism. In 2012, an edition of the

journal Critical Inquiry was devoted to 'Agency and Automatism: Photography as Art Since the Sixties' and Rosalind Krauss has written two monographs, Perpetual Inventory (2010) and Under Blue Cup (2011) in which automatism is central to her argument that, in the face of the postmedium condition, automatism allows artists 'the freedom to improvise' and invent new mediums.[16] However, is there any relation between the term, as used by Itten and these contemporary elaborations of automatism?

Itten was teaching his Design Course at the Bauhaus between 1919 and 1923 at the time as André Breton and Phillipe Soupault wrote The Magnetic Fields, the first example of automatic literature. Whilst his mentor, Adolf Hölzel, was committed to the value of automatism in the arts, the "excitement" that was generated around automatism, as a technique to release creative imagination, centred around André Breton and the rise of Surrealism. Automatism, adopted by the Surrealists as the method par excellence to tap into the unconscious and escape the rigours of rationality and conventional thought, drew on the Freudian psychoanalytic technique of free association. In the first Surrealist Manifesto, published in 1924, Breton defined pure psychic automatism as the method:

> by means of which one intends to express, either verbally, or in writing, or in any other manner, the actual functioning of thought. Dictated by thought, in the absence of any control exercised by reason, free of any aesthetic or moral concern.[17]

Through the technique of automatism Breton imagined that the oppositions between subject and object could be broken down and that perception and representation could instead be thought of as the 'products of the dissociation of a single original faculty'; for Breton, the eidetic (aesthetic) image opens up this realm.[18]

The notion of psychic automatism, that is central to the thinking and practices of Surrealism, seems to operate in a different order to the concept of automatism that has become associated with photography, particularly through the work of the philosopher and film theorist Stanley Cavell. While psychic automatism is concerned with a mechanism to allow psychic faculties to flourish,[19] Cavell's conceptualization of automatism in photography and film, appears, at first glance, to be concerned with the technology and the idea that the camera is an automat. In Cavell's view, says Diarmuid Costello,

automatism, refers to the 'brute automatism of the camera itself, the fact that cameras are capable of producing an image of whatever they record without subjective mediation.' In the spirit of this "brute automatism", all artist media could be seen to be automatisms. However, in an era of media obsolescence, observes Cavell, these automatisms are being lost to modern artists. Thus, he says 'there are no longer known structures which must be followed if one it to speak and be understood. The medium is to be invented out of itself.'[21]

In Under Blue Cup (and also in Perpetual Inventory), Krauss concurs with Cavell's assessment of medium obsolescence. She draws on his ideas of automatism to develop her thesis that, in the face of the post-medium condition, artists can or need to invent their own mediums. She argues that in the face of the exhaustion of traditional media-specific art forms and the paradigm shift that has ushered in the post-medium condition, artists have sought new technical supports from outside the conventional artistic media – often obsolete and outmoded commercial technologies and practices from mass media and mass culture. Through articulating the new technical supports invented by artists – Ed Ruscha's use of the automobile; William Kentridge's drawings for projection; James Coleman's adaptation of the slide tape; Christina Marclay's work with synchronous sound track of commercial films; Bruce Nauman's adoption of the architectural trope of the promenade; Sophie Calle's parody of investigative journalism; Marcel Broodthaer's museum without walls; and finally Haun Farocki's foregrounding of the video editing bench – Krauss argues that the artists had to discover the "rules" of their technical support and out of these rules forge a new practice. She proposes that Cavell's notion of automatism accounts for the discovery of 'the rules by which practitioners of a given discipline gain the freedom to improvise'.[22] For Krauss, linking the notion automatism to the "technical support" frees artistic practice from the strictures of "medium specificity" and allows practice to be understood in terms of Cavell's automatism.

Costello suggests that Krauss derives her understanding of artistic media as 'not simply as physical materials but physical-materials-in-certain-characteristic-applications', from Cavell.[23] However, he takes issue with her interpretation of Cavell's position on the invention of new media and proposes that Krauss' notion of automatism is of a different order to Cavell's. Costello proposes that while for Cavell, automatism is about the "brute" technicity of the camera – the fact that a camera can produce an unmediated image (for example

Henri Cartier-Bresson's *Visit of Cardinal Pacelli*, 1938, which
will be discussed below), Krauss' conception involves two kinds
of automatism: firstly a quasi-automatic automatism (automatic)
that is associated with the interaction between the technology and
the artist; and secondly a psychic automatism or "automatisms of
the unconscious" (autographic), where unexpected connections,
associations and solutions arise in the working process. Costello
claims that Krauss derives her two senses of automatism from
Kentridge's description of his working process, where images are not
preplanned but emerge through the regime of drawing.[24] This may be
immediately true, but the notion of "automatisms of the unconscious"
relates back to Surrealism and the notion psychic automatism.

 This brings us back to Itten and the question raised earlier:
Is there any relation between the term, as used by Itten and these
contemporary elaborations of automatism? Can we figure a more
nuanced understanding of "automatism" that sits in the interstitial
space between Rosalind Krauss' conception of automatism as a
form of psychic automatism and Cavell's technical conception of the
brute automatism of the camera, and that takes into account the
dynamics of picturing that is revealed through Itten's mode of
teaching? Cavell sets this thought in motion when he poses the
category of automatism. In setting up the frame he says that he needs
to (at least at the outset) 'neutralize the presence of the physical
mechanism of camera and projector', and 'free the idea of the medium
[...] from its physical base', since any consideration of automatism
is both a historical and ontological question.[25] This bracketing out
allows Cavell to turn to modernist painting, and particularly Jackson
Pollock's embrace of automatism.

 It is part of the canon of art history and theory that Pollock's
adoption of automatism was influenced by Surrealism. However,
drawing on Rubin, Cavell argues that for Pollock it was not the
method or technique of automatism that was important. Rather it
was the "idea" of automatism. Thus, whilst, '[t]he surrealists looked
for automatism which would create images [...] Pollock looked for an
automatism with which to create paintings.'[26] Cavell claims that the
automatism that Pollock invented was not "action painting". Rather,
through the evolution of all-over line what was revealed as painting
was 'it's flatness in that it is totally there', in the sense that it is 'wholly
open to you in front of your senses as no other form of art is.'[27] In
other words, conditions of possibility of modern painting did not
require a recession into another world. The apparatus or technologies

that were involved in the production of this "new automatism" included the rhythms of Pollock's body, the "idea of automatism," the automatism of the paint and canvas, the discursive framing and reception of the paintings and history material practice of painting.[28]

If the automatisms of painting arise in the interplay between the material and the discursive, what are the automatisms of photography? Earlier I cited Costello who has argued that, for Cavell, it was the "brute automatism of the camera itself". In The World Viewed (1979), Cavell made the statement that: 'A painting is a world; a photograph is of the world.'[29] Does this "distancing" from the world deny photography the means to allow us to become part of the teeming life of the work? Is the photograph's fate to be of the world and never be a world? Ben Woods has certainly aimed at making his photo-drawings worlds, presences that 'enact invisible forces'.[30] However, as we have seen, he has taken creative license with photography and has, as Hannah Hoch did before in her photomontages, pieced together shapes to define planes, joined planes to mark out a territory and activated a force field to create an aesthetic plane of composition. This is the "work" that the digital has celebrated.

In taking photography as photography-as-such, Cavell seems to have accepted the "brute" automatism of the camera. The fact of the camera's mechanism, the fact that its material reality is "an opening in a box" that crops a slice of the world and brackets out the rest of the world is, for Cavell, 'the best emblem of the fact that a camera holding on an object is holding the rest of the world away.'[31] Thus, he concludes that while the camera has been 'praised for extending the senses' he suggests that the praise should be more for confining the senses, 'leaving room for thought'.[32]

But does photography necessarily confine the senses, as Cavell would seem to be arguing? Does the "cropping" of a slice of the world cut the rest of the world out? At first glance, we would say that this is true of Olive Cotton's Drain Pipes of 1937.[33] Here the cropping does point to the world outside the frame, the pipes all lined up in a row and the world beyond them tantalizes for its absence. However, if we take our instructions from Itten and go beyond the figure to the abstract framework that holds it together, we experience a sensation of pressure as shapes push and shove, rhythms march and accents whip us around the picture. Through activating design principles, the aim has always been to keep our attention in the picture frame, but in Cotton's Drain Pipes I would suggests that the dynamism builds us into the picture. Cotton's Tea Cup Ballet (1935) also does precisely

this. We become caught up in the waltz of the tea cups and through the rhythms, repetition the force of vectors they produce we are deftly moved through around the space.[34] I am reminded here of a painting, *At the Cirque Fernando: The Ringmaster* (1888) by Toulouse Lautrec, and how we are drawn into the world of the circus through the ring master and, through the line of his whip, we are led up the horse's fine rump, and become swept up and catapulted around the circus ring at fast speed, egged on by the repetitions of the black and white of the gentlemen's suits and the racy red of the rows of seating.[35] We are moving so fast, one would fear being cast out of the frame and dumped, if it were not for the antics of the clown, whose cocky red hat catches us and draws us back round to the ring master, and once again off we go with incredible speed.

But lets stop for a moment and return to photography, and this time to Cartier-Bresson's *Visit of Cardinal Pacelli* (1938).[36] When we view Henri Cartier-Bresson's *Visit of Cardinal Pacelli*, we may, as Carol Armstrong has done, start with Barthes' 'Photographic Message' and go on to marvel that 'without any interventions of the photographer's agency save for the quick gesture of raising the hand and clicking the shutter' the camera automatically generated the content that we have come to accept as Cartier-Bresson's photograph.[37] This is of course true. But in addition to these, when confronted with the photograph, we are brought up close to through the generosity of the camera's viewpoint. What we experience is a tight spiralling inward through the repetition of heads that creates intensity at the point of what Armstrong calls 'the scene of the kiss of Judas'.

But what is the camera's role in all of this? Armstrong calls her article, 'Automatism and agency intertwined', and tells us that (apparently) Cartier-Bresson held the camera high over his head and had no conception of what would be in the frame.[38] Yet in her attribution of agency to Cartier Bresson, she seems to be suggesting that it is only the human who has agency. The automatism of the camera is just that, brute mechanics of the camera, the fact that cameras are capable of producing an image without subjective intervention,[39] *and* the question of chance. Armstrong says of this photograph:

> The photograph's resemblance to the scene of the kiss of Judas in the history of painting is merely fortuitous, a matter of pure luck. So too is the host of details surrounding the heads and

kissing of hands at the center: the cardinal's skull cap and its similarity to a yarmulke, a woman's face between the two men, a partial profile above her, a Hitleresque face and medal in the upper-left corner, a grimacing face behind the shoulder in the lower-right corner, a gendarme peering forward in the upper right, and so on. These details come together with the pre-Occupation date of that Parisian moment as unwilled facts caught willy-nilly, automatically, and all at once by the camera [...]. [40]

In his article, 'Arts, agents, artifacts: Photography's automatism', Patrick Maynard introduces an ambiguity between brute automatism and the notion of the "self-acting" machine. For Aristotle, he claims, the term *autómaton*, meant self-action or, as he would have it chance.[41] He cites the nineteenth century art historian, Lady Eastlake (aka Elizabeth Rigby) to support the view that self-action is about chance. Thus he says that Eastlake meditated on:

> the medium's strikingly accident-prone feature, its lack of "power of selection and rejection", with emphasis on photography's propensity for unnecessary surface texture and detail – that is, noise.[42]

However, aren't these "propensities" of the photograph what allows us to invent a new medium out of itself? This brings me back to Benjamin Woods and his accommodation (what he calls "tactful participation") in relation to the other participants engaged as part of his action improvisations. Here he sees that in practice, tact is required so that one doesn't 'seize hold of or manipulate or possess' and that he must be tactful, 'not only towards other people, but other forces, other actions and other matters, that are "other" only because they enact' an entanglement of difference.[43]

In the constellation or articulation through which art emerges there is, as Donna Haraway proposes, no ontological distinction between 'who makes and who is made in the relation between human and machine'.[44] In fact it may be that through the intertwining of automatism and agency that a new automatism comes into being, as "self-action," and thinks itself a cyborg – or what Haraway calls a material-semiotic actor. In the assemblage that constitutes the material-semiotic, the "actants" may be human or non-human, machine or non-machine, discursive or material, symbolic or

semiotic.[45] What is critical to her position is that the material-semiotic "articulata" becomes an "apparatus" of production. Thus, the apparatus or technologies that were involved in the production of the "new automatism" in Jackson Pollock's "drip paintings" included the rhythms of Pollock's body, the "idea of automatism", the automatism of the paint and canvas, the discursive framing and reception of the paintings and history material practice of painting. For Cavell too, automatism in photography involves the complex articulation between the mechanical, the material and the discursive. It is not just a question of the brute automatism of the camera.

As I have encountered Wood's photo-drawings from his action improvisations, returned to the Bauhaus of the early twentieth century to reconsider Itten's Basic Course on Design and Form, stepped through Cavell's explication of automatism and Krauss' adaptation of it in Under Blue Cup, I sense that a more nuanced and complex understanding of the notion of automatism is emerging. This expanding sense of the term takes into account what Costello calls "the autographic" and the "automatic" but in a materialist rather than a modernist sense. For the autographic is not just the province of the human actor and the automatic is not just the domain of the mechanical technology. The automat becomes a material-discursive event that undoes representation and creates something unimaginable yet precisely "true-to-life". In this re-articulation of the notion of the automat, we may move beyond representationalism, into the world of the event where the photography is an intensive reality that we may live in and with rather than merely look at.

Figure 2. Benjamin Woods, multiple positions, circumstances, times, bodies, cuts (thank you Megan Dennis), 2012, digital picture, variable dimensions.

Notes

1. Gilles Deleuze and Félix Guattari, *What Is Philosophy?* trans. Hugh Tomlinson and Graham Burchell (New York: Columbia University Press, 1994), 202 and *passim*.

2. Ben Woods, *Becoming Becoming Open All Around*, (Unpublished MFA thesis, University of Melbourne, 2011), 78.

3. Ibid., 23.

4. Ibid., 72

5. Ibid.

6. Ibid., 38.

7. In 1923 Walter Gropius met with Itten and 'remarked that he could no longer be responsible' for Itten's teaching practices. This led Itten to leave the Bauhaus. Johannes Itten, *Design and Form: The Basic Course at the Bauhaus*, (London: Thames and Hudson, 1965) 17.

8. Ibid., 8.

9. David A. Lauer and Stephen Pentak, *Design Basics*, 4th Edition. (Fort Worth: Harcourt Brace College Publishers, 1990), 2.

[10.] The principles of design have been presented as "Ideal Forms" (in the Platonic sense of the word).

[11.] Itten, *Design and Form*, 11.

[12.] Ibid., 45.

[13.] Ibid., 129.

[14.] Ibid., 130.

[15.] Ibid., 8.

[16.] Rosalind Krauss, *Under Blue Cup* (Cambridge MA: The MIT Press, 2011), 16. And see: Rosalind Krauss, *Perpetual Inventory* (Cambridge, MA: MIT Press, 2010); *Critical Inquiry*, Vol. 38, No. 4, 'Agency and Automatism: Photography as Art Since the Sixties', ed. Diarmud Costello et al, (Summer 2012).

[17.] André Breton, 'First Manifesto of Surrealism' 1924, trans. A. S. Kline (2010), available at: http://www.poetryintranslation.com/klineasmanifesto.htm [accessed 28 June 2013].

[18.] André Breton, *The Automatic Message, The Magnetic Fields, The Immaculate Conception*, trans. by David Gasgoyne et al. (London: Atlas Press, 1933), 32.

[19.] Ibid., 27.

[20.] Dairmud Costello, 'Automat, Automatic, Automatism: Rosalind Krauss and Stanley Cavell on Photography and the Photographically Dependent Arts', *Critical Inquiry*, Vol. 38, No. 4 (Summer 2012), 836.

[21.] Stanley Cavell, cited in Costello, 'Automat, Automatic, Automatism', 840-841.

[22.] Krauss, *Under Blue Cup*, 16.

[23.] Costello, 'Automat, Automatic, Automatism', 821.

[24.] See: William Kentridge, '"Fortuna": Neither Programme Nor Chance in the Making of Images', *Cycnos*, Vol. 11 No. 1, 17 June 2008, available at: http://revel.unice.fr/cycnos/?id=1379 [accessed 26 June 2013].

[25.] Stanley Cavell, *The World Viewed* (Cambridge: Harvard University Press, 1979), 105.

[26.] Ibid., 108.

[27.] Ibid., 109.

28. In context of gender, Theresa de Lauretis has used the term "technologies of gender" to describe the material discursive formation of subjectivity. See de Lauretis *Technologies of Gender: essays on theory, film and fiction* (Bloomington : Indiana University Press (1987).

29. Cavell, *The World Viewed*, 24.

30. Woods, *Becoming Becoming Open*, 82.

31. Cavell, *The World Viewed*, 24.

32. Ibid.

33. Olive Cotton, *Drainpipes* (1937), available at: http://nla.gov.au/nla. pic-an12824764 [accessed 26 June 2013].

34. Olive Cotton, *Tea Cup Ballet* (1935), available at: http://www. art gallery.nsw.gov.au/collection/works/218.1980/ [accessed 26 June 2013].

35. Henri de Toulouse Lautrec, *At the Cirque Fernando: The Ringmaster* (1888), available at: http://www.toulouse-lautrec-foundation. org/At-the-Cirque-Fernando-The-Ringmaster.html [accessed 26 June 2013].

36. Henri Cartier-Bresson, *The Visit of cardinal Pacelli* (1938), available at: http://www.magnumphotos.com/C.aspx? vp3 =SearchResult&ALID=2TYRYD17HHQQ [accessed 26 June 2013].

37. Carol Armstrong, 'Automatism and Agency Intertwined: A Spectrum of Photographic Intentionality', *Critical Inquiry*, Vol. 38, No. 4, (Summer 2012), 706. Cartier Bresson called his photography "instant drawing" (ibid., 710).

38. Ibid., 706.

39. Costello, 'Automat, Automatic, Automatism', 836.

40. Armstrong, 'Automatism and Agency Intertwined', 705-6.

41. Patrick Maynard, 'Arts, Agents, Artifacts: Photography's Automatisms', *Critical Inquiry*, Vol. 38, No. 4, (Summer 2012), 731.

42. Ibid.

43. Woods, *Becoming Becoming Open*, 78.

44. Donna Haraway, *The Haraway Reader* (New York: Routledge, 2004), 35.

45. See also Bruno Latour's elaboration of objects as actors, particularly his article 'Mixing Humans and Nonhumans Together:

The Sociology of a Door Stopper', *Social Problems*, Vol. 35, No. 3 (1998), 298-310. In his theorizing, Latour conceives of objects as lieutenants who have been delegated to carry out particular functions. Thus he argues that what defines our social relations is in large measure prescribed back to us by nonhumans. In this, he continues, 'knowledge, morality, craft, force, sociability are not properties of humans but of humans accompanied by their retinue of delegated characters' (ibid., 301).

8

After the Dark Room: *Ana-materialism and the Sensuous Fractalities of Speed & Light* (or does the image still speak a thousand words?)

JOHNNY GOLDING

In my world, there have been at least three types of darkroom: (1) the laboratory, with its chemical baths and dull-orange exposures; (2) the backroom sex club, with its fetishized rhythms and differently organised friendships of circulation and exchange; and finally (3) the closet, with its secrets and wounds and dreams and escape plans, inserted neatly between shoes, trousers, shirts and suits. Each has its own set of rules and regulations, its own dangers and provocations, its own pungent aromas, mess, and light source poetics. All require a particular technical knowledge, a practicality laced with, and an expertise specific to each of those very different, darkroom heterotopias. To varying degrees, each might require some form of curiosity, experimentation and risk, tugging on the wider, and

sometimes, wilder, sensations of attraction, limit, destruction, reason, taste. But most of all, and no matter how different each darkroom might be from the other, they all have one thing in common, one thing that puts them into this realm of the dark: each, in their own way, explicitly colonises the present – makes it inhabitable and, indeed, makes the instant of time itself come alive. There is no abyssal logic or reference to self-reflexive unities so often characterising traditional notions of the "now" as something quite a bit different than the Hegelian reconfiguration of a negative/naught time. Lyotard might put it like this:

> (T)his is what you, Western philosophers, understand under the name of reflection: the protracted unfolding, the extended run of concepts, answers, and dramatic actions through which you imagine the mind coming to itself. The slow odyssey you dream of – that the mind returns experienced, and in agreement with itself. Such returns are the law of the (hi)stories, even those (hi) stories that narrate the absence of return. But reflection has nothing to do with them; it is their secret victim. [...] Presence is sacrificed in these (hi)stories: holiness. So that, on this expeditious slope, the unthought dominates, as does the lay person, who believes her or himself to be in possession of the reason of her or his life, and of her or his thought, within her/himself; who believes her or himself to have paid the price by sacrificing her/himself. But the holiness of the instant never finds reparation in a sacrificial (hi)story.[1]

Instead, each of these darkroom spatialities mentioned above work off the collapse of the past and the future into an immediate intensity that draws together, and indeed swallows up, subject, object, anything in between or in its path; swallowed all up into a black-hole *cogito*, a black-hole *cogito* dot of a "being-there", right here, right now. Let's unpack this last remark. In saying "a black-hole cogito dot of a being-there, right here, right now," I mean that all the expertise(s), curiosities, wonderments and so on, specific to each spatiality as named above, creates a bond – let's say it's something akin to a "magnetic" attraction with rough-edged consequences; that is to say, consequences emerging out of something quite different than rational/logical deduction. In this case, that is to say, in "the darkroom" case, one is not only "in the moment", one is the moment. But there is more: for this "self" in that darkroom is not some kind of homogeneous

Sherlock Holmes in search of the Truth; nor is it necessarily a "room" with discreet boundaries (like walls and floors and ceiling wax). Rather, it is a multiplicity/slice-fragment of self, fastening onto what lies to hand, where the fastening (as it were), not to mention the "that which lies to hand" is couched (Heidegger might say, "enframed") precisely by a double-helix set of relations.

This "double-helix set" is, on the one hand, coloured by one's actual abilities, established, say, through discipline, knowledge-practice; (i.e., being good at your trade: be it art, sex, rock n roll). It is created on the other, by the spatial-temporality of a "being-there-interior" (i.e. the darkroom itself), kitted out with well-chosen (or at any rate, more or less chosen) tools of that trade, ingredients including the smells, sounds and contours of the odd-bod materialities inadvertently or otherwise laying to hand. This heady, volatile mix, creates a "coincidence" in the strongest sense of the word to "co-inside" and, in so doing, drags the spectator-subject-fractal-sliced-self into the mix, the "being-there-interiority" mix, simultaneously, violently, brilliantly, instantaneously, penetrating that "*cogito*-fractal-self" and, immediately also, being penetrated by it.[2] It sets up what Jean Luc Nancy calls a "contagion", a "viral attraction" of distance and withdrawal alongside an immediacy (of intensity), a present/ing that creates, to quote Nancy, "a force that forces form to touch itself".[3] And what is this 'force that forces [makes/compels/demands] form to touch itself' (in the fullest, sensuous, masturbatory meaning of "touching oneself")? It is nothing more nor less, than a radical intensity, an immediacy shot through (and with), indeed "corrupted" by, the senses.

Let's try it again: And what is this 'force that forces [makes/compels/demands] form to touch itself: it is the attraction (erotic, curious, hungry, chemical) of a *cogito* dot of a "being-there-interiority" right now, able to touch itself, whilst simultaneously able to dis-appear (as in to disjunctively take a step apart, create a distance all the while – durationally-touching, in the fullest sense to lick, to penetrate and be penetrated, apart and yet together). An odd kind of "black-hole" aesthetics, this ontologically productive, substantive, sensuous (forced to touch and be touched) *cogito*, both dis-appearing and, simultaneously, re-presenting "itself" – not as a "model" or as a "representation" – but as radical intensity. This "radical intensity" is so named because in this carnal dance of touch-and-be-touched surface interiorities, a kind of plural or multiply dimensional materiality – an ana-materiality – neither real nor unreal, neither time stamped but

completely temporal, is made manifest. The "thing" (*das Ding*) that
is made manifest has a very common name: image. Thus, and as
Jean-Luc Nancy neatly summarises in his *The Ground of the Image*:
'*Cogito es imago*'.[4]

And now, it gets worse (or perhaps it gets better). But for better
(or for worse), three points follow from this claim: First: one begins
to "see" that the "image", not to mention *cogito* (both "the mind's
eye" and the *cogito*-dot of a being-there-interiority) is, to echo the
work of Henry Rogers in his *The Words I thought I Saw*, and to
paraphrase Nancy: the image is neither world nor language.[5] It is a
surface that eats and is eaten by this double dance, emboldened by
darkroom aesthetics. *Cogito es imago*. Second: because this "*cogito =
image*", this "visual-thing", is "forced to force form to touch itself", it
leaps out of the realm of the Hegelian "idea" to establish at the very
instant of its "coming to presence" the "holy" – in the sense of the
word "sacred"; that is, something able to "stand apart" whilst being
"together".[6] Third and final: the image, which "stands apart whilst
being-there" does not embolden or inhabit identity – or indeed have
anything to do with identity. For this "standing apart, whilst standing
together" touching, penetrated/penetrating etc., is not the same as
the rather infamous Heideggerian restatement of the A = A identity
equation, whereby the emphasis is placed on the "=" connecting A
to itself.[7] It is not about a Heideggerian "belonging" (or, indeed, any
belonging) nor is it forming a totalised unity sutured and cohered
via a thesis/antithesis sublation. For its very presence, the presence
of "image" is precisely and nothing other than radical connectedness,
radical sur-face self-coincidence, the fatal attraction of black-hole
darkrooms, embodying/dis-robing the senses themselves in all their
fractal iterative roughness. A "dis-identity". Over to Jean-Luc:

> In coming to the fore [the image] goes within. But it's "within"
> is not anything other than its "fore": its ontological content
> is sur-face, ex-position, ex-pression. The surface, here, is not
> relative to a spectator facing it: it is the site of a concentration
> in co-incidence. That is why it has no model [and that is why
> it makes no sense to speak of it in terms of "representation"
> "semiotics" or even dialectical materialism, not to mention
> "social agency"]. Its model is in it; it is its "idea" or its energy. It
> is an idea that is energy, a pressure, traction and an attraction
> of sameness. Not an "idea" ([in the Hegelian sense as] idea
> or eidolon), which is an intelligible form, but a force that

forces form to touch itself. If the spectator remains across from it, facing it, that spectator [self – she who stands in front and "rationalises" the image] sees only a disjunction between resemblance and dissimilarity. [But] If she enters into this self-coincidence, then she enters into the image, [she] no longer looks at it – though [she] does not cease to be in front of it. [He or She] penetrates it, is penetrated by it: by it, its distance and its distinction, at the same time. [...]One could say that the image – neither world nor language – is a "real presence". [...] This presence is a sacred intimacy that a fragment of matter gives to be taken in and absorbed. It is a real presence because it is a contagious presence, participating and participated, communication and communicated in the distinction of its intimacy... But in this way, it does not exist, it is there. Sense exists, or rather, it is the movement and flight of exiting: of *ex-ire*, of going outside oneself, exceeding, exiling. Sense essentially disidentifies.[8]

We have travelled on the "there" of sense and sensualities, a complicated journey of image and imagination. Perhaps now, Heidegger's well-worn phrase 'technology has nothing to do with the technological', may begin to make more sense, especially now when it comes to the discussion of photography, the digital, the human being (or any other kind of being) – and the image. Analogue or digital technological advancement/enhancement is not really the issue. But neither is it about a "logic of techné" nor a poetic *per se* (that is, a logic relying on the ability to grasp an "out there" (*Dasein*) to create that "relation" of "little b: being/entity" to "Big B: Being" in all its glorious folds, dwellings and onto-theo-logics).[9] In fact we can go one lateral step further: the "gathering" is far more wildly libidinal, far more electric, far more uncertain, more jagged and though it is has its logic, it is without a necessary "rationality". Indeed, it is radically uncertain, whilst being iteratively "connected" in the carnal-knowledge cogito sense of the senses.

Dirty, dirty: those darkrooms of life, those fractalities of sonorous, sensuous image/ing.

As is well known, Baudelaire was very worried about photography. He thought (rightly) that it had a "common" alliance with "the people" (which he called "the mob") and, just like the mob, photography, since its birth, has just refused to "know its place". Like a rusty old school master admonishing an unruly pupil, Baudelaire tut-tutted his fears:

> If photography is permitted to supplement some of art's
> functions, they will forthwith be usurped and corrupted by
> it, thanks to photography's natural alliance with the mob.
> It must therefore revert to its proper duty, which is to serve
> as the handmaiden of science and the arts.[10]

How upset would he be, were he alive today! For not only has
photography gone and corrupted art; it has corrupted the very
bastion of civilization: philosophy.

Notes

1. Jean-Françoise Lyotard, "La Presence/Presence," in his
Que peindre? Adami, Arakawa, Buren / *What to Paint?* Adami,
Arakawa, Buren, translated by Antony Hudek, Vlad Ionescu and
Peter W. Milne, (Leuven University Press: 2013), Vol. 5, 144-145.
Emphasis mine.

2. The use of the word fractal is not standing-in for "fraction", the
latter of which implies being a segment of a whole or totality; the
former implying being a "splice" without necessarily invoking (or
being dependent upon) a bounded unity. This point, which draws a
rather different "picture" than that of the kind fragment Jean-Luc Nancy
and others will come to rely upon, will be developed later in the
argument. But for the concept of fractal as that which algorithmically
conceptualises "roughness," see Benoît Mandelbrot, *The Fractal
Geometry of Nature*, (New York: Henry Holt & Company, 1983), espe-
cially Parts I-III, 1-83. For an account of the recursivity of 'roughness'
for the less mathematically inclined see Mandelbrot's, *The Fractalist:
Memoir of a Scientific Maverick* (New York: Pantheon Books, 2012). For
a thoroughly enjoyable romp through the fractalist forests of science
and of light, see Nigel Lesmoir-Gordon, Will Rood & Ralph Edney,
Introducing Fractals: A Graphic Guide, (London: Icon Books, 2009).

3. Jean-Luc Nancy, in his *The Ground of the Image*, translated by Jeff Fort, Perspectives in Continental Philosophy Series, (New York: Fordham, 2005).

4. Nancy, *The Ground of the Image*, 8-9. For a detailed elaboration of Jean-Luc Nancy's significant revision of Heidegger's concept of the "thing" (*das Ding*), see Nancy, *Being Singular Plural*, translated by Robert Richardson and Anne O'Brien as part of the series, *Crossing Aesthetics*, (Stanford: Standford University Press, 2000), especially Chapter 1: Of Being Singular Plural, 1-100. See also Simon Critchley, "With Being-With? Notes on Jean-Luc Nancy's Rewriting of Being and Time, in *SPP*, Vol. 1, No. 1, 53-67, available at http://after1968.org/app/webroot/uploads/critchley-nancy-singulier.pdf. [accessed 23/05/2013]. For Heidegger's initial development of *das Ding*, see his, 'Lecture given at the Bayerischen Akademie der Schönen on June 6, 1950', printed in the *Jahrbuch der Akademie, Band I, Gestalt und Gedanke* 1951, 128ff.

5. Henry Rogers, 'The Words I thought I Saw', in Rogers (ed), *I See What You're Saying* (Birmingham: IKON Books, 2013), 7-19.

6. Lyotard, *Que peindre?/What to Paint?*, 127ff.

7. Martin Heidegger, *Identity and Difference*, translated by Joan Stambaugh, (New York: Harper and Row/Harper Torch Books, 1969), 23-42. But see especially where he writes: 'The formula A=A speaks of equality. It doesn't define A as the same. [...] But that unity is by no means the stale emptiness of that which, in itself without relation, persists in monotony. [...] For the proposition really says: "A is A." What do we hear? With this "is," the principle of identity speaks of the Being of beings. As a law of thought, the principle is valid only insofar as it is a principle of Being that reads: To every being as such there belongs identity, the unity with itself.' 24, 26, respectively.

8. Nancy, *The Ground of the Image*, 9-10 and 68, respectively.

9. For a snapshot sense of techne as linked to poetics, see Heidegger's well known 'The Question Concerning Technology', in *The Question Concerning Technology and Other Essays*, translated by W. Lovitt, (New York: Harper & Row, 1977, 3-35. For a more detailed argument, see his 'The Thinker as Poet', and 'The Origin of the Work of Art,', in Heidegger's *Poetry, Language, Thought*, translated by Albert Hofstadter, (New York: Harper Collins, 2001), 1-14 and 15-86, respectively.

10. August Baudelaire, *Salon O* (1865), as quoted by Walter Benjamin, 'Little History of Photography', in his *The Work of Art in the Age of its Technological Reproducibility and other Writings on Media*, edited by Michael W. Jennings, Brigid Doherty, and Thomas Y. Levin; translated by Edmund Jepchott, et al., (Cambridge, MA: The Belknap Press of Harvard University, 2008), 294.

PROBLEMATISING AESTHETICS

9

Photographic Scale

ANDY FISHER

> *However often it is used, [scale] is seldom questioned.*

– Philippe Boudon

> *What is important in the play of scales, in effect, is not the privilege granted to the choice of some scale so much as the very principle of a variation in scale.*

– Paul Ricoeur [1]

A Scalar Delirium and the Derangement of Scale

THE FACT THAT there are more photographs produced and disseminated than ever before in our era of networked digital imaging is often remarked and conventionally signalled with reference to the more than two hundred million photographs now uploaded to

Facebook on a daily basis.[2] Disseminated globally and at ever-greater frequency, this unprecedented circulation of images is characterised by instantaneity, simultaneity, speed of exchange and changeability in both appearance and context.[3] This is an image ecology in which a certain literal experience of scale is foregrounded and presents obvious and pressing issues.

In light of this situation, I set out to develop a critical and theoretical interpretation of what scale means in and for photography, an investigation that is provoked by the expansive character of photography in the context of networked digital culture but that also involves questions relating to historical practices and theorisations of photography. Scale has very many different meanings in these contexts, whether technical, phenomenological, economic or geographical for example. These scales of the photographic are normally addressed separately in specialised discursive frameworks. Below, I explore an alternative, namely, that it is the relations pertaining between these diverse elements, which gives the clue to what scale means for photography. I will project a concept of "photographic scale" to delineate the relational form of scale as a concern for photography and argue that it is of ontological significance for photography. This concept denotes a ubiquitous, variegated and compound play between differing but necessarily associated scales that inform the spatiotemporality of photography, that allow for its sense as a form of visual representation, that structure its modes of materialisation and that describe key aspects of its determination as a global geo-political form.

There are few things more familiar in photography than the fact that photographs scale things up and down and that they come in different sizes. It is only slightly less obvious to note that they are made and reproduced according to techniques entailing and governing their scaling and rescaling, that they result from the use of formats infused with differently scaled values, that the photographic image can be useful as a tool of measurement but also grants a tendentious sense of omnipotence over otherwise unseen and distant things and, overall, that cameras and photographs take on a range of material scales to act within global circuits of social and economic exchange so that, somewhere down the line, a surplus of profit can be abstracted from their use. Even on the basis of this cursory list, it is clear that a wide variety of scalar operations, scaled phenomenon and forms of scaling are central to both specific photographic practices and to photography in general.

These different scales of photography operate within the contemporary image ecology in ways that temper and redispose the experiences and behaviours associated with photography. Modes of bodily comportment involved in taking up a device to make photographs have come to hinge on equipment increasingly evenly keyed into the horizon of networked global dissemination involving, for instance, expansive postures in which both eyes range over a screen held at arms length. This is a generalised mode of comportment between body and apparatus that compounds global commercial imperatives with only apparently immediate modes of perception. Such screens have tended, for example, to increase in size relative to the body of the device housing them, making perceptually emphatic the collapse of differences between what is viewed before the moment of capture, the resulting image and its unprecedented openness to publication.[4] But the economic and technical imperatives that inform changes in this immediate seeming mode of experience also saturate it with laboriously prepared external interests, setting up the body and apparatus as elements of a performance that unfolds within globally scaled processes.

The act of looking at photographs is also recast. It is set in rhythmic and mobile relationship to other images and a host of other viewers that challenge investments that might be maintained in the face of a single photograph. And much of what's important here occurs beneath the level of visual perception. As Mika Elo pointed out recently, the metadata that accompanies a digital image inflects its circulation with automatic linkages that 'go beyond visual mastery of spatiotemporal relations'.[5] This leads him to remark: 'Photographic interfaces, i.e., the ways in which photography faces the body, provide something like an "aesthetic horizon" for the experience of digital culture by engaging the contradictions of our time at the level of the senses.'[6] One might go as far to say that these contradictions take the form of a massively determined "face-off" between images and their users, a situation structured at and by various spatial and temporal scales.

Thus, issues of scale in photography cannot be limited to the visual forms and relative dimensions of things represented in photographs, though these too are inherently scaled.[7] Scale is a broader condition of all encounters with photographs, tactile and kinaesthetic as well as visual. Whether we come across them in print, hung or projected on walls or view them on screens, one faces photographs, also, as a reader accustomed to shifting scales: moving habitually

between the scale of a momentary event, situation, life, history or era, as well as being bound up with a particular detail, feature, body, locale, nation or as having global scope and reach. And, though it might seem strange to say so, photography – in the form of its apparatuses and the images that result from them – might be said to "read" those who use it in much the same way. Photographic equipment is designed around processes of scaling, as in the application of engineered ratios of aperture and focus that contribute to governing the composite process that is the making of a photograph. And these ratios take on social, aesthetic and affective scales as they take on meaning in their use, as they scale the world's visual registers in the act of registration. Cameras stand, one might say, as "anticipations of perception" and as answers to questions that the desire to make photographs has not yet asked, which places them, their users and those who view the results at the centre of a knot of scalar operations.

Each photograph, at whatever scale it is made, encountered or addressed, harbours within it a plethora of other scaled relations and material facts of scale that, so to speak, spiral upwards and down-wards, inwards and outwards, to enable and to impinge upon what the image is and how it can be used. Thus it is that a generalised body of individuals is inscribed in photography's technical and social process. In his essay, 'Nous Autres', Jean-Luc Nancy projects an inter-subjective account of photography inflected with just such a sense of scale:

> Each "subject" in the photo refers tacitly, obstinately, to all the others, to this prodigious universe of photos in(to) which we all take ourselves and one another, at some time or other, this colossal and labyrinthine phototheque in whose depths there stalks – like a Minotaur – the monster, the monstration, and the prodigious image of our strangeness.[8]

As noted above, the explosion of production, dissemination and consumption provoked by photography's networked digital condition encourages its description at engorged statistical scales. The 'colossal and labyrinthine phototheque' is metastasizing and with it the social uses and meanings of photography mutate. This has exciting and troubling implications, not least because photographs act within this sphere as ubiquitous vehicles for assumed human values whilst also undercutting what might ground these values. In *Being Singular Plural*, Nancy confronts expectations of sense conventionally ascribed

to the scale of the human with the infinitely scalable horizon of number, a confrontation that might be used here to inflect the familiarity of the human scale – as an expectation of photography – with questions arising at other registers:

> Man as the measure of all things has taken on a new, excessive meaning: far removed from every relation to the human as some mediocre standard and also far removed from its remnants, this meaning relates humans themselves to an immensity of responsibility.[9]

This statistical and ethical extension of Nancy's explicit theorisation of the photographic might be taken to figure the photographic, as such, in terms of its potential for sublimity. But it has also to be noted that other senses of scale are also at work in each instance and every event of photography. These combine to structure the enormity in which photography's appearances and their subjects are lodged. The task of theorising the intersubjective form and ethical horizon of this massive economy of images is not exhausted by reference to its potential for sublimity. When such issues of scale arise in photographic discourse, there is a tendency to reach a little too hastily for the category of the sublime, which, with no little irony, comes to function as a familiar and reassuring conceptual reflex. Whilst, from certain perspectives the category of the sublime might offer theoretical traction on photography's experiential registers of complexity and import, it also tends to short-circuit and to displace interrogation of photographic specificities, their contexts of mediation and how these combine in complex ways to constitute the photographic as such.[10]

At the outset, then, one might think scale separately according to the terms of one of its useful discursive frameworks, one might assume it to be an issue delimited by conventions of relative size or one might take it to invoke a sense of the sublimity of the photographic in general. But none of these assumptions exhaust the specific meanings of the term, nor do they help us to understand its general importance for photography. So how might one go about this?

The Principle of Variation in Photography's Play of Scales

The epigraph from Philippe Boudon above highlights the relatively unexamined concept of scale. The quotation from Paul Ricoeur marks the centrality of this concept to his theorisation of history, memory

and forgetting. But it serves here as a heuristic device to suggest how one might address scale as a question for photography, given that scale means so many different things in this sphere: its semantic diversity gives the clue to what the concept of scale means for photography. Indeed, I argue that the variation of its senses of scale – and not any one particular fact, phenomenon, technique, order or discourse of scale alone – have ontological significance for photography. The task is, then, to develop the implications of these suggestions by exploring what it means to conceptualise scale in this context, at this particular historical conjuncture and according to the "very principle of a variation" at work in photography's "play of scales".

The term "photographic scale" might thus be reserved to denote a dynamic nexus of operations, phenomena and forms through which this variegated play of scale takes on material form and might find its principle. The scope of the concept testifies to photography's profound ability to touch upon and be informed by other forms, practices and discourses. It therefore incorporates, but cannot be delimited by the explicit concerns for scale that have come to inform recent debates about different aspects of photography, such as those focusing on the imposing scale of the photographic tableau as a genre of artwork,[11] histories of the instrumental applications of various scales of measure in, to and with photographs;[12] or the global scope of networked digital photography.[13]

Within the variegated field denoted by photographic scale, three aspects stand out as predominant. Firstly, that all of photography's productions set space and time together and to scale in the form of an image. Secondly, all forms of photography necessarily find some kind of material form, however attenuated or dispersed, and do so in taking on scale. Thirdly, that photography not only has, so to speak, a weighty geo-political scale but that its geo-political import is grounded in and through the scaling operations and processes it operates within and serves to facilitate.

Photography's representational character as a visual image form, questions of the materiality and/or immateriality of the photographic image and photography's expanding and increasingly intensified roles in the global order of contemporary capitalism are bound up with one another in ways that invite conceptualisation as modes of photography's variegated scale. The visual character of photographic representation, phenomenological encounters with things photographic and the fact that photography's representations and its phenomenologies unfold within capitalism's global order of abstract

exchange, threaten to remain partial unless thought of in terms of the play that structures their variegation at and as scale.

These claims need, however, to be qualified. Perhaps most importantly it should be noted that recent attempts to theorise photography as a social form in relation to capitalism are, I think, right to establish parallels between the forms of social abstraction determining of social life and those characterizing the digital condition of photographic images. A compelling example is Peter Osborne's theorisation of the social ontology of the photographic according to its intrinsic historical-technical character and shifting cultural formations. He distinguishes between the "event of capture" and the "event of visualisation" to mark the distinctiveness of the digital image, including photography as one of its most important modes, and to reveal its relation to the forms of abstraction and exchange central to capitalism. Thus, in the digital image: 'the infinite possibilities for social exchange generated by the abstraction of value from use finds an equivalent visual form'.[14] And this form is one in which the "post-capture" life of inherently de- and re-realizable technical-image visualisations are opened up to the vagaries of infinite exchangeability:

> Via the multiplicity of visualizations, digitalization draws attention to the essentially de-realized character of the image. It is this de-realized image – supported in each instance by specific material processes – that strangely "corresponds" to the ontological status of the value-form.[15]

This enables him to project a determining parallel between image and exchange-form in the context of the social abstraction of value. But it also provokes questions as to what mediating forms, processes and experiences might flesh out the space between abstraction and exchange, on the one hand, and the specific uses and meanings of photographic images, on the other hand. What relates the general correspondence between image and value-form to the many different ways in which 'each instance' of the photographic is 'supported by specific material processes'? The concept of photographic scale articulated here is projected to elucidate this gap.

Scales of Scaling in Photography

One can step back briefly so as to set these claims in the context of related discourses on scale and its existing uses in and for photography. In general, scale denotes relative magnitude, extent, degree or propor-tion and the application of some standard of calculation. This always entails setting things at some level in relation to each other and often also the establishment of hierarchies between them. Scale refers to apparatuses or systems used for measuring: the graduated marks on a line or rule used to measure distances and ascertain relative dimensions; the equally divided grid-lines on the surface of a map, chart or plan that enable ratios of area and distance to be established; the ratio pertaining between a model and the reality it represents or projects.

Geography teaches that scale is a socially produced dimension of spatiality and that scales emerge from unevenly distributed and politically conflicted processes: 'geographical scales are both the realm and the outcome of the struggle for control over social space.'[16] Debates about the geo-politics of scale have seen many critical modulations of the concept, from scales that appear nested one in the next – from body to family, locale to nation, region and globe – to those moments at which social actors might "jump" between existing scales of social organisation, to arguments about whether it is an appropriate tool for investigation of contemporary social life at all.[17] These critical developments inform understanding of photography's globalised form and its social processes. But other photographic aspects of scale militate against taking geographical scale to exhaust the term in this context.

The labile relative dimensions of things encountered in embodied perception can also be thought in terms of scale. Things emerge from the depths of one's surroundings in sensible experience in ways that are organised according to what Maurice Merleau-Ponty named "spatial levels" of engagement and significance.[18] These phenomenological dimensions are inflected by the technical processes, forms and uses characteristic of photography, as it fills social space, impacts upon everyday experience and inscribes bodily comportment into globally networked contexts. Remarking this highlights the tension between scale as calculable abstraction and the idea that, ultimately, scaled phenomena find their sense in an axiomatic reference to the capacities and values of the human body.[19] But noting the phenomenological resonance of this fact does not simply return the notion of scale in photography to a defining homology between

visual perception and the representational functions granted to photographic images. Rather, it inverts the axiomatic reference to the scale of human embodiment, revealing it in, so to speak, eviscerated form as the condition of dispersed embodied experience in the age of the networked digital photograph.

Photography specifies spatial and temporal relationships between things in constitutively variable frames, the horizons of which are always scaled and, in principle, remain open to being rescaled. Any photographic representation or visual experience is bracketed, one might say structured, by the other possible scales at which it might have been – and still might be – actualized. Photography's mediation of actual size relationships with real things has always been subject to such shifting scalar possibilities and the ways in which they knit together discursive, phenomenological, technical and social processes in and at variable dimensions. It has always also held out the promise and/or levelled the threat that it will render the "natural" character of embodied perceptual experience and the "real" dimensions of things in technically contingent and radically changeable terms. And this aspect of photography is defining of its contribution to that nature and that reality of which it has come to form such a significant part.

Since its inception, photography has harboured scalar promises, for instance, that it might bring small, large, distant and hidden things into the range of human perception. It has also proven open to other uses – equally oriented to establishing the scale of things – that harbour scaled injustices. The development of these interrelated discourses of photomensuration has hinged on the establishment of increasingly expansive, increasingly manipulable and analysable photographically framed viewpoints. Photography also entails the creation of scalable spaces "within" the image. This is common to all photographic representation, but also underpins a wide range of specialised photomensuration strategies. For instance, the many projects that have set out to survey and measure the world photographically – in ethnographical, archaeological, geographical or geological terms – and the representational strategies these have adopted to establish the scale of things – rulers resting on rock formations, local guides standing next to pyramids, subjects of an ethnographical gaze posed against gridded backcloths – scaled abstractions organised according to rules that inscribe the self-evident appearance of photographic measure with discordant meanings harboured in the image but exceeding its representational framework.[21]

Questions about scale, forms of scaling and the application of scales of different kinds are obvious in photography and have been a recurring but notably muted concern for its critical and theoretical discourses. For example, scale is central to Walter Benjamin's influential conception of photographic reproduction, the spatial and temporal expansiveness of the close-up and slow-motion and, especially, the "unconscious optics" introduced by the camera, a notion explicitly characterised as a scale-effect: 'The enlargement of a snapshot does not simply render more precise what in any case was visible, it reveals entirely new structural formations'.[22] Susan Sontag's dour appreciation of the mass form of photography seeks to understand a closely related set of scalar concerns in a way that binds together the material modes, representational functions, aesthetic effects and world spanning cultures of the photograph:

> Photographed images do not seem to be statements about the world so much as pieces of it, miniatures of reality that anyone can make or acquire. Photographs, which fiddle with the scale of the world, themselves get reduced, blown up, cropped, retouched, doctored, tricked out.[23]

What might previously have been thought of as the immutable characteristics of the photograph's fixity and pastness have been rendered yet more unstable by, for instance, recent cameras that enable one to alter picture settings after the event of capture. Explicitly made to be "tricked out" in scalar terms, photography's unconscious optics is thus inflected with possibility to dilate the event and the functions of its pictorial authorship. Benjamin's and Sontag's photographic world is transformed and the site of this transformation is the defining suite of scaling operations built into the camera, reflected in its image and found in their uses.

In phenomenological terms the rhythms of photography's impact upon subjectivity find an enervating scalar outlet in Roland Barthes's *Camera Lucida*. His eidetic reduction of photography's normative use hinges upon a series of embodied acts – little moments of transformative interface between the privacy of affect and the banal enormity of photographic culture – that pivot from acedia to intense affect and, in doing so, project the ecstatic temporality of photography: 'I was leafing through an illustrated magazine. A photograph made me pause' being one such spur.[24] Barthes' subtle binding of affect to photographic temporality still rings true in

many respects, but its resonance in the present is complicated by the loosening of his – always tendentious – radicalisation of photography's realistic visual effects.

Vilém Flusser's account of photography as the exemplary form of technical image treats the photographic apparatus as a programmed modality of the social production of space. The spatiotemporal scaling operations embedded in cameras structure the interface between photographic apparatus, operator and world: a relationship in which the apparatus, famously, has the upper hand. Mathew Fuller describes this well:

> Here, iterations of multi-scalar relations of causality and interpenetration are compiled layer upon layer. Base and superstructure shot through a kaleidoscope. Programs and metaprograms are never clearly defined as distinct. The relation is simply one of scale, or of order.[25]

The application of technical and scientific concepts predetermine the photographic apparatus as a tool for schematising space and time in symbolic terms. The apparatus delimits individual freedoms and meanings traditionally associated with the making and viewing images. This generates and gives spatiotemporal flesh to Flusser's critique of technical image culture:

> The photographer's gesture as the search for a viewpoint onto a scene takes place within the possibilities offered by the apparatus. The photographer moves within specific categories of space and time regarding the scene: proximity and distance, bird- and worm's-eye views, frontal- and side-views, short or long exposures, etc. The Gestalt of space-time surrounding the scene is prefigured for the photographer by the categories of his camera. These categories are an a priori for him. He must "decide" within them: he must press the trigger.[26]

This might be taken as a signature form of photographic scale: its dissociation between the "human" quotient in imagination and the meaningful experiences taken to be embedded in visual culture. For Flusser, this dissociation is a core truth of the age of technical images and thus the source of critical potentials that might attain critical purchase on their era.

When one approaches the history of photography theory more broadly one finds it to be suffused with a muted concern for scale, which tends to feature merely to set the scene for other questions and problems. There is an implicit truth in this, scale does set the scene for photography's other questions and problems, quite literally. But it does so in more substantive ways than have been acknowledged to date.

Photographic Scale

In light of these implicit and explicit traces of scale in photography and as a starting point for conceptualising photographic scale as a variegated and ubiquitous modality of the photographic, one might observe a truism: There's no photography without it. That is, there is no photography of any kind without their being established a manifold of scalar relations which serve as material, conceptual and phenomenological horizons for the production, dissemination and consumption, as well as the form, appearance and meaning of photographs. There are always, as a matter of fact, multiple, different and overlapping scalar operations and scaled processes at work in each instance and every form of photography. These might be thought of as scalar adumbrations of the photographic that extend across the application of mathematically and scientifically derived technical scales in the design and operation of photographic equipment; the spatial and temporal possibilities held out by the photographic apparatuses so structured and the ways in which this sets the terms for decisions and actions performed in their use; the aesthetic experiences that any resulting photographs might engender; the possibilities of use that photographs as material objects might proffer; and the institutional, commercial and geo-political spheres of interest within which such uses and encounters may or may not unfold.

A range of relatively discreet scalar phenomena, possibilities and contexts are always operative at these different registers and more. Whilst, at any one level, a particular question of scale may appear dominant, others are also operative, albeit in latent form. To put this differently, other senses of scale always haunt the manifest as its supplement. They resonate within the dominant as its under- or overtones. And these relations change and shift from instance to instance, encounter to encounter, transmission to transmission as admixed scales that impinge upon the making and experience of photography at all levels. Photographic scale, it turns out, is modal and compound in form.

The variegated play characteristic of photographic scale reveals it to be a complex and shifting, but nonetheless concrete, matrix of broadly social, phenomenological, and technical modalities of the photographic. One of the distinctive features of this notion of photographic scale is the relationship it foregrounds between specific and general aspects of photography. The variegated admixture of scales that play across each and every moment, event or object of photography do so in ways that pertain to *whichever* form, use or object of photography *may* be in question. And yet, precisely as such, photographic scale is always also concrete in and specific to *that* particular instance of photography which *is* in question. In this manner photographic scale suggests itself as having an ontological status; as being what one might call an ontological modality of the photographic. In contrast to other ontological categories that are conventionally projected onto photography, the generality of photographic scale remains intimately entwined in the detailed specificity of photography's diverse moments and different uses.

At a range of levels, scalar operations and phenomena are central to diverse photographic processes, their uses and the discourses that frame these. But a basic function of all forms of photography is also to register the ostensible spatial and temporal state of things, to fix these together at a certain scale and according to a combination of prefigured and anticipated scales. One significant implication of this is that, in photography, one never encounters "space" or "time" – nor for that matter any place, thing, moment or event – other than through a combination of processes that entail the setting of salient aspects of appearance to scale in the more or less enduring but also changeable form of an image. If to scale in this sense is a basic function of photography – the interior horizon, so to speak, of the photograph as image – photographs of all kinds are also, as a matter of principle, subject to the demands of what one might contrastingly call "exterior horizons" entailing their being scaled and re-scaled. Any actualization of a photograph according to its particular scales is inscribed within a horizon of other scales not, or not yet, taken.

However much scale might be said to be central to photography, it cannot simply take over the theoretical roles ascribed to other categories of which similar generality is also claimed, for instance, photographic temporality and the persistent convention which tells us, after Barthes, that time as such is photography's *eidos*. Having remarked this, however, it is also important to note that photographic scale is not reducible to the contingent form of an empirical given. In

the form outlined above, it is always a feature of all modalities of the photographic, and necessarily so.

On the one hand, scale is integral to photography and the photograph but not in the manner of an essence, whether surreptitiously projected or made explicit. On the other hand, photographic scale allows for but is not contained by the self-evident empirical horizons of specific photographs. This latter horizon has often been central to claims on photography's role in the construction of place and its entanglements at the scale of individual experience.[27] But, just as every compelling claim on the generality of "the Photograph" as a paradoxical temporal ecstasy has emerged from a particular encounter with one or other variation on the range of photography's possible scaled materialisations (however attenuated its material form and singular its affective force), similarly, and without exception, all uses of photographs taken to enable meaningful engagements in and with particular places arise from an encounter with one or other scaled variation on photography's very ability to set up such relationships (however strong the attractions and values of the photographic particularities thus presented may be). Yet this does not mean that time or place are denuded of importance, that they are simply displaced by photographic scale as a newly revealed metaphysical principle, or as the actual form of photography's empirical contingency. Photographic scale does not displace these explicitly projected or implicitly assumed ontological categories, nor does it dissolve the strong affects and significant meanings that have been associated with them. Rather, photographic scale is that variegated play of concrete spatiotemporal possibilities through which these categories and particularities take on their form and force.

Notes

1. Philippe Boudon, 'The Point of View of Measurement in Architectural Conception: From the Question of Scale to Scale as a Question', in *Nordic Journal of Architectural Research*, Vol. 12, No. 1, 1999, 7-18. Paul Ricoeur, *Memory, History, Forgetting*, trans. Kathleen Blamey and David Pellaeur, (Chicago and London: University of Chicago Press, 2004).

2. Accounts of contemporary photography very often frame themselves, for good reason, by noting such statistical facts. A recent example is Nathanial Cunningham, *Face Value: An Essay on the Politics of Photography* (New York: Working Group, 2012), 10.

3. For an account of the historical ontology of photography that focuses attention on its determination by Capitalism's modes of abstraction and exchange, see Peter Osborne 'Photography in an Expanding Field: Distributive Unity and Dominant Form', in David Green (ed), *Where is the Photograph*, (Brighton & Maidstone: photoworks & photoforum, 2003), 63-70; and 'Infinite Exchange: The Social Ontology of the Photographic Image', *Philosophy of Photography*, Vol. 1, No. 1, (Spring 2010), 59-68. An interesting account of the economic forces and modes of cultural inertia surrounding the development of digital cameras is Kamal Munir, 'The Social Construction of Events: A Study of Institutional Change in the Photographic Field', *Organization Studies*, Vol. 1, No. 26, (2005), 93-112.

4. See Daniel Rubinstein and Katrina Sluis, 'A Life More Photographic: Mapping the Networked Digital Image', *Photographies*, Vol. 1, No. 1, (2008), 9-28. Note their account of screen size relative to the apparatus and questions of its functioning but, perhaps especially, the manner in which their account of the networked digital snapshot accrues scaled meanings that reach well beyond its visual form: 'Through the semantic mechanisms of tagging and metadata, the specificity of each online snapshot is obliterated by the way in which a single hyperlinked keyword can group together thousands of disparate images. Can 4,150,058 photographs tagged with "party" be wrong?', 24.

5. Mika Elo, 'Notes on Haptic Realism', *Philosophy of Photography*, Vol. 3, No. 1, (2012), 20-21.

6. Ibid., 25.

7. This comment marks the difference between the present study and the limited purview of one of the very few other existing theoretical studies of scale in photography, Patrick Maynard, 'Scales of Space and Time in Photography: "Perception Points Two Ways"', in Scott Walden (ed), *Photography and Philosophy: Essays on the Pencil of Nature*, (London: Blackwell, 2008), 187-209.

8. Jean-Luc Nancy, 'Nous Autres', in *The Ground of The Image*, trans. Jeff Fort, (New York: Fordham University Press, 2005), 100-07.

9. Jean-Luc Nancy, *Being Singular Plural*, trans. Robert D. Richardson & Anne E. O'Byrne (Stanford CA: Stanford University Press, 2000), 179.

10. In this light, the interest of James Elkin's interrogation of scale as an issue for photography is undercut by the manner in which it appeals to sublime artistic effects in order to distinguish it from other modes of imaging. See his, *Six Stories from the end of Representation: Images in Painting, Photography, Astronomy, Microscopy, Physics and Quantum Mechanics, 1980-2000*, (Stanford, CA: Stanford University Press, 2008). An alternative approach to bridging the gap between technical and critical issues in photography is found in Sean Snyder, 'Optics, Compression. Propaganda', *Art & Research: A Journal of Ideas, Contexts and Methods*, Vol. 2, No. 1, (Summer 2008), available at: http://www.artandresearch.org.uk/v2n1/snyder.html [accessed 7 November 2012].

11. The central text for debates on the photographic tableau in the context of contemporary art is Michael Fried, *Why Photography Matters as Art as Never Before*, (New Haven and London: Yale University Press, 2008). See my analysis in Andrew Fisher, 'The Involution of Photography', *Radical Philosophy*, No. 157, September/October 2009, 37-46. For a short but incisive critique of Fried on the tableau see, Michael Lobel, 'Scale Models', (*Artforum*, October 2010) 256-60. The Fotomuseum Winterthur's blog *Still Searching* recently hosted an exchange of views between Hilde Van Gelder and David Campany that foregrounded scale as a problematic aspect of such artworks, whilst

also exemplifying the limited terms in which it tends to be addressed: 'What Has Photography Done (31 May 2012), available at: http://blog. fotomuseum.ch/2012/05/part-1-what-has-photography-done/ [accessed 7 November 2012].

12. See Marina Benjamin, 'Sliding Scales: Microphotography and the Victorian Obsession with the Miniscule', in Francis Spufford and Jenny Uglow (eds), *Cultural Babbage: Technology, Time and Invention*, (London: Faber and Faber, 1996), 99-122. Lorraine Daston and Peter Galison, *Objectivity*, (New York: Zone Books, 2010). Much attention has been paid to such issues recently in German language research, notably: Thomas Cohnen, *Fotografischer Kosmos: Der Beitrag eines Medium zur visuellen Ordnung der Welt*, (Beilefeld: Transcript Verlag, 2008); Arthur Engelbert, *Global Images: Eine Studie zur Praxis der Bilder*, (Bielefeld: Transcript Verlag, 2011); Ingeborg Reichle and Stefan Siegel (eds.), *Maßlose Bilder: Visuelle Ästhetik der Transgression*, (München: Wilhem Fink Verlag, 2009).

13. See Matthew Fuller, *Media Ecologies: Materialist Energies in Art and Technoculture*, (Cambridge MA: MIT Press, 2005).

14. Osborne, 'Infinite Exchange', 67.

15. Ibid., (emphasis in original).

16. Eric Swyngedouw, 'The Mammon Quest: "Glocalisation", Interspatial Competition and the Monetary Order: The Construction of New Scales', in M. Dunford and G. Kafkalas (eds), *Cities and Regions in the New Europe*, (London: Belhaven Press, 1992), 60.

17. For example see Neil Smith, *Uneven Development; Nature, Capital and the Production of Space*, (London: Blackwell, 1984); Neil Brenner, 'Between Fixity and Motion: Accumulation, Territorial Organisation, and the Historical Geography of Spatial Scales', *Society and Space*, Vol. 16, No. 4, (1998), 459-81; Eric Shepherd and Robert McMaster (eds), *Scale & Geographic Inquiry: Nature, Society, and Method*, (Malden MA and Oxford: Blackwell, 2004); Andrew Herod, *Scale*, (London and New York: Routledge, 2011); Denis Cosgrove, *Geography and Vision: Seeing, Imagining and Representing the World*, (London: I. B. Taurus, 2008). Explicit studies of the relationship between geography and photography are relatively few. What there is tends to focus on the photographic construction of place as in Joan Schwartz, and James Ryan (eds), *Picturing Place: Photography and the Geographical Imagination*, (London and New York: I. B. Taurus, 2003). By way of contrast, see El Hadi Jazairy (ed), *New Geographies 4: Scales of the Earth*, (Cambridge MA: Harvard University Press, 2011).

18. See the "working note" entitled 'Scale – ontological significance of this notion', in Maurice Merleau-Ponty, *The Visible and the Invisible*, ed. Claude Lefort, trans. Alphonso Lingis (Evanston: Northwestern University Press, 1964), 226-27. See also Lingis's sensualist articulation of Merleau-Ponty's notion of "perceptual levels" in *The Imperative*, (Bloomington and Indianapolis: Indiana University Press, 1998), 25-40.

[19.] See, for instance, Mary Ann Doane's statement of this view: 'scale as a concept in general can only be understood through its reference to the human body', in 'The Close-up: Scale and Detail in the Cinema', *Differences: A Journal of Feminist Cultural Studies*, Vol. 14, No. 3, Fall 2003, 108.

[20.] Perhaps the most iconic example of a photograph in this vein is Timothy O'Sullivan's *South Side of Inscription Rock*, New Mexico of 1873. See Françoise Heilbrun's 'Around the World: Explorers, Travelers, and Tourists' in Michel Frizot (ed), *A New History of Photography*, (Cologne: Könemann, 1998), 149-173. See also, Mary Warner Marien's discussion of 'Topological Surveys and Photography' in *Photography: A Cultural History*, (London: Laurence Hill Publishing, 2002), 115-131 and the canonical historical framing of such practices in Beaumont Newhall, *The History of Photography from 1839 to the Present*, enlarged and revised edition, (New York: Museum of Modern Art New York & Bullfinch Press/Little Brown and Co., Boston, New York & London, 1982), 85-115. See also Rosalind Krauss, 'Photography's Discursive Spaces' in *The Originality of the Avant-Garde and Other Modernist Myths*, (Cambridge MA: MIT Press, 1985).

[21.] For a survey of the different meanings given to scale in the social sciences see Clark Gibson et al, 'Scaling Issues in the Social Sciences: A Report for the International Human Dimensions Programme (IDHP) on Global Environmental Change', IDHP Working Paper No. 1, (Bloomington, IN: Indiana University, 1998); Darrel G. Jenerette, and Jianguo Wu, 'On the Definition of Scale', *Bulletin of the Ecological Society of America*, Vol. 81, No. 1, 2007, 104-05; J. A. Weins, 'Spatial Scaling in Ecology', *Functional Ecology*, Vol. 3, No. 4, 1989, 385-97. Chunglin Kwa narrates the history of imaging practices prefiguring and partly shaping the development of ecology as a science, with emphasis on its ambivalent relationship to aerial photography in, 'Painting and Photographing Landscapes: Pictorial Conventions and Gestalts', *Configurations*, No. 16, 2008, 57-75.

[22.] Walter Benjamin, 'The Work of Art in the Age of Mechanical Reproduction', in *Illuminations*, ed. Hannah Arendt, trans. Harry Zohn, (New York: Schocken Books, 1969), 236-7.

[23.] Susan Sontag, *On Photography*, (London and New York: Penguin Books 1979), 4.

[24.] Roland Barthes, *Camera Lucida. Reflections on Photography*, trans. Richard Howard (New York:York: Hill and Wang, 1981), 23. See also my analysis of these themes in Andrew Fisher, 'Beyond Barthes: Rethinking the Phenomenology of Photography', in *Radical Philosophy*, No. 148, March/April 2008, 19-29.

[25.] Matthew Fuller, *Media Ecologies*, 2.

[26.] Vilém Flusser, 'Towards a Theory of Techno-Imagination', in *Philosophy of Photography*, Vol. 2, No. 2, 2012, 198.

27. With regard to the relationship between scale and place as spatial categories of photography and discourse on landscape, see: Hilde Van Gelder and Helen Westgeest, 'Place and Space in Photography: Positioning Toward Virtual Places in Spatial Objects', in *Photography Theory in Historical Perspective: Case Studies from Contemporary Art*, (Chichester: Wiley-Blackwell, 2011), 112-51. For critical alternatives see, David Cunningham 'The Spectres of Abstraction and the Place of Photography', in *Philosophy of Photography*, Vol. 3, No. 1, Autumn 2012, 195-210; John Roberts, 'Photography, Landscape and the Production of Space', in *Philosophy of Photography*, Vol. 1, No. 2, Autumn 2010), 135-56.

10

Oscillations Between Disciplinary and Productive Subjectivity in James Coupe's Auto-Generative Online Film Project *Today, too, I experienced something I hope to understand in a few days* (2010).

MARIA WALSH

ALMOST TWENTY YEARS have passed since Jean Baudrillard sent out his warning cry that distinctions between the real and its representations were collapsing under the tyranny of the social genetic code of simulation, which he described as 'the automatic writing of the world'.[1] While, as Steven Shaviro claims, Baudrillard has 'gone from being a prophet of urgency and extremity' and 'seems like a nostalgic whiner, yearning for past that never existed',[2] his theory of communication as code in which all signs and their messages operate according to the logic of the 'mystical elegance of the binary system of zero and one' can still be said to underpin the crisis in photography

generated by the digital.³ Digitality severed photography's indexical
relation to the real and ushered in an era in which images circulate,
proliferate and are consumed as bits of information with which
we interface rather than as representations of reality that we look at
or through. If the photographic image preserved, both materially
and semiotically, traces of the past like relics to be excavated by a
viewer in the present, what happens to our subjectivity when the
image becomes a sign to decode in reference to other signs, rather than
to an indexical real? While we can of course celebrate the machinic
and cyborg subjectivities that abound in accounts of technology
that view '[a] reciprocal rapprochement between genetics, animal
communication and linguistics' as leading to 'a complete science of
the dynamics of semiosis',⁴ theorists as diverse as Vilém Flusser to
Steven Shaviro and Jonathan Beller insist that we need to decipher
the images produced by the apparatuses that create the world-as
screen in order to situate ourselves in relation to them rather than be
positioned by them. As Flusser says:

> [...] omnipresent technical images have begun magically
> to restructure "reality" into an image-like scenario. What
> is involved here is a kind of oblivion. Man forgets that
> he produces images in order to find his way in the world; he
> now tries to find his way in images. He no longer deciphers
> his own images, but lives in their function. Imagination
> becomes hallucination.⁵

Although Flusser is not a traditional humanist in the sense of elevating
the human to a hierarchical position above both first and second
orders of "nature", his insistence on the necessity for breaking out
of the magical circuit of hallucination links to Beller's suggestion
that 'our encounters with images take place in a translinguistic
environment that both utilizes thought and is beyond it' and that the
overall effect of this ever-increasing quantity of images is the radical
alienation of consciousness into a mode of public unconsciousness, the
reduction of consciousness 'to something of the order of a free-floating
hallucination, cut away as it is from all ground'.⁶ Beller actually
situates this severing in relation to the photographic image in a way
that counters the usual history and theory of photography as an index
of the real. He refers to the German literary critic Wlad Godwich
who states that:

> Where with language we have a discourse on the world, with
> human beings facing the world in order to name it, photography
> substitutes the simple appearance of things: it is a discourse of
> [not on] the world. [...] Images now allow for the paradox that
> the world states itself before human language [...] Images are
> scrambling the function of language which must operate out of
> the imaginary to function optimally.[7]

There are echoes here with Shaviro's claim in *Post-Cinematic Affect*
that, because of breakdown of the opposition between reality-based
and image-based modes of presentation in the contemporary world of
electronic media and global capital, '[t]oday the most vivid and intense
reality is precisely the reality of images'.[8] In this climate, the negative
critiques performed for example by the Frankfurt school are no longer
tenable, as, according to Flusser, in finding super-human powers
such as capitalism behind the image, they themselves uncannily
unleashed even larger spectres than the ones they sought to eradicate,
thereby augmenting the hallucinatory magical realm they sought to
destroy. Flusser recommends taking the position from the outset that
'programming is a stupid, automatic, unintentional process' and,
that photographs – we can substitute technical images here – 'suppress
our critical consciousness in order to make us forget the absurdity
of functioning'.[9] Rather than finding super-human powers at work
behind images, we need to 'create room for human intention in
a world dominated by apparatus'.[10]

I begin with this brief account of where we now might be placed
in relation to technical images, in an electronic culture in which
images are ungrounded from medium specificity while nonetheless
having distinct apparatuses, in order to create a context for the
artwork that motivates the arguments in this chapter, James Coupe's
online film project *Today, too, I experienced something I hope to
understand in a few days* (2010). It will be my contention that Coupe's
work, in exposing the automatic functionality of the apparatus and
its programming, reveals the persistence of the human desire to
recognise and be recognised by others, a desire which creates a new
immaterial materiality that emerges beyond the capturing of the
human by purely mechanical or automatic systems. Flusser states that
apparatuses 'automatically assimilate [...] attempts at liberation, and
incorporate them in their programs in order to enrich the programs'
rather than to enrich human experience.[11] He sees the task of a
photographic philosophy as being 'to reveal the struggle between

Figure 1.

Figure 2.

man and apparatus in the realm of photography [or technical images], and thus to contribute to a possible solution to the conflict'.[12] I am not proposing that Coupe's work offers such a solution, but that it exemplifies the struggle. What in *Today, too, I experienced something I hope to understand in a few days* is ultimately a computerised programmable interchange between different types of technical images – video portraits, Facebook profiles, and YouTube video films – can also be read as performing a complexification of the digital flow of images and intransigent human desires for recognition. I shall explore how in this work something jars in the machinic apparatus, which offers a reflexive pause in the habitual modes of viewing and consuming images via screen interfaces.

Today, too, I experienced something I hope to understand in a few days is comprised of three elements, engaging with and operating within the ready-made data banks of information and images that circulate in virtual space and that we unthinkingly use to encode our identities. The first element is a series of video portraits of volunteers, some shot by Coupe in Seattle where he is based, the rest shot in Barrow and Manchester in the UK,[13] using poses and actions loosely based on Danish experimental film-maker Jorgen Leth's 1967 film The Perfect Human. Coupe's title is a line from the film which is perhaps better known as the premise of Leth's and Lars von Trier's The Five Obstructions, 2003, in which Leth attempts to remake his original film five times according to von Trier's dictates. Coupe instructs his volunteers to grin, scratch, munch, jump and stare, against a clinical white background reproducing the same laboratory quality as Leth's film which lends the protagonists a specimen-like aspect. The videos are uploaded to a database where a programme automatically edits them in the style of Leth's film, the result lending a strangely mechanical appearance to the actions and gestures of the volunteers. The second element of the work uses text from status profiles submitted by Facebook users who voluntarily signed up on Facebook to participate in Coupe's project. The Facebook posts were limited respectively to Barrow and Manchester for the specific AND exhibitions, but afterwards, the project continued with footage from all three shoots, and status updates from anyone in the world. A software application automatically matches the Facebook profiles with the demographic of the video portraits, the Facebook profile texts serving as subtitles to the portraits, e.g. the profile 'Male 22' (fig. 1) refers to a video portrait of a grinning young man whose subtitle reads 'I am a bomb technician'. The final component of the project involves

software using metadata tags that searches YouTube for videos and/ or images that link to code words in the subtitles, the final works being shown on YouTube as split screen films, the video portrait on one screen, its paired YouTube video/image on the other. Although all the protagonists in the project volunteered, watching the split screen films on Youtube raises questions about control and freedom in an era in which images and text are easily exchanged and substitutable, the work seeming to propound the neo-liberal idea of the subject as an unbound network of potential with the capacity for endless modulation. Does this work merely cleverly illustrate the way in which identity is territorialized by the virtual informational machines that track our movements and channel our desires in feedback loops of constant modulation – our user profiles and interactions giving feedback to the machine in the aestheticisation of everyday life that Felix Guattari calls 'subjectivity's entry into the machine'[14] – or does the exposure of these conditions, the making visible of these virtual operations which are usually hidden in the flow of information, offer some resistance to the circuit of visual capture to which we are subject in this electronic age? *Today, too, I experienced something I hope to understand in a few days* exemplifies how text and image are circulated in our communication systems according to standardised frames of exchange, what Flusser might call 'programmed magic'.[15]

The utilisation of the frame is key to this standardisation in which the "real" is fragmented into bite sized chunks and all fragments take on the same value. Taking Deleuze slightly out of context, Jonathan Beller says that: "'The frame ensures a deterritorialization of the image" because it "gives a common standard to things which do not have one – long shots of countryside and close-ups of the face, an astronomical system and a single drop of water"'.[16] What for Beller is the cinematic organisation of the world, which can be linked to Flusser's "photographic universe", is determined by the logic of capital – equivalent value – and this moves us, Beller says, beyond representation and into simulation. The picture Beller paints is familiar from postmodern theorists such as Baudrillard, with the difference being that Beller sees this condition as productive. It is productive of 'new affects, desires and identity formations', which, while these latter can be exchanged as commodities whose value is interchangeable, are also open to counterlogical trajectories.[17] I shall explore what a counterlogical trajectory might be in relation to Coupe's artwork as I go through a series of theoretical manoeuvres in this chapter that lead away from postmodern theory *per se* to

reworkings of Freud and Benjamin in order to think about the
ubiquitous imaging of the world as not simply a screen in relation to
which we are posited as a stain, nor an interface in relation to which
we have agency and choice, but something in-between.[18]

*Today, too, I experienced something I hope to understand in
a few days* seems to me to operate, as does the social networking
site Facebook, between the modalities of, on the one hand, Western
capitalist disciplinary societies, in which the surveillance techniques
of subjection are internalized, and, on the other hand, societies of
control, which, as Deleuze stated in his 1980 essay 'Postscript on
the Societies of Control', deploy the technique of surfing which
transverses the internalized dynamics of subjection in favour of a
dispersal of subject positions across a network.[19] For many theorists
and practitioners, including Coupe, this is a productive space which
allows us to operate as agents of our own identities. He says:

> An algorithm assumes a role previously performed by the State
> apparatus, and what results is a human petri dish in which we
> exchange data about ourselves for an opportunity to discover
> more about who we are. Inside this kind of environment, there
> is a "real" dimension that cannot find a parallel either in virtual
> or physical space, rather, it only makes sense between the two.
> Via training grounds like Facebook, YouTube and Twitter, we
> are becoming virtuosic practitioners of this hybrid networked
> space, developing strategies that can be seen in a wide range of
> spheres. So increasingly such spaces constitute a form of reality,
> both in terms of their integration into our everyday lives and
> also in the influence they have on how we process information
> elsewhere. So in that sense [...] Facebook is a portrait of us, and
> *Today, too, I experienced something I hope to understand in a
> few days* brings that to the fore.[20]

The issue I want to explore further is the double-edged aspect of
how images of the world are pictured, circulated and exchanged via
the digital algorithm. Can we say, after Walter Benjamin, that we
enjoy our subjection to the technical apparatuses that constitute our
subjectivity to such an extent that we are content to give ourselves
completely over to them or is there still room to speak of a critical
response in relation to the dominant trend in media theory that
celebrates our capacities as users of technology to create versions
of "reality" that evade forms of centralised power?[21] Do the video

portraits simply transform their protagonists into informational data to be processed by the surfing (more specifically algorithmic linking) machinations of a disinterested programme with which we interface in a more or less disinterested way due to the endless layering and substitutability of images in screen space? Whose gaze, whose desire, is being addressed in this work? Is there enough of a pause in the exchange and conversion of selection data to necessitate such questions or are they redundant in the age of proliferating simulations of human interchange?

In considering technological apparatuses as a means of both presenting and producing self-styled communicative images, it is tempting to use psychoanalytic tropes of mirroring in which the self-presentation or self-performance acts as a mirror that reflects back to oneself an image of oneself that conjoins with one's narcissism.[22] Through the medium of online photography in Facebook, the narcissistic component of the gaze is accentuated. The user, him or herself, puts images out there that convey a sense or perhaps the style(s) of oneself that one wants to communicate to others; how one wants to be seen in order to attract other users. We might say that online self-presentation partakes of "an exhibitionist dispositif" which operates like an "attraction" in Tom Gunning's sense of "the cinema of attractions", a phrase which has been used to apply more generally to all media exhibitionist events that show rather than tell. In 'Digital Attractions: Reloading Early Cinema in Online Video Collections', Joost Broeren uses Gunning's term to discuss YouTube videos in terms of how the latter are oriented towards the spectator/ viewer/user in a manner which relates back to my earlier point about how the world is now being imaged before being spoken about – the gaze and gestures of the participants is directed towards the camera, the presentation is frontal as in showing rather than telling a story, the frontal display and elicitation of the gaze allude to a present tense within the frame of capture.[23] Within the circuit of continual exchange and the illusion of a present tense, value is flattened. However, in Coupe's films, the system begins to repeat, as there are obviously less video portraits than Youtube videos, an aspect of the programme that exposes the recombinatory programming of online picturing and communication. While Coupe has abdicated responsibility in a parody of the technology he is deploying, nonetheless, on another level, his split screen machinic pairings tap into the sadistic voyeurism on the other side of the "exhibitionist dispositif" and in this, they expose a contradiction at the heart of digital communication, i.e.

that the flow of code can still be interrupted by a phenomenology of
the body, albeit displaced across "deconnected" time-spaces. Not
all the pairings exhibit the disinterested aesthetics of a seemingly
benign global image bank whose recombinations might be judged
and passed over according to how "cool" they might be, for example,
the video portrait of a young girl which is subtitled 'is tired n fed
up' and juxtaposed with a YouTube video of a young Asian man
playing guitar crooning about being fed up.[24] Aside from alluding to
the ways in which the material we put out there on social networking
sites is continually being electronically linked to form identikits that
are ultimately of use somewhere down the line to some financial
corporation, some of the juxtapositions are discomfiting, for example
the pairing of the video portrait of a 50 year old woman with a toothy
grin whose subtitles read '...so hypo' with a YouTube video of Tina
Turner, which appears unwittingly sadistic. But there are also other
discomfiting moments that break through the blasé automaticity of
the pairings and the purely narcissistic exhibitionism encouraged by
the "exhibitionist dispositifs" deployed in the work. The films dated
1 SEP 2010 and 19 AUG 2010 show the same supposedly 43-year-old
man in an anorak, whose portrait is paired in the one with YouTube
footage of Barack Obama trying to sell his vision of healthcare to the
American public and with footage of a commentator on the current
credit crisis in the other. In these pairings, as in the tradition of avant-
garde split screen film, the split screens begin to comment dialectically
on one another – the resolute presence of the man in the video portrait
makes Obama seem a merely silver-tongued performer not to be
trusted. Instead of simply invoking a perverse gaze that gains pleasure
in looking at others' discomfort or laughs at the ridiculousness of an
image in the spirit of the "attraction", an inadvertent counterlogic to
the unproblematic consumption of subjectivity emerges. Although it
may be difficult to maintain this kind of critical reading in relation
to a technology that uses code to automatically select and recombine
images, there is still a general sense in which the capturing of the
human body in the field of vision, a process that makes it both
"dehumanised and excessive", opens up a complex space between
user/viewer and images that is irreducible to neither the embodied
individual nor to the automaticity of the machine.[25]

On the one hand, the subjects of the video portraits elicit a
to-be-looked-at-ness characteristic of the voyeuristic gaze, their
look directed at the camera with which, in classical theories of
spectatorship, we are said to identify. But at the same time, the

consumption of these figures is offset by both the text and by the juxtaposed YouTube clips, as well as the automatic editing which gives them a skittish animalistic look. As we watch these films, it is as if the subjects are caught in a diagnostic gaze that scrutinises them in their textual laboratories to evaluate whether they align with or diverge from the narratives that they are embedded within. But on the other hand, due to the surface exchangeability of information the diagnostic gaze, which harks back to modernity and the fascination with photography as a new technological means of revealing "visual knowledge" about a person's interiority through the translation of bodily signifiers, transmogrifies into a virtual gaze, a free-floating gaze of consumption that simply scans the surface and forgets what went before in the seemingly endless flow and exchangeability of images.[26] Yet, I want to persist with the notion that there can be moments of destabilization within the recombinatory aesthetic of digital image-generation processes.

In order to address this issue, I want firstly to link the virtual gaze to the relay of positions intrinsic to scopophilia that Freud describes in his essay 'Instincts & Their Vicissitudes' and which unsettles the paradigm of seeing the spectator-users as voyeurs and the performers and/or the apparatus as exhibitionist. In 'Show Me Yours: Cyber-Exhibitionism from Perversion to Politics', Julie Levin Russo contrasts the model of visuality that derives from Foucault's panopticon with Freud's account of scopophilia.[27] In the former, the surveillance that characterizes disciplinary societies has been theorized as a hierarchical model wherein the looker sees all; the looked at sees nothing but internalises the imagined look of the other, thereby setting up the monitoring gaze within the self. This is in contrast to surveillance in control societies which operates on a horizontal plane where interiority has been emptied into the outside, prosthetic technologies modulating part selves and affects in a non-directional manner, except of course when the system registers an aberration to the usual flow of movement in public space. As opposed to the Foucauldian model of the panoptic which has been readily applied in media aesthetics, Russo's point is that Freud's model of display and consumption in 'Instincts & Their Vicissitudes' sets up a chain of reversals that more interestingly corresponds to the way that cyber-communication operates fluidly between domination and dispersal. Although Russo is talking about webcam and livejournal blogs, her reformulation of the exhibitionist/voyeur dialectic in terms of the dispersal of positions in Freud is useful in considering the reversals of position between

subjection and empowerment that might occur in the interface between the video portrait films and their viewers/users. She could almost be describing Coupe's piece in the following citation:

> In their integration of writing and images, self-display and participation, present-tense transience and persistent traces, they demonstrate that while technology, desire, and hegemony are in transformation, we are in the midst of a murky confusion of boundaries more than a radical break with their modern forms.[28]

In returning to Freud's essay, Russo attempts to go beyond the reduction of cyber-communication as representing "compliant subjects" caught in structures of domination that replicate the cultural epidemic of micro celebrity which is exacerbated by the "Broadcast Yourself" injunction of the YouTube company slogan.[29] She attempts to invoke a model of engagement that allows for slippages between activity and passivity that characterises the modulations of identity that seem to characterise our habitation of images today.

In Freud's account of scopophilia, rather than either simply subjecting another to a controlling gaze or being subjected to the gaze of the other, the phenomenon is conceived of as a four part process, whereby the initial auto-erotic taking by the subject of its own body as the object of desire is redirected towards an extraneous object. This leads to voyeurism *per se*, but then this energy is redirected back to the subject's own person resulting in a new aim – to be looked at, which, in turn, constitutes a new subject to whom one displays oneself (as subject) in order to be looked at (as object).[30] This kind of splitting of the self into both subject and object can be applied to the ways in which we inhabit public space today, the internet being such a public space. In effect, we need to do this kind of splitting in order to operate between the domains of domination and dispersal in which we find ourselves in relation to contemporary technologies.[31] While it would be too schematic to map this model onto the presentation and consumption of these online portraits and the automated recombinatory effects of the computer code, the point I want to make is that our technologies not only tap into this component instinct for self-display as an object, but, in giving it prosthetic expression in a technical image, they might allow us to connect with the "real" dimension that Coupe describes as not having a parallel either in virtual or physical space, but only between the two. Via

the disinterested seeing of the camera and the disinterested selection processes of the computer optic, the subjects on either side of the screen experience their own objecthood as both virtual and physical.

Linked, at least in time, to Freud's ideas about the flow and conversion of energy between different psychical and physical registers is Walter Benjamin's concept of innervation.[32] Innervation was a concept Benjamin explored in relation to how to engage with technology in a redemptive, i.e. humanising, way. While most commentators from Miriam Bratu Hansen to Celia Lury agree that the redemptive moment *vis-à-vis* technology is no longer politically tenable due to how technology has been deployed for destructive ends beyond Benjamin's wildest dreams, it is still important to find a way of articulating the intersubjective nature of our engagement with disinterested machines. If the Freudian model proposed by Russo suggests a space of oscillation between subjection and subjectification, Benjamin's notion of innervation proposes a mimetic incorporation of technology in which images given to us by the mechanical eye of the camera or the disinterested computer optic, while not having an intentional target as such, generate connective energies like neural pathways that operate between humans and machines. 'Technology becomes an organ of the collective', producing emotion in the beholder through bodily movement converting 'mental, affective energy into somatic, motoric form' and also 'reconverting, and recovering, split off psychic energy through motoric stimulation'.[33] This mode of reception creates a mimetic transduction between different entities that generates relations between them in an affinitive rather than a possessive or defensive manner. Through the affinitive connection that stems from innervation, we can be in a connective relation to that which we do not like or which is not the same as us, e.g. machines, part selves and affects, and code. For me, the motoric movements that engage our sensoriums in *Today, too, I experienced something I hope to understand in a few days* are the movements of the humans, captured and edited by the apparatus, whose puppet-like animation generates an excess through which we connect with something beyond the frame, that sense of the "real" between so-called reality and virtuality. Ultimately, this leads me to the earlier version of Benjamin's 'Work of Art' essay in which he discusses innervation and alienation by contrast to the infamous later versions in which these concepts either disappear or are relegated a minor place.[34] In the early version of the 'Work of Art' essay, Benjamin discusses how mediation has created a shift in the phenomenology of performance. As Lury

explains, he speaks about how, when the screen actor confronts the apparatus, the audience is constructed as identifying not with the critical impersonal attitude of the camera as in the later version of the essay, which of course has become the *sine qua non* of film and media studies, but with the actor as:

> their stand-in, as a representative of their own daily battle with an alienating technology who takes "revenge in their place". In the mimetic identification, gestures and emotions are enlarged the way reality is enlarged by the camera lens:

> 'The actor's forced self-alienation in front of the camera, microphones, and klieg lights, the extreme presence of mind required in the absence of the aura of live performance, show the masses how "one's humanity" (or whatever may appear to them as such) can assert itself in the face of the apparatus.'[35]

For Steven Shaviro, 'alienation is a quaint luxury' in our electronic world of 'forcible involvement, relentless inclusion, compulsory monetarisation'.[36] However, he also admits that 'something needs to remain incommensurable, non-negotiable, unexchangeable outside the circle of capital'.[37] Watching the protagonists who have given themselves to be imaged in this project, who act as stand-ins for our sense that in life we are already taking part in a bad film,[38] something happens in the oscillation between object and subject positions or the awareness of these positions being traded or exchanged. We can laugh at the "stupidity" of the programme, but we can also become aware of an excess on the side of the image that is not simply commensurate with the technological sublime of data, but rather that stems from the mismatch between this and the intransigent performances of the volunteers who give themselves over to the programme. Alienation in this respect is not negative but is a productive realisation inscribed via the automaticity of technology. It is located neither in the text as a play of signification nor 'in a sentient organism [such as the spectator] but rather is constituted in a two-way (reversible, reciprocal but not symmetrical) relation of mimesis between the image and the viewer'.[39] For Lury, the open productivity of 'the o/1 dimension of time',[40] with all the latent immediacies of readymade image banks that are ready to erupt into the time-space of the individual to 'disturb the pre-mediation of the already completed personality' is characteristic of the splitting of viewpoint afforded by digitalisation.[41] While there

may be a *naïveté* to the notion, stemming from both Freud and Benjamin as read in this article, that technology can be used in a playful manner (this would include sadistic relations as well as more fluid ones), I would suggest that *Today, too, I experienced something I hope to understand in a few days* proposes ways of thinking about digitalisation that re-imagines the world, which is key to how we are to continue to live and survive with images. As Flusser stated: 'we can observe nearly everywhere how apparatus of every sort tend towards programming our lives for a kind of dumb automation'.[42] It is important to be cautious in relation to the celebratory techno-aesthetics of much current thinking that claims that because we seem to be no longer passively consuming information, but making it over – for example uploading our own videos, making and exchanging our own images – that we automatically create virtual communities with the potential for subversion. By contrast to this approach Flusser argues for photographers 'to show that there is no room for human freedom in the realm of the automated, programmed and programming apparatus; and having shown this to argue how despite apparatus it is possible to create room for freedom'.[43] By exposing the conditions of capture and mediation in relation to the recombinatory principles of 0/1 code, Coupe's work offers a limit situation for us to consider the humanity implicit within technologies of visuality, enabling us to imagine the function of the apparatus in generating new narratives of human engagement and interaction. To imagine another kind of magic, one in which we are not held in thrall by the image, but which allows us to find ways of reflecting on the world and of maintaining the zero degree of difference between appearance and intention.

Notes

1. Jean Baudrillard, cited in Celia Lury, *Prosthetic Culture: Photography, Memory and Identity* (London and New York: Routledge, 1998), 144.

2. Steven Shaviro, 'The Pinocchio Theory', available at: www.shaviro.com/Blog/?p=561 [accessed 17 April 2012].

3. Jean Baudrillard, *Symbolic Exchange and Death*, trans. Iain Hamilton Grant (London, California and New Dehli: Sage Publications, 1993), 58.

4. Thomas Sebeok, cited in Baudrillard, *Symbolic Exchange*, 59.

5. Vilém Flusser, *Towards a Philosophy of Photography* (Gottingen: European Photography, 1984), 7.

6. Jonathan Beller, *The Cinematic Mode of Production: Attention economy and the society of the spectacle* (Hanover & London: University Press of New England, 2006), 103, 15.

7. Wlad Godwich, cited in Beller, ibid., 15.

8. Steven Shaviro, *Post-Cinematic Affect* (Winchester, UK and Washington, USA: Zero Books, 2010), 38.

9. Flusser, *Towards a Philosophy of Photography*, 46. Flusser describes how we currently live in a photographic universe, by contrast to the historical universe of modernity. The photographic universe consists of technical apparatuses – photography, cinema, television and computer technology – that produce or generate technical images.

10. Ibid., 54.

11. Ibid.

12. Ibid.

13. The project was commissioned by the Lancashire-based digital arts organisation Folly for its Abandon Normal Devices (AND) project in Spring 2010. It was site-specific to Barrow-in-Furness, but it has been continuing since and was part of the AND festival in Manchester in October 2010. The first test set of video portraits were shot in Seattle, the others being shot in Barrow and Manchester for the AND exhibitions. During the festival period from 15 March to 10 April, one film a day was generated. Since then and up until December 2011, the films appeared intermittently. At the time of writing, there are 95 films in total, views of single works range from 11 to 218 and there have been no comments posted.

14. Félix Guattari, cited in Lury, *Prosthetic Culture*, 157.

15. Flusser, *Towards a Philosophy of Photography*, 14.

16. Beller, *The Cinematic Mode*, 105.

17. Ibid., 108.

18. In *The Four Fundamental Concepts of Psychoanalysis* (London: Vintage, 1998), Jacques Lacan posits the notion that the clarity of the visual field is premised on an occluded point that he refers to as a stain. The spectator can occupy such a point in relation to the gaze of the world in our screen-based culture.

19. Gilles Deleuze, 'Postscript on the Societies of Control', *October*, No. 59, Winter 1992, 3-7.

20. Email correspondence with the artist, 15 May 2012.

21. In his well-known essay 'The Work of Art in the Age of its Technical Reproducibility' Benjamin wrote about how humankind has reached such a degree of self-alienation that 'it can experience its own annihilation as a supreme aesthetic pleasure'. Walter Benjamin, *Selected writings. Vol.3, 1935-1938*, trans. Edmund Jephcott et al, ed. Howard Eiland and Michael W. Jennings, (Cambridge MA: Harvard University Press (1936), 2002), 122.

22. It is interesting in this light too that the films are automatically uploaded to the Facebook pages of the volunteers who generated the data.

23. Joost Broeren, 'Digital Attractions: Reloading Early Cinema in Online Video Collections', in *The YouTube Reader*, ed. Pelle Snickars & Patrick Vonderau (Stockholm: National Library of Sweden, 2009), 154-164.

24. Thorsten Botz-Bornstein discusses how "cool" 'represents a paradoxical fusion of submission and subversion', in 'What Does it Mean to be Cool?', *Philosophy Now*, No. 80 (Aug/Sep 2010), 6. It can be seen as a decadent attitude giving rise to passivity, but its capacity to elicit fascination and desire gives it a strange kind of autonomy which is, I think, relevant to our photographic universe. For Botz-Bornstein, the paradoxical nature of "cool" means that it is neither total control nor total detachment but that 'the aesthetics and ethics of cool fractures and alienates in order to bring forward unusual constellations of ideas and actions' (ibid., 7).

25. Lury, *Prosthetic Culture*, 214. This automated excess is also a paradigm of the internet itself, the infinite vastness of which cannot be comprehended, but which yet operates according to various control protocols.

26. Joanna Lowry's description of the diagnostic gaze in relation to Phil Collins' video installation *The return of the real* (2005) is apropos here: 'The spectator is a witness, one who scrutinises the face on screen, looking for signs of self-possession or disintegration, seeking a glimpse of the truth, trying to match the fleeting expressions to the tone of voice or the translated subtitles that flicker across the screen. He or she begins to take up a diagnostic gaze, a disinterested form of observation, matching words to gestures, fleeting expressions, seeing the screen as a surface made up of symptomatic signs rather than as producing a representation of a person'. Lowry, 'Projecting Symptoms', *Screen Space: The Projected Image in Contemporary Art*, ed. Tamara Trodd (Manchester: Manchester University Press: 2010), 108.

27. Julie Levin Russo, 'Show Me Yours: Cyber-Exhibitionism from Perversion to Politics', *Camera Obscura* 73, Vol. 25, No. 1 (2010), 131-159.

28. Ibid., 151.

29. Ibid., 138.

30. Ibid., 137.

31. Coupe maps this subject/object split onto an earlier work of his *(re)collector* (2007), a public art installation in which a network of cameras, installed around Cambridge in the UK, were programmed to recognize "cinematic behaviours" corresponding to sequences in *Blow Up*, Michelangelo Antonioni's film adaptation of Julio Cortazar's short story 'Las Babas del Diablo'. He states that participants to the gallery watched themselves on screen, then observed the city from the perspective of the camera footage, as well as becoming 'an object within the scenes that [they know] the *(re)collector* system is capturing' (Coupe,

"(re)collector", unpublished PhD dissertation, University of Washington, 2009, 65). Thanks to Johanna Gosse for sending me this material.

32. Miriam Bratu Hansen writes about how Benjamin used the concept of innervation, which he may have gleaned from Freud, as a neurophysiological process that mediates between internal and external, psychic and motoric, human and mechanical registers. See 'Benjamin and Cinema: Not a One-Way Street', *Critical Inquiry*, Vol. 25, No. 2, Winter 1999, 313. It is his concept for a mimetic reception of the external world and is thereby bound up with an enabling reception of technology (ibid., 317).

33. Ibid., 317.

34. Both Hansen and Lury refer to Benjamin's earlier version of the 'Work of Art' essay.

35. Lury, *Prosthetic Culture*, 210, quoting Benjamin, as cited in Miriam Bratu Hansen 'Of Mice and Ducks: Benjamin and Adorno on Disney', *The South Altlantic Quarterly*, Vol. 92, No. 1, 43.

36. Shaviro, *Post-Cinematic Affect*, 62.

37. Ibid., 63.

38. I am loosely paraphrasing Gilles Deleuze here.

39. Lury, *Prosthetic Culture*, 210.

40. Ibid., 211.

41. Ibid., 208. Lury is referring to Paul Virilio's 1994 book *The Vision Machine* here.

42. Flusser, *Towards a Philosophy of Photoraphy*, 57.

43. Ibid., 59.

I I

Beyond the Beyond

THE 7ᵀᴴ BERLIN Biennale can be taken as an example which shows
that the task of political representation, or rather the representation
of politics within the field of art, necessitates a thinking beyond the
logic of the representation of the real. However, I will argue that
there is no possibility of escaping or getting beyond representation
tout court. The act of display within the gallery as such determines
the paradoxical impossibility of direct representation, in the same
way that political representation within current forms of democracy
precludes the possibility of direct presentation of the desires and
demands of the *polis*. As such, representation must be problematized
from within rather than stepped over. This problematization requires
an operation from the demand of display which depends upon the
registering of the traumatic relation that art has to the presentation
of the real. As such, the possibility of a "beyond representation" is
a necessary, but false, conceit. In contradistinction to this I propose

a realism of art that follows a logic laid out in the work of Quentin
Meillassoux, Ray Brassier, Reza Negarestani and Gabriel Catren,
which embarks via a further traumatic wounding of art's narcissism.

In his foreword to the 2012 Berlin Biennale catalogue, *Forget Fear*,
the curator Artur Żmijewski expounds his dissatisfaction with much
of contemporary art. His mood when viewing art, as he describes it,
has gone from one of elation to one of depression and lassitude. His
disappointment stems precisely from the lack of political engagement
and social critique proposed by artists of the current generation. The
diagnosis is severe but, in the most part, accurate. He identifies the
dominant curatorial strategy as an administration of art objects,
which are still, he asserts, imbued with the belief in the magical power
of the object:

> [...] it seems as if producing an object and distributing it among
> people is sufficient to effect change, political change as well.
> The art object alone, whatever else it may be, is expected to
> perform the social and political work assigned to it, without
> human agency, without any work at convincing, without
> difference of opinion or conflict, and thus essentially without
> any politics.[1]

This impotent art practice, he asserts, doesn't act and doesn't
work. Limited political ambition stems, he suggests, from the lack
of commitment of the artist or viewer; art 'usually goes no further
than presenting ideas that no-one has any intention of putting into
practice'.[2] Art is safeguarded against real politics by the institutional
borders, practiced by both artists, curators and the administrative
staff, who imagine the world of art to progress by, what Żmijewski
calls, the "logic of the miracle". Anything can happen, because art
(but not the system of art) is miraculous, the figures in it can somehow
transcend the banalities of the system and produce something
truly radical, sexy, or wonderful. Art under this logic is seen as the
theological curative for the ethical misadventures of the art system
(theological because it proceeds by way of the miracle, the eruptive
event from the outside). Żmijewski rightly decries this formulation,
admitting that the true miracle would be the abolishment of the
system of regulation and the liberation of art from the ideology of
impotence. Velvet critique emerges from the radicalism of the artist,
as though the curator, as a professional figure, shears art from its
radical potential in order to adhere to a caffeine free version of reality

to be presented in the institution. 'The curator has become a traveling producer of exhibitions, one who speaks of social issues in the soft language of pretended engagement.'[3]

Żmijewski, an artist turned temporary curator for the Biennale, admonishes the curatorial for its inability to represent the radical or political claims of art, instead declaring art, in the absence of the curatorial shield, as the pure site of political engagement. The problem for Żmijewski is that the artist is a victim of the system that surrounds her. She engages in an 'individualistic politics of survival', against a system that otherwise batters her with, from one side, the expectations of the market, and from the other the misrepresentation by the culturally dominant curator or hyper-bureaucratic institution.[4] And, because the curator cannot directly engage the artist in discourse about her work, lest the discussion lead to dissent or a break-down of relations, the artist's position is at one and the same time protected from intrusion and victimised by the system within which it operates. Through the safeguard of the institution art is drained of its own power, foreclosing the possibility for it to act in the world.

In another essay Żmijewski, bifurcates the field of art; autonomous art is opposed to socially engaged art.[5] Yet, this bifurcation results ultimately in the denial by the viewer of the art's capabilities. Even the most engaged practice cannot get purchase in the world because the velvet critique of the institution smooths it out, flattening its otherwise hyperbolic affects. I would argue in addendum to Żmijewski, that the audience's expectation of this type of velvety smoothness has been embedded so deeply into our consciousness that we find it difficult to extricate ourselves. Żmijewski asks, how are we in the position whereby artists, perhaps capable agents in the production of new realities, have such limited political scope that their work is incapable of producing real political change? The platitudinous answer to this question comes down to a distinction between "true" art and the vapid institution, whereby the institution occupies the shadow of totalitarianism in its bureaucratization. The statement in his essay that '[w]e have all bought about this situation together', indicates Żmijewski's nuanced understanding of the problem, despite his characterization of the bifurcation.[6] However, this does not reduce his sustained belief in the delimitation of art (contemporary, autonomous) from political art.

As a corrective to these tendencies, Żmijewski has proposed *Forget Fear*, the 7th installment of the Berlin Biennale. Without embarking on a thoroughgoing critique of the biennale, and it

certainly has been attacked from many quarters, I want to pin-point one distinct example of the contradiction between the project and the extra-diegetic claims of the catalogue essay, and assert why this might be interesting in thinking the question of representation that I am claiming is inherent in this discourse.

Upon entering the ground floor of the *Kunst-Werke*, the perennial location of the biennale, the scene is immediately set. Occupy Berlin has been invited to "occupy" the lower part of the building, erecting tents, displaying placards, distributing hand-drawn notes. Scrawled wall texts, graffiti, blankets, bookshelves stacked with German translations of Marx, Althusser, Hardt & Negri, etc.; an improvised, but fully operational radio studio; long, laboriously transcribed texts and so on adorn the imposing space lending an air of amateurish camaraderie not usually seen inside an art gallery. It is not immediately clear whether the participants live here, however the remnants of sleeping, washing and eating appear scattered around the "campsite" and the implication is certainly that the Occupy movement is here for the long haul.

The banal linguistic fact that an occupy movement cannot be invited to "occupy" without logically defeating the very status of the occupation leads fruitfully on to the real crux. If Żmijewski has invited Occupy Berlin into the KW to promote them as an example of his attempted shift from one framework for contemporary art to another, then his precise framing of them in the institution forecloses the effectiveness of this action and proves, perversely, his point about the art world. To extrapolate it is necessary to address his introductory proposition in more adequate terms. To summarise and paraphrase Żmijewski's account, contemporary art proceeds by these three main logics: (1) It produces a subject (the viewer) who is incapable or unwilling to follow-through on the radical claims of the art (if it has those claims in the first place). (2) It is both the victim of and safeguarded by the institution, and as such proceeds by a victimological individualism. (3) It is a sop to the voodoo capitalism at the heart of the art market.

The subjectivity that contemporary art interpellates is riven with the conditions of our current ideology, and differs by degree from previous regimes. My claim is that art, far from being a victim in this logic, is in fact, in part, an agent in the creation of it. Tactically withdrawing from the system, opposing it from a position of authority or ethical purity, or suggesting that art is somehow a corrective for the worst traits of the market/world misunderstands, in truth, the ways in

which art itself is implicated in the production of this scenario.

If contemporary art can be characterised, under Żmijewski's auspices, as a practice of increased autonomy (and its failure to "do" politics) then autonomy, in contradistinction to engagement, cannot be political. This bifurcatory move not only restricts politics to social practices, creating a hierarchy of politicality, but also underestimates the power of the image. The poor image can never engage with politics, and must therefore be limited to a non-politicality, incapable of impeding on our systems of distribution. This formulation, however, rests on a particular assumption: that the difference between engaged and autonomous practices is measured by the latter's capacity to produce an immanent fidelity, or in other words in the capacity to concretize with no excess. On the one hand I would argue that the material presence of the engaged practices – the fact that they exist in a world striated with atelic materialities – prohibits their direct representational capacity, and on the other, that it is precisely these atelic affects, which are distinguishable in both regimes of art practice that Żmijewski describes, that prehend politics.

My claim, contra to Żmijewski, is that contemporary art is not marked by an increased autonomy of objects (bad) in distinction from a relational practice (good), but that all contemporary art is precisely an ideological operation that interpellates a type of subjectivity that defends and reinstates the project of correlationism that presupposes the human subject as independent from and in priority over the object.[7] What I will call the condition of the contemporary – that is, the conceptual and contextual apparatus art both engenders and engages with – is precisely the project of private individuation determined firstly by the specular relation between subject and object, and secondly by the confirmation of this as ground. The reason the Berlin Biennale example is important is that Żmijewski presupposes that the presentation of the Occupy movement in the gallery is an example of "real" politics, but does so through an occlusion of the problematic of representation which undermines his own position in relation to the real. I propose that the inclusion of the Occupy movement is an action akin to the Duchampian readymade, and as such should be treated as part of that history. Furthermore, the Duchampian gesture produces a fantasy of bifurcation between the human subject and art object that reinstates and defends the dogma of the absolutisation of human access that has, under Quentin Meillassoux's telling of it, haunted much of post-Kantian thought and as such cannot think the reality of the non-correlated real.[8] In

contradistinction to this I will go on to propose that art as such always already engages in a presentation of the real that is not correlated to human thought, and does so through a cut from interpretation that Duchamp cannot account for. However, because contemporary art proceeds via a Duchampian logic, we act as though this is not the case. Instead the viewer is given priority in the formation of meaning as though they were free to do so. I will argue that this freedom interpellates a type of subjectivity that plays out within and, in part, produces the conditions for neo-liberal politics.

In Marcel Duchamp's short text 'The Creative Act', he outlines the phrase that comes to shadow much of the last 60 years of art production; the art coefficient:

> [...] in the chain of reactions accompanying the creative act, a link is missing. This gap, representing the inability of the artist to express fully his intention, this difference between what he intended to realize and did realize, is the personal "art coefficient" contained in the work. In other words, the personal "art coefficient" is like an arithmetical relation between the unexpressed but intended and the unintentionally expressed. To avoid a misunderstanding, we must remember that this "art coefficient" is a personal expression of art à l'état brut, that is, still in a raw state, which must be "refined" as pure sugar from molasses by the spectator;[9]

For Duchamp, and his legacy, this refining process is the process of acting as a viewer on the work of art. As he continues, 'the creative act is not performed by the artist alone; the spectator brings the work in contact with the external world by deciphering and interpreting its inner qualification and thus adds his contribution to the creative act.'[10] Contemporary art precisely produces a scenario whereby the viewer is interpellated as a free subject within the realm of decision about the work. This space opened by the work for the viewer to occupy is what I will call a correlate space, determined by its openness to the viewer's interpretive impulse.

In the setting up of a local field of apolitical openness which makes a universal appeal to the viewer to co-produce meaning, contemporary art repeats the Duchampian gesture of the ready-made. That is, it privileges the performative gesture of the artist and the interpretation by subject as the site of meaning production. The Duchampian art-coefficient proposes, as we know, the

co-determination of the work of art by the subject-viewer. This "co-" moment rests on the productive agency of the artist and, in the face of extant materialities, or as Duchamp calls it "art in its raw state", the viewer as refiner of emphatic materiality. This configuration invites the spectator to complete the artwork by the way of interpretation; that is the debt the spectator has to pay in order to safeguard the specular circle. As Duchamp put it, the viewer "refines" the artness of the work. Precisely, this coefficient presupposes an active figure, the artist or the audience, and a passive material, the art object. As an active subject, the viewer is privileged, capable and unrestricted. This is art's political ambition, to produce a type of subject that can enjoy their own freedom within the experience of viewing art. Yet, I would argue, this is exactly what predisposes the viewer to understand themselves as the pre-determined privileged figure within the relation. And thus confirms the dominance of subject over object, culture over nature and man over the object of the world.

So, if the artist-coefficient is the *sine qua non* of contemporary art, and the net result of this openness to the viewer is the interpellation of a certain kind of subjectivity – a subject who finds itself as the locus of meaning production – then art in this category builds into itself a teleology of interpretation. The subject as inbuilt addressee precipitates a conservative logic of humanism that places art as a communicative device determined by its relation to cognition. Art, then, is forever seen as an object, as Meillassoux puts it, "for us".[11] The problems with this conception are twofold. The prioritisation of the human subject in its relation to the art object is an anthropocentricism which continues the work of post-Kantian thought to place humanity at the core of existence. And, this occludes the truth of the art object: that its materiality, its "objectness", is indifferent to our experience of it. This occlusion presupposes a dominant subject-viewer who sees the work of art as open to their own interpretation, and all interpretations as equally valid.

I want to draw a correlation between the kind of subject interpellated by this openness and the type under the governmental project of neo-liberalism; that is a free, unregulated individualised subject, with the personal freedoms that the politics of liberalism promised. As Jon Cruddas and Jonathan Rutherford explain in their essay 'Ethical Socialism', the historical declination of the welfare state, Geoffrey Howe's 1981 "austerity budget" that cut public spending and increased taxes, and Thatcher's degradation of socialism, were crucial in the destruction of social responsibility and the creation of

'a new popular compact between the individual and the market' which 'displace[d] the old statist, social welfare contract'.[12] This creation of a new type of individualism has, through its linkage of the individual to capital, eviscerated the idea of the public sphere as a political space, thus confining politics to an elite political class and producing a form of hyper-consumerism driven by desire. I would go so far as to suggest that contemporary art has been at the avant garde of the creation of this form of political subjectivity, has laid the ground for the shift to individualism and, through its appeal to the private experience of the viewer, devalued the idea of a common. Contemporary art, then, despite its claims to ethical or critical politics, is both the worst expression and progenitor of neo-liberalism.

Neo-liberalism marks not just the political-economic nexus of the ideology of no ideology, but the period during which the individual subject took firm root in the public consciousness. In an interview for the Independent newspaper in May 1981 Margaret Thatcher said:

> What's irritated me about the whole direction of politics in the last 30 years is that it's always been towards the collectivist society. People have forgotten about the personal society. And they say: do I count, do I matter? To which the short answer is, yes. And therefore, it isn't that I set out on economic policies; it's that I set out really to change the approach, and changing the economics is the means of changing that approach. If you change the approach you really are after the heart and soul of the nation. Economics are the method; the object is to change the heart and soul.[13]

Born from Thatcher's so-called "revolution of the soul" that produced a subject in compact with the market, this type of neo-liberal subject was no longer engaged in the public realm of politics, but in the private realm of material accumulation. The individual was to take greater and greater responsibility for their position in life, their compact with the market allowing the government to dismantle the welfare state. Whereas before the nation state had taken moral responsibility for its citizens' well being, through the economic shift towards individualism the state was able to renege on this promise and offer a very different one, that of the freedom of the individual to consume.

My claim would be that it is our responsibility now to rethink

what art can be outside of the framework of the contemporary. The relational or cognizable prioritising, the production of correlate space in other words, inherent in contemporary art necessarily occludes the reality of the art object – a reality that we cannot account for through cognisance, the reality of 'an anterior world expressed as indifferent to humans'.[14] What remains now, beyond the contemporary, is to account for that exterior reality. To do so would, I suggest, problematize the humanism of contemporary art, thus eviscerating the correlate space, claiming art as part beyond the realm of the "for us", part entangled in that realm, and not operating through the aegis of the private interpretative mode.

The artwork can neither be contained by thought nor is it produced merely as a vehicle for thought. However it both brings with it and is instaurated by atelic affects that are reliant upon the contingency of materials which, pertaining to no idealism, may or may not perturb other objects, including the viewer, but are not activated by or for the viewer. Art is capable of making, and regularly does make, propositions about the world in a non-conceptual way. That is to say, the work of the work of art is extra-philosophical, it can produce determinations that are beyond thought, beyond philosophy, beyond the human. The artwork, instead of being a purely relational or communicative device, is an irruption of non-thought. This non-thought touches upon an "unknown" that is both the horizon and beyond the horizon of what thought can think, and may or may not; and this possible but not necessary condition is important as it may or may not cause things to happen. There is, to reiterate, no necessity for the unknown to make itself self-evident through affectivity. It is as likely as not that the irruption of non-thought within the work will contingently act upon anything else. So, the atelic affect is not necessarily affective but contingently so. This contingency of affect that perseveres through the logic of the unaddressed expression – the material quality of all objects not addressed to a viewer, just emphatically there – is, I am claiming, a challenge to the Duchampian model of contemporary art.

If we understand the contemporary as a condition of the absolutisation of the co-relation between artwork and viewer, then it follows that this condition cannot be the basis for understanding the contingencies at stake within the materials of the work. As Iranian philosopher, Reza Negarestani suggests:

If we consider art as a material-driven process of production, these anonymous materials enjoy an autonomy of their own; and such autonomy continuously interferes with the artwork itself regardless of the decisions of the artist – that is, whether or not the artist determines to be "open" to their influence. In other words, the contingency of the artist's materials cannot be the strict subject of the artist's openness. Contingent materials cannot be directly embraced.[15]

As that which cannot be encompassed, contingency erupts from the object. Expressed through the immanent materiality of the work of art, as something that surprises and leads the artist rather than being controlled by them, contingency names the unknown of the infinite reality that lies beyond the horizon of thought. It is the eruption of non-thought. Materiality, then, is the site for the post-human to express itself through a non-intentional affect:

> *Incognitum Hactenus* – not known yet or nameless and without origin until now – is a mode of time in which the innermost monstrosities of the earth or ungraspable time scales can emerge according to the chronological time that belongs to the surface biosphere of the earth and its populations. *Incognitum Hactenus* is a double-dealing mode of time connecting abyssal time scales to our chronological time, thus exposing to us the horror of times beyond [...] anything can happen for some weird reason; yet also, without any reason, nothing at all can happen. Things leak into each other according to a logic that does not belong to us and cannot be correlated to our chronological time.[16]

For Negarestani, material comes with a set of affordances that can channel or determine the process of production, so, instead of the openness of the contemporary period, art should be based on what he calls the "formidable ascesis of closure". Materials afford certain aspects of themselves to be produced as such.

In the quote from earlier in this chapter Duchamp, in a way presaging Negarestani's description of autonomous materials, formulates a gap between the expressed but intended and the unintentionally expressed. For him the unintentionally expressed is what is given over to the viewer by the artist for the production of meaning to occur. However, contra Negarestani, Duchamp suggests

that the viewer's refining of the work of art is complete, that the materials lose their autonomy in the refining process which apparently leaves no excess. What occurs in the Duchampian paradigm is the internalising of the expectation of apophenia, or rather, contemporary art attaches itself to the production of subjectivity through the appeal to apophenia alone. What the atelic affect engenders is a thinking of the work of art shorn from its attachment to the addressed subject. Instead, it institutes a thinking that moves beyond the humanism of the contemporary focus on the subject towards a radical object-focused thought. To quote Ray Brassier: 'it is no longer thought that determines the object, whether through representation or intuition, but rather the object that seizes thought, and forces it to think it [...] according to it'.[17] However, and this is the key, contemporary art acts as though this is not the case. It registers this reality, but then papers over that by returning the work to the realm of interpretation.

As Slavoj Žižek suggests, according to Freud man has experienced three humiliations, three "narcissistic illnesses," as he calls them:

> First, Copernicus demonstrated that Earth turns around the Sun and thus deprived us, humans, of the central place in the universe. Then, Darwin demonstrated our origin from blind evolution, thereby depriving us of the privileged place among living beings. Finally, when Freud himself rendered visible the predominant role of the unconscious in psychic processes, it became clear that our ego is not even a master in his own house.[18]

These scientific de-centring moments in the history of, at least the West, are examples of the process of thought towards a deepening of the knowledge of the absolute, or to put it in another way, the production of discourse that accounts for a non-human correlated world. The task of a realism that understands itself as continuing the trajectory of these three humiliations is to propose a universal continuum of the real from which the human is cut. This scission, or trauma, is the differentiation of the organic from the inorganic, and thus marks the production of the human from the non-human.[19] The obverse tendency in post-Kantian thought as registered by Meillassoux has been to return the human to the centre of the universe, thus pursuing a counter-revolutionary logic of humanism that presupposes a dominance of culture over nature and subject over object. I want to propose the possibility of following a Copernican logic that can think

the radically immanent materiality of the artwork as an expression of
its indifference to the human, and as such a presentation of the real
that traumatizes the dominance of the relational within art.

The original trauma that cuts out a slice of the real from which
the human is formed is registered by art in two ways. Firstly, by
the nature of the artwork as an object that withdraws from our
experience of it into its inaccessible real core (*vis à vis* Graham
Harman's object oriented philosophy), a withdrawal that discloses the
materiality of the object. And secondly, by the rehabilitation of the
trauma via a privileging of the human in the subject/object relation
as the occasion of meaning production. Which is to say, the subject
re-gains dominance over the object via a specular process of the
encounter. This twofold registering of the trauma, the disclosure and
subsequent rehabilitation that the artwork performs, problematizes
the process of presenting artwork to a public. To evidence this
traumatic cut and the de-monstering of the real via the exhibitionary
act requires a fidelity to the real, or complicity with the 'true-to-the-
universe logic' that the thought of Copernicus demands.[20] Art is not
any less real than that which is outside it, however, through the act
of display it presupposes the primacy of relations, and as such cannot
think the true-to-the-universe thought.[21] This inability to think
beyond the relational creates an immunising layer that protects art
from the incursions of the real, describing a predetermined critical
distance from which art operates.

The surficial limit of contemporary art is safeguarded by the
liberal tolerant institution's economic openness to non-art. As
described by Negarestani, for such openness, 'the outside is nothing
but an environment which has already been afforded as that which
does not fundamentally endanger either the survival of the subject or
its environing order'.[22] As such, art's institutions, and by that I mean
the institution of art itself, protects its borders by the operation of
tolerance, whereby the monstrous outside is brought into the realm
of art via the act of representation, or more precisely, demonstration.
The de-monstering of the demonstration supposed by the readymade
is performed by the gatekeepers at the limits of contemporary art;
the artist, the curator, the institution and so on. We can think this
through the myth of Medusa. Perseus decapitates the monster, holding
the snake-haired head aloft in a ritual form of demonstration. From
then on he wields the head as a weapon of his own, thus re-presenting
the monster (that which is outside the limit) in a form of de-monstered,
or humanised, figuration. Perseus stands in for, and operates as, the

figuration of the narrativised real within the regime of contemporary criticality; he stands as the exception within the generic. Thus, the act of the presentation of art as a readymade, cut from the "real" and re-presented within the gallery, relies precisely on the human figure's dominance over the real and, furthermore, occludes the traumatic cut via a fantasy of dominance at the point of encounter. The inaccessible real that registers as the trauma of the non-correlated world without us, and is expressed through the unintentional materialities of the work, is foreclosed by an insistence on a humanist agenda that proposes art as an object of human encounter whereby, as Duchamp suggests, the viewer "refines" the artness of the work. In this scheme the human apprehension is the prioritised relationship that determines the decisional field. The human makes the cut, the "scission" of the decision, which papers over the truth of the work of art.

The viewer, like the gatekeeper artist, safeguards the work from the radical outside by their already negotiated openness to it. To pursue a Copernican logic whereby the work partakes in a humiliation of the humanist centering of the subject would demand an alternate understanding of art. Focused not on the production of meaning via only the encounter of the artwork by the human, but by an understanding of its distributed affects through an ecology of true-to-the-universe objects, this logic would de-centre the human from the production of art, replacing the logic of the specular relation between subject and object with a mesh of objects to which the artist must be complicit. [23]

This cleaving to, and the cleaving from, the object, or eruption of subjectivity from the objective, the cut of the organic from the inorganic, expresses an understanding of the real synchronous with science, rather than conditioned by thought. As demanded by Gabriel Catren in his essay 'Outland Empire', this synchronous relation between philosophy and science, exercises a speculative absolutism that deepens the 'narcissistic wound' inflicted by modern science.[24] With the true-to-the-universal thought of de-centred artwork – an artwork that understands its relation to the human as contingent – and not as the primary site of meaning production, we can witness a continued deepening of that wound. If we have always returned the artwork into the "truth of the human" through the rehabilitation of the traumatic cut, then Catren's insistence on the fidelity of thought to science can overturn the reliance of art on thought. It is worth quoting Catren at length here:

The infinite process of theoretical knowledge does not advance by attempting to grasp an "uncorrelated absolute" through a philosophical "ruse" capable of discontinuously leaping over the subject's shadow, but instead through a continual deepening of scientific labour seeking to locally absolve it from its conjunctural transcendental limitations, expand its categorical, critical, and methodological tools, and progressively subsume its unreflected conditions and presuppositions. Far from any "humanist" or "idealist" reduction of scientific rationality, this reflection upon the transcendental localization of the subject of science should allow the latter to radicalize the inhuman scope of knowledge by producing a differential surplus value of unconditionality and universality. In other words, such a reflexive torsion should permit the subject of science to continuously go through the transcendental glass and force its progressive escape from the transcendental anthropocentrism of pre-critical science: it is necessary to think the particular – empirical and transcendental – localization of the subject of science within the real in order for theoretical reason not to be too human.[25]

Far from proposing we abandon the human, as some reactions to the expanded field of philosophy to which Catren's essay nominatively belongs suggest, Speculative Realism instead pursues a logic of scientific realism. This interpretation of scientific realism describes the universal absolute not as an intimate or an alternative outside but as a continuum of an immanent real that necessarily includes and implicates the human. Art has yet to address adequately the implications of these demands from Catren. The eradicable desire for the new, the expansion of art into non-art via the demonstrative arm of the gatekeeper, the figuration of the hero artist from the generic field, the exoticisation of the "other", the romanticism of the alternative and the expectation of the bolt of inspiration from the blue are just some examples of the platitudes by which art progresses. Catren's 'Outland Empire' overturns these age worn clichés through a simple but effective re-design of the landscape confronting us. It is beyond the scope of this text to do justice to the extent of this intense and rich essay, but instead I hope to point towards a few instructive moments.

The operation of reflexive analysis that Catren proposes for the 'different "transcendental" conditions of research' that can go beyond

anthropocentricism, the limitations placed on the experiments of
science by the limits of the human, implicates us in a speculative
mode of thought.[26] A wound has been stitched up by the Kantian
conservative revolution; to perform a dehiscence we must analyse the
conditions under which thought is performed. This dehiscence, Catren
suggests, will finally make philosophy modern; 'Philosophy will
finally be modern only if it can sublate the critical moment, crush
the Ptolemaic counter-revolution and deepen the narcissistic wounds
inflicted by modern science'.[27] From a philosophy synchronous
with science, Catren proposes a speculative absolutism that can
think beyond the limits of the correlation between human and world
that has been transcendentalised in post-Kantian thought. The
transcendentalised correlation supposes that we can never think the
real without thinking our relation to it. A Copernican revolution must
be capable of thinking the absolute, which in Catren's terms comes to
mean the real, un-correlated to human access to it. We must perform
a traumatic cut between the real and human access.

Through a decentring logic of true-to-the-universe thought, we
can re-understand art's role as one not of the production of the fantasy
of human dominance, but the furthering of the work of the absolute.
With this in mind the Berlin example might operate rather differently.
Art's recuperation of a form of life, on this occasion championed by
Żmijewski, needs to be problematized as an act of representation that
cannot be escaped. Therefore, under the logic of the readymade there
is no possibility of a "beyond representation" as such, and we must
abandon the belief that we can step over the problem of representation
in one bound.

As Maya and Reuben Fowkes point out in their essay on
the instrumentalisation of the Occupy movement's forms within
contemporary art, '# Occupy Art', 'If 2011 witnessed the euphoric
phase of the movements as they burst onto the flat screen of global
consciousness, 2012 has seen contemporary art rush to capitalise, with
a stream of major art events referencing the Occupy phenomenon'.[28]
Art here operates through a logic of voracious capitalisation, thus, by
adopting its very operating structure, repeats the forms of capitalism
it naïvely supposes it resists. To pass beyond this recuperation of
political movements into art in arguably exploitative terms, art must
think otherwise than this form of appropriation. If Occupy is the
"real" as such, that is the extant material substrate of existence from
which politics draws its motifs, language and power, then Żmijewski
exploits the power of the institution to tolerate the real in a move

that reasserts the power of the human rather than acknowledging human finitude's limit form. Which is to say that a true-to-the-universe art would make a third move beyond the twofold registering and rehabilitation of the trauma. This third move would involve a further dehiscence of the stitched-up wound in human narcissism expressed not only through the work of art as such, but by the production of new institutions of art that can operate to expand on the speculative absolutism that is the otherwise occluded real of art. To do this would require a radical adjustment in all aspects of art production, reception and distribution to account for the entangled reality from which art is shorn, to ensure art not be, as Catren proposes, "too human". If we can understand that rather than determining the object, thought erupts from the object, so much that subjectivisation is the process of the eruption of the organic from the non-organic, then we can begin to account for the ecological entanglement of objects that engenders a radical new politics of interdependence and commonality, which butchers the human-prioritised correlate space of the encounter.

Acknowledgment

The author would like to acknowledge the debt to the Matter of Contradiction working group in the development of the research for this essay, particularly Fabien Giraud, Ida Soulard, Sam Basu, Christopher Kulendran Thomas, Andy Weir, Vincent Normand and co.

Notes

1. Artur Żmijewski, *Forget Fear*: Berlin Biennale catalogue (2012), 11.

2. Ibid., 12.

3. Ibid., 13.

4. Ibid., 15.

5. Artur Żmijewski, 'Applied Social Arts', in *Krytyka Polityczna*, No. 11-12, 2007, available at: http://www.krytykapolityczna.pl/English/Applied-Social-Arts/menu-id-113.html) [accessed 4 May 2013].

6. Żmijewski, *Forget Fear*, 15.

7. Correlationism is a term used by Quentin Meillassoux to describe much of post-Kantianism. He defines correlationism as 'the idea according to which we only ever have access to the correlation between thinking and being, and never to either term considered apart from the other'. *After Finitude*, trans. Ray Brassier (London: Bloomsbury Academic, 2010), 5.

8. Ibid.

9. Marcel Duchamp, 'The Creative Act', in Robert Lebel, *Marcel Duchamp* (New York: Paragraphic Books, 1959), 77-8.
10. Ibid.

11. Meillassoux, *After Finitude.*

12. Jon Cruddas and Jonathan Rutherford, 'Ethical Socialism', *Soundings* No. 44 (Spring 2010), 11.

13. Margaret Thatcher, 'Mrs. Thatcher: The First Two Years', interview with Margaret Thatcher by Roland Butt. *Sunday Times*, 3 May 1981, available at: http://www.margaretthatcher.org/document/104475 [accessed 4 May 2013].

14. Ray Brassier, *Nihil Unbound: Enlightenment and Extinction* (Basingstoke & New York: Palgrave Macmillan, 2007), xi.

15. Reza Negarestani, 'Contingency and Complicity', in *The Medium of Contingency*, ed. Robin McKay (Falmouth: Urbanomic, 2011), 11.

16. Reza Negarestani, *Cyclonopedia: Complicity with Anonymous Materials* (Melbourne: Re.Press, 2008), 49. My emphasis.

17. Brassier, *Nihil Unbound*, 149.

18. Slavoj Žižek, 'How to Read Lacan' (1997), available at: http://www.lacan.com/zizhowto.html [accessed 4 May 2013].

19. See Reza Negarestani, 'Globe of Revolution', in Identities: *Journal for Politics, Gender and Culture*, No. 17 (2011), 25-54.

20. Negarestani, 'Globe of Revolution'.

21. Negarestani, 'Globe of Revolution'.

22. Negarestani, *Cyclonopedia*, 197.

23. The concepts of "ecology" and "the mesh" are developed by Tim Morton in both *The Ecological Thought* (Cambridge MA: Harvard University, Press 2012) and *Ecology Without Nature* (Cambridge MA: Harvard University, Press 2009).

24. Gabriel Catren, 'Outland Empire', in *The Speculative Turn*, ed. Levi Bryant et al (Melbourne: Re.Press, 2011), 335.

25. Ibid., 342.

26. Ibid., 334.

27. Ibid., 335.

28. Maja and Reuben Fowkes, '#Occupy Art', *Art Monthly*, No. 359, Sept 2012, 12.

ATMOSPHERIC TECHNOLOGIES
AND THE POLITICAL

12

Eyes of the Machine: *The Role of Imaginative*
Processes in the Construction of Unseen Realities
via Photographic Images.

COLLEEN BOYLE

THE RELATIONSHIP BETWEEN optical technologies and human
perception may be relatively young when compared with distant star
clusters and galaxies, however it is a relationship that has proven
to be intensely co-dependent, particularly within the space sciences.
Technology has enabled the extension of our limited vision and image-
making capabilities, going well beyond what the naked eye can see
and exposing remote or hitherto unseen aspects of reality. Today,
sophisticated space-imaging technology such as the Chandra X-ray
Observatory and the Hubble Space Telescope reveal the cosmos in
every wavelength from infra-red to ultraviolet and X-ray, continuing
to provide what Susan Sontag describes as a 'unique system of
disclosures' that shows us reality as we have never seen it before.[1]

From the first telescopes onwards, we have found fascination with the seemingly magical way in which imaging technologies could transgress the physical limits of scale and distance, but it is their mechanical capacity to present the external world as a seemingly fixed and objective reality that we truly hold in awe. Modern photography arrived at a time when Western thought was predisposed towards logical positivism, laying the ground for the ever-present association of the photograph with an indexical relationship to reality.[2] The so-called death of analogue photography may have shaken our faith in the veracity of the photographic image but the rhetoric of objectivity and transparency, particularly within the epistemic framework of science, prevails. Indeed, without some form of continuing faith in the indexical link of image to reality, knowledge construction within the framework of science would become problematic. As Bruno Latour so aptly puts it: '[y]es, scientists master the world, but only if the world comes to them in the form of two-dimensional, superposable, combinable inscriptions'.[3] The advent of photography provided the sciences with a method of observation that matched a post scientific-revolutionary desire for evidential disclosure of the world. The camera became the eye of science and, when combined with technology such as rocket propulsion and satellites, a hitherto unseen world was opened up before us. At the core of contemporary unmanned space exploration sits the remote sensor, the disembodied eye of science that completely relies upon the axiomatic nature of the relation that the photograph is supposed to have with reality. In the case of the remotely sensed image, the camera does not lie but more importantly it must not, because no one is there to see otherwise.

Just as Fox Mulder wanted to believe in UFOs, we want to believe in the reality presented to us by photographs. The potentially problematic way in which photographic technology transforms reality – via the transgression of normative vision – is set aside in favour of an ideal, objective truth. However, the link between the photograph and reality is not as clear-cut as the sciences would hope and it is also a topic that has been well addressed by others in various fields.[4] I shall touch on certain elements of that discourse, but my primary concern here is to explore the possibility that the photograph forms a perceptual bridge – an interface – between what we know and what we can imagine, playing a pivotal role in constructing our perception of unseen realities. Through various image examples, primarily from the space sciences, I will explore ways in which the mechanical "vision" of the photograph acts as a starting point: a pictorial space

that invites the construction of a more holistic reality and one that may begin with "objective" knowledge but which is completed by the "subjective" imagination.

The Inner Eye, The Photograph, The Non-finito

The word "imagination", despite its everyday and frequent use, remains as ambiguous as the act itself. A dictionary definition describes it as 'a mental faculty forming images or concepts of external objects not present to the senses', which places it firmly within the realm of perception.[5] However, imagination has also been attributed with privileged links to the productive powers of creativity. Edward S. Casey's phenomenological account points out that when it comes to philosophy, imagination has historically occupied all manner of places within an hierarchical structure of the mind and has been assigned a diversity of roles therein: subordinated by some (Plato); superordinated by others (the Romantics and the Surrealists), and placed squarely in the middle by more (Aristotle, Hobbes, Hume, Kant).[6] Even psychology provides a muddy account as it seeks to explain imagination by associating it with sensation, memory, and imitation.[7] Casey ultimately laments the lack of recognition of imagination as a particular and unique function of the mind and is disappointed that 'imagining has almost invariably been relegated to a secondary or tertiary status in which it merely subtends some supposedly superior cognitive agency such as intellect or (more frequently) modifies some presumably more original source such as sensation'.[8] Instead, Casey proffers a 'multiplicity of the mental' with no hierarchical structure, 'only a proliferation of unforeclosable possibilities'.[9] Imagination is not a self-contained or autonomous bubble of internalized images but part of a broader process that can be productive and affective, spontaneous and unstructured, intentional and controlled.

If we return once again to the dictionary definition mentioned above, we find a second, yet ultimately as important, aspect assigned to imagination: images or concepts of external objects not present to the senses. Casey may malign the fact that imagination was often described as a mere modifier of 'some presumably more original source' but this is what it must be. What is imagined must always be something other to what I receive via my senses. This is not a mere rhetorical statement, but a phenomenological truth. Suppose you are looking at a photograph of an apple. Concentrate on looking at that

apple, be aware of your act of looking, of seeing and perceiving the image of the apple. Now, as you continue the act of seeing the apple before you, imagine the apple, internalize the image. You will quickly realize that it is quite impossible to simultaneously see and imagine the apple.[10] The imagined must remain unseen. What is imagined is never immediately available to the senses but this does not mean the removal of imagination from any perceptual "hierarchy" or "multiplicity" if one exists. Imagination is an integral part of our everyday perceptual processes, from daydreams to scientific analysis.

For Wilfrid Sellars, the imagination is productive. It is the binding ingredient between the phenomenological and conceptual components of perception. For him, the imagination plays a role in bringing the sensed external object (which for him exists independently of any observer) to the subject's conception. But more importantly, in this context, the 'imagination "converts" the subject's visual sensing – the underlying non-conceptual phenomenal state – into something altogether much richer, through the fusion of images with the visual sensing of a coloured, spatial array'.[11] The result is what Sellars calls a "sense-image-model", or, what others have referred to as a schema: an underlying model of perceptual experience, constructed by and continually modified by sense experience that allows me to understand what it is like to perceive something from various points of view. Furthermore, Sellars claims that even if we are unsure of the specific type of object we are looking at, we can have some idea of its physical properties due to previous sense experience of similar objects. Paul Coates takes this one, albeit subtle, step further stating that: 'The imagination produces in the perceiver an implicit awareness, or set of expectations, of the likely ways in which the phenomenal, or sensory, aspect of an experience will be transformed'.[12] We become prepared for further, differing types of sense experience, imaginatively and – productively. It is with our imagination that we bridge the gap between what we already know, what we see, and the infinite possibilities of what we are yet to see.

English clergyman and writer/artist William Gilpin (1724-1804) thought that the imagination was a truly creative force that could 'aid the poet's or the painter's art; exalt the idea; and picture things unseen'.[13] On his many walks through the picturesque English countryside Gilpin made countless sketches and written descriptions of the landscape he encountered, many of which were published as armchair travel guides intended to provide the reader with an evocative, albeit dislocated, experience of the places he had

witnessed first hand. He declared that when the viewer's imagination was applied to the *non-finito* (unfinished state) of the sketch that it had 'the power, of creating something more itself', in effect actively constructing a new reality.[14] Not an external reality signified by the sketch, but an internal, unseen reality of the mind. By using the imagination to complete the sketch, the viewer creates a reality that sits outside the constraints of the image.

Although history and discourse have yielded variations on the definition, role, and importance of the human imagination there are certain aspects to which I will remain allegiant. The imagination is a productive perceptual interface, not a passive receptacle for sense data. Imagination must construct from previously received sense data; there cannot be simultaneous input and output as illustrated by the apple example. The imagination plays an important, yet ambiguous, role in the construction of a "sense-image-model" or schema and as such imagination allows us to understand objects we have not encountered previously by referring to what we already have. The imagination's capacity for data combination is literally infinite. Each image it produces leads to another resulting in Casey's "proliferation of unforeclosable possibilities". And finally, the reality created by the imagination is a counterpart of, but not indexical to, an external reality. The reality of the imagination remains internalized: resolutely unseen. It is from this place of vivid darkness that we have the potential to see the world afresh.

Sights Unseen

Prior to the invention of the hot-air balloon, it was only by exercising our imaginations that we could see the Earth from a distance. In 1500, Jacopo de Barbari produced a truly visionary print commonly known as, 'A Bird's Eye View of Venice' (fig. 1). In order to create this, albeit flawed, depiction of Venice as seen from an elevated perspective, Barbari needed to draw on his existing experience of seeing things from above and then attempt to imaginatively add to that basic schema. The resulting image clearly shows an artist grappling with unknown territory, pushing the outer limits of his established visual knowledge in order to create the as yet unseen reality proposed by his imagination. Unless I use my imagination, my visual perception remains restricted by space, time and physics. However, I can use my imagination to fill in the blind spots, the gaps in representation and experience and free my perception of its physical bonds. Thus,

Figure 1. Jacopo de' Barbari, 'A Bird's Eye View of Venice', 1500.

Jacopo de Barbari could perceive of a view of Venice he had never seen: the city as if seen by a bird in flight.

Once photography was established as a stable process, did our imaginations yield to the authority of the mechanically made image? Did this internal process waiver, after photography had so emphatically recreated the external world? If the camera can so easily reveal unseen aspects of reality for us, do we need to imagine it any more? Don Ihde has claimed that transformations imposed by technologically mediated vision are "non-neutrally acidic" to traditional visual culture.[15] In other words, once we have learned how to see via the photograph we cannot go back, the eye can no longer be naked. Others, such as Marx Wartofsky, have claimed that photography didn't merely change how we interpreted what we could see; it actually changed what we could see, integrating itself into our perceptual processes like a discreet virus. He holds that – although the camera may not see – we can now see like cameras and perceive of the world as photographs, pictorializing the reality we encounter via the eye.[16] However, it remains to be determined whether this "acid attack" on our perceptual processes includes the expulsion of the imagination.

According to Wartofsky the 'hidden or tacit presupposition that the camera "sees" what we would see, were we present' is the most deceptive piece of "knowledge" we can take to any new observation.[17] In our enthusiasm for the so-called objectivity of the photograph, we often forget how narrow and abstracted its field of vision is. The

photograph is a tenuous representation ripped from an infinite continuum of reality: it is fragmented and incomplete. Furthermore, the transgression of normative vision via technology leads to an aura of fascination surrounding the photographic image and distracts us from the fact that the very process of taking a photograph conceals as it simultaneously reveals.[18] In effect, the photograph entirely alters the context in which we see the object and yet we continue to equate the way our eyes work with the workings of the camera.

This shortcoming of photographic representation was conveniently overlooked in the early days of space exploration. The fascination with what the technology could reveal completely overshadowed what it left out. In 1946, the United States Army launched the third of a number of German V-2 rockets that had been captured during World War II. On board was a 35mm motion picture camera that made a continuous record of the rocket's journey: from the ground, through the atmosphere, into "outer-space" at an altitude of approximately 65 miles (just under 105 km), and then back down again. The pictures revealed just a thin slice of the Earth's cloudy surface, not an entire globe. Compared to today's satellite technology, this rocket-propelled photographic mission may seem rudimentary.

Figure 2. The first view of Earth from space from a camera on V-2 #13, 24 October 1946, (White Sands Missile Range/Applied Physics Laboratory).

Figure 3, The first television image of Earth from space showing a sun-lit area of the Central Pacific ocean, Project Explorer VI, 14 August, 1959, (NASA)

Figure 4. Half-disk mosaic image of Mercury, Mariner spacecraft, 1974, (NASA).

However, this image (fig. 2) provided us with a glimpse of something we had never seen before, something that prior to the camera (and the rocket) had lain beyond our capacity to represent: ourselves. Here was a powerful example of the capacity for technology to reveal the unseen, devoid of any human or subjective intervention.

Suddenly, the military were thinking about what they might be able to see, not just shoot. In 1957 the Russians sent up Sputnik, but it was not equipped to take photographs. In response, the USA rushed out Project Explorer in 1958. Three satellites and only one year later, Explorer IV took the first television images of the Earth from space (fig. 3) and the potential for space-borne cameras to see what we could not was realised. The newly formed NASA immediately identified the technology's potential for meteorological studies and the Department of Defence was keen to explore any military applications.

This prompted President Johnson to say at the time: 'Without the satellites I'd be acting by guess or and by God. But I know exactly how many missiles the enemy has'.[19] He didn't need to imagine anything, let alone use his own eyes: the satellite eyes showed "everything". In his enthusiasm for this new-found omnipotent view Johnson turned a blind eye to the fact that technologically mediated images can only provide selective access to unseen realities, restricted as they are to the very mechanism with which they reveal: the frame. The fragment of the Earth's surface revealed by a camera atop a V-2 or an orbiting satellite is just that: a fragment. President Johnson may have thought he saw all the enemy's missiles, but no doubt "God" still had a better view.

One method of getting around the fragmentary nature of the photograph is to bring the pieces together in order to make a greater whole. In the days of pre-digital, unmanned space exploration just such an approach was necessary if high-resolution images of large bodies such as planets were to be obtained. Individual photographs had to be manually stitched together to form mosaics such as Figure 4, a half-disk mosaic of Mercury, comprised of images taken by NASA's Mariner 10 spacecraft in 1974. Here, each raw image is clearly visible and no attempt has been made to hide the fact that the image is incomplete. Each image seems to maintain its individual integrity, as it simultaneously becomes more than itself. In this case, I use my imagination to see beyond the individual images, beyond the errors in contrast or brightness, beyond the evident borders between one image and its neighbour. As viewers we actively participate in the act of deception that the mosaic asks us to complete internally, beyond the

Figure 5. The Orion Nebula (M42) as imaged by the Hubble Space Telescope, (NASA, ESA, M.Robberto [ESA/STCCI] and the HST Orion Treasury Project Team).

picture plane itself. Within the internal space of our imaginations the incomplete, patchwork image of Mercury becomes unified and whole.

Today, the Hubble Space Telescope takes multiple images in order to superimpose them into one, "complete" image. It is tempting to think that what one sees in an image produced by Hubble is the raw "reality", but this is not generally the case – or at least, not what is released to the public. As is clearly stated on the Hubble website,

'Hubble images are made, not born. Images must be woven together
from the incoming data from the cameras, cleaned up and given
colours that bring out features that eyes would otherwise miss'.[20]
Evidently, when it comes to seeing the unseen, too much is at stake to
rely on physics alone.

One full-colour Hubble image, such as Figure 5, begins as seven
black and white images from three different cameras. Each image
is scaled and aligned in photo-editing software before data gaps and
other errors, such as dropped pixels, are filled in with information
from another camera. Each image is then assigned a colour, and
when combined they make a single, full-colour image. Because
the final image is comprised of photos taken on the very edge, or even
outside the visible spectrum, they contain aspects of reality that we
would never have seen with our own eyes. To reveal these features
– and show us what we might see if we could see beyond the visible
spectrum – red, blue, or green are assigned to specific images: blue to
those from short wavelength filters, red to those from long wavelength
filters, and green for those in the middle.[21] The resulting images have
little to do with what our eyes would see had we been present. Rather,
they are complex models, riddled with subjective choices that render
them just as much art as science. These images are truly revelatory,
truly fascinating, and truly transgress any sense of normative vision,
whatever that normative vision may have been. These images
have moved away from any original connection to an external reality
and have become heavily layered constructs. No longer a trace
of nature, these images are the visual equivalent of theatrical
performance, all made-up and set for the stage which, in this case,
means the Hubble website, coffee-table publications, and a vast
array of printable merchandise.

As visually attractive as these images may be, they successfully
deflect any attempt by the imagination to add to their visual presence.
Casey's "proliferation of unforeclosable possibilities" has been well
and truly foreclosed. The construction of these images requires a great
deal of subjective choice, but not by the viewer. In this case, all the
imagining is done before we even get a glimpse at that nebula, galaxy,
or star cluster. Once again everyday vision has been transgressed
by a technologically mediated version and we are left blinded by
fascination and a post-production "pop" aesthetic. And yet, there
remains one imaginative possibility: the idea that something this
spectacular and alien to our everyday experience can exist – out there,
somewhere – in a non-locatable space which can only be verified by

the eyes of a distant machine. The possibility of the object, as implied by its photographic image, is therefore interred within the equivalent non-locatable space of the imagination.

Bringing it Back

The majority of our internal image of the Earth from space has been constructed by hand-held photography conducted by NASA astronauts. Since NASA's Gemini program of the late 1960s, astronauts have been extensively trained in Earth-observation including landmark location and colour matching through the use of photographs. And yet, despite such training astronauts are literally left speechless when actually faced with the Earth slowly spinning below them in real-time.[22]

As I have explored in previous work, the gap between what astronauts see and what they have been prepared to see, via photographs, is vast.[23] It appears that their visual schema of the Earth from space, developed through the use of photographs without first-hand visual knowledge of the referent, is somehow inadequate. This visual incongruence seems to prove Wartofsky's theory that 'we are saddled with a model of human vision based on the notion of pictorial representation', expecting that the reality we encounter, particularly if we have not already seen it with our own eyes, should look like its photographic counterpart.[24] In this case, the reality of the Earth from space is found to be more spectacular, more beautiful, more luminescent than any photograph could ever portray.

Astronaut Andrew Thomas spent a considerable amount of time looking out the window and taking photographs when he completed his residency aboard the Mir Space Station in 1998. Although all Earth-observation photographs are ultimately of scientific value, Thomas' primary reasons for taking the photographs were as a personal record of his journey, expecting that the photographs would allow him to return to that moment arrested within the frame.[25] In this case, the photographs fell remarkably short of what Thomas saw and experienced and so he decided to draw. The process of drawing allowed him to mentally escape the confines of the spacecraft and to explore things he 'could not photograph, but could only imagine', making them 'much more unique than any photo' and a more accurate representation of his time in space.[26] Within his drawings, Thomas was able to imaginatively attend to what he felt was hidden or absent from the photograph, left free to engage subjectively with the view from the window and thus to create a personal record.

The astronaut-photographer in the pursuit of quality Earth observations, very carefully avoids subjectivity and the potential for "error" with which it is associated. Over the years, the technique of taking photographs in space has been gradually perfected; from John Glenn's drugstore-purchased modified 35mm rangefinder in 1962, to the Space Shuttle's "workhorse", the Hasselblad; and finally to today's Nikon digital cameras.[27] The likelihood of aberrations, such as motion-blur and sun-glare is minimized by carefully following pre-established photographic procedure. Margins of error for all variables are taken into consideration: obliquity (look angle); lens optics (primarily focal length); spacecraft altitude; film type, and high-contrast objects. Also, the conditions of space-flight photography make getting a blur-free photograph challenging. The astronaut-photographer on the Space Shuttle floats in near zero gravity, attempting to point the lens of the camera through a small viewing window at a slowly rotating target and around which they orbit every 90 minutes. However, even this has been carefully minimized by astronauts on the International Space Station who have learned to use feedback from their digital cameras to track the moving Earth below as they take their photographs.[28] In short, all "extraneous" phenomenological and experiential data has been filtered out in the pursuit of image clarity and the highest resolution possible (currently a spatial resolution of under six meters). The result is a body of beautiful, informative but essentially homogeneous photographs that disclose little of the phenomenological experience of seeing the Earth from space (fig. 6). As Thomas said when he first viewed his own photographs of Earth, "Anyone could have taken them" because any mark of the maker has been eradicated by uniform technical process.[29] For Thomas, without any mark of his making – erroneous or otherwise – any attempt to imagine himself back into the image, to rebuild his phenomenological experience, was thwarted.

As photographers, astronauts are at the mercy of NASA training, procedures that are designed to get the best photographic observations possible. However, as astronaut Marsha Ivins once explained, there was nothing in her training that prepared her for the sight of the Earth as seen from the unique vantage point of the Space Shuttle.[30] One look at the real thing revealed that the disparity between photograph and reality was immense. But this mismatch goes much deeper than the surface of the photograph. In this case, the photograph provided the astronaut with an incomplete schema or model, a broken code.[31] Bruno Latour reminds us that the Latin origin of the word

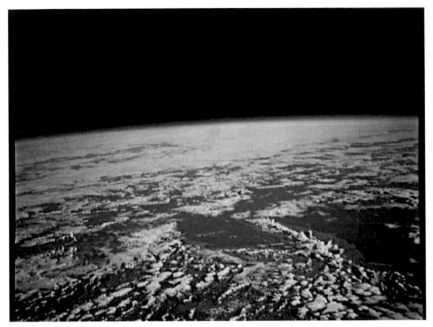

Figure 6. Earth as photographed from the Space Shuttle, STS-77, (Image courtesy of the Image Science & Analysis Laboratory, NASA Johnson Space Center).

"reference" is *referre*, "to bring back".[32] If the schema is the point at which representation and observation meet in the feedback loop of perception, here we find that what has been brought back by the photograph is somehow incomplete or corrupt. The photograph has become a fraudulent "ready-made" whose feedback to the referent has been prematurely halted, effectively circumventing the productive process of imaginatively adding to an initial schema. Photographs of the Earth from space can never hope to provide a window on reality. The gap between what the astronaut knows and what the photograph presents will remain difficult to bridge.

The success of "making and matching" a representation to an observed object is dependent on the original choice of schema to be developed.[33] Without some sort of initial schema there is nothing to go on with, nowhere to look. Through the process of drawing, Thomas attempted an on-site upgrade of his deficient, internal,

schema. Unfortunately, Thomas's schematic upgrade was doomed to fail as, in order to draw, he resorted to working from video stills of the scene from out of the window. In doing so, Thomas was blind-sided by the two-dimensionality of the image plane – seduced by its flat abstraction – and no modification of schemata could take place. Thomas once again failed to make contact with the referent and became perceptually trapped into looping back on the same deficient schema he had all along.[34]

Photographic images of our home planet from space may stand on shaky schematic ground but they are all we have got to go on. They add, ever so gradually, to our collective schema of the Earth, contributing to the construction of our inner vision of space. However, if we continue to fall prey to the prevailing belief in photography's connection to the world, if we continue to see the world through the persuasive lens of pictorial representation, then we will be sorely disappointed. We must free the photograph of the Earth from space from its indexical responsibilities and begin the process of imagining an alternative.

The Moon Considered as a Model, as a Photograph: Occlusion and Imagination

The problem of an obscure referent is not a new one. In the early days of photography it was difficult enough to picture what could be seen let alone what could not. Photographic technology in the 19th century was complex and required lengthy exposures to produce an image. Clumsy processes hindered the translation of reality to image, particularly in astronomy where the photographer needed to account for the subtle movement of celestial targets across the sky without the aid of automated tracking systems. This often resulted in blurry images that lacked detail and were thus only useful, in scientific terms, to an observer already well accustomed to the sight of the "real" object through the telescope.[35] An extraordinary example of a "work-around" solution to this problem can be found in the lunar photography of Scottish engineer and accomplished amateur astronomer, James Nasmyth. In 1874 he published a book called *The Moon: Considered as a Planet, a World, and a Satellite*.[36] It contained extraordinary images of the Moon, that proved to be a curious blend of both knowledge and imagination (fig. 7). The crisp, clear and detailed images were produced after a process of careful telescopic observation and drawing combined with plaster modelling techniques

that Nasmyth had learned from his landscape-painter father. The intricate models of the lunar surface were then photographed in a manner intended to create the illusion that the moon depicted in the image was the same moon that Nasmyth had seen through the telescope. But of course, this is far from the case. Due to the technical difficulties mentioned above, Nasmyth could not provide the viewer with the perfect view of the Moon as he had seen it because the referent was occluded by the very process that sought to expose it. Instead, Nasmyth arrived at the clever solution of shifting the photograph's indexical relationship from the referent to its model. These complex images ask that the viewer do several things simultaneously. One is to accept the plaster model moon in place of the actual Moon, not merely to acknowledge the model as a stand in but to allow the viewer's imagination to convince them of the model's status as the real Moon. The success of this unspoken contractual arrangement between viewer and representation is aided by the fact that this representation is presented as a photograph, in particular, a 19th century photograph at a time in which the veracity of the photographic image was as yet unchallenged. Boosted by such faith in the photograph's capacity to render reality truthfully, Nasmyth was able to ask the viewer to use their imagination to traverse the distance between the copy and the real. But, here lays a double deception with both model and photograph claiming an indexical relationship to a reality that quite simply remains out of sight. In this way, Nasmyth's photographs of the lunar surface provide the viewer with a veritable "babushka doll" of indexical relationship: a Moon, inside a model, inside a photograph. The resulting photographs become the encoded presence of dual realities: the moon that Nasmyth saw through his telescope with his own eyes and the one that he asked us to forge within our imaginations, and which is truly more than the sum of its parts.

Nasmyth's curiosity about the Moon extended to its geological formation. In order to help describe the various processes that Nasmyth thought might have formed the lunar landscape his book included images such as the wrinkled back of a hand, a shrivelled apple, and a cracked glass orb (fig. 8). In this way, Nasmyth could ignite a chain of analogous, visual relationships within the imagination of the viewer and any indexical relationship between photograph and object is forced to take second place. It is upon this potentially infinite string of association, that the viewer constructs knowledge of the Moon, from a cracked glass orb to the cratered lunar surface. Any recourse to indexical relationships, in this case, would

Figure 7. Lunar craters as modelled and photographed by
James Nasmyth, The Moon: Considered as a Planet, a World,
and a Satellite, 1874 (second edition 1885).

PLATE XVIII.

"Woodburytype"

GLASS GLOBE
CRACKED BY INTERNAL PRESSURE
ILLUSTRATING THE CAUSE OF THE BRIGHT STREAKS
RADIATING FROM TYCHO.

Figure 8. A photograph of a cracked glass orb as analogous reference
to the geological forces that shaped the Moon, James Nasmyth, The Moon:
Considered as a Planet, a World, and a Satellite, 1874 (second edition 1885).

be a meaningless transgression. Indeed, analogy – as Barbara Maria
Stafford points out – is a process of connecting the disparate.

> It is the proportion or similarity that exists between two
> or more apparently dissimilar things: like the tensile harmony
> that Parmenides maintained fitted together fire and earth,
> or Empedocles believed conjoined love and hate, or Anaxagoras
> thought tied the visible to the invisible realm.[37]

Nasmyth thus takes his lead from Anaxagoras and reveals geological
forces that we shall never see, via the photographic image of an
everyday and accessible object. Our knowledge of the processes that
shaped the lunar landscape is thus forged within the intermediary
space of the imagination as it hops from image to image, from the seen
to the unseen.

Mikael Pettersson has recently explored the relationship
between the seen and the unseen, and the role the imagination plays
in traversing the two, in relation to Richard Wollheim's theory of
pictorial "seeing-in".[38] According to Wollheim's theory, we undergo
a twofold perceptual process when we look at an image: we see the
content/subject of the image but also the medium/surface in which it
is presented.[39] For example, when I look at Nasmyth's cracked
glass-orb, I see the orb itself but I simultaneously see that it is printed
on paper. Because of this twofold process, we are not always able to
say exactly "where" we see the picture. Pettersson takes this further in
an exploration of how visual occlusion or quasi-occlusion within
an image (for example, one object obscuring another, a cat with its
tail behind) can lead to a non-localized experience of seeing-in or what
he describes as a "non-localized pictorial experience".[40] By this, he
means a perceptual experience that is "seen" in the non-locatable
and intangible space of the imagination. In short, when an element of
an image is occluded from our vision it is our imagination that fills
in the gaps.

However, let us take this proposition one step further again.
What if we accept the photograph as a total visual occlusion? For
Vilém Flusser, the photograph itself blinds us to that we wish to see,
putting itself in front of the object. In his eyes, "technical images"
such as photographs are not windows on reality, but 'computed
possibilities (models, projections onto the environment)' that have
no indexical relationship to the world.[41] He refers to a kind of
"programming imagination" (*Einbildungskraft*), one that is capable

of recognizing that, although 'the last vestiges of materiality are attached to photographs, their value does not lie in the thing but in the information on their surface'.[42] The examples I have examined thus far would seem to correlate such a proposal and espouse the concept of photograph as simultaneously an occlusion – to an a priori, external reality – and a threshold to an infinity of possible realities of the mind. Photographs ask that we accept their encoded surface in place of the real, diverting our line of sight and blocking access to the external reality we so desire. They simultaneously occlude what they present, literally arresting our gaze as we attempt to "see in" to the reality of the image. This occlusion forces us to internalize the image and thus render the world imaginable. Each image we encounter, each occlusion, adds to an internal mosaic of our subjective reality as imperfect and as incomplete as the 1968 image of Mercury.

Fragments, Torrents, Models

The contemporary experience of images – in particular, the photograph in all its diversity – is such that we have a myriad of images upon which to draw, in order to fill any gaps in our direct experience of the external world. Reality itself has become fragmented by pictorial duplication, dispersed amongst what Siegfried Kracauer once described as a "blizzard", a blizzard that has now well and truly become a "torrent".[43] In order to see anything nearing a degree of totality or wholeness, we must adapt, casting aside our craving for the assurance of a concrete reality reinforced through the relentlessly monocular view of the traditional perspectival, isolated image. To truly perceive the unseen, we must discard our normative vision and trust in the eyes of the machine to provide, not a link to a traditional reality but the code – the fragments, the model – from which we are to build our own. By shifting the angle of our viewing, by bringing images together within our imaginations, we just might find that they can provide more than the sum of their parts. Just as two images taken from slightly different angles can be combined to realize a three-dimensional image, so too can a more holistic "vision" of reality be achieved by the imbrication, layering, and interposing of images in the non-localized zone of the imagination.

Photography is now as difficult to define as it is to contain; its practices are fluid and its physicality near to invisible. As the blizzard of the 1920s became the image torrent of today, a subtle shift occurred in how we use photography to relate to the external world. Artist

Penelope Umbrico recently went so far as to state that the 'image torrent is actually alive, emergent and perhaps more indexical than photography has ever been in the past', and that all images 'function as a collective visual index of data that represents us – a constantly changing and spontaneous auto-portrait. The index has shifted from visually descriptive truth to accumulative visual data'.[44] We now construct our concept of reality upon this accumulated visual data, each fragment of information scaled and aligned by the editing software of the imagination.

We may never see Earth's blue disc from space with our own eyes but we can construct our own perception of this, via a multitude of images presented to us in both print and electronic form. Personally, I have often wondered what it might have been like to be NASA astronaut John Glenn when, in 1962, he became the first American to orbit the Earth and the first human to take photographs of its surface. I wonder what aspects of the reality of that journey are not brought to me via the photographs and the films; what truths remain untold, what parts remain unseen in the gaps between the images. The photograph can no longer hold us with naïve realism; no longer tempt us with the seductive powers of positivism. Instead, the photograph reveals the world in a manner akin to the best form of striptease: always leaving something on, always covering what the eye desires and therefore leaving the rest up to our imaginations (fig. 9).

The photograph may bring us the world in pieces, but it is via the photograph that we are able to "imagine" ourselves into a broader field of reality. The photograph can only ever be a surface of code, a model – plaster moon or otherwise – a sketch, a *non-finito*, or a fragment. We add to this seductively incomplete rendering of reality with our own experience, drawing on existing schemata, other images, and visual impressions to construct an unseen reality within our minds. In some cases the foundations upon which we build these internal impressions may be shaky, our visual schemata may be lacking and this is a problem inherent in any concept of reality based solely upon the photograph. To use the parlance of space image processing: there will always be "data gaps" or "hot" or "dropped" pixels. However, it is in these inconsistencies, absences, and occlusions that we find the potential to see through the eyes of the machine in a truly imaginative and human way.

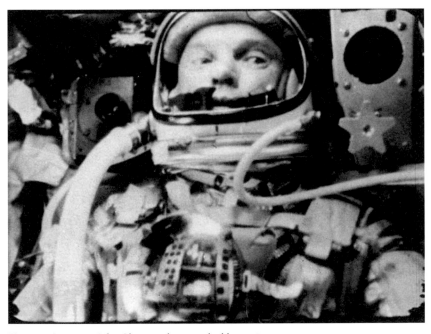

Figure 9. Astronaut John Glenn as photographed by a 16mm
motion picture camera on board Friendship 7, 1962, (NASA).

Notes

1. Susan Sontag, *On Photography* (New York: Farrar, Straus & Giroux, 1973), 119.

2. See: Alan Trachtenberg (ed), *Classic Essays on Photography* (New Haven: Leete's Island Books, 1980).

3. Bruno Latour, *Pandora's Hope: Essays on the Reality of Science Studies* (Cambridge MA: Harvard University Press, 1999), 29.

4. See, for example: Lorraine Daston & Peter Galison, *Objectivity* (New York: Zone Books, 2007); also: Ron Giere, *Scientific Perspectivism* (Chicago: The University of Chicago Press, 2006).

5. *Australian Concise Oxford* (1995).

6. Edward S. Casey, *Imagining: a Phenomenological Study* (Bloomington, IN: Indiana University Press, 1976).

7. Ibid., 10-20.

8. Ibid., 19.

9. Ibid.

[10.] It should be recognised that Sartre constructed a similar argument in his comprehensive work 'L'imaginaire'. See Jean-Paul Sartre, *The Imaginary: a Phenomenological Psychology of the Imagination*, trans. Jonathan Webber (London: Routledge, 2004).

[11.] Wilfred Sellars, cited in Paul Coates, 'Perception, Imagination, and Demonstrative Reference: A Sellarsian Account', in Willem A. DeVries (ed), *Empiricism, Perceptual Knowledge, Normativity, and Realism: Essays on Wilfrid Sellars* (Oxon: Oxford University Press, 2009), 69.

[12.] Ibid., 96.

[13.] William Gilpin, cited in Wendelin A. Guentner, 'British Aesthetic Discourse 1780-1830: the Sketch, the Non-Finito, and the Imagination,' *Art Journal*, Vol. 52, No. 2 (1993), 43.

[14.] Ibid.

[15.] Don Ihde, *Postphenomenology: Essays in the Postmodern Context* (Evanston, IL: Northwestern University Press, 1993), 43.

[16.] See: Marx Wartofsky, 'Cameras Can't See: *Representation, Photography, and Human Vision*', *Afterimage*, Vol. 7, No. 9 (April 1980), 8-9.

[17.] Ibid., 8.

[18.] Ihde, *Postphenomenology*, 47.

[19.] Beaumont Newhall, *Airborne Camera: The World from the Air and Outer Space* (London: The Focal Press, 1969), 115.

[20.] Hubblesite, *Behind the Pictures* (2012), available at: http://hubblesite.org/gallery/behind_the_pictures/ [accessed 24 October 2012].

[21.] Ibid. http://hubblesite.org/gallery/behind_the_pictures/meaning_of_color/ [accessed 20 June 2013].

[22.] See: Colleen Boyle, 'The Artist and the Astronaut', *Meanjin: Fine Writing and Provocative Ideas*, Vol. 59, No. 3 (2000), 201-210.

[23.] Ibid. See also: Coleen Boyle, *Resolution: the Photographic Images of NASA*, (unpublished Master of Arts thesis, The University of Melbourne, 2000).

[24.] Wartofsky, 'Cameras Can't See', 8.

[25.] Andrew Thomas, personal communication, 20 November 1998.

[26.] Ibid.

[27.] See: Boyle, 'The Artist and the Astronaut', and Douglas A. Vakoch (ed), *Psychology of Space Exploration: Contemporary Research in*

Historical Perspective (Washington DC: National Aeronautics and Space Administration, 2011), 81-85.

28. See: About.com Space/Astronomy, International Space Station Astronauts Set New Standard For Earth Photography (2002), para. 5, available at: http://space.about.com/od/livinginspace/a/astronaut_photo. htm [accessed 29 October 2012].

29. Thomas, personal communication, 20 November 1998.

30. BBC Productions, 'The Human Body', screened 20 May 1998.

31. Boyle, 'The Artist and the Astronaut'.

32. Latour, *Pandora's Hope*, 32.

33. E. H. Gombrich, *Art and Illusion* (London: Phaidon Press, 1962), 331.

34. Boyle, 'The Artist and the Astronaut', 209.

35. See: Frances Robertson, 'Science and Fiction: James Nasmyth's Photographic Images of the Moon', *Victorian Studies*, Vol. 48, No. 4, Summer 2006, 595-623.

36. James Nasmyth, *The Moon: Considered as a Planet, a World, and a Satellite* (London: J. Murray, 1874; Reprinted on demand by Memphis: General Books, 2011).

37. Barbara M. Stafford, *Visual Analogy: Consciousness as the Art of Connecting* (Cambridge, MA: MIT Press, 2001), 8.

38. Mikael Pettersson, 'Seeing What is Not There: Pictorial Experience, Imagination and Non-Localisation', *British Journal of Aesthetics*, Vol. 51, No. 3 (2011), 279-294.

39. Richard Wollheim, *Art and its Objects* (Cambridge: Cambridge University Press, 1980).

40. Pettersson, 'Seeing What is Not There'.

41. Vilém Flusser, *Writings*, ed. A. Ströhl (Minneapolis: University of Minnesota Press, 2002), 129.

42. Vilém Flusser, *Towards a Philosophy of Photography* (London: Reaktion Books, 2000), 51.

43. See: Siegfried Kracauer, 'Photography', in *The Mass Ornament: Weimar Essays*, trans. & ed. Thomas Y. Levin (Cambridge MA: Harvard University Press, 1995), 47-64.

44. Penelope Umbrico et al, 'Photography Now', *Art in America*, No. 3, March 2012, 79-82.

13

The Spinning Index: *Architectural Images and the Reversal of Causality*

ADAM BROWN

Introduction

IN CURRENT ARCHITECTURAL practice, visible traces of digital production represent a key trope, signifying technological advancement, and thereby historical progress. In James Bridle's bang-up-to-date formulation of the "new aesthetic", the defining feature of the trend he identifies in design, architecture and imaging is 'the eruption of the digital into the physical world', the foregrounding of the material trace of computer generation via pixilation, artefacts or other signifiers.[1] In the context of such a statement of faith in an unproblematic notion of progress, it is worth pointing out that probably as many projects exist which use digital construction and visualization technologies to reference historical architectural or cultural traditions. In both cases, such technologies could be argued

237

to facilitate the production of *signification* as much as completed architectural structures. In this light, it is irrelevant as to whether a new, digitally facilitated construction project conforms to the "new aesthetic" or the "neo Georgian" – what is specifically "new" is the radical acceleration and streamlining of the chain linking concept, image and realization. The pixel is an artifact which emerges specifically from the realm of digital imaging, as opposed to construction.

It could be claimed that the digital revolution represents the final cutting loose of the mechanisms of production and distribution from local and social circumstances. Virilio's argument, in *Speed and Politics*, is that it is precisely this speed which separates producer from consumer: digital practices accelerate the movement of capital and commodity beyond the speed of critique.[2] In Virilio's globally militarized society, production usurps the place of debate: a war machine needs to mobilize and fortify regardless of local opposition. Indeed, certain recent architectural structures arise with about as much local consultation as an army sequestering temporary barracks – the recent labelling of certain architectural agencies by Michael Speaks amongst others as evidential of a "new pragmatism" – such as the practices of Rem Koolhaas and Foreign Office Architects – is precisely in response to this will to build.[3] In such cases, digital technologies are central to both the acceleration and complexity of processes of conceptualisation and realisation. Overwhelmed by the complex beauty of shiny new technologies Bridle views Koolhaas as an autonomous agent who constructs prominent symbols of an exciting stylistic trend, not the *collective* which collaborated with the government of Beijing to clear the long established and culturally vital Hutong districts to make way for the CCTV building.[4] Later, the links between militarisation and architectural fantasy will be explored in reference to specific projects.

Speed, of course, is a vector function which can be defined as movement through space over time. For Virilio 'the speed of light does not merely transform the world. It becomes the world'.[5] Extrapolating Virilio's thesis, it is possible to claim that, in certain key circumstances, time can be said to move *backwards*, as if it is the pixel, not the quantum particle, which possesses the ability to move faster than the speed of light.

This hypothesis – in relation to architectural as well as other forms of photographic imagery – is only viable if the digital image is considered to be an assemblage of both material and discursive

elements. If the image arrives at its intended destination ahead of the circumstances which the receiver, in consensus with others, considers to constitute its genesis, then time travel is achieved. In the case of the urban development of Kamengrad/Andricgrad, interrogated below, a digital construction pre-empts the resolution of a contested territorial claim in favour of one ethno-cultural group. In another example, that of a speculative residential project in London, complex digital renderings are deployed to signify a referent that is not yet there, in order to increase the likelihood of the project coming into existence. A critical perspective on such projects makes it theoretically possible to reverse the direction of the causal sequence which gives rise to the indexical sign. Such a paradoxical formulation of indexicality arises in relation to the generation of certainties – in the form of social consensus, market conditions or constructions of identity – in advance of their reification in the form of physical entities – images, buildings, states. Rosalind Krauss provides a succinct summary: 'indexes establish their meaning along the axis of a physical relationship to their cause. They are the marks or traces of a particular cause, and that cause is the thing to which they refer.'[6] The function of the trace, or the existence of things that appear to be traces, in the digital production of space, serves to indicate a point of agreement, a constructed truth.

In the following interrogation of such images, it becomes clear that, *pace* Virilio, the acceleration of production relative to critical attention is part of the function of the technologies deployed in their manufacture: their development and dissemination could be viewed as a form of *de facto* deregulation of planning and consultation processes by means of automation. Koolhaas's structures in Beijing are a case in point. Furthermore, the development of new software/hardware assemblages which subsume visualization and construction processes on a single platform is indicative precisely of a new understanding of the role of reception in the process of production. The journey of building from desire, to model, to construction, and finally to occupancy, can finally be said to mechanize not only the processes of modeling and building, but also the positioning of the architectural structure as object of desire. In the process of spatial construction, taken as a whole, desire and reception are arguably the most important stages in a cyclical movement, as the following examples are intended to demonstrate.

As imaging and construction technologies advance, it similarly becomes possible and necessary to apply the tools of critical

enquiry through the entire process of construction. In a sense, the "imagification" of architecture, the notion that 'architecture has now entered fully into the realm of the new communications and entertainment industries' opens up the possibility of the deployment of critique derived from contextual examination of the image to all stages of the construction process.[7]

Time Travel on the Installment Plan: Highbury Stadium, London

It is not the development of the architectural mega-project which brings these issues into relief, but the multitude of smaller, speculative building projects which arose in the full heat of the property-fuelled boom of the Noughties. It is in this historical context that the technologies in question were developed and refined, and their spread was not principally due to their uptake by specific high profile architects, but their dissemination amongst the global speculative construction industry. The true nature of the financial relationships underpinning this industry is outlined by, amongst others, Wouter Vanstiphout, who remarks on the relationship between speculative building in Dubai, and the alienated flow of capital, which can lead to speculative structures generating more money unoccupied than occupied – in which case, the building functions perfectly well as sign, entirely cut free from functions of occupancy or use.[8] As Marshall Berman predicted, it becomes a pure unit of exchange value.[9]

As an example of the reception of such a building-as-sign, it is pertinent to begin with a speculative building project in London: the redevelopment of Highbury Stadium, formerly a football ground, retaining its form in the process of redevelopment – subject to conversion into dwelling units, and the famous pitch having undergone landscaping of a formal nature. The redevelopment process commenced in 2000, with the submission of a redevelopment plan to Islington Council, and the commissioning of developers Vision Four and architects Allies Morrison to oversee the project. The first of the units hit the market in October 2005, and 90% of apartments were pre-sold by 24th August 2008.[10] The project was officially opened by Arsene Wenger, manager of Arsenal Football Club, on 24th September 2009, the timeline of the project thereby bridging the crash of September 2008. The choice of a project which so neatly bridges this Rubicon would appear to be fortuitous (fig. 1).

The Highbury development mobilises issues of multiple histories, the city as playspace and a curious rotation of the architectural gaze.

Figure 1: Rendering of the pitch at the Highbury Stadium development, which has been turned into a formal garden (designer: Christopher Bradley-Hole)

Significantly, the development in question was originally conceived as a site of spectacle. Looking at visualisations of the interior private garden which will take the place of the pitch, and to which the public will only be admitted by the retention of a right of way along one side, one can map a complex relationship of views. From each of the flats surrounding the pitch, owner-occupiers will be able to gaze over this view in a perverse reconfiguration of the panopticon. The importance of this central visual feature to the appearance – and hence the value – of this development depends upon preservation of the spectacular function of the pitch. Such a spectacle subsumes desire, self-projection, and identity in a complex mesh the psychology of which could be the subject of another paper. From the terraces formerly tribalised by fans, the new cadres of owner-occupiers survey their property in an architectural configuration that places itself and its inhabitants centre stage. It is like the set of Rear Window turned inside-out, only with the residents in doubt as to whether they have witnessed a murder, a goal or a rise in the market value of their investment. The communal experience of the stands has been replaced by the individual, sound-insulated living unit, and the crowd now watches itself with a peculiar narcissistic gaze.

As the new occupants move around the central garden, unless they
slip into one of the carefully designed bowers which allow a degree
of privacy (and which are modeled on Arsenal's famous tactical
maneuvers on the field of play by designer Christopher Bradley-Hole),
they are fully under the gaze of their neighbours, who can presumably
deduce the rising or falling value of their investment based on
the kinds of people they identify. Residents take to the pitch as
players, in the idiomatic sense of having had the nous to make a
canny investment.

Unusually for an English residential property, for which the
desire not to be overlooked is a key consideration, Highbury stages
the act of overlooking and the condition of being overlooked by
retaining the form and foregrounding the iconic status of the site.
This cleverly elides negative connotations of intrusion and curtain-
twitching by preserving the spectacular function as a key element
of the building's form.

Tracing the Details

Exploring the techniques exploited by the producer of the renderings
to create this impression of a possible reality, one key feature is
the introduction of elements which are introduced after the
form is finalised. Trees, people, commodities and other details are
added which generate an impression of completion (fig. 2).

The visualisation deploys an array of details, without which
the image itself would fail to signify potential habitability. Even the
clean lines of contemporary architecture and interior design need
interruption and texture to function as traces (or in this case
pre-traces) of occupancy. Such details *stuff* the image, deploying
a version of the "reality effect" identified by Barthes in relation
to literary form, by introducing the impression of plenitude from
which each individual viewer can abstract his or her *punctum*.[11] In
this way, the image could indeed be regarded as a text, deploying
as it does a specifically literary device. The viewer is acknowledged
in the generation of fake chance events, features which have no
structural function. In alignment with Barthes' idea, such elements are
deliberately introduced into the "text" so that the viewer receives
the *sign* of indexicality, able to conceive either (a) that they are looking
at a possible real photographic image – an image "stencilled off a
future real", or (b) that the developer hassuch confidence –
and such competence – so as to have imagined every detail, to have

Figure 2: Rendering of interior courtyard, with trees 'flipped' 180 degrees horizontally, Highbury Stadium development, London 2005.

already preconceived all of the elements necessary to produce a habitable space.

The craft of the renderer is to create a simulacrum which is seamless – as is the conventional photographic image – but which allows for the substitution of the specific details introduced by the designer, with those arising from the desire of the potential purchaser. The viewer performs the operation of looking at an inhabited space and imagining it uninhabited. Paradoxically, the more the image exploits the appearance of the Real to generate interest and credibility, the more effectively the viewer can remove the traces of other (imaginary) people's actions from the image and replace them with their own, in a digital version of the forms of "staging" performed by real estate agencies to create a simulacrum of habitation in advance of property viewings: lifestyle as theatre.

The Pre-Trace & the Rotating Index

Digital imaging – and this category covers a range of technologies – is positioned somewhere between a depicted past and a projected future, but the rupture is not nearly so clear-cut. The causal chain of

visual production dictates that one can never *depict* the future, only generate projections. The "reality" of the future has not yet come into being from which an image can be stenciled according to the accepted trajectory of indexicality. However, in the production of renderings of future architectural projects, digital technologies *do* depict the future as if it existed already.

The purpose of such images is wholly to mobilise investment and assent for construction of the properties depicted, by the deployment of both form and content. They are designed to appeal to specific identifiable audiences: investors, purchasers, local authorities and media, for whom the issue of credibility – a truth function – is central, if differently inflected in each case.

It is possible to claim that in constructing an appearance of an existing lived reality, which previously arose from the camera's re-presentation of the trace of past circumstances, it has now become possible to speak of the trace of future events. With regard to property as commodity, the more believable such projected forms, the more capital may be invested, and the more likely it is that the depicted building will be constructed. Notwithstanding questions of transparent or deceptive intentions on the part of developer, architect or image-maker, an excess of signification becomes directly linked to the eventual existence of the building in that the more realistic it *appears*, the more likely it is to become reality.

Cross Platform, Crossing Causalities

One key aspect of these new technologies is their ability to merge on a single platform formerly distinct processes of architectural construction – imaging, costing, analysis and construction. Tor Lindstrand, in an interview by Heather Ring, remarks that '[the spreadsheet software package] Excel has had a greater impact on contemporary architecture than Rem Koolhaas, Zaha Hadid and Frank O. Gehry have managed together'.[12] Later in the same article, he enlarges on this point: 'the representation of objects as we see them and their measured description, two tasks that are conventionally distinguished in architectural drawing, will be shown to have been unwittingly, and in many respects mutually determined and transformed'.[13] The functions of recording, representing and projecting, once specific technical domains (perspective drawing, writing, engineering drawing), are now subsumed in one operation. For Vilém Flusser, this was already

implicit in the development of photographic technology:

> all apparatuses (not just computers) are calculating machines
> [...] the camera included, even if their inventors were not able
> to account for this. In all apparatuses (including the camera),
> thinking in numbers overrides linear, historical thinking.[14]

Via Flusser, it is possible to observe that it is digital photography
which ultimately reifies the core program of photographic practices,
as if the supercession of analogue technology by digital was the mere
stripping away of superfluous and restrictive elements, allowing
mechanisms of exchange, mediation and bureaucratisation to fully
realize themselves.

In 'Visualization and Cognition, Drawing Things Together',
Bruno Latour restores focus to the media in which scientific
observations are recorded: means of inscription, charts, data,
projective geometry, and industrial drawing.[15] The ability to record
multiple registers and fields of activity on paper or other portable
media confers agency on those with the ability to interpret them.
Latour considers two functions of the document: recording and
projection. Beginning in the apparently closed world of the laboratory,
in which recording media function as means of transcribing the
outcomes of causal processes – evidence which is temporally anterior –
he moves on to means of visualisation: engineering drawing,
projective geometry and economic forecasting.[16] On the flat surface
of the page, all these fields of operation come together:

> Industrial drawing not only creates a paper world that can be
> manipulated as if in three dimensions. It also creates a common
> place for many other inscriptions to come together; margins
> of tolerance can be inscribed on the drawing, the drawing can
> be used for economic calculation, or for defining the tasks to be
> made, or for organizing the repairs and the sales.[17]

Latour questions the supposed objectivity of laboratory processes
by insisting on the primacy of the record: in his early writing, which
radically remodels scientific method, he argues that experimental
design and its results become significant only in relation to
the situations in which they are deployed – the evidence emerging
from the lab is taken as proof, and the supposed objectivity
and repeatability of natural processes (the notion of which is a

development of the enlightenment split between "nature" and "society") becomes the Modern equivalent of the absolute authority of religious faith and the divine right of the monarch.[18]

The truth function of the photographic has its germination at this point. The camera itself could be described as a little laboratory, in which an experiment is endlessly repeated and its viability confirmed. Barthes himself is well aware of how, for photography to generate its specific force, one has to possess knowledge of the technical processes which give rise to the photograph. 'The first man, who saw the first photograph, (if we except Niepce, who made it) must have thought it was a painting.'[19] The difference between Niepce and this imaginary spectator is, of course, knowledge of the process by which the image is generated, the knowledge of which generates its referential power.

For Latour, 'a present day laboratory may still be defined as the unique place where a text is made to comment on things which are all present in it.'[20] By extension, such a text could indeed take the form of a positive review in an architectural journal, a contract or an entry on an accountant's spreadsheet, which in its turn could lead to future construction. This gives a contrary spin to Flusser's notion that a camera is a direct product, and the photographic image an indirect product, of scientific texts.[21] For photographic theory after Latour, (or indeed Deleuze) anything definable as a *product* is simply an assemblage located within a circulating network of forces, some able to be described as "material", some as "social". In such a circulating system, the accepted order of causality is scrambled, and the continuous restless redrawing of the network is a function of the forces that animate it from inside and outside. The accretion of previously distinct processes of building design and construction on a single prototyping platform merely represents the coming-to-maturity of such an assemblage. The "product" which is the contemporary software package capable of conflating these functions – Autodesk, Rhinoceros 3D amongst others – represents a new "thing", similar to a "camera", or a "stunning loft apartment": it gains the ability to signify in and of itself, and it acquires agency.

A Flag the Size of the Territory: Kamengrad

The final image interrogated here is taken from the published renderings of a project initiated by Sarajevo-born film director Emir (now Nemanja) Kusturica, on a peninsular location in the city of Višegrad.[22] Višegrad is located in the Serbian controlled territory

known as Republika Srpska, which was established as one of the two
entities of the newly partitioned Bosnia after the signing of the US/
EU brokered *General Framework Agreement for Peace in Bosnia and
Herzegovina* at Dayton in 1995. The partition is purely administrative
– Bosnia and Herzegovina is still a single state, albeit with a porous
internal set of borders separating the previously warring self-identified
ethno-cultural groups into their respectively cleansed zones.

Kamengrad is significant for a number of reasons: it brings the
thread relating to the war machine full circle – for Virilio, the territo-
rial struggles in the Balkans represent signal examples of the symbiotic
development of information and military technology.[23] In describing
the alignment of American propaganda, military power and control
of information infrastructure in the Kosovo conflict, Virilio uses
the terms "total cinema" and "total dramaturgy" – describing a
cycle of psychological preparation via propaganda, the pursuit of
conflict by the deployment of sophisticated aerial weaponry, and the
control of the dissemination of images of the conflict itself.[24] The
Kamengrad project achieves these goals simultaneously – it functions
as propaganda, it territorializes (and as we see later, demolishes),
and feeds its own representations back into the global field of
image exchange.

Kamengrad also presents a further twist in the notion of reverse
causality. If the deployment of *signs of the photographic* in the
marketing of residential developments generates capital in the form of
pre-sales, thus making the project more likely to become concrete, the
renderings of Kamengrad perform a similar operation by keying into
notions of statehood, the self-identification of a nation aligned to a
geographical location, and the importance of traces of past habitation
in a territory subject to the violent displacement of people over a long
period. In Kamengrad technology is deployed to territoralize and
reify a "state", a reverse operation to the radical deterritorialization
described by Virilio.

Bojan Aleksov writes tellingly of the construction of nationalist
monuments in Belgrade, focusing on the construction/reconstruction
of the Serbian Orthodox church of St. Sava, in the district known as
Englesovac.[25] The church was substantially designed in 1930 in a style
described as "Serbo-Byzantine", but has endured a tortuous process
of interrupted construction, falling prey to economic, political and
military circumstances. As Aleksov outlines, "Serbo-Byzantine"
is essentially a pastiche of medieval ecclesiastical styles, referencing
existing churches in Serbia, but also importantly in Kosovo.[26]

Architectural form is thus deployed to underline a territorial claim.
In Kamengrad, Kusturica is constructing a church with similar
referents: 'at the place where the small river connects to the big river,
you have a kind of church that will be designed as if it was made in the
Kosovo region 700 years ago.'[27]

Aleksov remarks how Serbian writer and poet Matija Bećković
recycled a well known communist era motto in support of the project –
"We are not building the Church, the Church is building us":

> Few remembered that some forty years earlier communist
> propagandists used the same motto in mobilizing the youth to
> volunteer their labor in the reconstruction and industrialization
> of the country. Their version was: "we are not building the
> railway, the railway is building us".[28]

The building exists as idea in order to generate assent and confer
a sense of identity. In the case of Kamengrad, the function of the
rendering is to generate the sense of a *fait accompli*, a sign of a pre-
sign. When Aleksov's article was published, in 2003, the St. Sava
church project had stalled due to economic circumstances in Serbia
proper – and at the time of writing it is still partially unfinished.
This paper therefore represents a pertinent (and thorough) critique
of a building that has had a longer and more significant existence
as idea than as bricks and mortar.

On June 18th 2011, the Serbian festival of Vidovdan, Kusturica,
internationally acclaimed film director (Underground, Black Cat
White Cat, The Time of the Gypsies), laid the first stone for the
construction of Andricgrad, which also possesses the alternative name
of Kamengrad (Stone City). This development project is intended to
form the backdrop for a future film based on the novel *The Bridge on
the Drina*, by Ivo Andrić, Nobel Prize winner and former resident of
Višegrad. The project will be funded to the tune of 15 million Euros by
the government of Serbia proper, with contributions from Kusturica
himself, and the government of Republika Srpska.[29] The funding
of the project is controversial at a time when a huge section of the
populations of both Serbia and Bosnia are living in dire poverty, but
has also been criticized for allegedly transgressing local regulations
relating to procurement.[30] Digital renditions of the new city quarter
show a church, a museum dedicated to Andrić, and the reconstruction
of a 16th century town square which will form the backdrop to the
movie. Kusturica has a track record in the creation of ethno-villages

in the construction of the wooden town of Kustendorf, also known
as Drvengrad ("wooden city"), on the border of Serbia and Bosnia.
The winner of the Phillippe Rothier Architecture Award in 2005,
Drvengrad hosts an annual film festival, and served as the backdrop to
Kusturica's 2004 film *Zivot je Cudo* ("Life is a Miracle").

Kamengrad is projected to come to completion in 2014 in a
location which in recent history has been the site of bloody territorial
struggle. In the turmoil of the wars in the former Yugoslavia, the town
of Višegrad and its surrounds was subjected to a program of ethnic
cleansing by Bosnian Serb forces and paramilitaries, amongst them
the notorious White Eagles, led by Milan Lukić, who was convicted in
2009 by the International Criminal Tribunal for the former Yugoslavia
(ICTY) in the Hague.[31] Over the course of 1992, more than 3000 men,
women and children were killed. Significantly, on Vidovdan 1992, 60
people were burnt alive in a house in Pionirska Street, by paramilitary
fighters under the command of Lukić. Serb paramilitaries are recorded
as having cut the throats of local residents and dumped their bodies
over the parapet of the famous Mehmet Pasha Sokolivić Bridge,
the town's most famous landmark, and a UNESCO designated heritage
site.[32] Over the course of the attack, the Muslim population of
Višegrad was virtually eliminated by murder or expulsion, and both
the town's mosques were destroyed. A town which was once ethnically
mixed, with a 60% Muslim population, is now almost wholly
composed of those who would define themselves as Serb, and remains
so to this day – those who were expelled have not returned, despite
the restoration of some traces of the city's Muslim heritage, and the
return of a very small number of former residents. Though the ICTY
has stopped short of using the term genocide, the events represent one
of the most clearly identifiable acts of etic cleansing in the history of
the Balkan conflicts of the 1990s.

However, this is not the history that Kusturica is hoping
to commemorate in his new "city", but the city of Višegrad as
immortalized in Ivo Andrić's nobel prize winning novel. The identity
of Andrić in relation to current Balkan formulations of ethnicity is
contested: throughout his life he lived in Croatia, Bosnia and Serbia,
and his novels chronicle the mixed ethnic and cultural history of
the region. Milorad Dodik, president of the entity of Republika
Srpska, at the unveiling of a statue to Andrić in the construction
site of Kamengrad on 28 June 2012, stated 'This stone town should
change the image of the whole municipality [of Višegrad] but also
send a clear message that Serbian people do not want to give up on

their great men.'[33] Kusturica and Dodik's efforts to claim Andrić as a
Serbian celebrity, and locate his memorial within Republika Srpska,
simultaneously identifies Andrić as a part of Serbian heritage, and
endows Republika Srpska with the ability to confer such an honour.
Essentially, the act of monumentalizing Andrić is mutually reinforcing.

Kusturica's published statements appear to make a claim
for Kamengrad as 'a city of peace and tolerance',[34] and yet in
uncritically enlisting the financial support and endorsement
of the governing entities and figures of Republika Srpska – in
particular its controversially nationalist president Dodik – prove
the opposite, by promoting the continued existence of an ethnic
enclave which was formed by the violent expulsion of its Muslim
population. In the absence of a thorough process of reconciliation
and reparation, Republika Srpska could be said to represent the
fulfilment of nationalist plans for an ethnic Serb state in Bosnia.
The commencement of construction on June 28th 2011 – Vidovdan
– is interpreted by both sectors of the community as a clear act
of triumphalism: the chosen date is loaded, grimly pitting the
commemoration of one set of victims of violence – the Serbs killed at
the battle of Kosovo Polje in 1389, who are commemorated annually
at Vidovdan – against another, victims of ethnic cleansing in Višegrad
in 1992. To the outside world, this is just a stone laying ceremony.
Locally, it is deeply symbolic.

Contemporaneous with the publication of the Kamengrad
renderings, local controversy erupted regarding the erection of a
monument to Muslim victims of ethnic violence at Višegrad. The
erection of the monument by organisations including Bosnian NGO
Cupria ("Bridge") and Women, Victims of War was the catalyst for
a legal action brought by local Serbian community organisations
over the use of the word "genocide" on the monument, a case which
found against the defendants, but which is under appeal.[35] Since the
inauguration of the monument in May 2011 it has been vandalized
by the erasure of the word "genocide" with white sticky tape. It is
significant to contrast the qualified but mainly positive international
reception which greeted Kusturica and Dodik's announcement,
with the lack of global reporting of these events. But then cenotaphs
never were a big feature of the entertainment industry.

In Višegrad, the origin of stone is significant. An online
tourist guide to the town coolly recommends a visit to the newly
reconstructed Emperor Mosque, yet claims that, as 'the original
materials (Biggar stone) were not used in the reconstruction, [...] the

mosque lost its original architectural value.'[36] Architectural integrity is in the eye of the beholder. Kusturica's original construction plan for Kamengrad involved the appropriation of stone from historical military monuments in Trebinje, remnants of the presence of Austro Hungarian forces in the time of empire. The process was under way, including the demolition of parts of the fortress, until his actions generated sufficient controversy amongst local residents.[37] Here, the destruction of traces of one historical narrative and the construction of another relate directly to the obfuscatory processes of digital construction. The provenance of the stone used in the construction of Kamengrad is not factored into the operations of the machine, but it is very much in the mind of its maker.

The notion of architectural form itself can be said to refer to an ideal physical state that a given structure will always aspire to, an ideal to which its condition under the effects of use or circumstances can be related, and that reconstruction will attempt to re-form. In relation to the image, M. Christine Boyer describes how:

> pictures and traditional architectural arrangements have come to be the standard by which many contemporary cityscapes are judged. Even though the city constructed in reality out of heterogeneous fragments and fortuitous juxtapositions is in fact alien to such formal and orderly scenery, the traditionalist conceives of this regulated re-presentation as an ideal return to the original, claiming that this replication of place is a fantastic duplication and perfect modeling of traditional compositional forms.[38]

Such stylistic reconstructions in no way represent the city's actual form – the city post-occupancy, hacked about, adapted and *detourned* by its occupants. As in the state architecture of Albert Speer, buildings constructed according to the primacy of form over occupancy fit into the category of the pre-ruin. In Speer's theory of ruin value, the architecture of a state deploys constructional principles – the use of stone being one – in order to decay aesthetically, anticipating its discovery in ruined form.[39] The digital "form" of Kamengrad could be said to be a representation of a *future pre-ruin*. Kamengrad's renderings are distinct from the photographs that will be produced of the site once construction is complete: they represent a proposal for a self-identified state's future remembrance of it's past – a constructive program for generating reminiscences untroubled by any complex

questions or dark passages. It is as if to say 'in the future, we will remember our past like this'.

In Kamengrad, the "reality effect" of the rendering plays its part, demonstrative of the will to build masquerading as the will to rebuild. The renderings are transmitted worldwide, and as with conventional photographic images wrenched from their context, the human narrative within which they come into being is elided, characteristic of the function of the reproduction of the image-without-text to obscure political history, as described by Barthes.[40] The absence of which they so tellingly speak – through the centrality of an Orthodox church to the layout of the site, the absence of balanced signifiers of a strong Muslim heritage, is legible only to those who know, or know of, the previous multi-ethnic, heterogeneous form of the city of which this cleansed digital construction represents a true ruin.[41] Vanstiphout remarks on how the absence of a minaret can be as significant as the presence of one:

> If it is true, as in Rotterdam for example, that the minaret of a mosque can be the focus of such a huge political effort to ban them, then the way that buildings look does have a political relevance. If people look at minarets in a political way, just as they look at the absence of minarets in a political way, then they look in a political way.[42]

There are no visible minarets in any of the published renderings of Kamengrad. Vanstiphout's argument foregrounds the importance of the politics of visuality in architecture and planning. With regard to the context of reception – *looking* – the photograph, the rendering, are as political as the photojournalistic image. In full awareness of the context of their production, the renderings of Kamengrad are as genuinely chilling as anything a war photographer could produce. It no longer matters whether the representation of human suffering features an identifiable human subject – human history can be read as powerfully from the architectural image.

Photographic representation can be claimed to both represent and anticipate form, whether it be photographic (the trace) or digital (the trace in reverse). The development of new digital assemblages challenges critical practice to reconsider the longstanding alignment of photography with representations of an existing reality, in relation to the status of the photographic message as a projection of desire. Barthes' *Camera Lucida* includes a single architectural image: Charles

Clifford's photograph of the Alhambra, Grenada, produced between 1854-1856. The represented building features 'crumbling Arab decoration' – the Alhambra being, of course, the formerly Moorish district of Grenada. From this image, Barthes takes a desire to dwell: 'it is quite simply *there* that I should like to live'.[43] However, he goes on to state that, 'looking at these landscapes of predilection, it is as if *I were certain* of having been there or going there'.[44] Photography of place, for Barthes, brings about both past and future certainties. The rendering appropriates this function of the photographic message, and renders it a function of will.

Conclusion: the Absent Centre.

My prime critical tool has been the interrogation of computer generated images in the light of various configurations of indexicality, some straightforward, some perverse. If indexicality is the key property of the photographic image that enables it to embody a truth function – its role as proof, as trace – then the photography-like images produced by digital prototyping technologies manifest the semblance of certainty as the root of a similar form of truth function. If one can say 'in this projected building, all algorithms support its structurally integrity, its construction appears to be cost effective, and audience/market responses to the visualisations are positive', then, by virtue of uncritical acceptance of its machinic origins, it comes to embody a form of truth. Consensus thereby proves the most important outcome of the three functions of the digital modelling process – structural integrity, cost, and market/social reception.

Margaret Olin, exploring anomalies regarding Barthes' use of photographs in *Camera Lucida*, makes strong claims for the primacy of reception over production:

> the most significant indexical power of the photograph may [...] lie not in the relation between the photograph and its subject, but in the relationship between the photograph and its beholder, or user, in what I would like to call a "performative index" or "index of identification".[45]

Olin contrasts the primal scene of photography, as it were, in which an image is germinated within the camera, with 'another, equally important moment, the moment of identification.'[46] She undertakes a subtle analysis of how many of Barthes' photographs

in *Camera Lucida* are indexical of an absent referent: it would seem that the identification of a *punctum* in many of the images is cut loose from the actual trace of the identified object in the photograph in question: that which moves the viewer (Barthes) is *not actually there*. The necklace, 'a slender ribbon of braided gold', that apparently transfixes him in his viewing of James Van der Zee's 1926 family portrait, is seen on inspection to be a pearl necklace.[47] However, Olin argues that this does not necessarily subvert the indexical status of the photographic image. It is the power of what Olin calls the "index of identification" that prompts him to identify with details which may be absent.

Camera Lucida contains many such paradoxes and elisions – such complexity reinforces its power as a critical text. The absent centre of the contemporary photographic assemblage underlines the significance of a discourse of absence that runs through the whole history of photography. In the projects under discussion here, that absence takes specific form – the absence of a guarantee of stable economic value with regard to the speculative building industry, and the forced absence of a section of the population of Višegrad against the background of the absence of recognised statehood. Each absence is legible from the rendering under examination, against the operations of an indexical link that reifies a contrary *presence* by the deployment of the machine and its apparent truth function.

Here, Olin's critique supports Latour's reconfiguration of the operations of the laboratory: it could be argued that scientific method, and by extension technological processes, have as their primary function the generation of assent, through processes of identification. Their intended outcome is not the experimental result, or in the case of the camera the image, but the *effects* of such an assemblage: the uncritical perpetuation and acceleration of cycles of production and reception.

Notes

1. James Bridle, 'Waving at the Machines', transcript of presentation to Web Directions South, (2011), available at: http://www.webdirections. org/resources/james-bridle-waving-at-the-machines/ [Accessed 18 April 2013].

2. Paul Virilio, *Speed and Politics*, trans. Mark Polizzotti (Los Angeles: Semiotext(e), 2006).

3. William S. Saunders (ed), *The New Architectural Pragmatism: a Harvard Design Magazine Reader* (Minneapolis: University of Minnesota Press, 2007).

4. Jonathan Glancey, 'Welcome to the Future', Guardian, (27 August 2007), available at: http://www.guardian.co.uk/artanddesign/2007/ aug/27/architecture.chinaarts2008 [Accessed 18 April 2013].

5. Paul Virilio, 'The Kosovo War Took Place In Orbital Space', interview with John Armitage, trans. Patrice Riemens (2000), available at: http://www.ctheory.net/articles.aspx?id=132 [accessed 18 April 2013].

6. Rosalind E. Krauss, 'Notes on the Index: 1', in *The Originality of the Avant Garde and Other Modernist Myths* (Cambridge, MA: MIT press, 1986), 198.

7. K. Michael Hays, 'Ideologies of Media and the Architecture of Cities in Transition', in A. Graafland and D. Hauptmann (eds), *Cities in Transition*, (Rotterdam: 010 Publishers, 2001), 262-73.

8. Rory Hyde, 'Historian of the present: Wouter Vanstiphout', interview with Vanstiphout, in Australian Design Review, 12 Aug 2011, available at: http://www.australiandesignreview.com/features/2313-historian-of-the-present-wouter-vanstiphout [accessed 18 April 2013].

9. Marshall Bermann, *All that is Solid Melts into Air* (London: Verso, 1983).

10. Niki May Young, 'Football fans snap up luxury Highbury Stadium development apartments', in *World Architecture News*, (18 Aug 2008), available at: http://www.worldarchitecturenews.com/index.php?fuseaction=wanappln.projectview&upload_id=10219 [accessed 18 April 2013].

11. Roland Barthes, *Camera Lucida*, (London: Vintage, 1993).

12. Tor Lindstrand, interviewed by Heather Ring, in 'Architecture's Second Life', *Archinect*, (9 January 2007), available at: http://archinect.com/features/article/47037/architecture-s-second-life [accessed 20 April 2013].

13. Ibid.

14. Vilém Flusser, *Towards a Philosophy of Photography* (London, Reaktion: 2000), 31.

15. Bruno Latour, 'Visualization and Cognition, Drawing Things Together' (2008), available at: www.brunolatour.fr [accessed 02 Sept 2009].

16. Bruno Latour, *We Have Never Been Modern*, trans. C. Porter (Cambridge MA: Harvard University Press, 1993).

17. Latour, 'Visualization and Cognition'.

18. Latour, *We Have Never Been Modern*.

19. Barthes, *Camera Lucida*, 30.

20. Latour, 'Visualization and Cognition'.

21. Flusser, *Towards a Philosophy*, 14.

22. The image is available at: http://www.kustu.com/w2/_media/images:balkans:kamengrad:kamengrad-3d3.jpg [accessed 2 July 2013].

23. See Paul Virilio, *Strategy of Deception*, trans. Chris Turner (London: Verso, 2000); and Virilio, 'The Kosovo War'.

24. Virilio, *Strategy of Deception*, 72.

25. Bojan Aleksov, 'Nationalism in Construction: the Memorial Church of St. Sava on Vračar Hill, Belgrade', in *Balkanologie VII* (2), Dec 2003, available at: http://balkanologie.revues.org/index494.html [accessed 20 April 2013].

26. Ibid., 18.

27. Emir Kusturica, quoted in Ariston Anderson, 'Emir Kusturica on City Building and a New Renaissance', *Huffington Post*, 23 Dec 2011 available at: http://www.huffingtonpost.com/ariston-anderson/emir-kusturica_b_1164222.html [accessed 20 April 2013].

28. Aleksov, 'Nationalism in Construction', 41.

29. Elvira Jukić, 'Kusturica and Dodik unveil Andrić Sculpture in Bosnia', Sarajevo, BIRN, 29 June 2012, available at: http://www. balkaninsight.com/en/article/kusturica-dodik-open-sculpture-of-nobel-winning-writer [Accessed 20 April 2013].

30. Elvira Jukić, 'State Funding for Kusturica's Mini-City Queried', Sarajevo, BIRN, 11 Jan 2012, available at: http://www.balkaninsight.com/en/article/irregularities-in-constructing-kusturica-s-andricgrad-ngo-said [accessed 20 April 2013].

31. United Nations, 'Milan Lukić & Sredoje Lukić (IT-98-32/1) "Višegrad"', (2009), available at: http://www.icty.org/case/milan_lukic_sredoje_lukić/4 [accessed 7 May 2013].

32. Ibid.

33. Jukić, 'Kusturica and Dodik'.

34. Anderson, 'Kusturica on City Building'.

35. Peter Lippman, 'Bosnia-Herzegovina Journal #4: Bratunac, Višegrad, Elections', in *Balkan itness* (2012), available at: http://balkanwitness.glypx.com/journal2012-4.htm [accessed 20 April 2013].

36. Putovani Balkanom, online entry for Višegrad (2012), available at: http://putovatibalkanom.net/node/1727.

37. B92 'Film Director Accused of Demolishing Centuries Old Fortress', (Belgrade, B92 Society, 15 June 2012), available at: http://www.b92.net/eng/news/society-article. php?yyyy=2012&mm=06&dd=15&nav_id=80784; Jukic, 'Kusturica's Building Plans'.

38. M Christine Boyer, *The City of Collective Memory: its Historical Imagery and Architectural Entertainments* (Cambridge, MA: MIT press, 1996), 371.

39. Albert Speer, *Inside the Third Reich* (London: Weidenfeld & Nicolson, 1970).

40. Roland Barthes, 'The Great Family of Man', in *Mythologies* (London, Paladin, 1972).

41. The inclusion of an "Ottoman caravanserai" is the only architectural reference to the multicultural history of the city, but a place of temporary accommodation is no substitute for signs of permanent dwelling. Chillingly, the Caravanserai is represented online by an interactive 3D walkthrough which resembles nothing so much as the kind of video game known as a "first person shooter", bringing the parallels between military, gaming and visualization technologies into stark relief.

42. Vanstiphout, quoted in Hyde, 'Historian of the present'.

43. Barthes, *Camera Lucida*, 39. Emphasis in original.

44. Ibid., 40.

45. Margaret Olin, 'Barthes' Mistaken Identification', in Geoffrey Batchen (ed), *Photography Degree Zero: Reflections on Roland Barthes's Camera Lucida* (Cambridge, MA: MIT Press, 2009), 85.

46. Ibid., 75.

47. Barthes, *Camera Lucida*, 53.

14

The Image as a Networked Interface:
The Textualization of the Photographic Image

Y A E L E Y L A T V A N - E S S E N

Photographs as "Living Images"

IN HIS BOOK *What Do Pictures Want*, William J. Mitchell tries to break away from the perception of an image as an object.[1] He sees the image as an entity with a life of its own:

> Images are like living organisms; living organisms are best described as things that have desires [...] Therefore, the question of what pictures want is inevitable.[2]

Mitchell proposes relating to pictures as to living entities with needs, which we should try to relate to on their own terms. Thus, reference to them should derive from the unique character of the spaces in which they operate and from the historical contexts latent in them,

from learning the meaning of their continuing life and their possible effect and attempting to enquire into the unique voice emerging from them.

The suggestion that we attribute a subjectivity of their own to living images, as opposed to examining them according to the meanings they create, can be seen as sequential to thought rooted in the theories of Nietzsche and Heidegger, and later, in the works of other theoreticians such as Gilles Deleuze and Jean-Luc Nancy, who sought to relate to a work of art using the question of its "being".[3] The image, according to them, has its own being that is not derived from the object it represents. It is not a copy or an imitation of something external to it; it is an autonomous entity in its own right. But at the same time, the existence of the image is always linked to the fact that it is observed by an external subject. The visibility of the image is inherent in its unique visuality and is embedded in the ways it is looked at. I will relate to the photographic image as a "living image" and show the substantial impact of digital technologies on the way photographs "function" and "come to life". In addition, with reference to Mitchell's suggestion that we see the particular visibility of an image as the source of its "life", I will suggest that its "life" stems, in many respects, from methods of distribution and accessibility via Internet and cellular communication platforms that are based on textual mechanisms. These mechanisms are embedded within the pictorial information of the image and inherent in it. I will present the "life" of the photographic image in the context of perceiving it as an entity existing in a network in which economic, political, cultural and social factors largely influence its visibility. I will show, how in different contexts, photographic images become interfaces for a wide range of information, much wider than presented on their surfaces.[4] Although Mitchell is one of the key representatives of the "pictorial turn" in cultural studies, I will suggest seeing textualization as a key factor in the "living" attribute of the photograph as analyzed by him. The living mechanism of the photograph in the digital age is essentially linked to procedures of textualization derived from the unique characteristics of photography's new apparatuses and from the mechanisms of making those photographs visible.

Textualization and visibility mechanisms include many aspects which present a variety of means of "granting life" to the image. I shall begin with an example of a photograph that appeared in Israeli media on the day Israeli soldier Gilad Shalit returned after more than five years in captivity in Gaza. It represents one of the most touching

moments during the release, as Gilad and his father are reunited while Prime Minister Benjamin Netanyahu watches from the sidelines (fig. 1). The photo was published by the Governmental Advertising Bureau and appeared on the front pages of the newspapers and websites that covered the event in Israel. It was part of a government campaign, during the return of Shalit, presenting Prime Minister Netanyahu as a responsible and authoritative leader. One can regard this photograph as a part of the mechanism used by the state to establish its power, as demonstrated by Althusser in his essay 'Ideology and Ideological State Apparatuses'.[5] Althusser points out that ideology, which is the basis of state power, always rests on a "big Other" and grows around it, while the other subjects are defined in relation to it and receive their subjectivity from it. Ideological apparatuses include media organizations such as the press (whether state controlled or otherwise), and function most effectively when their workings are "silent", when their political message is passed off as simple fact. However, the attempt to depict Netanyahu as a "big Other" in this photograph failed to remain a disguised message and responses were soon to come.

The new means of image distribution led to dozens, if not more, of satirical meme versions of the original photo shortly after it was published. They were distributed using social networks, smart phones and email. The consumer of images having access to relevant databases strengthens the potential possibility to implement what is referred to by Roland Barthes as the recalcitrant and anti-authoritarian nature embedded in them.[6] In a spoof of the movie *Forrest Gump*, Netanyahu's image was planted into pictures that were taken from a visual database, available on the Internet, of historical cultural and political events which have played a significant role in the construction of a shared Israeli identity. At a later stage, this series of photos evolved into a more complex dialogue offering a reflexive reading not only of the specific situation of the original photo, but of the photographic act itself. This could be seen, for example, in the use of a photograph that had triggered a great public uproar in Israel about a year before the release of the captive soldier.[7] It showed a soldier having her picture taken with Palestinian detainees whom she has been assigned to guard. The picture was publicly revealed after being published in her Facebook album where she proudly presented it as a source of personal empowerment. The meme using his image (fig. 2) relates to Netanyahu's explicit awareness of the power of media in general, and photography in particular.

Figure 1. Moshe Milner (photographer) Israeli Government Press Office, 2011.

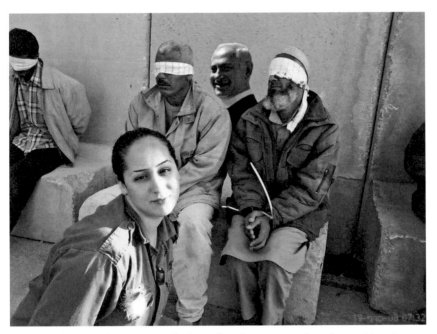

Figure 2. Eden Abergil, Roni Brot. Bibi Gump, http://room404.net/?attachment_id=45642

In response to the series of images distributed on the net, Netanyahu published an image in his Facebook album. In this image he is seen observing his own speech at the session regarding the foundation of a Palestinian state in the UN General Assembly a few months earlier, a speech for which he was even praised by his rivals, not only for his rhetorical capabilities, but also for his mastering of the television medium – for being aware of the power of the photographic image.

For Mitchell, the image always precedes the word, evading complete explanation and often ascribing an idea or a concept before existing vocabulary is able to contain it and create any kind of expression in language for the image. Despite the fact that the memes I have related to are, for the most part, not accompanied by any text, their ironic dimension is a direct outcome of the existence of an implicit text concealed in the original photograph of Netanyahu observing the reunification between father and son. The "life" of the images in the context in which they appear can be seen as being derived, first and foremost, from the resistance of the recipients to receiving the requested "translation" of the image into verbal language. The source of this resistance is in the identification of the visual mechanisms which have been directed towards a reading of the photographic text as one which can clearly be seen as propaganda.[8] The implicit text in the original photograph could be seen as constituting a kind of direct translation, whereas the transformation of the photograph to meme images can be read as an attempt to shift the mechanism of translation from dealing with the representative aspect of the photograph with the various components presented in it, to dealing with the meanings derived from the photographic syntax which is being used. In this way, meaning is given to the contents of the photograph in the wide contexts of its method of creation and distribution.

The dialogue which is created in the back-and-forth movement formed between the meme image and the source images can also be viewed on the basis of an important distinction indicated by Rosalind Kraus in her article 'Photography's Discursive Spaces'.[9] The article demonstrates how the same image, which was photographed at Pyramid Lake in Nevada, functions at first appearance as a photographic model of quiet and mysterious beauty, while its lithographic copy appears as a formalistic representation lacking inspiration. Kraus argues that the reason for this lies in the fact that the two images serve different purposes, and thus, they represent two different discursive regimes.[10] If we relate this to the picture of

Gilad Shalit's return home, the aim of the picture was to unify two regimes of discourse – the personal-emotional and the political – in which the picture was meant to exist, in a kind of dual convergence between subject and ideology as explained by Althusser. By use of the meme, these two discursive regimes are separated from one another, so that the discourse becomes a satirical political text, while being completely severed from the emotional elements which were at the centre of the discursive regime to which the picture was related at its source. The ability to create an illustration of this text repeatedly and in a renewed manner, through a variety of images, retains the meanings of the textuality of the images in their different versions. But at the same time, it creates a new syntax of visual text, constituting a basis for its repetition, which then intensifies the satiric element lying at the basis of the "vitality" of the image. The memes to which I have referred are, as noted, based on mechanisms of textualization which are a function of the closed text-image relations of propaganda. However, beyond the translation mechanisms that I have pointed out, it is important to note that a central and significant component in the "living" mechanisms of the photograph, which constitute the basis of the cited memes, is their availability on the Internet and on web-based and cellular platforms of distribution. The availability of images on the basis of which the memes were prepared, and the speed of their creation and distribution, constitutes a significant element in their viral character and contributes to the variety of versions which developed from the source photograph. If Mitchell relates to the conditions of image existence, we could say that time becomes an essential component in the life of an image. Photographic images have never functioned in empty space, but the age of Internet and cellular devices has enabled minimal reaction time from the moment of image reception to its distribution in its renewed version, and this affects the character of the dialogue between the creators of images and their recipients, who are able to devise a variety of interpretations of the photographed text.[11]

The Photograph and the Database Apparatus – Photography and the Big Picture

The digital era proposes a fundamental change with regard to the interface between mechanisms of photographic life and new systems of textualization. Both Marshall McLuhan and Vilem Flusser, to whom I will relate at length later on, viewed the photographic

medium as heralding an age of information and a telematic
society, even in its analogical period. McLuhan, in his seminal
text *Understanding Media*, writes that the photograph plays an
important part in the transfer from mechanical industrialization to
a graphic era of the electronic man.[12] While Flusser, writing 20 years
after McLuhan, maintains that technical images are a completely
new type of media, and despite the fact that in many respects they
remind one of traditional images, they can definitely be viewed as
a cultural revolution.[13] Several years later, Lev Manovich continues
this line, based on knowledge of the innovative means posed by
digital technologies, and argues for a direct association between
the photographic medium and databases, predicting that this link
portends a significant paradigmatic change.

In his 1998 article 'Data-Base as a Symbolic Form', Manovich
argues that the main characteristic of the digital era is a fundamental
change which he views primarily as a transition from the paradigm of
linear perspective (on which the principle of Camera Obscura is based)
to the perspective of databases.[14] The database functions not only
as a cultural structure that changes its appearance with innovations
in technology, but also as an expression of new cultural conditions.
Databases represent the essence of the digital era because they are
perceived as a way of thought, and not only as vessels for information
preservation. In his book *The Language of New Media* Manovich
points to the parallel development of media technologies, starting
with photography, and progressing to information technologies based
on computerized systems.[15] As these technologies maturate, they
converge into a single technology via the computer. Manovich marks
two central points in time for this linkage. The first dates from the
1830s with the invention of photography and Babbage's development
of the analytical engine. The second marks the invention of the
motion picture in the 1890s, only a few years after Hollerith's data
processing machine was built and used by the American government
for a population census. The linkage between these technologies today
is reflected not only in technological devices that can perform both
functions simultaneously, but rather in their integration, as embodied
in various new Google applications. This link places the visual in new
territories and has deep cultural implications.

In her book, *On Photography*, Susan Sontag points out the
double function of the photographic medium.[16] Her premise,
that anything within our world can serve as camera material, is based
on two essential ways that cameras define reality for an advanced

industrialized society: as a spectacle for the masses, and as an object
of surveillance for sovereigns (by building photographic databases).
Sontag's argument is completely relevant in the post-capitalist era,
in which surveillance exists not only in the context of authority but
expands its boundaries to include giant corporations that control
the information expanse. This is explicit in the genealogy of Google,
but it is valid as well for Facebook, Microsoft and others. In the
following section, I will refer mainly to recent applications developed
by Google and to artistic reactions to them. The examples I present
will demonstrate the novel ways that new photographic apparatuses,
which are related to the concept of the database, redefine the
photographic image.

The creations of photography-based databases are at the core
of Google's current activity. The firm, which started off writing
algorithms for textual search engines in the virtual world, has
become a company deeply invested in developing and producing
photographic techniques and practices in the actual world. As the
Google Earth project focused on mapping Earth through existing
satellite technologies, Google Street View moved on to building
physical "vision machines", which were also used as the platform for
the Google Art Project.[17] The mission Google set for itself in the
visual context is to represent space by producing the "big picture"
of the world, a representation that can be perceived as "Big Optics".[18]
Google presents a new kind of space takeover on a global scale.
The ability to present space using the medium of photography has
become an instrument for Google to deepen its control over global
databases and strengthen its economic, and therefore its cultural
and political power.

The "vision machines" built by Google over the last few years
distinctly exemplify the assertion made by Vilém Flusser. As early as
the 1980s, Flusser rejected the perception of the act of photographing
as representation, and instead argued that it was a conceptual action
which essentially consisted of decoding and re-encoding reality. In
his book *Towards a Philosophy of Photography* he argued that, rather
than perceiving the photographic apparatus as a tool or machine
which affects the physical activity of the user by simulating an action,
we should understand it as having a symbolic function, and as such
producing a simulation of thought.[19] Its purpose is to influence
the way we perceive the world, by enabling the creation of images
that relate to reality, within the predetermined norms and parameters
and the possible permutations. Flusser's perception of the semiotics

of photography, more than creating "traces" of what is real, defines the processing achieved with the apparatus, in whose framework the translation of the visual phenomenon into signs takes place. Thus, the apparatus serves as a means of providing meaning. 'It is not what is shown in a technical image but rather the technical image itself that is the message.'[20] So images, whose source are technical via the apparatus, serve as projections directed outside – and therefore they can play a significant critical role.

> Because technical images are projections [...] they must be decoded not as representations of things out in the world but as signposts directed outward. It is their projector, their program that is the object of criticism. What technical images show, depends on which direction they are pointing. That is to say, their significance is their meaning. In their case, the two coincide. The semantic and the pragmatic dimensions of the technical image are identical.[21]

Flusser wrote this text referring to the photographic apparatus without having been able to predict the future development of digital technologies and their effect on the realm of photography, as we are witnessing at present. Nevertheless, in an analysis of platforms for visual presentation of photographic reality developed by Google, the distinction made by Flusser is fundamental.

Analyzing the new Google photographic apparatuses, it can be argued that these apparatuses – by photographing and representing space – reconstruct this space and create visions of second, third and fourth order that mediate and influence the way it is represented: the driverless cars that are equipped with automatic vision mechanisms; the multiple camera "photographic machines" that enable 360 degrees of vision; software that integrates photographs taken by different cameras; and a set of symbols and textual representation for navigating in the photographed space that interfaces with other visual and textual representation systems of the same space, and with Google's general database. In this context, photographic images do not function autonomously, but rather constitute an integral part of one reservoir of data in which the text and the image function as different levels within a complex structure of data.

A good method to examine the meanings of the use of Google's new photographic tools is to have a look at the critical projects that have been created by various artists which play on or respond

to these meanings. Indeed, we have recently witnessed how artists relate to the new spaces of Google Earth and Google Street View: Among these projects are Jon Rafman's *Nine Eyes*, in which he tries to find frames that refer to photographic genres from the field of artistic photography; *A Series of Unfortunate Events* by Michael Wolf; and *No Man's Land* by Mishka Henner which presents a series of photographs of call-girls in different places in the world; In this context, I relate to two art works which focus on the symbolic function of the Google photographic apparatus. One is Ariel Caine's *After the Bechers* based on photos taken by the apparatus of Google Earth, and the second is *Street Ghosts* by Paolo Cirio, which refers to Google Street View's inclusion of coincidental pedestrians in their visual databases.

Using Google Earth, Ariel Caine presents photographs taken of industrial buildings that were previously documented by Bernd and Hilla Becher as part of their typological research.[22] In these works, we clearly view the ways that meanings of the image derive primarily from the specific use of the photographic apparatus. In general, the new mechanisms of vision which are supplied by the Google Earth application enable an overview whose visual representations in culture exist primarily in relation to virtual reality – it is a view that almost does not exist in relation to "reality" as it is reflected in what we see before us in our daily lives. Viewing structures from above, presents the perspective used in architectural plans which form the language used by urban planners, architects and interior decorators to organize the space they mould and which they control. Caine's choice of images is in contrast to the typological process defined by the Bechers, who used a street-level perspective to photograph the façades of architectural structures – the industrial structures which operated during the First and Second World Wars in Germany – which were taken out of their physical context by the photographs that isolated them from their external environment. In place of the horizontal and categorized view which tries to order existing knowledge, as proposed by the Bechers, Ariel Caine presents an overview, reflecting expanding boundaries of knowledge beyond the limits of the photographed object. In this manner, the factories are presented by means of satellite photographs used by Google, in relation to the geographical spaces in which they are located and operate. Thus, they are presented as part of a larger system of the post-industrial world in which the new methods of vision in their real and virtual contexts serve as central components in a new productive economy. However, like the Bechers,

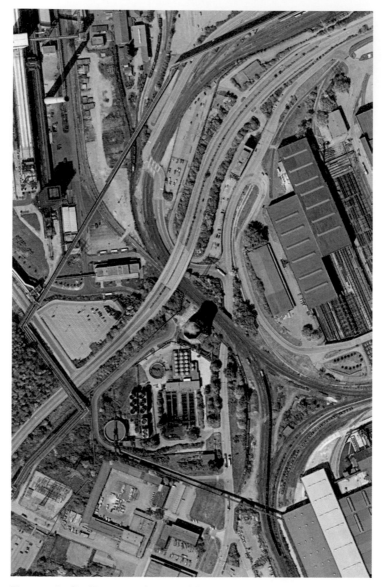

Figure 3. Cooling Tower, Duisburg-Bruckhausen, Germany, 2009.
Pigment Print on Archival Paper, 175cm x 110cm.

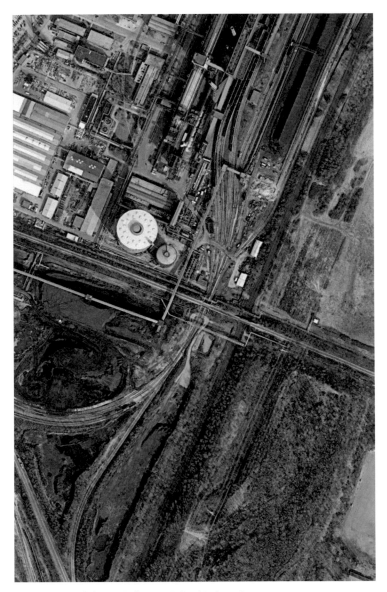

Figure 4. Consolidation Collinery, Gelsenkirchen, Germany, 2011. Pigment Print on Archival Paper, 181cm x 105cm.

who adopted the tactic of fragmentation in creating a series which includes discrete elements fulfilling a predetermined typological logic, Caine creates fragmentation whose source is in the restrictions of the photographic apparatus set up by Google. In order to create visibility of the sites as existing in a high quality photograph printed with high resolution, he has disassembled the chosen frame to hundreds of smaller frames and using a picture processing program, he has combined them in a way which has created the representation of a spatial sequence. The continuum of consciousness achieved in the Becher's work using cataloguing methodologies, has been converted into a creation of sequencing which is meant to respond to a functional need. However, simultaneously, it demonstrates the meanings derived from the use of new photographic apparatuses that dictate the ways in which the real world is mediated through them.

An additional work which arouses interest in the context of Flusser's argument is the work of Paolo Cirio, *Street Ghosts*. In this work, Cirio pasted posters of people who had been photographed by the cameras of the Google Street View project in public spaces in New York, London and Berlin. The posters of low resolution images, returned the photographed subjects to the same locations in real space in which they had been originally photographed. However, the pasted images in public spaces were not exact reproductions of what appeared in the Google application. They had undergone processing which blurred their entire bodies, creating an image which looks like a human shadow. 'These images do not offer details, but the blurred colors and lines on the posters give a gauzy, spectral aspect to the human figures, unveiling their presence like a digital shadow haunting the real world.'[23]

Cirio's work protests against the way in which the photographic apparatus expropriates the right to privacy of those who are photographed in the project. The blurring of the faces of the photographed individuals alludes to a social/ethical code safeguarded by international regulation which requires that Google blur faces with special algorithms which have been written for that purpose. Paolo Cirio protests the distinction made by the lawmakers between the face of the individual and his/her body, a distinction which in his opinion is hypocritical: an individual can also be identified by the rest of his/her body, by the clothes s/he wears or his/her hair.[24] The ability to identify a person is made possible for anyone, which creates a potential for invading someone else's private space. Cirio explains that the motivation for this work derives from the desire to

Figure 5. Street Ghosts, Ebor Street, London, 2012

re-contextualize not only data, but also a conflict. He defines his work as an installation taking place on what he terms a "battlefield" where a war is taking place between private and public interests over control of privacy and personal habit, and in whose framework individuals become victims of the struggle over ownership of information.[25] In reaction to the way the company operates without taking the trouble to receive express permission from the photographed persons for inclusion of their images in the framework of the project, he uses these images without receiving permission from Google. He defines the work as a war for control in which the strong, in his words, are the victors and in this victory is the power to affect the design of relations between the private and the public in our living space.[26] In this work, he investigates the question of who has power: Is it the artists, the giant companies, the legal system, the public or is it the power of technology? The photographed images, in his view, are entities which serve as a reconfiguration of informational power, and they are agents in the struggle resulting from the new possibilities posed by the apparatus which enable these images to exist. Like the work of Caine, this work also demonstrates that the types of life of a photograph stem from the unique character of the spaces within which they operate on

Figure 6. Ebor Street, London (Google Street View), 2008.

Photography and Textualization

I contended above that there was a process in which a new form
of textualization of the photographic image was created. I will
expand on this process in what follows. I also maintain that this new
direction, coming from the association between photographs and
databases, and from the specifications latent in the apparatuses of
digital cameras, requires renewed thought about the characterization
of relations between text and image, as well as about the relevance of
the determination, expressed saliently by Mitchell, of the totality of
the visual turn relative to the linguistic turn which preceded it.

Walter Benjamin was one of the first to assume a theoretical
foundation for the photographic medium, in the first half of the
twentieth century. In many ways, his approach to translation may
be considered a basis for the analysis of the relations between the
photographic image and text, as they are manifested in the realm of
new technologies of photography and information. The photograph,
argued Benjamin, needs a text to accompany it. The relation between
them could be limited to that of similarity but, as with a translation
between one language and another, it should not necessarily aspire to
this. They do not exist in a relationship of mediation with the aim of

transmitting "an utterance" from one language to another, but rather are present in a state in which both serve as source and translation, and they can be identified as 'making both the original and the translation recognizable as fragments of a greater language, just as fragments are part of a vessel.'[27]

It is not necessary for the text to decode the photograph and to transmit what it is saying. That could harm the "deliverability" of the photograph. The role of the text is rather to "broaden" the source in a way that will not supply ready-made interpretations accompanying its appearance and its distribution. It should aspire to simulate a way of directing towards the intended meaning of the photograph, as if it is a text written from within it. Therefore, the text does not transmit content, facts or statements of certainty, but rather something else which can be viewed as a difference or as a remainder which is created in the transmission and in the struggle between the mediums of photography and writing.[28] This determination by Benjamin should be seen in relation to his general argument with regard to photography. In his view, what makes this medium so meaningful is not a unique result of the technical procedures on which it is constructed but rather of the historical, political, social and legal circumstances in which it was created. In the opening paragraphs of his article 'A Short History of Photography', Benjamin presents a symptomatic approach in his analysis of the invention of photography. He views photography as an entanglement of cultural, scientific, political and economic factors, and not as the sole cause of what came in its wake. Indeed, the invention led to significant changes in the possibilities for the existence of modern man which were expressed in their modes of action and their points of view.[29] He argues that, since the development of photography as a significant medium, not only is it present in everything but it also supplies the conditions for the appearance of other things.

In digital photographic platforms, textual information is automatically embedded in every photograph saved on the memory card of the camera, and this constitutes an inseparable component of the Exchangeable image file format (Exif) photo data. In addition to colour values of the pixels which compose picture files, wide textual information is included with regard to various parameters of the photograph as documented by the camera apparatus at the time of the shooting itself. These parameters include *inter alia*, the geographic location based on GPS, the time the picture was taken, the name of the picture, the file format, the camera model and its specifications,

the type of lens, and the parameters connected to the time of exposure, the width of the lens, the speed of the aperture adjuster and others.[30] When feeding photographs into databases additional data may be added which is not received automatically as part of the act of photographing itself. This includes information about the photographer, copyrights, and free text describing the picture and the context in which it was photographed. This is in addition to the systems of categorization and tagging which grant the photograph additional meanings beyond the preliminary information assigned to it. Textual information of the picture is of great significance to the way in which this image is "located" in the databases and in the contexts constructed as a result between the picture and the additional components of the database. However, no less importantly, it also constitutes a central element in the ability of the photograph to be retrieved after its insertion in the database and the resulting future contexts which may be produced with regard to it.

In semiotic terms, one can regard the pictorial databases as a textual structure that contains visual documents. Naming, categorizing, and tagging systems that are attached to the visual documents, or alternatively, computerized vision and artificial intelligence systems, are all based on applying textual mechanisms (algorithms) to the image. Much has been written about the significance of the formulation method of the Google search algorithm, regarding the visibility level of certain sites as opposed to others (meaning the level of their precedence as search results), and about the implications of the manipulative measures used to promote sites.[31] Google's search engine is built according to a certain network structurality, on which a website's connectivity level is based. There is not necessarily a connection between a site's visibility and its cultural relevance or values. What gives specific websites preference over others often depends to a large extent on economic and political factors.

Jacques Rancière points to the connection between visibility and politics. He offers tools of thought to deal with the modified meaning of the photographic act in an era of significant change regarding the visibility of images.[32] Relating to aesthetic space, he argues that nowadays when discussing an image, one cannot relate only to the mechanisms with which an individual spectator perceives it, but should examine it in a much wider context, derived from the new means of image creation, distribution, preservation and accessibility. Politics revolves around 'what is seen and what can be said about it, around what has the ability to see and the talent to speak'.[33]

On the other hand, he asserts, words do not merely prescribe what the images should do as a narrative doctrine; they have the ability to execute political actions. They stipulate the "sensory division" by becoming images.[34]

In Rancière's opinion, the image no longer exists as a category because the distance required to differentiate between an image and reality has been lost. Therefore, one should think of images in terms of the actions they perform. Representation has always been controlled by rules about what is and what is not representable. However, the future of images appears to be a regime in which nothing is unrepresentable. This is not to say that images or reality will disappear. It only signifies a new kind of "imageness". And indeed, the availability of digital cameras and the quality of the photography options in smart phones and pocket cameras substantially influence the meanings derived from photography. In today's world, in which everything seems to be being photographed, the basic practices of making images visible change significantly and become dependent on storing and mining data in the public and private information space. The visibility (and invisibility) referred to by Rancière can be directly connected to database politics. Representation has lost significance. It is what enables the image's visibility that is now significant.

The idea that "everything is becoming photographed" can be seen as another expression of the fixation of the "visual turn" in culture. This is evident in the work of theoreticians such as Guy Debord, Martin Jay, Jonathan Crary and William J. Mitchell who coined the term. Central to this turn is the spatialization of information, which we have been witnessing in recent years, as in Google's space visualization applications. In these applications, the mechanisms for navigating in the representations of visual space are based on a clear and homogeneous system of signs that apply to the represented space a spatial logic that is suitable for computer screens, tablets or smart phones. Google's projects, which create a visual representation of space, can be seen as an alternative for its textual interfaces, and thus as an intensification of this tendency. But at the same time, one can see this as the beginning of its inversion, which can be perceived according to Manovich's argument regarding the replacement of the linear perspective paradigm with the database paradigm, which I referred to above. This change leads to a situation in which the spatial interface of the database applies semiotic structures, based on a textual reading of the visual representation system of the space, and thus re-textualizes the photographic image in which the space

is represented. The "vision machines" built by Google are aimed at turning the space into an information interface that intersects with its parallel information organizing platforms. This mapping process is executed using visual means, but it simultaneously acts as a definite semiotic system that "returns" linguistic dimensions to the space.
In the Google Art Project, this manoeuvre acquires additional aspects. The images documented in the project are transformed – not only into digital photographs, but into something that is closer to text. At the core of the Google Art Project stands a deconstructive apparatus that encourages the visitor to fragmentize space by dividing it into its basic elements, and to reorganize it independently as a simulation of the curatorial practice that it enables.

Making the visual visible by a process of textualization intensifies as picture identification applications and artificial intelligence evolve, and the result is the sophistication of tagging and cataloguing systems. In this context, I would like to comment briefly about the Instagram application, which supposedly contradicts this trend as it is based on communication through images, (not necessarily relying on an accompanying text or tagging system). In my opinion, phenomena like Instagram can be explained in an analogy to Žižek's claim that the return to the real by means of its virtualization constitutes the loss of touch with the real. Instagram's popularity can arguably be seen, *inter alia*, as a reaction to the phenomenon of image textualization becoming rooted in an age of networked databases. The communicative act in Instagram is essentially based on images (despite its tagging attributions), but at the same time it produces visual manipulation that can be perceived as another text. This text is not disguised; it produces some kind of an estrangement in regard to photographing as an act of representation. The purchase of this application by Facebook exemplifies my fundamental argument regarding the new status of the photographic image as the networked interface in a meta-data space, which allows complex visibility through diverse processes of textualization.

The textualization mechanisms undergone by the images stored on a cloud, can be seen as mechanisms of contextualization in real time, enabling the simultaneous existence of different fields of discourse. These processes involve both the creators of the photographs and their recipients in the creation of dynamic interpretation mechanisms, in which political, social, cultural and economic meanings are subordinate to the possibilities and limitations of the storage and retrieval platforms from which they

derive. In this way, a process takes place in which personal contexts are expressed along with wider collective ones, which may lead to a focus on ideological struggles, differing world-views or different frames of reference. This to claim that there is an external interpretive system based on photography, but rather that dynamic systems are assimilated in the way that digital photography is framed, and in the systems within which images are stored. Considered in a digital context, the lack of separation between text and photographed image which Benjamin referred to is structural, and this is what enables the vitality of the image proposed by Mitchell.

Notes

1. William J. Mitchell, *What Do Pictures Want? The Lives and Loves of Images* (Chicago: University of Chicago Press, 2005).

2. Ibid., 11.

3. See Hagi Kenaan, 'The Image's Address: Beyond the Frontal Gaze', *Theory and Criticism*, 37, Autumn 2010 [in Hebrew].

4. I will not refer to the implications of manipulation possibilities on photographic images by the use of image processing software. However, it should be noted that these possibilities have largely influenced the world of photography in the last two decades, and have brought up many questions regarding the validity of photography as means of documentation and the connection between physical and photographed reality.

5. Louis Althusser, 'Ideology and Ideological State Apparatuses', trans. Ben Brewster *Lenin and Philosophy and Other Essays* (New York: Monthly Review Press, 1971), available at: http://www.marxists.org/reference/archive/althusser/1970/ideology.htm [accessed 8 May 2013].

6. Roland Barthes, *Image – Music – Text*, ed. & trans. Stephen Heath (New York: The Noonday Press, 1977), 148.

7. See the article in Haaretz dealing with the case: 'IDF soldier posts images of blindfolded Palestinians on Facebook, from "best time of my life"' (16 Aug 2010), available at: http://www.haaretz.com/news/national/idf-soldier-posts-images-of-blindfolded-palestinians-on-facebook-from-best-time-of-my-life-1.308402 [accessed 6 May 2013].

8. In Althusser's terms, it can be argued that the act of translation operates to a great extent in an analogy to the mode of action of ideology: just as ideology comes into being in concrete history, in accordance with specific conditions, so too is the act of translation culturally conditioned. Its results are not "natural" – assimilated in any translation is the camouflage of it being an interested representation having a concrete aim.

9. Rosalind E. Krauss, 'Photography's Discursive Spaces', in *The Originality of the Avant-Garde and other Modernist Myths* (Cambridge MA: MIT Press, 1985), 131-150.

10. Ibid., 132.

11. The increasing speed of image production and circulation has complex political effects, and arguably alters our experience of the reality of "real time". For a wide ranging discussion of these issues see: Paul Cook, 'Paul Virilio: "The Politics of Real Time"', *Ctheory.net* (16 Jan 2003), available at: http://www.ctheory.net/articles.aspx?id=360 [accessed 6 May 2013].

12. Marshall McLuhan, *Understanding Media: The Extension of Man* (Cambridge, MA: The MIT Press 1964 2001).

13. Vilém Flusser, *Into the Universe of Technical Images* (Minnesota: University of Minnesota Press, 2011).

14. Lev Manovich, 'Data-Base as a Symbolic Form' (1998), available at: http://transcriptions.english.ucsb.edu/archive/courses/warner/english197/Schedule_files/Manovich/Database_as_symbolic_form.htm. [accessed 7 July 2010].

15. Lev Manovich, *The Language of New Media* (Cambridge, MA: The MIT Press, 2001).

16. Susan Sontag, *On Photography* (New York: Farrar, Straus & Giroux, 1977).

17. I choose to avoid a discussion of the wide cultural implications of the choices made in this project concerning institutions and content and the ways the museum collections are presented. These issues are, however, very important, especially in a global project such as this one, which has no competition.

18. The idea of "Big Optics" can be related to what Virilio calls "Grand-Scale Transhorizon Optics" (see: Cook, 'Paul Virilio'). Thinking

in terms of the "big picture" of the world does not remain only in its metaphoric dimensions. As early as 2007, Microsoft launched an application which not only could create panorama photographs, but also, using tailored geographical parameters, could integrate photographs taken at different times and by different people into a visual sequence of geographical space as it is presented on internet. See: TED.com, 'Blaise Aguera y Arcas demos Photosynth' (March 2007), available at: http://www.ted.com/talks/blaise_aguera_y_arcas_demos_photosynth.html [accessed 6 May 2013].

19. Vilém Flusser, *Towards a Philosophy of Photography* (London: Reakton Books, 2000), 36, 83.

20. Ibid., 36.

21. Ibid.

22. For an overview of the Bechers' work, see Blake Stimson, 'The Photographic Comportment of Bernd and Hilla Becher', *Tate Papers* (Spring 2004), available at: http://www.tate.org.uk/download/file/fid/7229 [accessed 7 May 2013].

23. Paolo Cirio, 'Street Ghosts: Artist's Statement' (15 Sept 2012), available at: http://streetghosts.net/index.php#theory [accessed 7 May 2013].

24. Ibid. In this context, it is interesting to consider the reaction of Emmanuel Levinas to the image of the face as it is expressed in his book *Totality and Infinity*. In his view, the meeting with another face is confirmation of the possibility of cracking the ideal space in which abstract thought exists, and of opposing the hegemony of the firmly established philosophical position according to which the field of thought is all-encompassing in principle. See Kenaan, 'The Image's Address'.

25. Cirio, Ibid.

26. Ibid.

27. Walter Benjamin, 'The Task of the Translator', in *Illuminations*, ed. Hannah Arendt, trans. Harry Zorn (London: Pimlico, 1999), 79.

28. Ariella Azoulay, 'Introduction: Unsigned Photograph', in Walter Benjamin, *A Short History of Photography* (Tel Aviv: Babel, 2004) [Hebrew translation].

29. Walter Benjamin, 'A Short History of Photography', trans. William M. Ivins Jr., *Screen*, Vol. 13, No. 1 (1972), 5-26.

30. For a comprehensive and professional detailing of the various parameters, see: Camera & Imaging Products Association, 'Exchangeable image file format for digital still cameras: Exif Version 2.3' (26 April 2010), available at: http://www.cipa.jp/english/hyoujunka/kikaku/pdf/DC-008-2010_E.pdf [accessed 7 May 2013].

[31.] See Konrad Becker & Felix Stalder (eds), *Deep Search: The Politics of Search beyond Google* (Innsbruck: Studien Verlag; Piscataway, NJ: Transaction Publishers, 2009).

[32.] Jacques Rancière, *The Politics of Aesthetics: The Distribution of the Sensible*, trans. Gabriel Rockhill (London: Continuum, 2004).

[33.] Ibid., 12-13. See also Jacques Rancière, *Disagreement: Politics and Philosophy*, trans. Julie Rose (Minneapolis: University of Minnesota, 1999), 57-8.

[34.] Rancière, *Politics of Aesthetics*, 87.

Coda: *Learning to See*

JOHHNY GOLDING

In a book concerned with contemporary photography – or indeed any photography – one might have initially wondered at the minimalist approach we adopted in terms of the actual showing of an image. This has not been because of a dearth in the quality of selection, for which we have been spoiled for choice and for which the best are foreground in the second book of this AHRC series, *The Incomplete Image: Photography in the Age of Thinking Machines*. Moreover, it is not due to the, often all too predictable, tendency to privilege academic writing over the artwork itself, in a bid to give the latter a certain kind of gravitas whilst simultaneously embedding the former with a certain kind of "street-cred". Nor for that matter were we trying to move rapidly away from the, also rather predictable, use of image as though it could act as an "example" of some abstract debating point; or conversely to have a concept staged or represented (somehow) by the image.

It is rather that, in the wake of digital transformation, with its multi-mobile media image-making, image-taking and image dissemination, the very notion of what it means to be "visual" and with it, what it means to "see" is radically disfigured, troubled,

unhinged. With *On the Verge of Photography*, the artists, philosophers, cultural technologists and designers have immersed ourselves in the drawing boards of science and of life for another re-think, another revision, of "image/imaging" and the multiplicity of its being pictured, here, now.

Yes, this includes the modest photo/graph of those initial image pioneers of the early 19th century. But we find, also, that the usual suspects associated with photography – the very act of witnessing, the neat capturing of a history of the past or of a present, or, of any time and place, alongside the question of perception/observation/vantage point/punctum; indeed, the very question of truth not to mention what remains in the realm of the human/social "eye" – all run into difficulty as the newly entrenched variables of a post-industrialised/ quantum mechanics world come to the fore. These variables include, though are not limited to surface-screen ana-materialisms, neither "virtual" nor "real". They include the sensuous life and times – one could say, fractal embodiments – of light, speed, energy, intensity and mass.

Which leads us to another, somewhat curious set of truths about photography in the 21st century: that beauty, taste, indeed image itself no longer rests in the eye of the beholder; it is the beholder, a composite verge of multiversal and networked entanglements. Suddenly photography and the metaphysics to which it has clung for so long, gets a whole, new, deeply troubling, facelift.

BARBARA BOLT is a practicing artist and art theorist in the fields of new materialisms, artistic research, research ethics and aesthetics. Professor Bolt is the Associate Director, Research and Research Training at the Victorian College of Arts at the University of Melbourne. Her many books include *Carnal Knowledge* (with Estelle Barrett, 2012), *Heidegger Reframed* (2010) and *Art Beyond Representation* (2004).

COLLEEN BOYLE is an artist, writer and tutor in Art History at the University of Melbourne. Currently she is researching the relation between new media, perception and cosmology within the context of "outer-space" visuality.

ADAM BROWN is a writer, artist and educationalist whose interests cover the liminal spaces between analogue and digital media and their impact on media studies pedagogy. Currently Curriculum Manager for Media and Digital Arts at Working Men's College, Camden, he was Head of BA Photography and Digital arts at James Cook University, and led Photography and Media Arts at UCA Maidstone.

MIKA ELO is Associate Professor in Media Aesthetics at University of Lapland, Rovaniemi, Finland and advanced researcher at Aalto University, Helsinki. Dr Elo's curatorial, visual artwork and research focuses on the epistemology of artistic research-practice, photography theory and philosophical media theory.

YAEL EYLAT VAN-ESSEN, former Head of the Art Department and Academic Director of the Curatorial Studies Program at the Kibbutzim College of Education, Technology and the Arts, is currently teaching at Tel-Aviv University and in Holon Institute of Technology, where she is the curator of the Research Gallery. Dr Eylat Van-Essen's current research locates visuality through the inter-disciplinary platform of digital culture, new media art and museology.

ANDY FISHER is a lecturer in visual cultures at Goldsmiths College, University of London and a founding editor of the journal *Philosophy of Photography*. His research focuses on photography, photography theory, and their relation to phenomenology, cultural practice and contemporary philosophy. He is currently working on a book about scale and the photographic.

EVE FORREST is Research Fellow at Edinburgh Napier University looking at the impact of ePunditry on print journalism. Dr Forrest is also a Research Associate at the Centre for Research in Media and Cultural Studies, at the University of Sunderland. With broad interests in phenomenological philosophy, cultural anthropology, media studies and ethnography, Eve is interested in exploring and untangling everyday practices online and offline, as well as considering the more sensory and corporeal aspects of photograph taking.

JOHNNY GOLDING is Director of the Centre for Fine Art, (CFAR) and Research Professor of Philosophy & Fine Art at the School of Art, Birmingham Institute of Art and Design (BIAD), Birmingham City University. Her work covers the intersecting landscapes of fine art embedded through the lens of contemporary philosophy and modern physics. Author of several books, articles, videos, she is also Executive Editor of *Zetesis: research generated by curiosity, the International Journal for Fine Art, Philosophy and the Wild Sciences* and co-investigator for the AHRC Photography Research Network.

MARK MARTINEZ is a researcher at the University of Minnesota specializing in Critical Media Studies. His work is concerned with philosophies of communication as developed through the platforms of continental philosophy, historiography, science and technology studies as well as post-humanist and non-human studies. DANIEL PALMER is Senior Lecturer in Art History & Theory at Monash Art, Design and Architecture (MADA). Co-author of *Twelve Australian Photo Artists* (with Blair French, 2009), Dr Palmer's work regularly appears in *Photographies*, *Philosophy of Photography* and *Angelaki*.

DANIEL RUBINSTEIN is the Head of MA Photography at Central Saint Martins, University of the Arts London. Dr Rubinstein's work examines the photographic image in the context of contemporary philosophy, networked and mediated urban environments, modern science and digital platforms within visual culture. Currently he is the editor of journal *Philosophy of Photography* and is the Lead Investigator on the AHRC Photography Research Network.

SUSAN SCHUPPLI is a Senior Lecturer in the Centre for Research Architecture, Goldsmiths. Previously she participated in the Whitney Independent Study Program and completed her MFA at the University of California San Diego. Her creative projects have been exhibited throughout Canada, USA, Australia and Europe. Currently Dr Schuppli is working on an MIT Press book and film on the "Material Witness".

TOM TREVATT is a London based writer and curator. Co-founder of *The Matter of Contradiction*, a long-term collaborative project dealing with the effects of the anthropocene on art and curatorial practice, he is also a Researcher at Goldsmiths, University of London.

MARIA WALSH is Senior Lecturer in Art History and Theory at Chelsea College of Art & Design, University of the Arts London. Her most current monograph, *Art & Psychoanalysis* (I.B. Tauris, 2012), is concerned with the importance of psychoanalysis for artists, art critics and historians throughout the twentieth century. Dr Walsh has contributed numerous chapters and articles on cinematic screen space and intersubjectivity to various books and journals.

About.com Space/Astronomy. International Space Station Astronauts Set New
 Standard For Earth Photography, 2002. Available at: http://space.
 about.com/od/livinginspace/a/astronaut_photo.htm. Adams, Robert.
 Beauty in Photography. Millerton, NY: Aperture, 1981

Adorno, Theodor W. *Aesthetic Theory*. Edited by Rolf Tiedemann and Gretel
 Adorno. London & Boston: Routledge, 1984.

Aleksov, Bojan (2003), 'Nationalism in Construction: the Memorial Church
 of St. Sava on Vračar Hill, Belgrade'. In *Balkanologie* VII(2).
 Dec 2003. 47–72. Available at: http://balkanologie.revues.org/
 index494.html.

Althusser, Louis. 'Ideology and Ideological State Apparatuses'. Translated
 by Ben Brewster. From *Lenin and Philosophy and Other Essays*.
 New York: Monthly Review Press, 1971. Available at: http://www.
 marxists.org/reference/archive/althusser/1970/ideology.htm.

Anderson, Ariston. 'Emir Kusturica on City Building and a New Renaissance'.
 Huffington Post. 23 Dec 2011. Available at: http://www.huffington
 post.com/ariston-anderson/emir-kusturica_b_1164222.html.

Anzieu, Didier. *The Skin Ego (Le Moi-peau)*. Translated by Chris Turner.
 New Haven: Yale University Press, 1989.

Armstrong, Carol. 'Automatism and Agency Intertwined: A Spectrum of
 Photographic Intentionality', *Critical Inquiry*, Vol. 38, No. 4,
 Summer 2012: 705–726.

Azoulay, Ariella. 'Introduction: Unsigned Photograph'. In Walter Benjamin.
 A Short History of Photography. Tel Aviv: Babel. [Hebrew
 translation], 2004.

_____. *The Civil Contract of Photography*. New York & London:
 Zone, 2008.

B92. 'Film Director Accused of Demolishing Centuries Old Fortress'. *B92
 Society*, Belgrade, 15 June 2012. Available at: http://www.b92.net/
 eng/news/society-article.php?yyyy=2012&mm=06&dd=15&nav_
 id=80784.

Balkanom, Putovani. *Entry for Visegrad*, 2012. Available at: http://
 putovatibalkanom.net/node/1727.

Barthes, Roland. 'The Great Family of Man'. *Mythologies*. London:
 Paladin, 1972.

_____. *Image–Music–Text*. Edited and Translated by Stephen Heath. New
 York: The Noonday Press, 1977.

_____. *Camera Lucida*. Reflections on Photography. Translated by Richard
 Howard. New York: Hill and Wang, 1981.

Bataille, Georges. 'The Solar Anus'. In *Visions of Excess: Selected Writings,
 1927–1939*. Edited by Allan Stoekl. Translated by Allan Stoekl et al.
 Minneapolis: University of Minnesota Press, 1985.

Baudrillard, Jean. *Simulations*. Translated by Paul Foss et al. New York:
 Semiotext(e), 1983.

_____. *Symbolic Exchange and Death*. Translated by Iain Hamilton Grant.
 London, California & New Dehli: Sage Publications, 1993.

_____. 'The Vanishing Point of Communication'. In David B. Clarke et
 al (eds). *Jean Baudrillard: Fatal Theories*. Oxon: Routledge, 2009.
 15–23.

BBC Productions. 'The Human Body'. Screened 20 May 1998.

Becker, Konrad & Felix Stalder (eds). *Deep Search: The Politics of Search beyond Google*. Innsbruck: Studien Verlag; Piscataway, NJ: Transaction Publishers, 2009.

Beller, Jonathan. *The Cinematic Mode of Production: Attention economy and the society of the spectacle*. Hanover & London: University Press of New England, 2006.

Belting, Hans. *An Anthropology of Images: Picture, Medium, Body*. Translated by Thomas Dunlap. New Jersey: Princeton University Press, 2011.

Benjamin, Marina. 'Sliding Scales: Microphotography and the Victorian Obsession with the Miniscule'. In Francis Spufford and Jenny Uglow (eds). *Cultural Babbage: Technology, Time and Invention*. London: Faber & Faber, 1996. 99–122.

Benjamin, Walter. 'A Short History of Photography'. Translated by William M. Ivins Jr. *Screen* Vol. 13, No. 1, 1972: 5–26.

_____. 'The Task of the Translator'. In *Illuminations*. Edited by Hannah Arendt. Translated by Harry Zorn. London: Pimlico. 70–82, 1999.

_____. *Selected writings. Vol.2, 1927–1934*. Translated by Edmund Jephcott et al. Edited by Howard Eiland and Michael W. Jennings. London & Cambridge MA: The Belknap Press of Harvard University Press, 2002.

_____. *Selected writings. Vol.3, 1935–1938*. Translated by Edmund Jephcott et al. Edited by Howard Eiland and Michael W. Jennings. London and Cambridge MA: The Belknap Press of Harvard University Press, 2002

_____. *The Work of Art in the Age of its Mechanical Reproducibility and Other Writings on Media*. Edited by Michael W. Jennings et al. Translated by Edmund Jephcott et al. London and Cambridge, MA: The Belnap Press of Harvard University Press, 2008.

Bermann, Marshall. *All that is Solid Melts into Air*. London: Verso, 1983.

Boehm, Gottfried. *Wie Bilder Sinn erzeugen. Die Macht des Zeigens*. Berlin: Berlin University Press, 2007.

Bogost, Ian. *Alien Phenomenology: Or What its Like to be a Thing*. Minneapolis: University of Minnesota Press, 2012.

Bolt, Barbara. 'Unimaginable Happenings: Material Movements in the Plane of Composition'. *Deleuze and Contemporary Art*. Edited by Stephen Zepke and Simon O'Sullivan. Edinburgh: Edinburgh University Press, 2010. 266–285.

Botz-Bornstein, Thorsten. 'What Does it Mean to be Cool?'. *Philosophy Now*, 80, Aug/Sep 2010: 6–8.

Boudon, Philippe. 'The Point of View of Measurement in Architectural Conception: From the Question of Scale to Scale as a Question'. *Nordic Journal of Architectural Research*, 1999. Vol. 12, No. 1: 7–18.

Boyer, M. Christine. *The City of Collective Memory: its Historical Imagery and Architectural Entertainments*. Cambridge, MA: MIT Press, 1996.

Boyle, Coleen. 'The Artist and the Astronaut'. *Meanjin: Fine Writing and Provocative Ideas*, Vol. 59, No. 3, 2000: 201–210.

_____. *Resolution: the Photographic Images of NASA*. Unpublished Master of Arts thesis. Parkville: The University of Melbourne, 2000.

Brenner, Neil. 'Between Fixity and Motion: Accumulation, Territorial
 Organisation, and the Historical Geography of Spatial Scales'.
 Society and Space, Vol. 16, No. 4, 1998: 459–81.
Breton, André. *The Automatic Message, The Magnetic Fields, The Immaculate
 Conception*. Translated by David Gasgoyne et al. London: Atlas
 Press, 1933.
_____. 'First Manifesto of Surrealism [1924]'. Translated by A. S.
 Kline, 2010. Available at: http://www.poetryintranslation.com/
 klineasmanifesto.htm.
Bridle, James. 'Waving at the Machines'. Transcript of presentation to Web
 Directions South, 2011. Available at: http://www.webdirections.org/
 resources/james-bridle-waving-at-the-machines/.
Brassier, Ray. *Nihil Unbound: Enlightenment and Extinction*. Basingstoke &
 New York: Palgrave Macmillan, 2007.
Bredenkamp, Horst. *Theorie des Bild-Akts*. Frankfurt am Main:
 Suhrkamp, 2010.
Broeren, Joost. 'Digital Attractions: Reloading Early Cinema in Online
 Video Collections'. In Pelle Snickars & Patrick Vonderau (eds)
 The Youtube Reader. Stockholm: National Library of Sweden,
 2009. 154–164.
Burnett, Ron. *How Images Think*. Cambridge, MA & London: MIT
 Press, 2004.
Butt, Roland. 'Mrs. Thatcher: The First Two Years'. *Sunday Times*, 3
 May 1981. Available at: http://www.margaretthatcher.org/
 document/104475.
Caffentzis, George. 'Why Machines Cannot Create Value; or, Marx's Theory
 of Machines'. In Davis, J. et al (eds). *Cutting Edge: Technology,
 Information, Capitalism, and Social Revolution*. London:
 Verso, 1997.
Camera & Imaging Products Association. ' Exchangeable image file format for
 digital still cameras: Exif Version 2.3', 26 April 2010.
 Available at: http://www.cipa.jp/english/hyoujunka/kikaku/pdf/DC-
 008-2010_E.pdf.
Carman, Taylor. *Merleau-Ponty*. London: Routledge, 2008.
Carroll, Lewis. *Alice's Adventures in Wonderland and Through the
 Looking-glass*. Oxon: Oxford University Press, 1985.
Cartier-Bresson, Henri. The Visit of cardinal Pacelli (image),
 1938. Available at: http://www.magnumphotos.com/C.
 aspx?VP3=SearchResult&ALID=2TYRYD17HHQQ.
_____. *The Decisive Moment: Photography by Henri Cartier-Bresson*. New
 York: Simon and Schuster, 1952.
Casey, Edward S. *Imagining: a Phenomenological Study*. Bloomington, IN:
 Indiana University Press, 1976.
Catren, Gabriel. 'Outland Empire'. In *The Speculative Turn*. Edited by Levi
 Bryant et al. Melbourne: Re. Press, 2007.
Cavell, Stanley. *The World Viewed*. Cambridge MA: Harvard University
 Press, 1979.
Chevrier, Jean-François. 'The adventures of the picture form in the history of
 photography'. In Douglas Fogle (ed) *The Last Picture Show: Artists
 Using Photography 1960–1982*. Minneapolis: Walker Art Centre,
 2003. 113–28.
Cirio, Paolo. 'Street Ghosts: Artist's Statement'. 15 Sept 2012. Available at:

http://streetghosts.net/index.php#theory.

Clough, Patricia Ticineto, et al. 'Notes Towards a Theory of Affect-Itself.' *Ephemera: Theory & Politics in Organization* 7-1, 2007. Immaterial and Affective Labour: Explored: 15.

Coates, Paul. 'Perception, Imagination, and Demonstrative Reference: A Sellarsian Account'. In Willem A. DeVries (ed). *Empiricism, Perceptual Knowledge, Normativity, and Realism: Essays on Wilfrid Sellars*. Oxon: Oxford University Press, 2009. 63–100.

Thomas Cohnen. *Fotografischer Kosmos: Der Beitrag eines Medium zur visuellen Ordnung der Welt*. Beilefeld: Transcript Verlag, 2008.

Colebrook, Claire. *Ethics and Representation: From Kant to Post-structuralism*. Edinburgh: Edinburgh University Press, 1999.

Cook, Paul. 'Paul Virilio: "The Politics of Real Time"'. *Ctheory.net*. 16 Jan 2003. Available at: http://www.ctheory.net/articles.aspx?id=360.

Coplans, John. 'Concerning Various Small Fires: Edward Ruscha discusses his perplexing publications'. *Artforum*, Vol. 3, No. 5, 1965: 24–25.

Cosgrove, Denis. *Geography and Vision: Seeing, Imagining and Representing the World*. London: I. B. Taurus, 2008.

Costello, Dairmud. 'Automat, Automatic, Automatism: Rosalind Krauss and Stanley Cavell on Photography and the Photographically Dependent Arts'. *Critical Inquiry*, Vol. 38, No. 4, 2012: 819–854.

Cotton, Olive. *Tea Cup Ballet* (image), 1935. Available at: http://www.artgallery.nsw.gov.au/collection/works/218.1980/.

————. *Drainpipes* (image), 1937. Available at: http://nla.gov.au/nla.pic-an12824764.

Critchley, Simon. "With Being-With? Notes on Jean-Luc Nancy's Rewriting of Being and Time., in *SPP*, Vol. 1, No. 1, pp. 53-67. At http://after1968.org/app/webroot/uploads/critchley-nancy-singulier.pdf

Crouch, Ian. 'Building Towns for Literary Native Sons'. *New Yorker*. June 29, 2011. Available at: http://www.newyorker.com/online/blogs/books/2011/06/building-towns-for-literary-native-sons-1.html.

Cruddas, Jon, and Jonathan Rutherford (2010). 'Ethical Socialism'. *Soundings*, No. 44, Spring 2010: 10–21.

Cubitt, Sean, et al. 'Enumerating Photography from Spot Meter to CCD'. *Theory, Culture and Society* [forthcoming 2013].

Cunningham, David. 'The Spectres of Abstraction and the Place of Photography'. *Philosophy of Photography*, Vol. 3, No. 1, Autumn 2012: 195–210.

Cunningham, Nathanial. *Face Value: An Essay on the Politics of Photography*. New York: Working Group, 2012.

Daston, Lorraine & Peter Galison. *Objectivity*, Zone Books, New York, 2007.

DeLanda, Manuel. *War in the Age of Intelligent Machines*. New York: Serve.

————. (2006). *A New Philosophy of Society: Assemblage Theory and Social Complexity*. New York: Continuum, 1991.

————. *Deleuze History and Science*. New York: Atropos Press, 2010.

————. *Philosophy and Simulation: the Emergence of Synthetic Reason*. New York: Continuum, 2011.

de Lauretis, Theresa. *Technologies of Gender: essays on theory, film and fiction*. Bloomington: Indiana University Press, 1987.

Deleuze, Gilles. *Cinema 2; The Time-Image*. Translated by Hugh Tomlinson and Robert Galeta. London: The Athlone Press, 1989.

————. *Negotiations*, 1972–1990. Translated by Martin Joughin.

New York: Columbia University Press, 1990.

_____. *The Logic of Sense*. Translated by Mark Lester. Edited by Constantin V. Boundas. New York: Columbia University Press, 1990.

_____. 'Postscript on the Societies of Control'. 1992, *October*, No. 59, Winter 1992: 3–7.

_____. *Difference and Repetition*. Translated by Paul Patton. London & New York: Continuum, 2004.

Deleuze, Gilles and Félix Guattari. *A Thousand Plateaus: Capitalism and Schizophrenia*. Translated by Brian Massumi. Minneapolis: University of Minnesota Press, 1987.

_____. *What Is Philosophy?* Translated by Hugh Tomlinson and Graham Burchell. New York: Columbia University Press, 1994.

Derrida, Jacques, *On Touching – Jean-Luc Nancy*. Translated by Christine Irizarry. California: Stanford University Press, 2005.

Descartes, René. *Philosophical Writings*. Translated by Elizabeth Anscombe and Peter T. Geach. Great Britain: Thomas Nelson and Sons Limited, 1970.

Doane, Mary Ann. 'The Close-up: Scale and Detail in the Cinema'. *Differences: A Journal of Feminist Cultural Studies*. 2003, Vol. 14, No. 3, Fall 2003: 89–111.

Duchamp, Marcel. 'The Creative Act'. In Robert Lebel. *Marcel Duchamp*. New York: Paragraphic Books, 1959. 77–8.

Edwards, Elizabeth. 'Thinking Photography Beyond the Visual'. In J. J. Long et al. (eds). *Photography, Theoretical Snapshots*. Oxon: Routledge, 2009. 31–49.

El Hadi, Jazairy (ed). *New Geographies 4: Scales of the Earth*. Cambridge MA: Harvard University Press, 2011.

Elkin, James. *Six Stories from the end of Representation: Images in Painting, Photography, Astronomy, Microscopy, Physics and Quantum Mechanics, 1980–2000*. Stanford, CA: Stanford University Press, 2008.

Elo, Mika. 'Digital finger: Beyond phenomenological figures of touch'. *Journal of Aesthetics and Culture*, vol. 4, 2012. (Online) http://aestheticsandculture.net/index.php/jac/article/view/14982.

Engelbert, Arthur. *Global Images: Eine Studie zur Praxis der Bilder*. Bielefeld: Transcript Verlag, 2011.

Fallah-Adl, H., et al. 'Atmospheric Correction', 1995. Available at: http://www.umiacs.umd.edu/labs/GC/atmo/.

Filler, Martin. 'Smash it: who cares?' *New York Review of Books*, 2012. 8 Nov 2012. Available at: http://www.nybooks.com/articles/archives/2012/nov/08/smash-it-who-cares/?pagination=false.

Fisher, Andrew. 'Beyond Barthes: Rethinking the Phenomenology of Photography'. *Radical Philosophy*, No. 148. March/April 2008: 19–29.

_____. 'The Involution of Photography'. *Radical Philosophy*, 2009. No. 157. September/October. 37–46.

Flickr. Explore front page Available at:. http://www.flickr.com/explore/.

Flusser, Vilém. *Towards a Philosophy of Photography*. Gottingen, West Germany: European Photography (1984). Translated by Anthony Matthews. London: Reaktion Books, 2000.

————. *Writings*. Edited by A. Ströhl. Minneapolis: University of Minnesota Press, 2002.

————. *Into the Universe of Technical Images*. Translated by Nancy Ann Roth, Minneapolis: University of Minnesota Press, 2011.

————. 'The gesture of photographing'. Translated by Nancy Roth. *Journal of Visual Culture*, Vol. 10, No. 3, 2011: 279–93.

————. 'Immaterialism'. *Philosophy of Photography*, Vol. 2, No. 2, 2012: 219–225.

Foucault, Michel. 'The Discourse on Language'. Translated by Rupert Swyer. In L. Searle and H. Adams (eds). *Critical Theory Since 1965*. Gainseville FL: University Press of Florida, 1986. 148–162.

Fowkes, Maja and Reuben. '#Occupy Art'. *Art Monthly*, No. 359, September 2012.

Freud, Sigmund (1999). 'Verneinung'. In Anna Freud et al. (eds), *Gesammelte Werke*, Vol. XIV. Frankfurt am Main: Fischer Verlag. 11–15.

Fried, Michael. *Why Photography Matters as Art as Never Before*. New Haven & London: Yale University Press, 2008.

Frohne, Ursula. 'Berührung mit der Wirklichkeit. Körper und Kontingenz als Signaturen des Realen in der Gegenwartkunst'. In Hans Belting et al. (eds). *Quel Corps?* München: Wilhelm Fink Verlag, 2002. 401–26.

Fuller, Matthew. Media Ecologies: Materialist Energies in Art and Technoculture. Cambridge MA: MIT Press, 2005.

Gautrand, Jean-Claude. 'Pictorialist techniques'. In Michel Frizot (ed). *A New History of Photography*. Köln: Könemann, 1998.

Geimer, Peter. 'Self-Generated Images'. In Jacques Khalip and Robert Mitchell (eds). *Releasing the Image: From Literature to New Media*. California: Stanford University Press, 2011. 27–43.

Gibson, Clark, et al. 'Scaling Issues in the Social Sciences: A Report for the International Human Dimensions Programme (IHDP) on Global Environmental Change'. *IHDP Working Paper* No. 1. Bloomington, IN: Indiana University, 1998.

Giere, Ron. *Scientific Perspectivism*. Chicago: The University of Chicago Press, 2006.

Glancey, Jonathan. 'Welcome to the Future'. *Guardian*, 27 August 2007. Available at: http://www.guardian.co.uk/artanddesign/2007/aug/27/architecture.chinaarts2008.

Golding, Johnny. 'Ana-materialism and the Pineal Eye: Becoming Mouth-breast (or Visual Arts After Descartes, Bataille, Butler, Deleuze and Synthia with An "s"'. In P. Baler (ed). *The Next Thing: Art in the Twenty-First Century*. Lanhan, MD: Farleigh Dickenson/Rowan and Littlefield Publishing Group, 2013, 105-120. Earlier version in *Philosophy of Photography*, Vol. 3, No 1, 2012: 99-121.

————. 'Conversion on the Road to Damascus: Minority Report on Art'. In Gest: *Laboratory of Synthesis*. #1. Edited by Robert Garnett and Andrew Hunt. London: BookWorks in collaboration with Kingston University, 2010.

————. 'Fractal Philosophy and the Small Matter of Learning how to Listen (Attunement as the Task of Art)'. In Simon O'Sullivan and Stephen Zepke (eds). *Deleuze and Contemporary Art*. Edinburgh: Edinburgh University Press, 2010, 133-154.

————. 'The Assassination of Time: (or the Birth of Zeta-physics)'. In Hanjo Berressem and Leyla Haferkamp (eds). *Writing History/Deleuzian*

Events. Koln: DAAD, 2009. 132–145.

Gombrich, E. H. *Art and Illusion*. London: Phaidon Press, 1962.

Gosse, Johanna. 'Virtual Panopticons: The Ethics of Observation in the Digital Age'. College Art Association conference. Los Angeles. 22–25 Feb 2012.

Green, David and Joanna Lowry. 'From the presence to the per-formative: Rethinking photographic indexicality'. In David Green (ed). *Where is the Photograph?* Kent and Brighton: Photoworks/Photoforum, 2003. 47–60.

_____. *Stillness and Time; Photography and the Moving Image*. Brighton: Photoworks/Photoforum, 2006.

Gribbin, John R. *In Search of the Multiverse: Parallel Worlds, Hidden Dimensions, and the Ultimate Quest for the Frontiers of Reality*. Reprint edition. Hoboken, NJ: John Wiley & Sons 2010.

Grosz, Elizabeth. 'Histories of the Present and Future: Feminism, Power, Bodies.' *Thinking the Limits of the Body*. Jeffrey Jerome Cohen and Gail Weiss (eds). Albany: State University of New York Press, 2003. 13–24.

_____. *Time Travels: Feminism, Nature, Power*. Next Wave: New Directions in Women's Studies. London: Duke University Press, 2005.

Guentner, Wendelin A. 'British Aesthetic Discourse 1780–1830: the Sketch, the Non-Finito, and the Imagination'. *Art Journal*, Vol. 52, No. 2, 1993: 40–47.

Gunkel, David K. *Thinking Otherwise: Philosophy, Communication, Technology*. Indiana: Purdue University Press, 2011.

Haaretz Service. 'IDF soldier posts images of blindfolded Palestinians on Facebook, from "best time of my life"'. 16 Aug 2010. Available at: http://www.haaretz.com/news/national/idf-soldier-posts-images-of-blindfolded-palestinians-on-facebook-from-best-time-of-my-life-1.308402.

Hansen, Miriam Bratu. 'Of Mice and Ducks: Benjamin and Adorno on Disney'. *The South Atlantic Quarterly*, Vol. 92, No. 2, 1993: 27–61.

_____. 'Benjamin and Cinema: Not a One-Way Street', *Critical Inquiry*, Vol. 25, No. 2, Winter 1999: 306–343.

_____. 'The mass production of senses: Classical cinema as vernacular modernism', *Modernism/Modernity*, Vol. 6, No. 2, 1999: 59–77.

Haraway, Donna. *The Haraway Reader*. New York: Routledge, 2004.

Hays, K. Michael. 'Ideologies of Media and the Architecture of Cities in Transition'. In Arie Graafland and Deborah Hauptmann (eds). *Cities in Transition*. Rotterdam: 010 Publishers, 2001.

Hayles, N. Katherine. *How We Became Posthuman: Virtual Bodies in Cybernetics, Literature, and Informatics*. Chicago: University of Chicago Press, 1999.

Head, Henry and Gordon M. Holmes. 'Sensory disturbances from cerebral lesions'. *Brain*, Vol. 34, Nos. 2–3, 1911: 102–254.

Heidegger, Martin. *Being and Time*. Translated by Edward Robinson and John Macquarrie. Malden, MA & Oxford: Blackwell, 1962.

_____. *Identity and Difference*. Translated by Joan Stambaugh. New York: Harper & Row/ Harper Torch Books, 1969.

_____. *Nietzsche; The Eternal Recurrence of the Same*. Translated by David Farrell Krell. San Francisco: Harper, 1991.

_____. *Poetry, Language, Thought*. Translated by Albert Hofstadter. New
 York: Harper Collins, 2001.
Heilbrun, Françoise. 'Around the World: Explorers, Travelers, and Tourists'.
 In Michel Frizot (ed). *A New History of Photography*. Cologne:
 Könemann, 1998. 149–173.
Herod, Andrew. *Scale*. London and New York: Routledge, 2011.
Hooper, John. 'Serbian film director's "theme park" echoes The Bridge on the
 Drina'. *Guardian*. 11 Oct 2012. Available at: http://www.guardian.
 co.uk/world/2012/oct/11/serb-director-emir-kusturica-visegrad-
 andricgrad.
Hubbard, Phil (2005). 'Space/Place'. In David Atkinson et al. (eds). *Cultural
 Geography: A critical dictionary of key concepts*. London: IB
 Taurus, 2005.
Hubblesite. *Behind the Pictures*. Available at: http://hubblesite.org/gallery/
 behind_the_pictures/.
Hurriyet Daily News. 'Famous Director's Mini-town draws Bosniak
 Ire'. 22 June 2012. Available at: http://www.hurriyetdailynews.
 com/famous-directors-mini-town-draws-bosniak-ire.
 aspx?pageID=238&nID=23731&NewsCatID=381.
Hyde, Rory. 'Historian of the present: Wouter Vanstiphout'. Interview with
 Vanstiphout. *Australian Design Review*. 12 Aug 2011. Available at:
 http://www.australiandesignreview.com/features/2313-historian-of-
 the-present-wouter-vanstiphout.
Ihde, Don. *Postphenomenology: Essays in the Postmodern Context*. Evanston,
 IL: Northwestern University Press, 1993.
_____. *Postphenomenology and Technoscience: The Peking University
 lectures*. New York: SUNY Press, 2009.
Ingold, Tim. *The Perception on the Environment*. London: Routledge, 2000.
_____. *Lines: A Brief History*. Oxon: Routledge, 2007.
_____. 'Bindings Against Boundaries: Entanglements of Life in an Open
 World'. *Environment and Planning*. A 40(8). 1796–1810, 2008.
_____. *Being Alive: Essays on Movement, Knowledge and Description*.
 London: Routledge, 2011.
Introna, Lucas. 'The Enframing of Code'. *Theory, Culture & Society, 2011*,
 Vol. 28, No. 6. 113–141.
Itten, Johannes. *Design and Form: The Basic Course at the Bauhaus*. London:
 Thames and Hudson, 1965.
Jaksic, Bosko. 'Kusturica's Nationalist Remake'. *PressEurop*. 27 June 2012.
 Translated from Politika, Belgrade. Available at: http://www.
 presseurop.eu/en/content/article/2254111-kusturica-s-nationalist-
 remake.
Jenerette, Darrel G., and Jianguo Wu. 'On the Definition of Scale'. *Bulletin of
 the Ecological Society of America*, Vol. 81, No. 1, 2007: 104–05.
Jukić, Elvira. 'Kusturica's Building Plans Get Stony Response from
 Trebinje'. Sarajevo, BIRN. 18 June 2012. Available at: http://www.
 balkaninsight.com/en/article/trebinje-protests-over-kusturica-
 taking-stone-for-mini-town.
_____. 'Kusturica and Dodik unveil Andrić Sculpture in Bosnia'. Sarajevo,
 BIRN. 29 June 2012. Available at: http://www.balkaninsight.com/en/
 article/kusturica-dodik-open-sculpture-of-nobel-winning-writer.
_____. 'State Funding for Kusturica's Mini-City Queried'. Sarajevo, BIRN.
 11 Jan 2012. Available at: http://www.balkaninsight.com/en/article/

irregularities-in-constructing-kusturica-s-andricgrad-ngo-said.

Kant, Immanuel. *Critique of Pure Reason*. Translated by F Max Müller and Marcus Weigelt. London & New York: Penguin, 2007.

Kenaan, Hagi. 'The Image's Address: Beyond the Frontal Gaze'. *Theory and Criticism*, 37. Autumn 2010.

Kentridge William. '"Fortuna": Neither Programme Nor Chance in the Making of Images'. *Cycnos*, Vol. 11, No. 1. 17, June 2008. Available at: http://revel.unice.fr/cycnos/?id=1379.

Kirschenbaum, Matthew G. Mechanisms: *New Media and the Forensic Imagination*. Cambridge, MD: MIT Press, 2008.

Kitchin, Rob, and Martin Dodge. *Code/space: Software and Everyday Life*. Cambridge MD: MIT Press, 2011.

Kracauer, Siegfried. 'Photography'. *In The Mass Ornament: Weimar Essays*. Translated & Edited by Thomas Y. Levin. Cambridge MA: Harvard University Press, 1995. 47–64.

Krauss, Rosalind E. *The Originality of the Avant Garde and Other Modernist Myths*. Cambridge, MD: MIT press, 1985.

———. *Perpetual Inventory*, Cambridge, MD: MIT Press, 2010.

———. *Under Blue Cup*, Cambridge, MD: MIT Press, 2011.

Krois, John M. *Bildkörper und Körperschema*. Edited by Horst Bredenkamp and Marion Lauschke. Berlin: Akademie Verlag, 2011.

Kustu.com. Kamengrad (image), 2011. Available at: http://www.kustu.com/w2/_media/images:balkans:kamengrad:kamengrad-3d3.jpg.

Kwa, Chunglin. 'Painting and Photographing Landscapes: Pictorial Conventions and Gestalts'. *Configurations*, No. 16, 2008: 57–75.

Lacan, Jacques. *The Four Fundamental Concepts of Psycho-analysis*. Edited by Jacques-Alain Miller. Translated by Alan Sheridan. London: Vintage Books, 1998.

Larsen, Jonas. 'Practices and Flows of Digital Photography: An Ethnographic Framework'. *Mobilities*, Vol. 3, No. 1, 2008: 141–160.

Latour, Bruno. ' Mixing Humans and Nonhumans Together: The Sociology of a Door-closer'. *Social Problems*, Vol. 35, No. 3, 1998: 298–310.

———. *We Have Never Been Modern*. Translated by C. Porter. Cambridge MD: Harvard University Press, 1993.

———. *Pandora's Hope: Essays on the Reality of Science Studies*. Cambridge MA: Harvard University Press, 1999.

———. 'Visualization and Cognition, Drawing Things Together', 2008. Available at: www.brunolatour.fr.

Lesmoir-Gordon, Nigel, Will Rood & Ralph Edney. *Introducing Fractals: A Graphic Guide*. London: Icon Books, 2009.

Lauer, David A. and Stephen Pentak. *Design Basics, 4ᵗʰ Edition*. Fort Worth: Harcourt Brace College Publishers, 1990.

Laurier, Eric, et al. 'Driving and passengering: notes on the ordinary organisation of car travel'. *Mobilities*, Vol. 3, No. 1, 2008: 1–23.

Lautrec, Henri de Toulouse. At the Cirque Fernando: The Ringmaster (image), 1888. Available at: http://www.toulouse-lautrec-foundation.org/At-the-Cirque-Fernando–The-Ringmaster.html.

Lenoir, Timothy. 'Makeover: Writing the Body into the Posthuman Technoscape Part Two: Corporeal Axiomatics'. *Configurations*, Vol. 10, 2002: 373–4.

Lingis, Alphonso. *The Imperative*. Bloomington & Indianapolis: Indiana University Press, 1998.

Lippman, Peter. 'Bosnia-Herzegovina Journal #4: Bratunac, Višegrad, Elections'. *Balkan Witness*, 2012. Available at: http://balkanwitness. glypx.com/journal2012-4.htm. [Accessed 20 April 2013].

Lippit, Akira Mizuta. *Atomic Light: Shadow Optics*. Minneapolis & London: University of Minnesota Press, 2005.

Lister, Martin. 'A Sack in the Sand. Photography in the Age of Information'. *Convergence: The International Journal of Research into New Media Technologies*, Vol. 13, No. 3, 2007: 251–274.

Lobel, Michael. 'Scale Models'. *Artforum*, October 2010: 256–60.

Lowry, Joanna. 'Projecting Symptoms'. In Tamara Trodd (ed). *Screen Space: The Projected Image in Contemporary Art*. Manchester: Manchester University Press, 2010. 93–110.

Lund, Katrin. 'Seeing in Motion and the Touching Eye: Walking Over Scotland's Mountains'. *Etnofoor*, Vol. 18, No. 1, 2005: 27–42.

Lury, Celia. *Prosthetic Culture: Photography, Memory and Identity*, London & New York: Routledge, 1998.

Lyotard, Jean-Françoise. *Que peindre?* Adami, Arakawa, Buren/What to Paint? Adami, Arakawa, Buren. Volume 5. Translated by Antony Hudek, Vlad Ionescu and Peter W. Milne. Leuven: Leuven University Press, 2013.

Mandelbrot, Benoît. *The Fractalist: Memoir of a Scientific Maverick*. New York: Pantheon Books, 2012.

_____. *The Fractal Geometry of Nature*. New York: Henry Holt and Company, 1983.

Manovich, Lev. 'Data-Base as a Symbolic Form', 1998. Available at: http:// transcriptions.english.ucsb.edu/archive/courses/warner/english197/ Schedule_files/Manovich/Database_as_symbolic_form.htm.

_____. *The Language of New Media*. Cambridge, MA and London: MIT Press, 2001.

Marien, Mary Warner. 'Topological Surveys and Photography'. In *Photography: A Cultural History*. London: Laurence Hill Publishing, 2002. 115–131.

Massumi, Brian. *A User's Guide to Capitalism and Schizophrenia: Deviations From Deleuze and Guattari*. Cambridge, MA: MIT Press, 1992.

_____. 'The Future Birth of the Affective Fact.' Conference Genealogies of Biopolitics. Montreal: Concordia University, Université du Québec à Montréal, Université de Montréal, 2005.

Maynard, Patrick. 'Scales of Space and Time in Photography: "Perception Points Two Ways"'. In Scott Walden (ed). *Photography and Philosophy: Essays on the Pencil of Nature*. London: Blackwell, 2008. 187–209.

_____. 'Arts, Agents, Artifacts: Photography's Automatisms', *Critical Inquiry*, Vol. 38, No. 4, Summer 2012: 727–745.

McLuhan, Marshall. *Understanding Media, The Extension of Man*. Cambridge, MA: MIT Press, 2001 (1964).

Meillassoux, Quentin. *After Finitude*. Translated by Ray Brassier. London: Bloomsbury Academic, 2010.

Merleau-Ponty, Maurice. Phénoménologie de la perception, Paris: Gallimard. (Phenomenology of Perception. Translated by Paul Kegan. London and New York: Routledge, 1962 (1945).

_____. The Visible and the Invisible. Edited by Claude Lefort. Translated by Alphonso Lingis. Evanston: Northwestern University Press, 1964.

Microsoft (2008). Newsletter, September 2008. Available at: http://www. microsoft.com/belux/interactive/newsletter/08-09/articles/ photosynth.aspx.

Miller, John. 'Double or nothing: On the art of Douglas Huebler'. Artforum, Vol. 44, No. 8, 2006: 220–27.

Mitchell, William J. The Reconfigured Eye. Visual Truth in the Post-Photographic Era. Cambridge, MA & London: MIT Press, 1992.

_____. What Do Pictures Want? The Lives and Loves of Images. Chicago: University of Chicago Press, 2005.

Moores, Shaun. 'Media Uses and Everyday Environmental Experiences: A Positive Critique of Phenomenological Geography'. Participations, Vol. 3, No. 2, 2006: November special edition. Available at: http:// www.participations.org/.

_____. Media, Place and Mobility. London: Palgrave, 2012.

Morton, Tim. Ecology Without Nature. Cambridge, MA: Harvard University Press, 2009.

_____. The Ecological Thought. Cambridge MA: Harvard University Press, 2012.

Müller-Pohle, Andreas (1985). 'Information Strategies'. Translated by Jean Säfken. European Photography, 21, 6:1, 1985: 5–14. Available at: http://equivalence.com/labor/lab_mp_wri_inf_e.shtml.

Munir, Kamal. 'The Social Construction of Events: A Study of Institutional Change in the Photographic Field'. Organization Studies, Vol. 1, No. 26, 2005: 93–112.

Nechvatal, Joseph. Towards An Immersive Intelligence: Essays on the Work of Art in the Age of Computer Technology and Virtual Reality 1993–2006. New York: Edgewise Press, 2009.

Nake, Frieder. 'Surface, interface, subface: Three cases of interaction and one concept'. In Uwe Seifert et al (eds). Paradoxes of Interactivity: Perspectives for Media Theory, Human-Computer Interaction, and Artistic Investigations. Berlin: Transcript, 2008. 92–109.

Nancy, Jean-Luc. The Ground of the Image. Translated by Jeff Fort. Stanford, CA: Stanford University Press, 2005.

_____. Being Singular Plural. Translated by Robert D. Richardson & Anne E. O'Byrne. Stanford, CA: Stanford University Press, 2000.

_____. Corpus. Translated by Richard A. Rand. New York: Fordham University Press.

NASA, 2012. 'Landsat 7'. US Government. Print, 2008.

Nasmyth, James. The Moon: Considered as a Planet, a World, and a Satellite. London: J. Murray, 1874. (Reprinted on demand by Memphis: General Books, 2011).

Negarestani, Reza. Cyclonopedia: Complicity with Anonymous Materials. Melbourne: Re.Press, 2008.

_____. 'Contingency and Complicity'. In The Medium of Contingency. Edited by Robin McKay. Falmouth: Urbanomic, 2011.

_____. 'Globe of Revolution', in Identities: Journal for Politics, Gender and Culture, No. 17, 2011: 25–54.

Newell, Richard. 'Bosnia twenty years on: victims return to Višegrad to bury their dead'. Open Democracy. 20 June 2012. Available at: http:// www.opendemocracy.net/richard-newell/bosnia-twenty-years-on-victims-return-to-vi%c5%A1egrad-to-bury-their-dead.

Newhall, Beaumont. Airborne Camera: The World from the Air and Outer

Space. London: The Focal Press, 1969.

_____. *The History of Photography from 1839 to the Present,* enlarged and revised edition. New York: Museum of Modern Art New York & Bullfinch Press/ Boston, New York & London: Little Brown & Co, 1982. 85–115.

Nietzsche, Friedrich. *The Gay Science: With a Prelude in German Rhymes and an Appendix of Songs.* Edited by Bernard Williams. Translated by Josefine Nauckhoff & Adrian Del Carlo. Cambridge: Cambridge University Press, 2001.

Olin, Margaret. 'Barthes' Mistaken Identification'. In Geoffrey Batchen (ed). *Photography Degree Zero: Reflections on Roland Barthes's Camera Lucida.* Cambridge, MA: MIT Press, 2009.

_____. *Touching Photographs.* Chicago & London: University of Chicago Press, 2012.

Olkowski, Dorothea. 'Time Lost, Instaneity and the Image'. *Parallax,* Vol. 9, No. 1, 2003: 28–38.

Osborne, Peter. 'Photography in an Expanding Field: Distributive Unity and Dominant Form'. In David Green (ed). *Where is the Photograph.* Brighton & Maidstone: photoworks & photoforum, 2003. 63–70.

_____. 'Infinite Exchange: The Social Ontology of the Photographic Image'. *Philosophy of Photography,* Vol. 1, No. 1, Spring 2010: 59–68.

Olympus (2012). 'Olympus OM-D' advertising promotion. Available at: http://olympusomd.com/en-AU/omd/e-m5/overview/features/#/?page=concept.

Palmer, Daniel. 'Emotional Archives: Online Photo Sharing and the Cultivation of the Self'. *Photographies,* Vol. 3, No. 2, 2010: 155–171.

_____. 'The Rhetoric of the JPEG'. In Martin Lister (ed). *The Photographic Image in Digital Culture, Second edition.* London: Routledge, 2013.

_____. 'A Collaborative Turn in Contemporary Photography?' *Photographies,* Vol. 6, No. 1, 2013: 117-127.

Parkes, Don, and Nigel Thrift. 'Putting Time in Its Place'. In Tommy Carlstein (ed). *Making Sense of Time.* New York: J. Wiley, 1978.

Parr, Adrian. *The Deleuze Dictionary: 2nd Revised Edition.* Edinburgh: Edinburgh University Press, 2010.

Penrose, Roger. *The Emperor's New Mind: Concerning Computers, Minds, and the Laws of Physics.* Oxon: Oxford University Press, 1999.

Pettersson, Mikael. 'Seeing What is Not There: Pictorial Experience, Imagination and Non-Localisation'. *British Journal of Aesthetics,* Vol. 51, No. 3, 2011: 279–294.

Photosynth. Press release, August 21 2008. Available at: http://www.microsoft.com/india/msindia/pressreleases/microsoft-live-labs-introduces-photosynth-a-breakthrough-visual-medium/90/.

Pink, Sarah. *Doing Visual Ethnography* (2nd Ed). London: Sage, 2007.

_____. 'Sensory digital photography: rethinking 'moving' and the image'. *Visual Studies,* Vol. 26, No. 1, 2011: 4–13.

_____. 'Amateur Photographic Practice, Collective Representation and the Constitution of Place'. *Visual Studies,* Vol. 26, No. 2, 2011: 92–101.

_____. *Situating Everyday Life.* London: Sage, 2012.

Popper, Karl R. *Objective Knowledge: An Evolutionary Approach.* 7th edition. Oxon: Clarendon Press, 1992.

Purdy, Ray, and Denise Leung (eds). *Evidence from Earth Observation Satellites: Emerging Legal Issues*. Bedfordshire: Martinus Nijhof Publishers, 2012.

Purdy, Ray, and Richard Macrory. 'Satellite Photographs: 21st Century Evidence?' *New Law Journal*, 7 March 2003: 337–38.

Rafman, Jon. 'The Nine Eyes of Google Street View'. *Art Fag City*. 12 August 2009. Available at: http://www.artfagcity.com/2009/08/12/img-mgmt-the-nine-eyes-of-google-street-view.

Rancière, Jacques. *Disagreement: Politics and Philosophy*. Translated by Julie Rose. Minneapolis: University of Minnesota, 1999.

_____. *The Politics of Aesthetics: The Distribution of the Sensible*. Translated by Gabriel Rockhill. London: Continuum, 2004.

_____. *The Emancipated Spectator*. Translated by Gregory Elliot. London & New York: Verso, 2009.

Reichle, Ingeborg and Stefan Siegel (eds). *Maßlose Bilder: Visuelle Ästhetik der Transgression*. München: Wilhem Fink Verlag, 2009.

Relph, Edward. *Place and Placelessness*. London: Pion Ltd, 1976.

Rheinberger, Hans Jorg. *Toward a History of Epistemic Things: Synthesizing Proteins in the Test Tube*. Stanford, CA: Stanford University Press, 1997.

_____. *Historicizing Epistemology: an Essay*. Translated by David Fernbach. Stanford, CA: Stanford University Press, 2010.

Ricoeur, Paul. *Memory, History, Forgetting*. Translated by Kathleen Blamey and David Pellaeur. Chicago & London: University of Chicago Press, 2004.

Ring, Heather. 'Architecture's Second Life'. *Archinect*. 9 January 2007. Available at: http://archinect.com/features/article/47037/architecture-s-second-life.

Roberts, John. 'Photography, Landscape and the Production of Space'. *Philosophy of Photography*, Vol. 1, No. 2, 2010. Autumn 2010. 135–56.

Robertson, Frances. 'Science and Fiction: James Nasmyth's Photographic Images of the Moon'. *Victorian Studies*, Vol. 48, No. 4, Summer 2006: 595–623.

Rogers, Henry. *The Words I Thought I Saw*. In Rogers (ed). *I See What You're Saying: The Materialisation of Words in Contemporary Art*. Birmingham: IKON Gallery/Emerson Press, 2013, pp. 7-19.

Rubinstein, Daniel, and Katrina Sluis. 'A Life More Photographic: Mapping the Networked Image'. *Photographies*, Vol. 1, No. 1, 2008: 9–28.

_____. 'The Digital Image in Photographic Culture; Algorithmic Photography and the Crisis of Representation.' In Martin Lister (ed). *The Photographic Image in Digital Culture*, 2nd Edition. London: Routledge, 2013.

Russo, Julie Levin. 'Show Me Yours: Cyber-Exhibitionism from Perversion to Politics'. *Camera Obscura 73*. Vol. 25, No. 1, 2010: 131–159.

Saunders, William S. (ed). *The New Architectural Pragmatism: a Harvard Design Magazine Reader*. Minneapolis: University of Minnesota Press, 2007.

Schuppli, Susan. 'The Most Dangerous Film in the World.' In Frederik Le Roy, et al (eds). *Tickle Your Catastrophe, Ghent University, the Kask (Ghent Royal Academy of Fine Arts) and Vooruit*. Ghent, 2010. 130–45.

Seamon, David (1979). *A Geography of the Lifeworld*. New York: St Martins Press, 1979.

_____. (2006). 'A Geography of Lifeworld in Retrospect: a Response to Shaun Moores'. *Participations*, Vol. 3, No. 2, 2006. November special edition. Available at: http://www.participations.org/.

Schwartz, Joan and James Ryan (eds). *Picturing Place: Photography and the Geographical Imagination*. London & New York: I. B. Taurus, 2003.

Shannon, Claude E., and Warren Weaver. *The Mathematical Theory of Communication*. Urbana, IL: University of Illinois Press, 1948.

Shaviro, Steven. 'The Pinocchio Theory', 2010. Available at: www.shaviro.com/Blog/?p=561.

_____. Post-Cinematic Affect, Winchester, UK & Washington, USA: Zero Books, 2010.

Shepherd, Eric and Robert McMaster (eds). *Scale & Geographic Inquiry: Nature, Society, and Method*. Malden, MA & Oxon: Blackwell, 2004.

Slater, Don. 'Domestic Photography and Digital Culture'. In Martin Lister (ed). *The Photographic Image in Digital Culture*. London: Routledge, 1995. 129–146.

Smith, Neil. *Uneven Development; Nature, Capital and the Production of Space*. London: Blackwell, 1984.

Snyder, Sean. 'Optics, Compression. Propaganda'. *Art & Research: A Journal of Ideas, Contexts and Methods*. Vol. 2, No. 1, 2008. Summer 2008. Available at: http://www.artandresearch.org.uk/v2n1/snyder.html.

Sobchack, Vivian. 'Phenomenology, Mass Media and Being-in-the-world: An Interview with Vivian Sobchack'. In Marquard Smith (ed). *Visual Culture Studies*. London: Sage, 2008. 115–131.

Solomon-Godeau, Abigail. *Photography at the Dock: Essays on Photographic History, Institutions, and Practices*. Minneapolis: University of Minnesota, 1991.

Sontag, Susan. *On Photography*. New York: Farrar, Straus & Giroux/ Middlesex: Penguin Books 1997 (1973).

Speer, Albert. *Inside the Third Reich*. London: Weidenfeld & Nicolson, 1970.

Stafford, Barbara M. *Visual Analogy: Consciousness as the Art of Connecting*. Cambridge, MA: MIT Press, 2001.

Stallabrass, Julian. 'Sixty billion sunsets'. *In Gargantua: Manufactured Mass Culture*. London: Verso, 1996. 13–39.

Stiegler, Bernard. 'The Discrete Image', in Jacques Derrida and Bernard Stiegler, *Echographies of television*. Cambridge: Polity, 2002.

_____. 'The Tongue of the Eye. What 'Art History' Means'. In Jacques Khalip and Robert Mitchell (eds). *Releasing the Image: From Literature to New Media*. Stanford CA: Stanford University Press, 2001. 221–235.

Steinmann, Kate. 'Apparatus, Capture, Trace: Photography and Biopolitics'. Fillip. Fall 2011. Available at: http://fillip.ca/content/apparatus-capture-trace-photography-and-biopolitics.

Stimson, Blake. 'The Photographic Comportment of Bernd and Hilla Becher'. *Tate Papers*. Spring 2004. Available at: http://www.tate.org.uk/download/file/fid/7229.

Swyngedouw, Eric. 'The Mammon Quest: "Glocalisation", Interspatial Competition and the Monetary Order: The Construction of New Scales'. In M. Dunford and G. Kafkalas (eds). *Cities and Regions in*

the New Europe. London: Belhaven Press, 1992. 39–68.

Tagg, John. 'Mindless Photography'. In Edward Welch et al. (eds). Photography; Theoretical Snapshots. London: Routledge, 2009.

TED.com. 'Blaise Aguera y Arcas demos Photosynth'. March 2007. Available at: http://www.ted.com/talks/blaise_aguera_y_arcas_demos_photosynth.html.

Thrift, Nigel. Non-representational Theory: Space, Politics, Affect. Oxon: Routledge, 2008.

Trachtenberg, Alan (ed). Classic Essays on Photography. New Haven: Leete's Island Books, 1980.

Tuan, Yi-Fu. Space and Place. London: Edward Arnold, 1997.

Umbrico, Penelope, et al. 'Photography Now'. Art in America, No. 3. March 2012: 79–82.

United Nations (2009). 'Milan Lukić & Sredoje Lukić (IT-98-32/1) "Višegrad"', 2009. Available at: http://www.icty.org/case/milan_lukic_sredoje_lukic/4.

Uricchio, William. 'The Algorithmic Turn: Photosynth, Augmented Reality and the Changing Implications of the Image'. Visual Studies, Vol. 26, No. 1, 2011: 25–35.

Van House, Nancy. 'Personal Photography, Digital Technologies and the Uses of the Visual'. Visual Studies, Vol. 26, No. 2, 2011. 124–134.

Vasseleu, Cathryn. 'Touch, digital communication and the ticklish'. Angelaki, Vol. 4, No. 2, 1999. 153–62.

Vergunst, Jo. 'Technology and Technique in a Useful Ethnography of Movement'. Mobilities. Vol. 6, No. 2, 2011: 203–219.

Virilio, Paul. The Vision Machine. Translated by Julie Rose. Bloomington: Indiana University Press, 1994.

_____. Strategy of Deception. Translated by Chris Turner. London: Verso, 2000.

_____. 'The Kosovo War Took Place In Orbital Space'. Interview with John Armitage. Translated by Patrice Riemens, 2000. Available at: http://www.ctheory.net/articles.aspx?id=132.

_____. Speed and Politics. Translated by Mark Polizzotti. Los Angeles: Semiotext(e).

Vakoch, Douglas A. (ed) 2011, Psychology of Space Exploration: Contemporary Research in Historical Perspective. Washington DC: National Aeronautics and Space Administration, 2006.

Van Gelder, Hilde, and David Campany. 'What Has Photography Done?' Still Searching. 31 May 2012. Available at: http://blog.fotomuseum.ch/2012/05/part-1-what-has-photography-done/.

Van Gelder, Hilde and Helen Westgeest. 'Place and Space in Photography: Positioning Toward Virtual Places in Spatial Objects'. In Photography Theory in Historical Perspective: Case Studies from Contemporary Art. Chichester: Wiley-Blackwell, 2011. 112–51.

Waldenfels, Bernhard. Bruchlinien der Erfahrung. Phänomenologie Psychoanalyse Phänomenotechnik. Frankfurt am Main: Suhrkamp, 2002.

Wartofsky, Marx. 'Cameras Can't See: Representation, Photography, and Human Vision'. Afterimage, Vol. 7, No. 9. April 1980: 8–9.

Weins, J. A. (1989). 'Spatial Scaling in Ecology'. Functional Ecology, Vol. 3, No. 4, 1989: 385–97.

Wiley, Chris. 'Depth of focus'. Frieze. No. 143, November–December 2011. 88.

Wollheim, Richard (1980). *Art and its Objects*. Cambridge:
 Cambridge University Press, 1980.
Woods, Ben. *Becoming Becoming Open All Around*. (Unpublished MFA thesis,
 University of Melbourne), 2011.
Wortmann, Volker. *Authentisches Bild und authentisierende Form*. Köln: Von
 Halem Verlag, 2003.
Wunderlich, Filipa Matos. 'Walking and Rhythmicity: Sensing Urban Space'.
 Journal of Urban Design. Vol. 13, No. 1, 2008: 125–139.
Yale Center for Earth Observation, The. 'Filling Gaps in Landsat Etm Images'.
 Connecticut: Yale University, 2011. Available at: http://www.yale.
 edu/ceo%3E.
Young, Niki May. 'Football fans snap up luxury Highbury Stadium
 development apartments'. In *World Architecture News*. 18 Aug
 2008. Available at: http://www.worldarchitecturenews.com/index.
 php?fuseaction=wanappln.projectview&upload_id=10219.
Žižek, Slavoj. 'How to Read Lacan', 1997. Available at: http://www.lacan.com/
 zizhowto.html.
Żmijewski, Artur. 'Applied Social Arts'. *Krytyka Polityczna*, no. 11-12, 2007.
 Available at: http://www.krytykapolityczna.pl/English/Applied-
 Social-Arts/menu-id-113.html.
_____. Forget Fear: Berlin Biennale catalogue 2012.